500 TEAPOTS

Contemporary Explorations of a Timeless Design

500 TEAPOTS 500 TEAPOTS 500 TEAPOT
500 TEAPOTS 500 TEAPOTS 500 TEAPOT
500 TEAPOTS 500 TEAPOTS 500 TEAPOT
500 TEAPOTS 500 TEAPOTS 500 TEAPOT
500 TEAPOTS 500 TEAPOTS 500 TEAPOT
500 TEAPOTS 500 TEAPOTS 500 TEAPOT
500 TEAPOTS 500 TEAPOTS 500 TEAPOT
500 TEAPOTS 500 TEAPOTS 500 TEAPOT
500 TEAPOTS 500 TEAPOTS 500 TEAPOT
500 TEAPOTS 500 TEAPOTS 500 TEAPOT
500 TEAPOTS 500 TEAPOTS 500 TEAPOT
500 TEAPOTS 500 TEAPOTS 500 TEAPOT
500 TEAPOTS 500 TEAPOTS 500 TEAPOT
500 TEAPOTS 500 TEAPOTS 500 TEAPOT
500 TEAPOTS 500 TEAPOTS 500 TEAPOT

500 TEAPOTS

Contemporary
Explorations of a
Timeless Design

Introduction by Leslie Ferrin

LARK BOOKS
A Division of Sterling Publishing Co., Inc.
New York

Editor: **Suzanne J. E. Tourtillott**
Art Director: **Tom Metcalf**
Cover Designer: **Barbara Zaretsky**
Assistant Art Director: **Shannon Yokeley**
Editorial Assistance: **Veronika Gunter, Delores Gosnell**
Special Editorial Assistance: **Rosemary Kast**

Library of Congress Cataloging-in-Publication Data

500 teapots : contemporary explorations of a timeless design / [editor, Suzanne J.E.
Tourtillott] ; introduction by Kathy Triplett.–1st ed.
 p. cm.
 Includes index.
 ISBN 1-57990-341-x (pbk.)
 1. Ceramic teapots–History–20th century–Catalogs.
 I. Title: Five-hundred teapots. II. Tourtillott, Suzanne J. E.

 NK4695.T43 A14 2002
 738'.8–dc21

 2002070078

10 9 8 7 6 5 4 3 2 1

First Edition

Published by Lark Books, a division of
Sterling Publishing Co., Inc.
387 Park Avenue South, New York, NY 10016

© 2002, Lark Books

Distributed in Canada by Sterling Publishing,
c/o Canadian Manda Group, One Atlantic Ave., Suite 105
Toronto, Ontario, Canada M6K 3E7

Distributed in the U.K. by Guild of Master Craftsman Publications Ltd., Castle Place, 166 High Street, Lewes, East Sussex, England
BN7 1XU
Tel: (+ 44) 1273 477374, Fax: (+ 44) 1273 478606, Email: pubs@thegmcgroup.com, Web: www.gmcpublications.com

Distributed in Australia by Capricorn Link (Australia) Pty Ltd.,
P.O. Box 704, Windsor, NSW 2756 Australia

If you have questions or comments about this book, please contact:
Lark Books
67 Broadway
Asheville, NC 28801
(828) 253-0467

Manufactured in China

ISBN 1-57990-341-x

Contents

INTRODUCTION

What have they done to the teapot? Why, some of these don't even hold water! After perusing these multitudes of images, you'll probably agree that many of these clayworkers' imaginations are brewing more than tea. After examining so many slides of teapot submissions, I returned to the studio sure that this idea had been taken as far as it could go. But then, I have thought that before and have been surprised at every turn how the clayworker's ingenuity persists in finding new resolutions that push the envelope even further.

Why has this particular ceramic object attracted so much attention? Perhaps it is a response to its history and the ritual of tea drinking that captures the imagination of both the maker and the collector. We feel so comfortable with this simple little domestic object, and it says so much about our lifestyle and about cultures around the world. With a heritage that dates back to China's Ming Dynasty, the teapot links ancient times with today, and may even thrust them into the future.

But how can such a model of domesticity become so liberated from its utilitarian origins and inspire such subversion? Though many of these pots simply ask to be used or just quietly contemplated, others may engage us in a dialogue about social protest or announce themselves as architecture or vehicles. Others make us laugh or even shock us. Some engage us with their symbolism or seduce us with their delicate quiet surfaces. Others employ animal or human imagery, thereby evoking a strong emotional response, a natural instinct, since the vessel is a powerful metaphor for the body. Both are containers, and the names for the parts of a pot often reference the body, i.e., the lip, neck, belly, and shoulder.

But the teapot has even more parts to consider than a simple vessel. Surely it is this fascination with the juxtaposition of spout, lid, handle, foot, and body that challenges potters, from their first attempts as students, to combine these elements to create a teapot that not only functions well, but has a pleasing sense of design. In addition, all kinds of clay-forming techniques can be utilized on one piece: extruded handles, pinched feet, thrown bodies, slab bases, etc. These all offer the clayworker an unlimited range of possibilities for innovation.

When I scrutinize the contrasts of creative expression in this book, I am reminded of an exercise that I do in my own work that explores the limits of scale. In this exercise I work in a restrained way on a very small detailed teapot with tiny tools and movements, and then on a larger one, using larger tools, with a more gestural approach. This exercise helps me to see more clearly the ways in which a small piece can be made to invoke monumentalism and the way a large piece can still be delicate or exquisite. As I look over the work of these teapot artists, I am made aware of just how much they are stretching the exploration of the teapot's function and meaning. Whether they are working with the limits of function or sending a cultural message, the teapot serves as a challenge to the artists to push their ideas to extremes.

When we think about the nature of clay, how it is transformed from an amorphous blob to these striking forms, we are astounded by the technical virtuosity evident. Though some pieces depend heavily on technique, the best move beyond it, to speak with a strong and convincing voice. Some may seem to lean more toward portraying the fired state of clay, its rock-like nature, whereas others focus more on capturing the clay's tactile qualities and gestural potential. What may, at first, appear to be carelessness may actually be calculated, and, rather than being an abandonment of technical craftsmanship, may be more a push to evoke the memory of wet clay. The unpredictability of the medium plays a role in this dance also. As all clayworkers know, control has to be forsaken at times and the tension between expectation and unpredictability must be embraced.

Whether the work is utilitarian or merely suggests the essence of "teapot," the more successful pieces will ask questions. They may ask to be picked up and poured, or they may ask the viewer to look at the world in an unexpected way. For me, they inspire the hands back into clay, to return to that unpredictable dance between intention and randomness. There will always be room for new ideas.

Kathy Triplett

Kathy Triplett

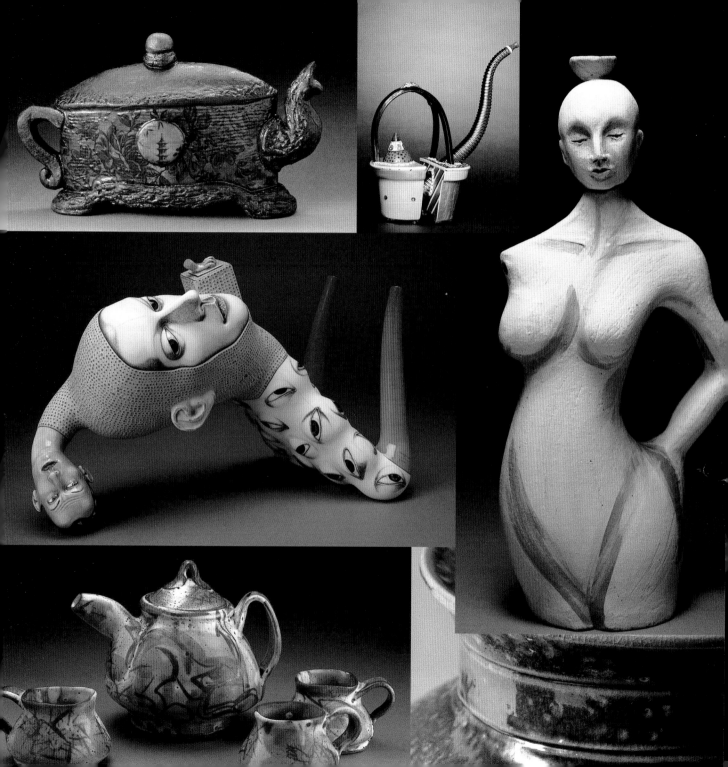

JIM CONNELL
Red Carved Teapot, 1998
13 x 9 x 7 in. (33 x 22.9 x 17.8 cm)
Thrown and carved porcelain;
cone 10 reduction

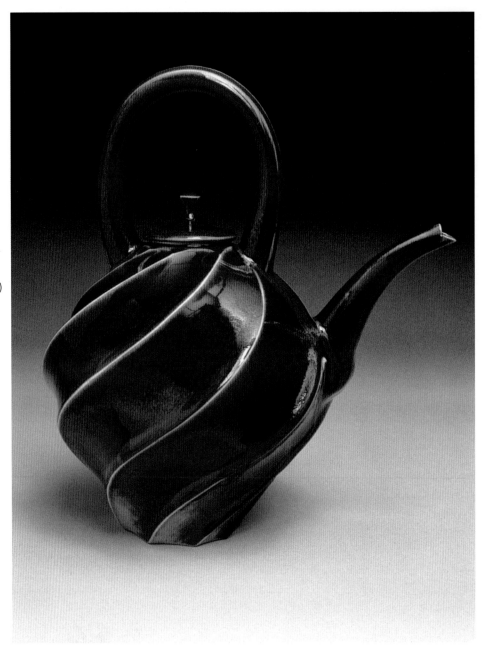

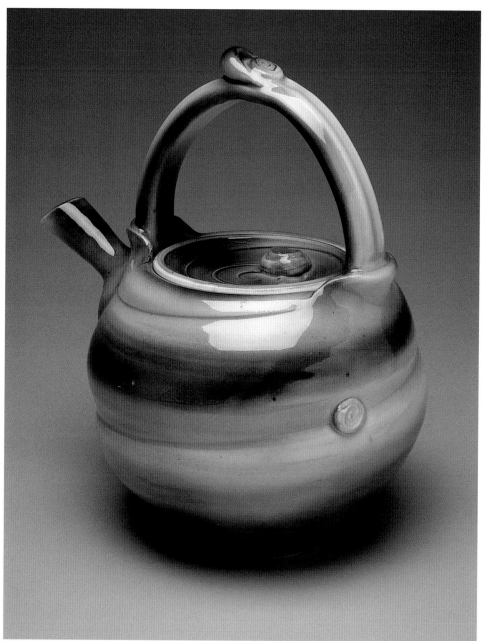

LAUREN KEARNS

Spiral Teapot # 1, 2001

10 x 8 in. (25.4 x 20.3 cm)

Hand-thrown grolleg porcelain clay body; airbrushed color; cone 9

Photo by Lyn Thompson

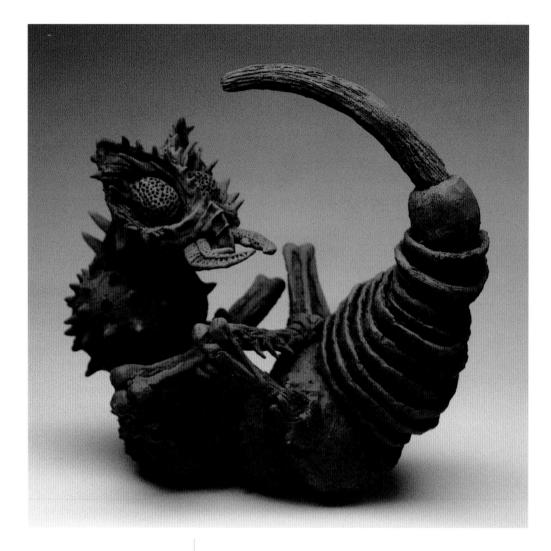

● **CARRIANNE HENDRICKSON**
● *In Its Final Hour*, 1999
● 30 x 32 x 24 in. (76.2 x 81.3 x 61 cm)
● Hand-built; glazed interior and black-stained
 exterior; cone 5
● Photo by artist

The design of this piece was based on my desire to make a teapot
that was not likely to appear functional or even appetizing, but
based instead on its sculptural quality.

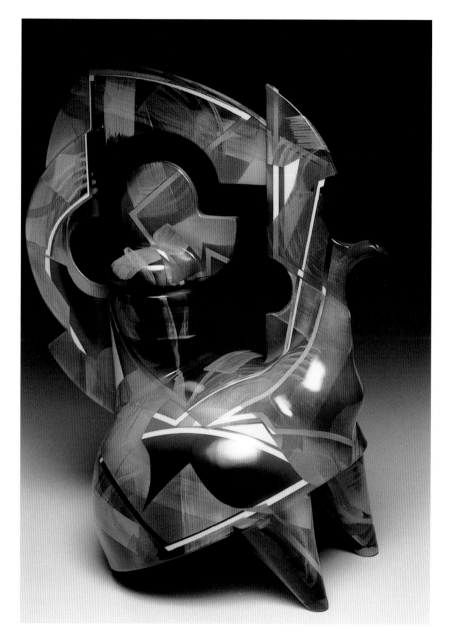

● **TOM HUBERT**
● *Squatting Teapot*, 1999
● 24 x 18 x 13 in. (61 x 45.7 x 33 cm)
● Wheel-thrown whiteware clay; extruded, slab built, and cast hemisphere low-fire; multi-fired underglazes and clear glaze; cone 02 bisque; cone 03 underglaze; cone 04 glaze
● Photo by artist

This large teapot provides a multitude of sculptural variations. I try to animate the form and decorate it to emphasize that energy.

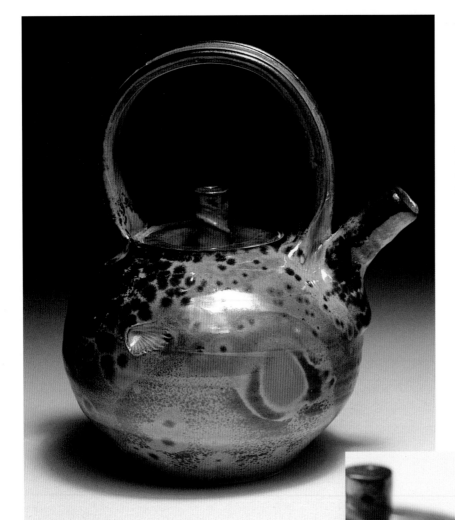

● **MALCOLM DAVIS**
● *Shino Teapot*, 2000
● 6 x 6 x 5½ in. (15.2 x 15.2 x 14 cm)
● Thrown porcelain, altered and assembled; red shino-type carbon trap glaze; bisque cone 010; glaze cone 10 gas heavy reduction

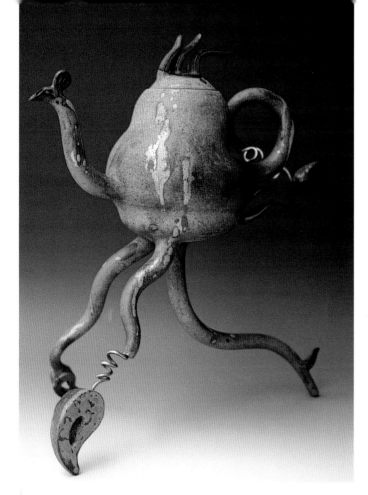

● **HWANG JENG-DAW**
● *Teapot: Walking Alien No. 16*, 2001
● 16½ x 19¾ x 10¼ in. (42 x 50 x 26 cm)
● Thrown and distorted colored clay; high-fire glazes; cone 8 oxidation

Both bronze and clay are flexible, but they are quite different materials. I try to join them together to express the unlimited possibility of both materials.

● **GALEEN MORLEY**
● *Return to the Source*, 2001
● 11¾ x 2¾ x 3¼ in. (30 x 6 x 8 cm)
● Slab-built terra cotta clay; black slip; layered glaze; bisque cone 02; glaze cone 04
● Photo by artist

I am constantly fascinated by glaze and the magic occurring in the contact with flame. The highs and lows between success and failure drive me onwards into uncertainty and adventure.

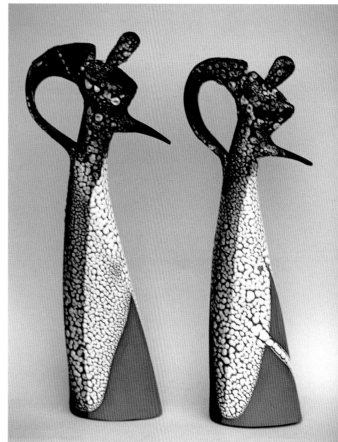

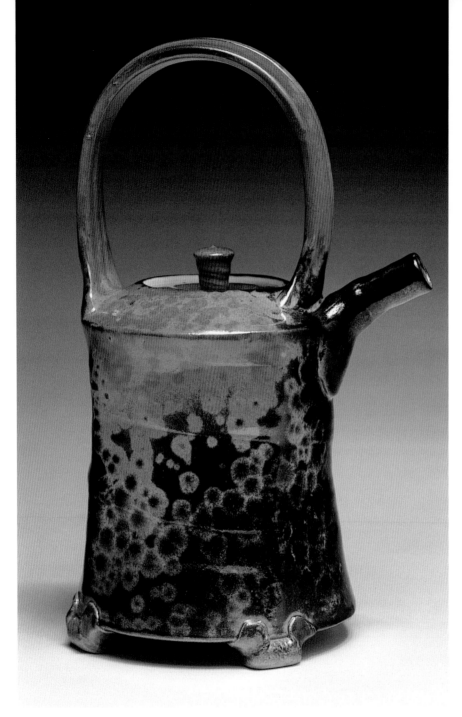

● **MALCOLM DAVIS**
● *Teapot with Feet*, 2000
● 9 ½ x 7 x 6 ½ in. (24.1 x 17.8 x 16.5 cm)
● Thrown porcelain with red shino-type carbon trap glaze; bisque cone 010; glaze cone 10 gas heavy reduction

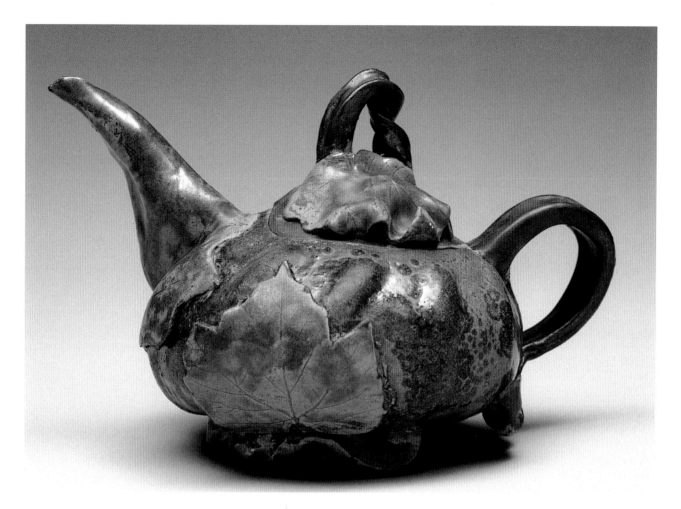

● **AMY LENHARTH**
● *Gourd Teapot*, 2000
● 10 x 10 x 8 in. (25.4 x 25.4 x 20.3 cm)
● Thrown and altered stoneware; shino
and oribe glazes; cone 10; gas reduction
● Photo by Janet Ryan

I use imprints of real leaves to make my
nature-inspired functional pots.

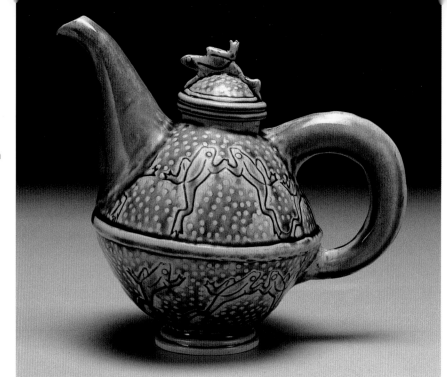

● **BARBARA KNUTSON**
● *Teapot with Frog*, 2000
● 8 x 9 x 5½ in. (20.3 x 22.9 x 14 cm)
● Slab built white stoneware, textured with stamps and rollers before construction; hollow handle; bisque cone 06; glaze cone 10 reduction

● **INGE ROBERTS**
● *Teapot—Rudez-Flowered*, 2001
● 7 x 10 x 4 in. (17.8 x 25.4 x 10.2 cm)
● Slab-built porcelain; impressed surface; stained bisque cone 04; glaze cone 10; oxidation
● Photo by Lee Fatherree

I work with thin porcelain slabs which I shape into my functional and sculptural pieces. The attached details are press molded from my collection of mostly European antique molds.

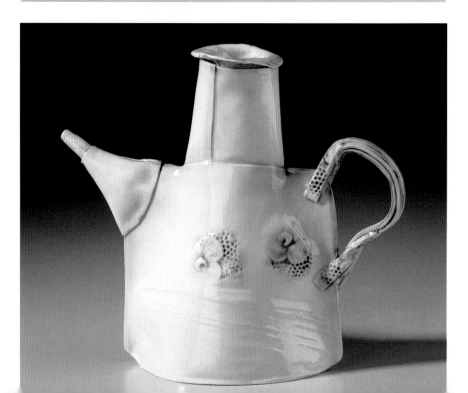

JIM CONNELL

Green Carved Teapot, 1998

17 x 10 x 7 in. (43.2 x 25.4 x 17.8 cm)

Thrown and carved stoneware;
cone 10 reduction

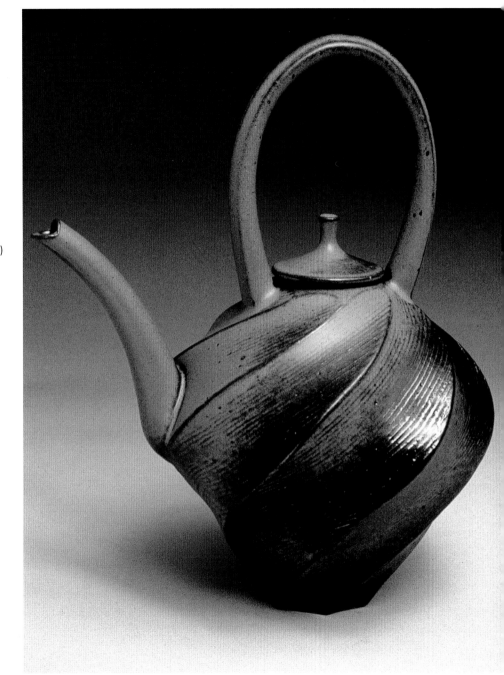

LJUBOV SEIDL
Party in the Gallery, 2001
9 ½ x 10 ½ (24 x 26.5 cm)
Wheel-thrown porcelain stoneware;
underglazes; sgraffito; cone 06; clear
glaze cone 5; gold cone 016

My inspiration comes from the
environment around me, especially
interiors and exteriors of old
houses and gardens.

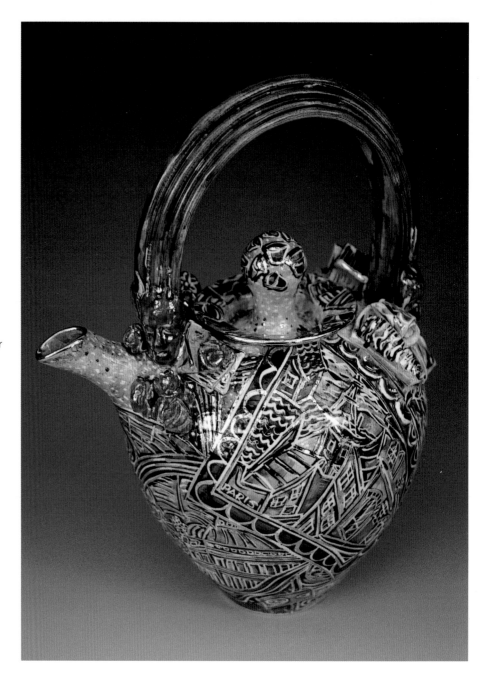

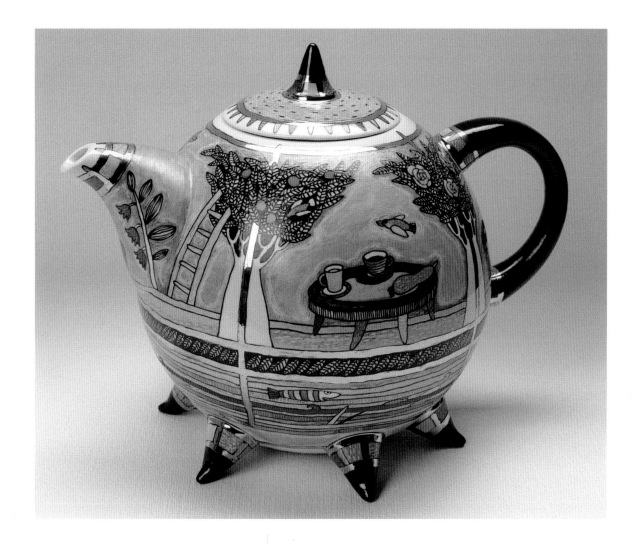

● **MARUTA RAUDE**
● *Tea in the Garden Near River*, 1999
● 8 x 10¼ x 6¾ in. (20.3 x 26 x 17.1 cm)
● Porcelain; bisque 1652°F (900°C); firing 2336°F (1280°C);
 surface painting 750°C (1382°F)
● Photo by Aigars Jukna

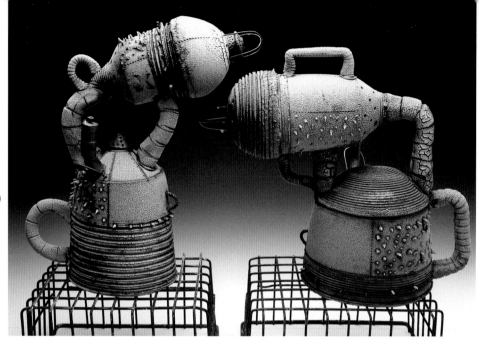

- **TODD SHANAFELT**
- *Dual Devices*, 2001
- 10 x 9 x 5 in. (25.4 x 22.9 x 12.7 cm)
- Wheel-thrown and altered stoneware; oxide; glaze; cone 03 oxidation
- Photo by artist

- **GRAHAM HAY**
- *Roll and Pour*, 2000
- 15 ¾ x 15 ¾ x 6 ¼ in. (40 x 40 x 16 cm)
- Thrown paperclay slab construction; glazes

This teapot is a visual play on dry (parched) earth, farming implements, drought conditions, and farm animals.

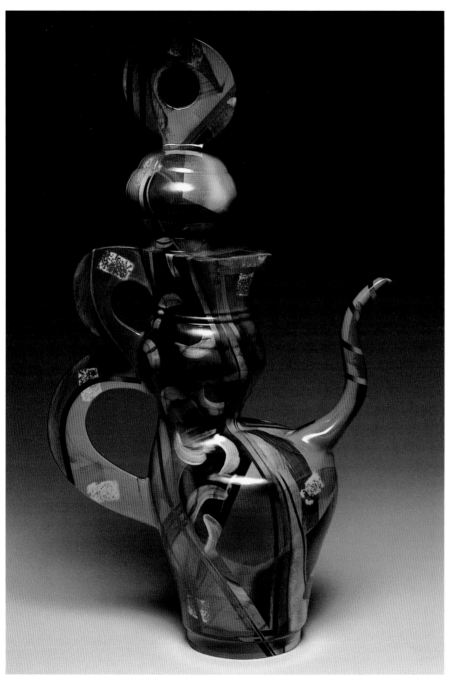

TOM HUBERT
Mad Hatter Teapot, 1999
25 x 11 x 8 in. (63.5 x 27.9 x 20.3 cm)
Wheel-thrown low-fire whiteware and slab parts; multiple-fired underglazes and clear glaze; cone 02 bisque; cone 03 underglaze; cone 04 glaze
Photo by artist

To produce these large teapots, I select various parts, assemble them in a sculptural (and often whimsical) form, then decorate them to enhance these qualities.

● **KAREN KOBLITZ**
● *Globalization # 3*, 2001
● 18 x 11 x 9 in. (45.7 x 27.9 x 22.9 cm)
● Thrown; low-fire underglaze and glaze; carved greenware; bisque cone 04; glaze cone 06

This teapot references Iznik (Turkish) pottery. I call this series "Globalization," because with the Internet and satellite TV we are one global community. The surface decoration (including Pokemon images, which are recognized world-wide) is a "wedding" of the collectible and high-end decorative art.

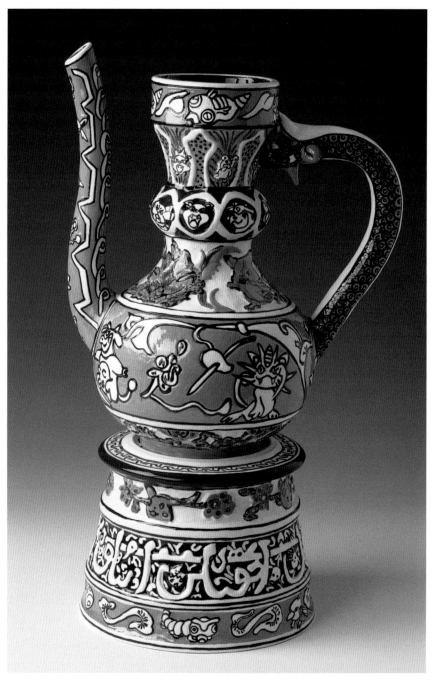

- **LINDA ARBUCKLE**
- *T-Pot: Wisteria Golden,* 1998
- 12 ½ x 4 ½ x 9 ½ in. (31.8 x 11.4 x 24.1 cm)
- Thrown, altered, and constructed terracotta; majolica glaze and decoration; cone 03
- Photo by University of Florida Office of Instructional Resources

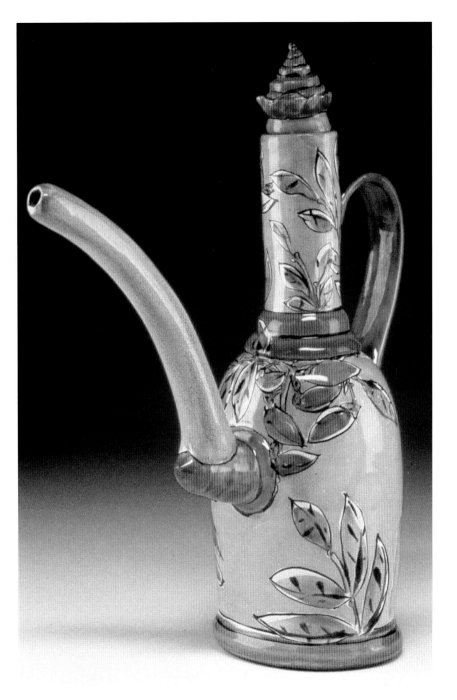

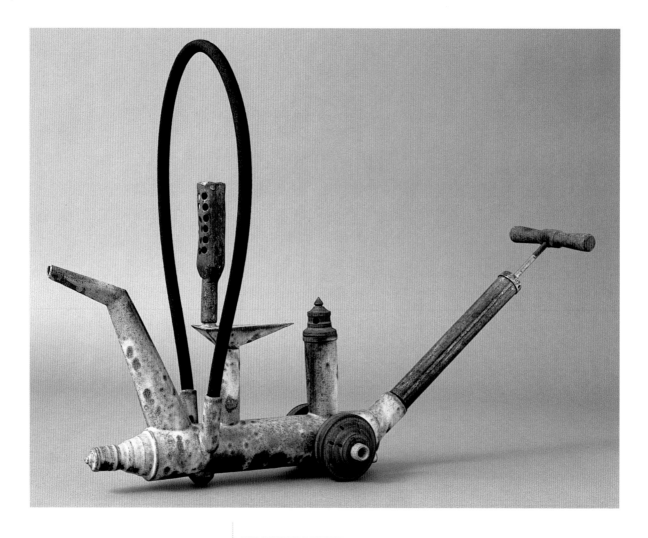

● **OLE MORTEN ROKVAM**
● *"477,"* 2001
● 2 ½ x 11 x 29 ½ in. (6.4 x 28 x 75 cm)
● Thrown and hand-built stoneware; reduction cone 10, 2336˚F (1280˚C); rubber hosing, metal and found
● objects Photo by Halvard Haugerud

● **SUSAN BEINER**
● *"Juicy" Teapot*, 2001
● 6 x 10 ½ x 5 ½ in. (15.2 x 26.7 x 14 cm)
● Slip-cast and hand-built porcelain; bisque cone 06; layered glazes multi-fired cone 6, cone 06, and cone 017
● Photo by Susan Einstein

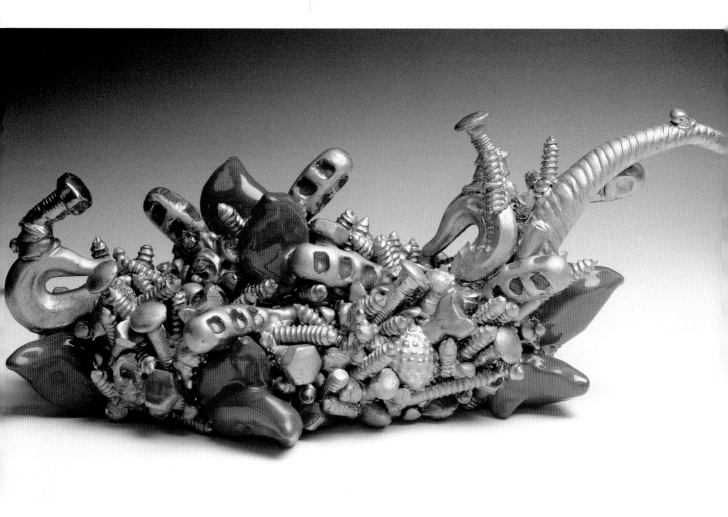

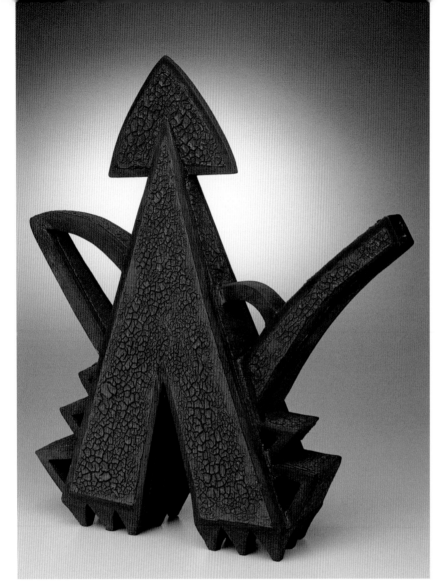

MARCIA KOCKA
Temple to Tea, 1998
18 x 12 x 3 in. (45.7 x 30.5 x 7.6 cm)
Slab built; cone 8 B3 Dar; brown-black clay; low-fire textured glaze; bisque cone 5; glaze cone 05
Photo by Forest Doud

I like a black background on much of my work and usually use a black underglaze, but in order to eliminate that step I tried using a black clay instead, and I like the result. The glaze ("Otto's Texture") separates during firing to reveal the dark clay underneath it.

● **ANNE FALLIS ELLIOTT**
● *Black Oval Teapot*, 2000
● 9 ¾ x 8 ½ x 6 in. (24.8 x 21.6 x 15.2 cm)
● Wheel-thrown and altered; ash glaze;
 cone 6 electric
● Photo by Kevin Noble

Teapots have been my main
focus for many years; my
biggest pleasure is to watch
their shapes change.

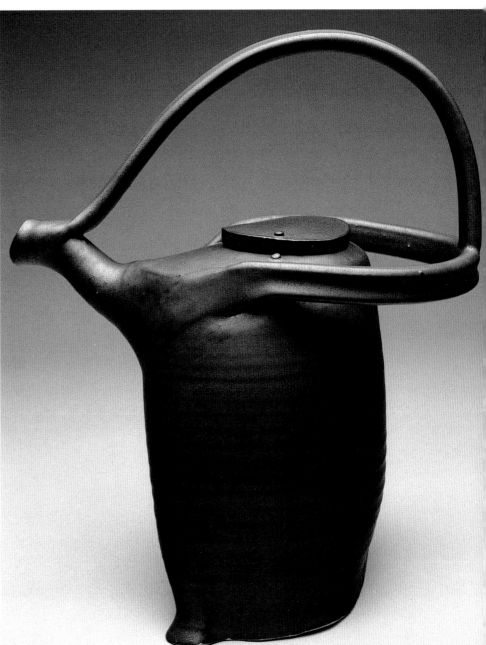

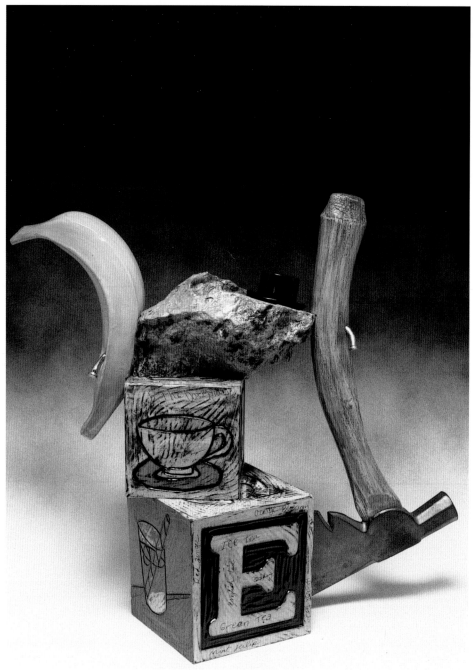

● **ROBIN CAMPO**
● *Chop Pot*, 1999
● 16 x 7 x 15 in. (40.6 x 17.8 x 38.1 cm)
● Slip-cast and assembled white earthen-
 ware; bisque cone 03; glaze and
 underglaze cone 05; luster cone 018
● Photo by artist

JOANNE ANDREWS

The Ugly Duckling Dreamed of Being a Swan, 2001

9 x 6 x 9 in. (22.9 x 15.2 x 22.9 cm)

Wheel-thrown and assembled earthenware;
slips, sgraffito; clear glaze cone 04

Photo by Diane Amato

I enjoy assembling wheel-thrown parts to create unexpected forms.

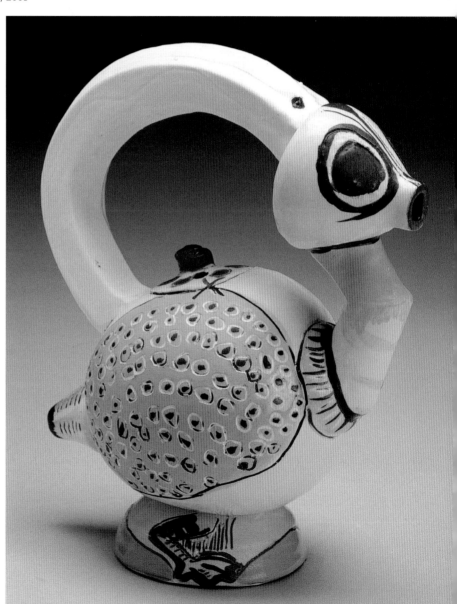

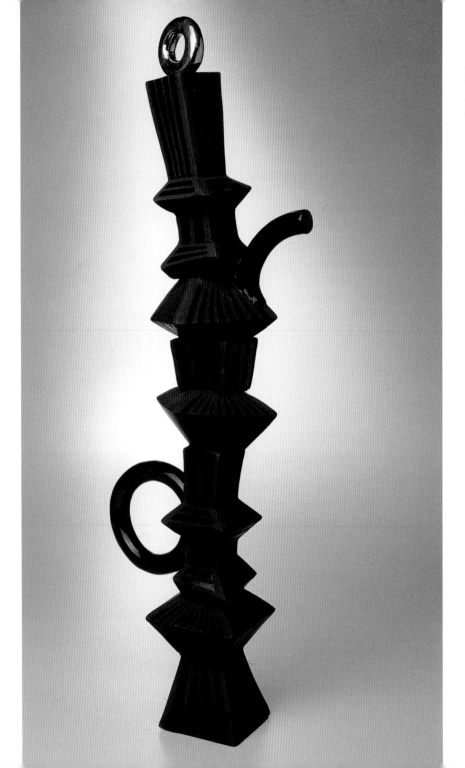

MARCIA KOCKA
Untitled, 2000
23 x 10 x 3 in. (58.4 x 25.4 x 4.6 cm)
Slab-built, low-fire white clay; black underglaze applied to entire piece (except silver circle at top); design masked off and clear glaze applied; colored glaze on handle and spout; bisque cone 04; glaze cone 05; luster cone 018
Photo by Forest Doud

I have a mold of a vase form I designed several years ago which was originally slab-made. I poured several of them, then cut them up and combined some of those with new slab parts. The handle, spout, and circle are extruded. This piece was especially fun to make because it was like building with blocks. I stacked a lot of cut-up shapes from my vase form mold, letting them lean the way they wanted.

HWANG JENG-DAW
Teapot: Born Again No. 3, 2001
13 ¾ x 7 ¾ x 4 ¾ in. (35 x 20 x 12 cm)
Thrown; high-fire glazes; cone 8 reduction

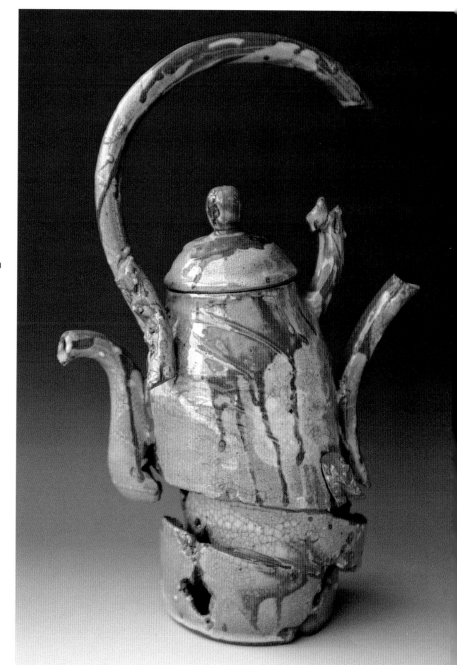

- **SUSAN BEINER**
- *"Graceful Waters" Teapot*, 2000
- 9 x 12 x 6 ½ in. (22.9 x 30.5 x 16.5 cm)
- Slip-cast and hand-built porcelain; bisque cone 06; layered
 glazes multi-fired cone 6, cone 06, and cone 017
- Photo by Susan Einstein

Working in my studio is a constant adventure. Exploring form is pure playfulness and allows me to weave through ideas. My senses come alive, and I delight in the celebration of voluptuous form and succulent color. I am captivated by the complexity of encrusted volume.

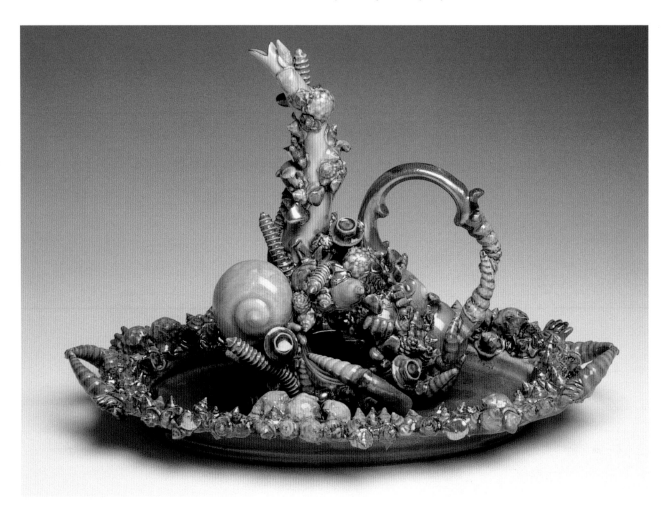

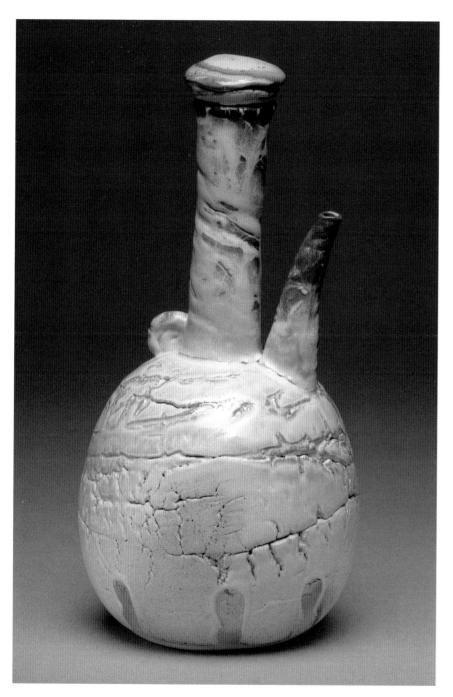

● **MARTA MATRAY GLOVICZKI**
● *Sodafired Teapot*, 2000
● 10 x 4 x 4 in. (25.4 x 10.2 x 10.2 cm)
● Hand-built porcelain; glazes; cone 10 soda
● Photo by Peter Lee

JEANETTE HARRIS

Shiro, 2000

7 ½ x 5 ½ x 4 ½ in. (19 x 14 x 11.4 cm)

Wheel-thrown stoneware; applied clay feet and handle; cone 6 oxidation; transparent glaze

Photo by Tom Holt

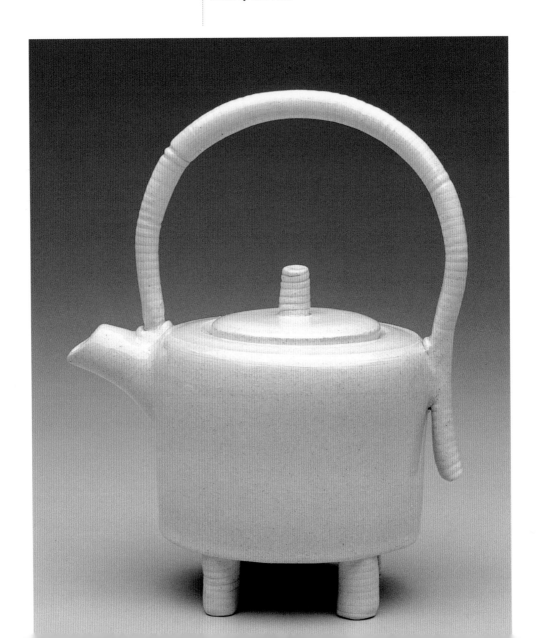

● **PATSY COX**
● *The Amazon Tea Set*, 1999
● 9 ½ x 9 ¾ x 9 in. (24 x 25 x 23 cm)
● Coil-thrown with thrown and pulled additions; burnished terra sigillata; cone 7

My work is about process. It is founded in the tradition and craft of ceramics, but focuses on taking functional forms into sculpture realms.

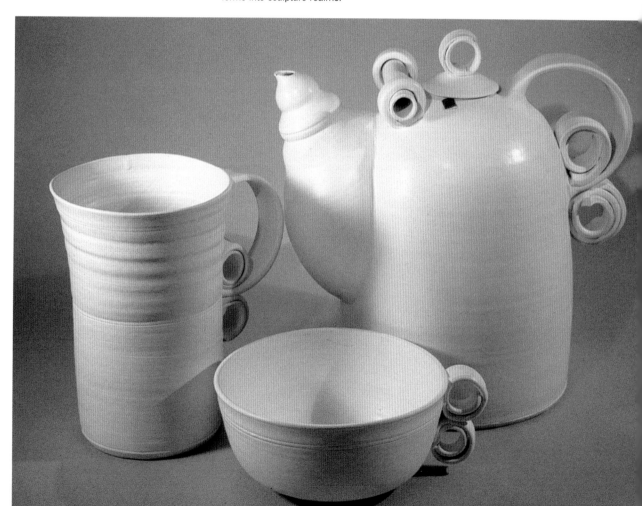

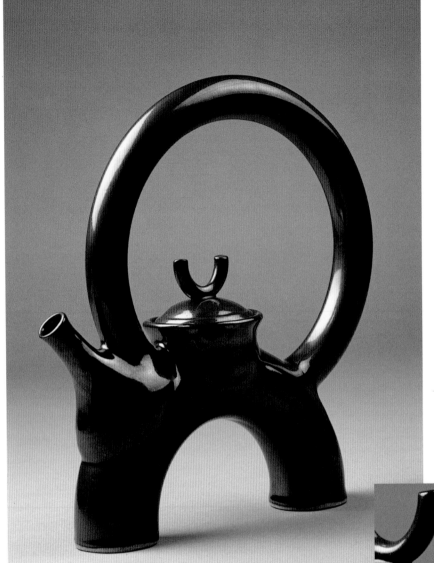

● **COBIE WESSELING**
● *Sharing a Cup*, 2001
● 10 ½ x 10 x 3 in. (26.7 x 25.4 x 7.6 cm)
● Assembled from six thrown parts; light smooth stoneware; Albany-based black satin glaze; glaze cone 10 reduction
● Photo by Laurence Brundrett

The idea for this teapot was developed while I was living in Jamaica in 1992 and collaborating with Chris Arnold, a young Jamaican potter.

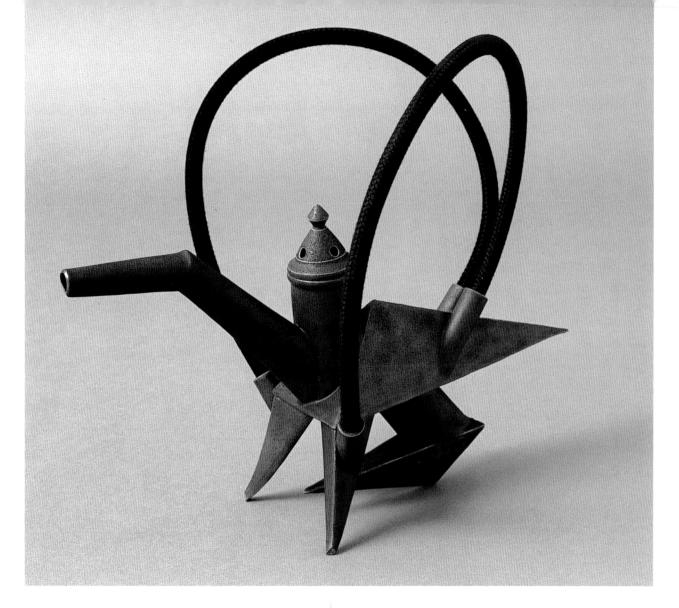

● **OLE MORTEN ROKVAM**
● *"473,"* 2001
● 15¼ x 3½ x 8¼ in. (39 x 9 x 21 cm)
● Glazed and reduction-fired stoneware cone 10,
2336˚F (1280˚C); sandblasted; rubber
hosing attachments
● Photo by Halvard Haugerud

- **JIM NEAL**
- *Joy*, 2001
- 11 x 13 x 6 in. (27.9 x 33 x 15.2 cm)
- Wheel-thrown, hand-built, and extruded
 terra cotta pieces; cone 04
- Photo by Michael Noa

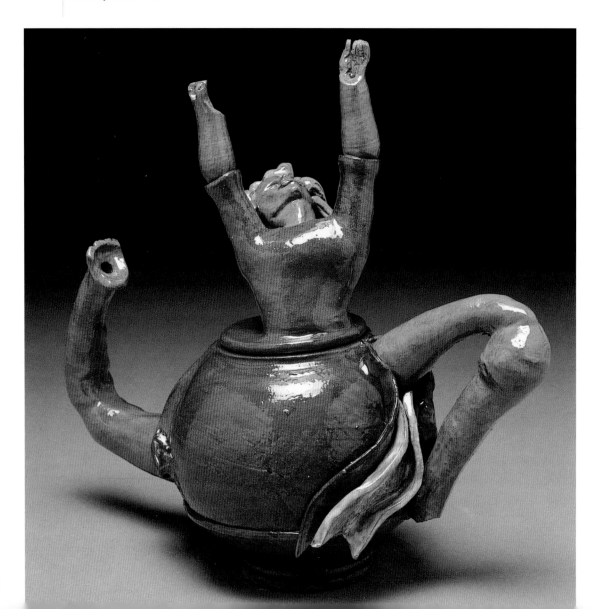

● **ROBIN CAMPO**
● *The Pass*, 2000
● 15 x 4 x 9 in. (38.1 x 10.2 x 22.9 cm)
● Slip-cast and assembled white earthenware;
 bisque cone 03; glaze and underglaze cone 05;
 luster and enamels cone 018
● Photo by artist

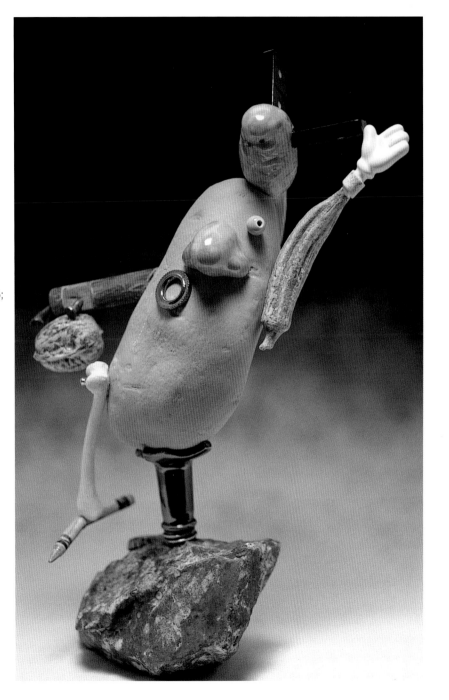

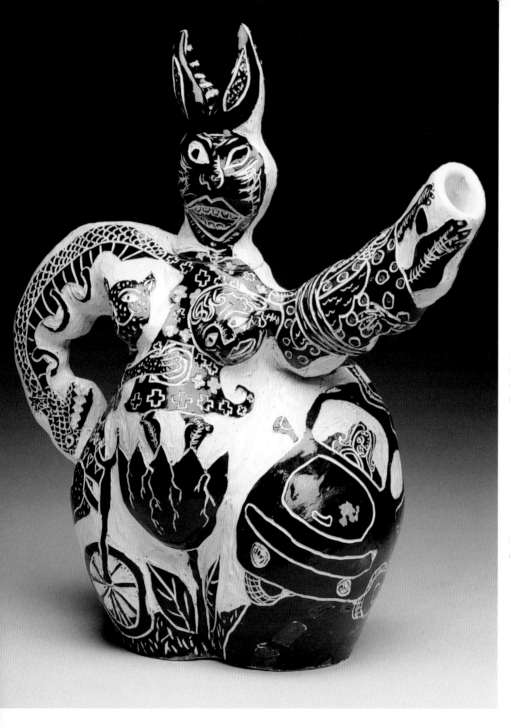

LAURA JEAN MCLAUGHLIN
Teapot, 1998
14 x 10 x 8 in. (35.6 x 25.4 x 20.3 cm)
Slab-built white stoneware; black slip
and sgraffito; glaze cone 9
Photo by Lonnie Graham

My work is funk-inspired. I use the subconscious
and surrealist art for imagery inspiration.

● **MARCIA KOCKA**
● *Ode to Op*, 2000
● 16 ½ x 10 x 3 ½ in. (41.9 x 25.4 x 8.9 cm)
● Slab-built, low-fire white clay; masked black and white underglaze-design; bisque cone 04; underglaze fire cone 04
● Photo by Forest Doud

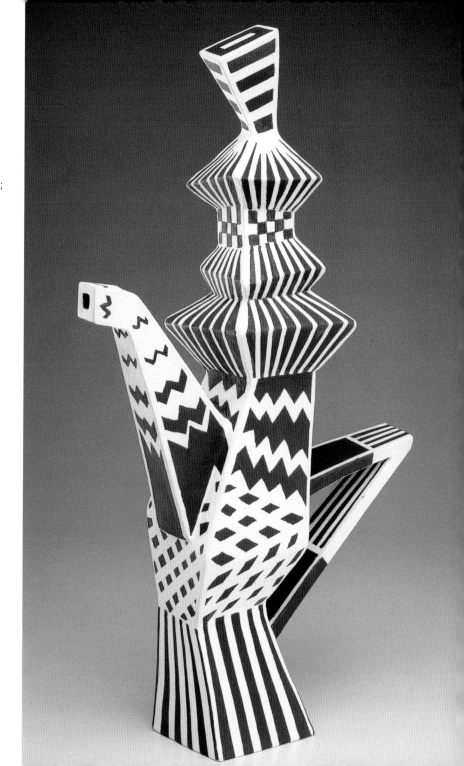

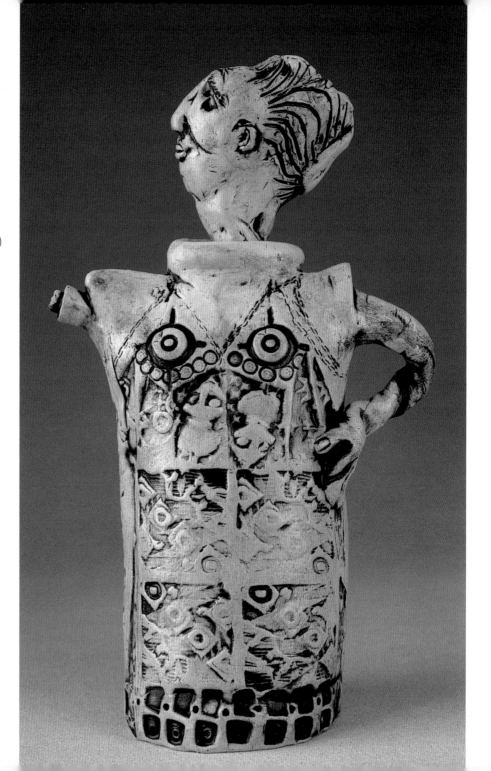

JEWELL GROSS BRENNEMAN

Yadda, Yadda, Yadda: Mice, 2001

10 x 6 x 3 ½ in. (25.4 x 15.2 x 8.9 cm)

Handbuilt clay, raku body, stamps, glaze inlay; cone 04

Photo by Gregory Staley

I am interested in marrying good form to lively surface decoration. I want the surface to contribute to meaningful content, with a push/pull between two and three dimensions.

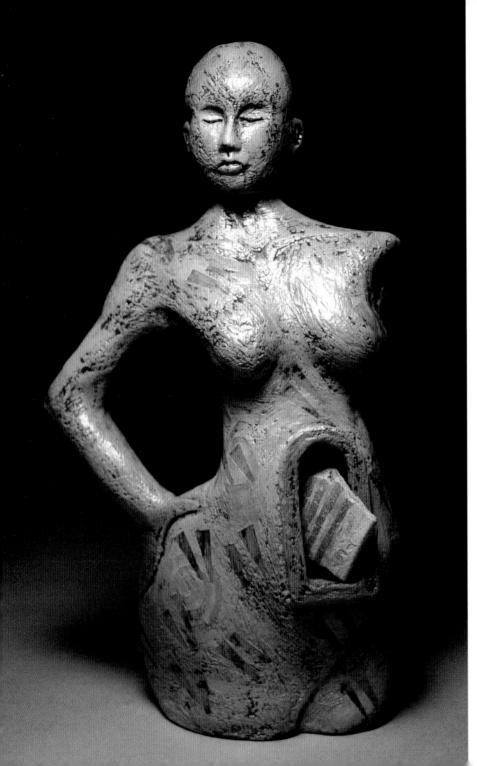

LINDA GANSTROM

A Shard-Carrying Heart/Home Teapot, 1996

12 x 8 x 4 in. (30.5 x 20.3 x 10.2 cm)

Hollow slab construction; pinched-head lid; stoneware clay slips, engobes, stencils, and glazes; cone 04

Photo by Sheldon Ganstrom

The niche in the teapot's belly is the heart/home, the seat of memory and identity. In this place it carries an ancient shard, a connection to artistic ancestors.

43

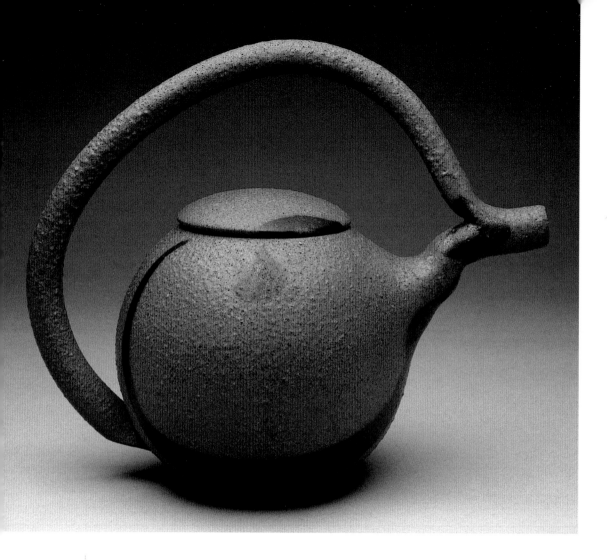

- **ANNE FALLIS ELLIOTT**
- *Brown Ash Teapot with Black Lines*, 2001
- 8 ½ x 10 x 5 ¾ in. (21.6 x 25.4 x 14.6 cm)
- Wheel-thrown white stoneware, ash-glazed with
 black line drawings; cone 7 electric
- Photo by Kevin Noble

My pots have always seemed like drawings to me, though I don't draw them first.
Now I've started to actually draw lines right on the pots.

LYNN SMISER BOWERS

Teapot with Striped Spout, 2001

6 x 7 x 5 in. (15.2 x 17.8 x 12.7 cm)

Wheel thrown; shino glazes; oxide brush work and wax-resist decoration; glaze cone 10 reduction

Photo by E. G. Schempf

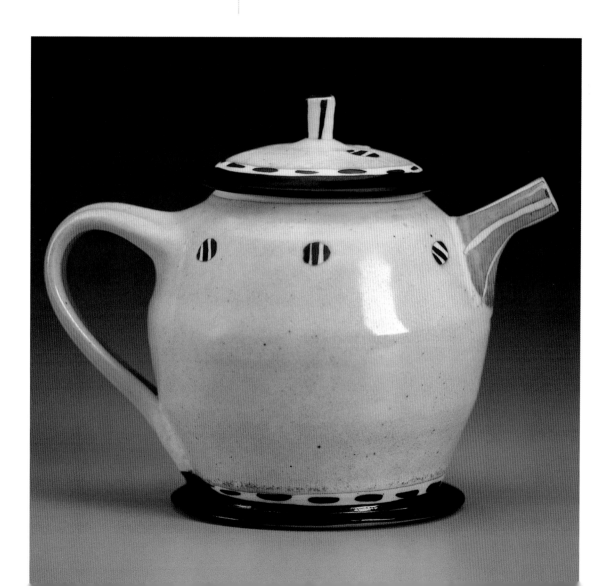

MEIRA MATHISON
Untitled, 2001
13 x 6 ½ x 1 ½ in. (33 x 16.5 x 3.8 cm)
Thrown and altered porcelain; cone 10 reduction; layered lithium glazes and sprinkled ash; tenmoku liner glaze
Photo by Janet Dwyer

I often work out of the Coleman Studio in Nevada. Time spent in the desert is sometimes reflected in my glaze colors and designs.

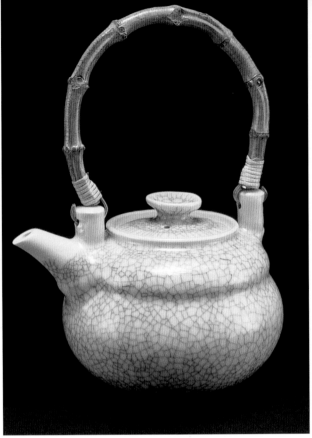

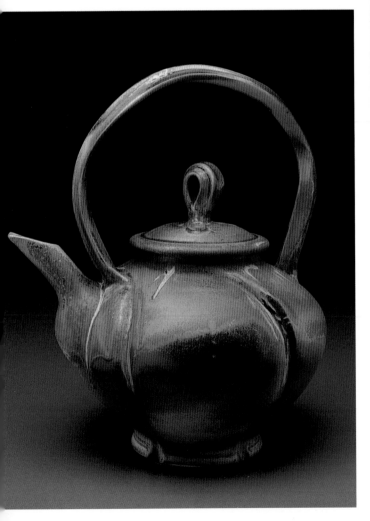

DEBORAH SHAPIRO
Crackle Teapot, 2001
6 x 8 x 6 ¾ in. (15.2 x 20.3 x 17 cm) excluding handle
Wheel-thrown grolleg porcelain; overlapping crackle and clear glazes; bisque cone 07; glaze cone 10 oxidation
Photo by Courtney Frisse

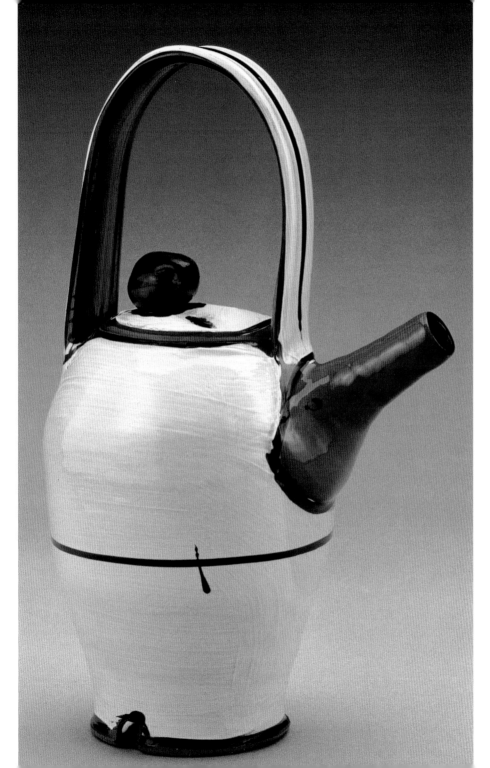

● **VICTORIA D. CHRISTEN**
● *White Teapot*, 2001
● 10 x 7 x 7 in. (25.4 x 17.8 x 17.8 cm)
● Wheel-thrown red earthenware;
 slip and underglaze; bisque 06;
 glaze cone 04

I see my pots as both containers
and dispensers of everyday materi-
als, and also as metaphors for the
body as both receiver and giver.

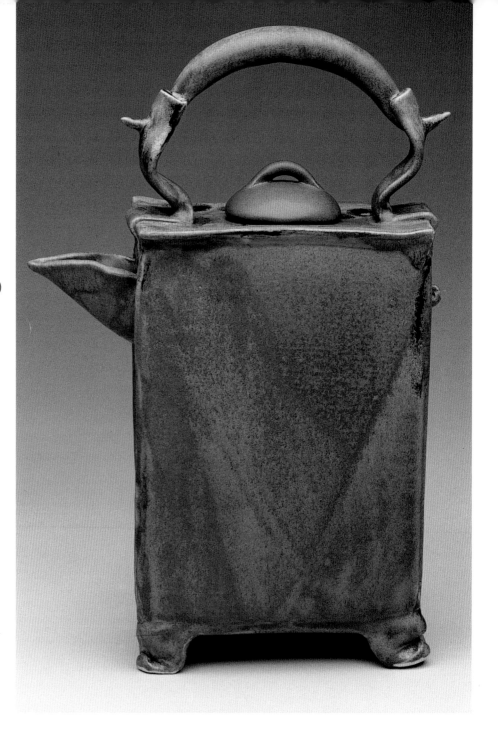

● **JEANETTE HARRIS**
● *China Tea*, 2001
● 14 x 3 x 7 in. (35.6 x 7.6 x 17.8 cm)
● Slab-built and hand-formed; cone 6 oxidation; copper/rutile glaze
● Photo by Tom Holt

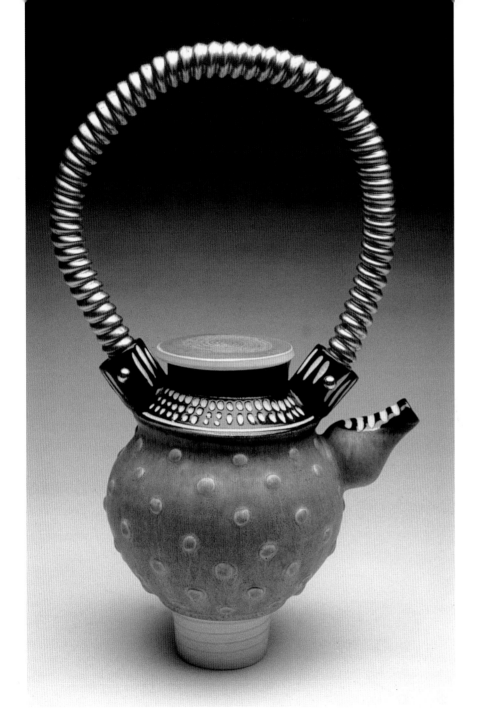

EILEEN P. GOLDENBERG
Teapot with Copper Handle, 2001
18 x 8 x 10 in. (45.7 x 20.3 x 25.4 cm)
Thrown porcelain; black and white
sgraffito and applied bumps;
jade glaze; cone 10

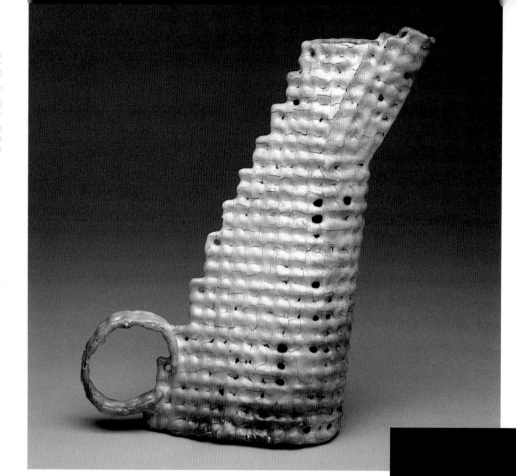

● **LINDA HANSEN MAU**
● *"Iced Tea"*, 1999
● 14 x 12 x 6 in. (35.6 x 30.5 x 15.2 cm)
● Porcelain paperclay; OM 4 terra sigillata;
cone 04 electric; smoked in open laundry
tub with newspaper.

BACIA EDELMAN

Lichen Teapot, 2001

9 x 12 ½ x 4 in. (22.9 x 31.8 x 10.2 cm)

Slab-built stoneware; underglazes painted over hand-textured surfaces; bisque cone 05; sprayed lichen glazes cone 6

Photo by artist

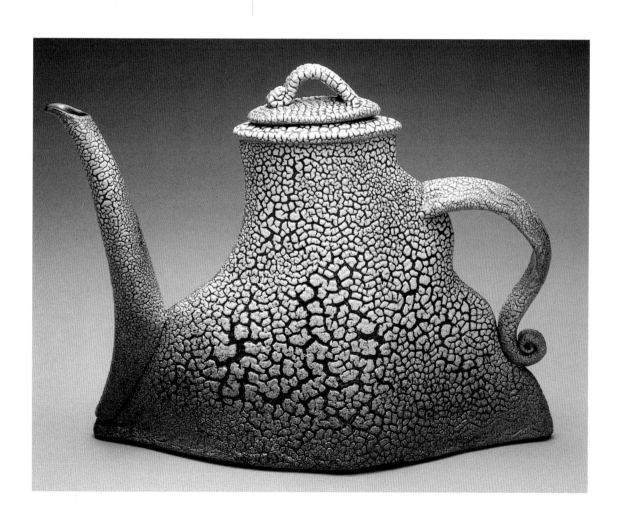

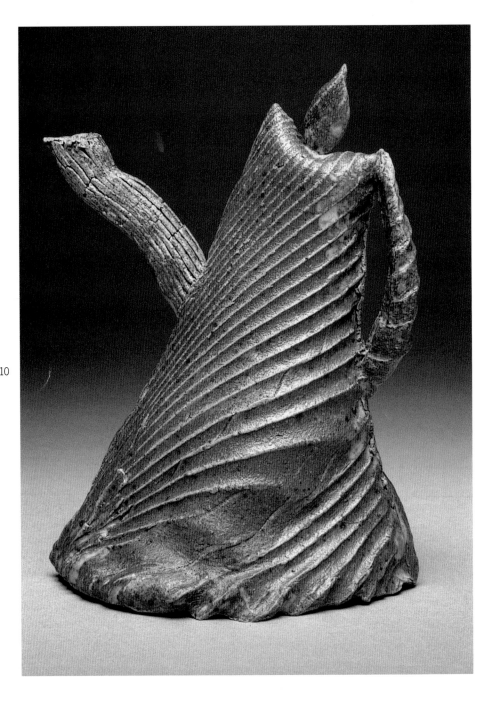

● **MARTA MATRAY GLOVICZKI**
● *Wire-Cut Teapot*, 2000
● 8 x 5 x 3 in. (20.3 x 12.7 x 7.6 cm)
● Slab-built stoneware; wire-cut relief
 pattern, glaze-fired in gas kiln; cone 10
● Photo by Peter Lee

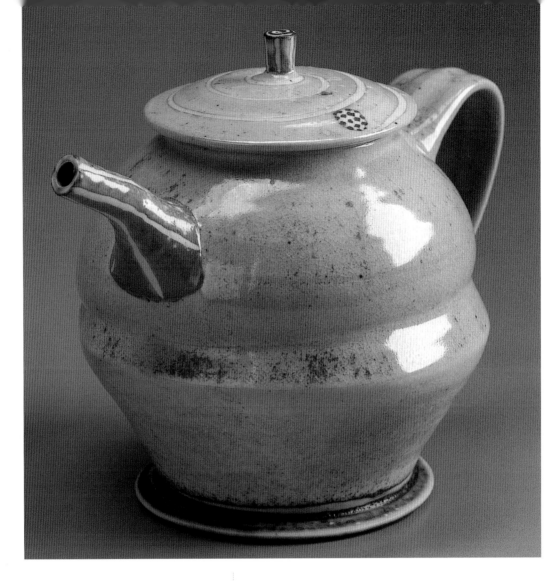

LYNN SMISER BOWERS
Teapot with Green Foot, 2001
8 x 8 x 6 in. (20.3 x 20.3 x 15.2 cm)
Wheel thrown; shino glazes; oxide
brush work and wax-resist decoration;
glaze cone 10 reduction

Creating a teapot is a choreography of balance,
timing, and grace.

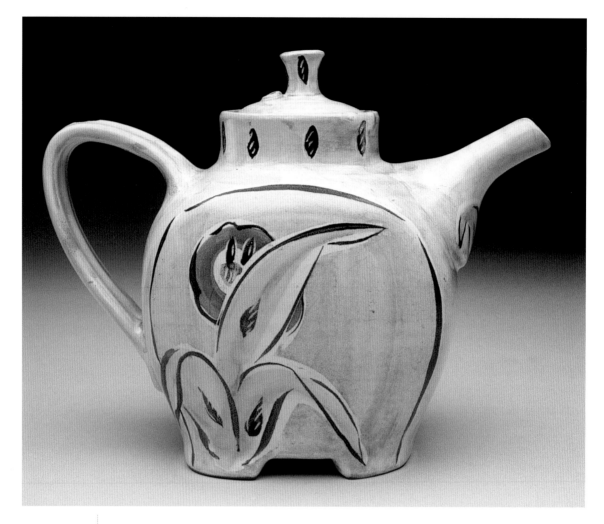

● **POSEY BACOPOULOS**
● *Oval Teapot*, 2000
● 7 x 8 x 5 in. (17.8 x 20.3 x 12.7 cm)
● Thrown, altered, and assembled;
 majolica on terra cotta; bisque cone
 06; glaze cone 04
● Photo by Kevin Noble

My work is about form, function, and surface. I try to integrate
these in a way that brings a sense of excitement to the pots.

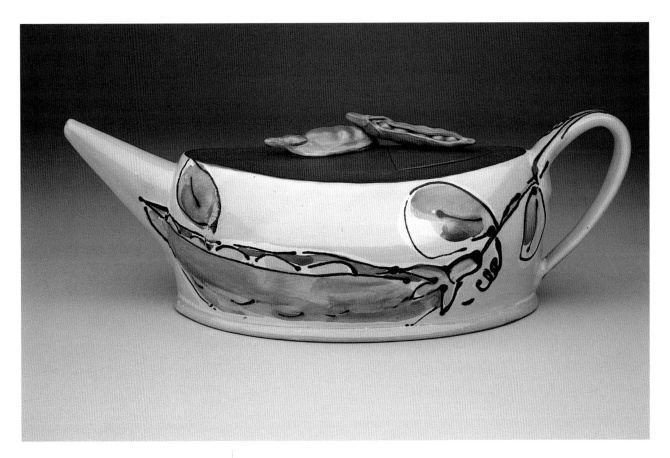

WYNNE WILBUR

Peaspot, 2001

5 x 12 ½ x 6 in. (12.7 x 31.8 x 15.2 cm)

Thrown and altered majolica on terracotta; bisque cone 05; glaze cone 03

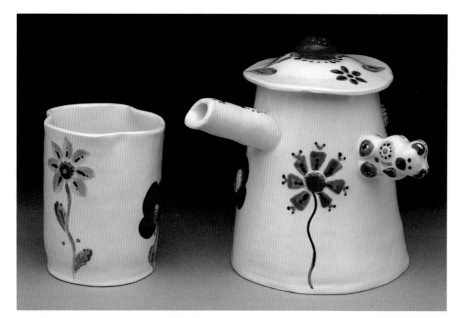

SABINE BRUNNER
Flower, 2001
4 ½ x 5 in. (11.4 x 12.7 cm)
Slab-built; low-fire glazes and luster on top; bisque cone 04; glaze 06; luster cone 019
Photo by George Post

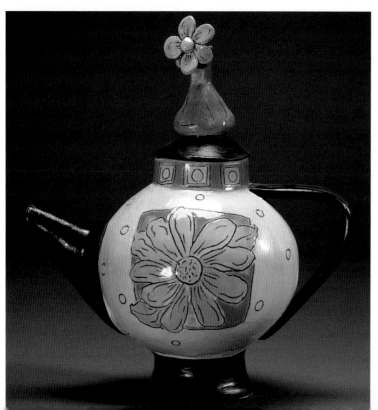

MARY MAE KEENAN
Flower-Pot, 2001
9 x 6 x 5 in. (22.9 x 15.2 x 12.7 cm)
Hand-built low-fire earthenware; hand-painted underglazes and oxides; bisque cone 04; glaze cone 06
Photo by Richard Sargeant

I am inspired by children's imagination, using bright colors and loose forms in order to create pieces that are not only functional but are a pleasure to look at.

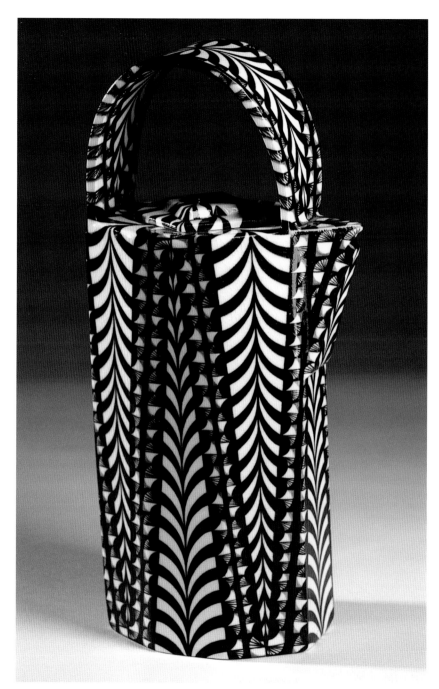

● **KATHRYN SHARBAUGH**
● *A New Twist*, 1999
● 10 x 5 x 3¾ in. (25.4 x 12.7 x 9.5 cm)
● Stiff porcelain slab construction; underglaze; bisque cone 04; sprayed overglaze cone 10

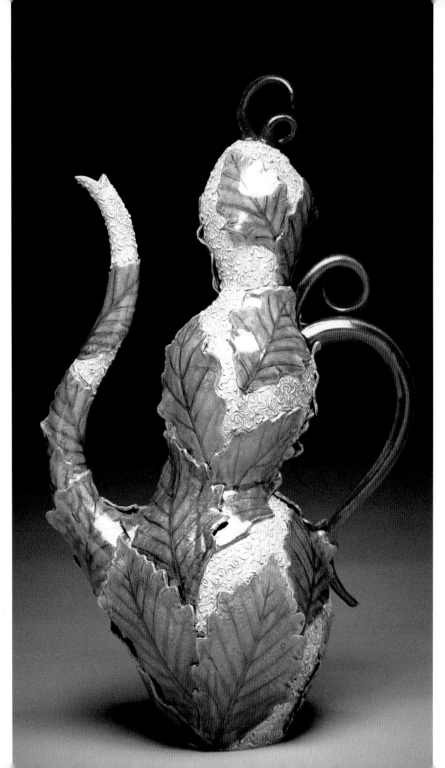

BETSY ROSENMILLER
Teapot, 2000
14 ½ x 9 x 4 ½ in. (36.8 x 22.9 x 11.4 cm)
Cast and hand-built porcelain; slip-trailed texture; glaze cone 5; china paint

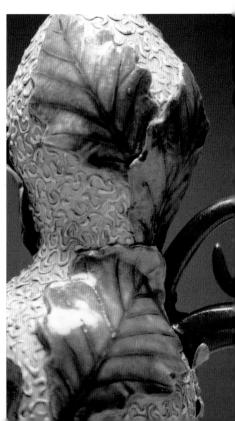

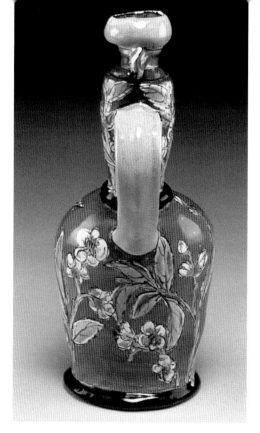

- **LINDA ARBUCKLE**
- *T-Pot: Fruition*, 1995
- 11 ½ x 5 ½ x 10 in. (29.2 x 14 x 25.4 cm)
- Thrown, altered, and assembled terra cotta; majolica glaze and decoration; cone 03
- Photo by University of Florida Office of Instructional Resources

Majolica allows for a lively, playful surface and lots of color.

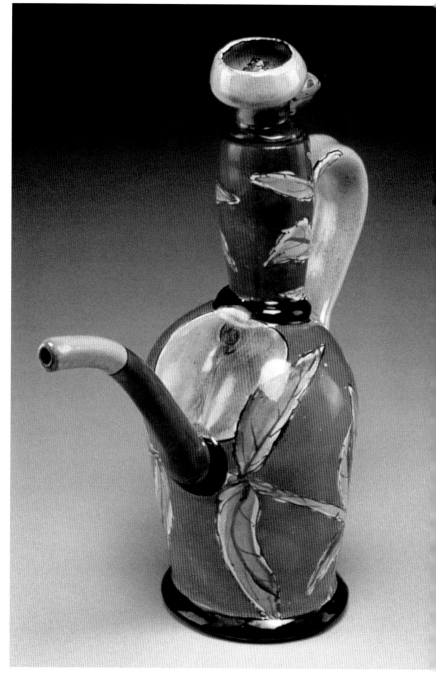

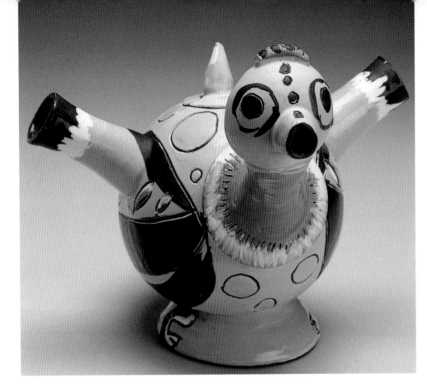

● **JOANNE ANDREWS**
● *A Splash of Water from the Pot Made Miss Chicken Squeak, "Hot!"*, 2001
● 7 x 9 x 10 in. (17.8 x 22.9 x 25.4 cm)
Wheel-thrown and assembled earthenware; slips; sgraffito; clear glaze cone 04

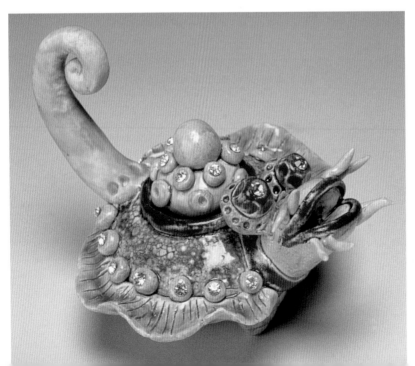

● **VIPOO SRIVILASA**
● *Mermaid's Pet Teapot No. 2*, 1999
● 3 ½ x 4 x 4 ¾ in. (9 x 10 x 12 cm)
● Hand-built paper clay; layered low-fire glazes over hand-textured surface and decorated with diamonds; bisque 1832°F (1000°C); glaze 2048°F (1120°C)
● Photo by Michael Kluvanek

ELEONORE CAMSTRA

Teapot, 2000

7 ½ x 8 ¼ x 4 ¾ in. (19 x 21 x 12 cm)

Sheets of English stoneware; gold-lustre covers the glaze; bisque cone 05A; glaze cone 5; lustre cone 018

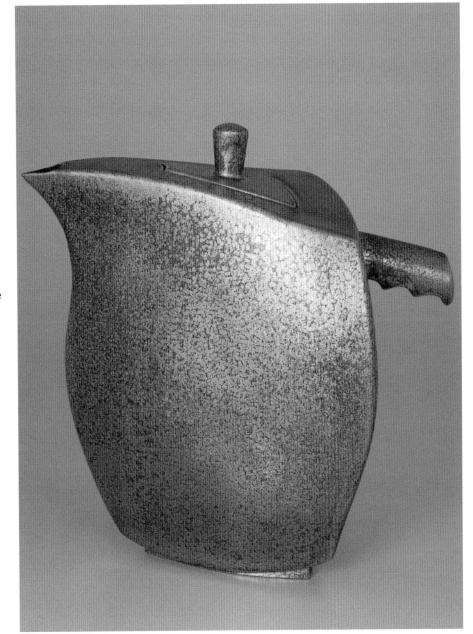

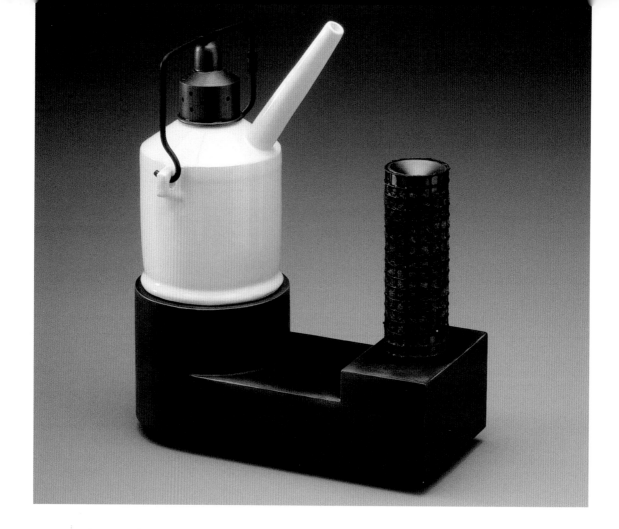

JOHN GOODHEART
The Progenitor's Teapot, 2001
9 x 3 ½ x 8 in. (22.9 x 8.9 x 20.3 cm)
Wheel-thrown low-fire whiteware with metal lid;
bisque cone 04; glaze cone 05
Photo by Kevin Montague and
Michael Cavanaugh

TODD SHANAFELT

Device tq3, 2001

11 x 9 x 9 in. (27.9 x 22.9 x 22.9 cm).

Wheel-thrown and altered stoneware; oxide; glaze; cone 03

Photo by artist

When I was a child, my auto-mechanic father had completely filled the garage with hundreds of tools and car parts. I've seemingly always been attracted to mechanical forms and use clay to reinvent forms that suggest utilitarian purposes, such as teapots.

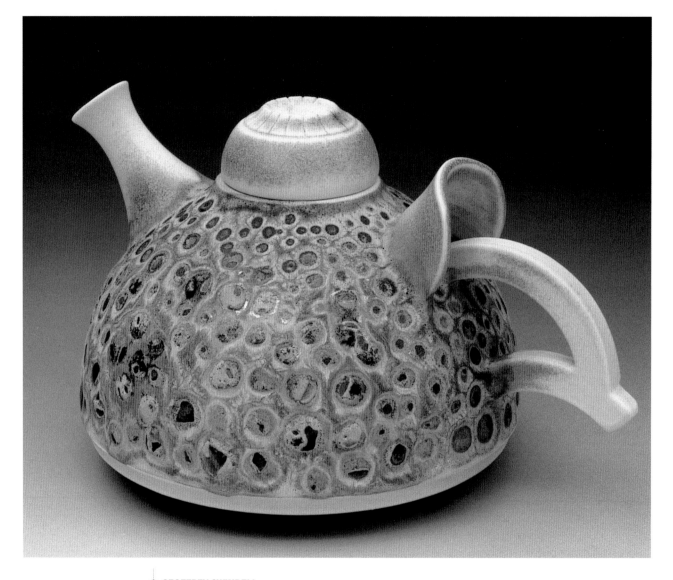

GEOFFREY SWINDELL
Teapot, 2001
3 x 3 ½ x 5 in. (7.6 x 8.9 x 12.7 cm)
Wheel-thrown porcelain; cone 8
Photo by Tom Swindell

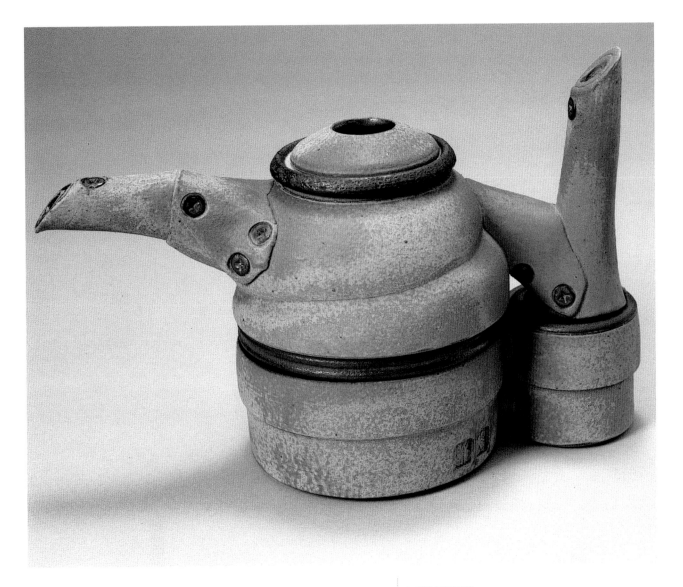

● **DAVID BOLTON**
● *Stacking Teapot (Series III)*, 2000
● 7 x 11 x 5 in. (17.8 x 27.9 x 12.7 cm)
● Thrown stoneware; pulled spout and handle;
 cone 9 reduction
● Photo by Patrick Young

HSIN-YI HUANG

Teapot, 2001

7 x 7 x 5 in. (17.8 x 17.8 x 12.7 cm)

Wheel-thrown porcelain; hand-faceted; ash glaze over colored slips; cone 10 reduction

Photo by Bill Buchaber

I used a cheese cutter to create the faceted surface. The key to getting this effect is to facet the pot while it is still soft and with the wheel slowly turning.

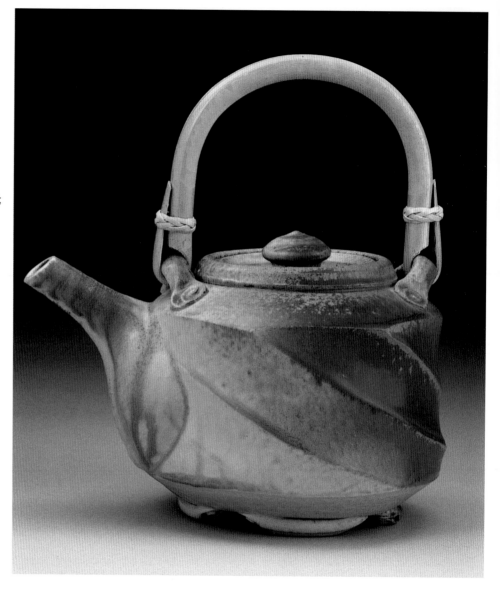

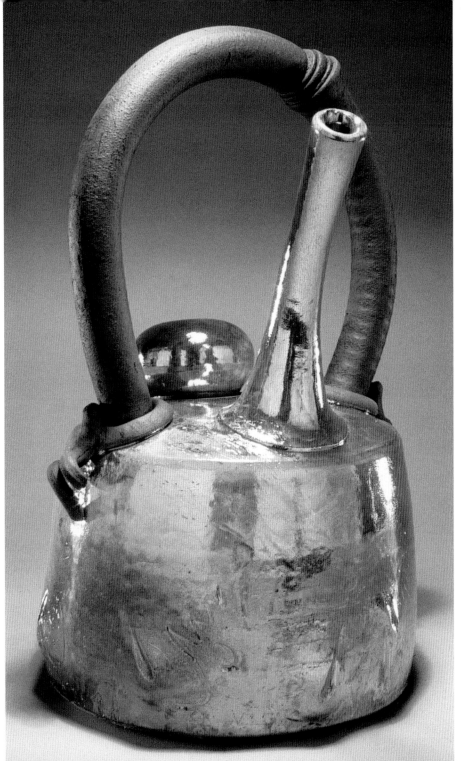

RON BOLING
Raku Tea Pot - Alluding to Function, 2001
21 x 11 in. (53.3 x 27.9 cm)
Wheel-thrown raku clay with extruded
handle; silver nitrate glaze; bisque
cone 07; glaze cone 07
Photo by John Hooper

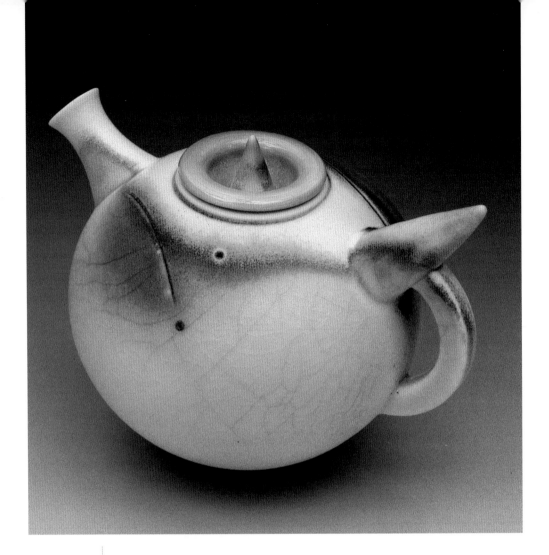

GEOFFREY SWINDELL

Teapot, 2001

3 x 4 x 5 ½ in. (7.6 x 10.2 x 14 cm)

Wheel-made porcelain; cone 8

Photo by Tom Swindell.

I find the teapot to be the greatest challenge a potter can face—with all the aesthetic considerations necessary in any work of art, plus it must be able to function in a very specific way.

DORA STROTHER

Dragon Tea Pot, 1998

10 x 9 ½ x 5 ½ in. (25.4 x 24.1 x 14 cm)

Wheel-thrown white clay (B-mix) with hand-built dragons on lid and as lugs; green celadon glaze; bisque cone 04; glaze cone 6

I am inspired by Chinese and Japanese pottery, and I feel that this inspiration manifests itself through my work.

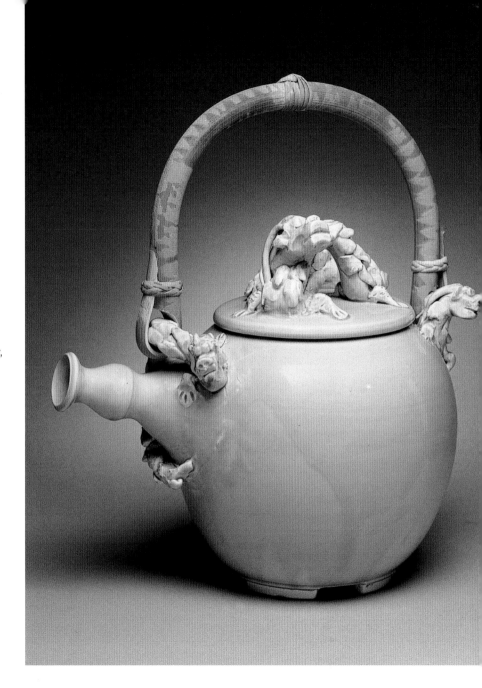

● **MEIRA MATHISON**
● *Untitled*, 2000
● 13 x 3½ x 7½ in. (33 x 8.9 x 19 cm)
● Thrown and altered porcelain; cone 10 reduction; layered shino glazes and sprinkled ash
● Photo by Janet Dwyer

My work has been influenced by living in a large Asian community located in Victoria, British Columbia.

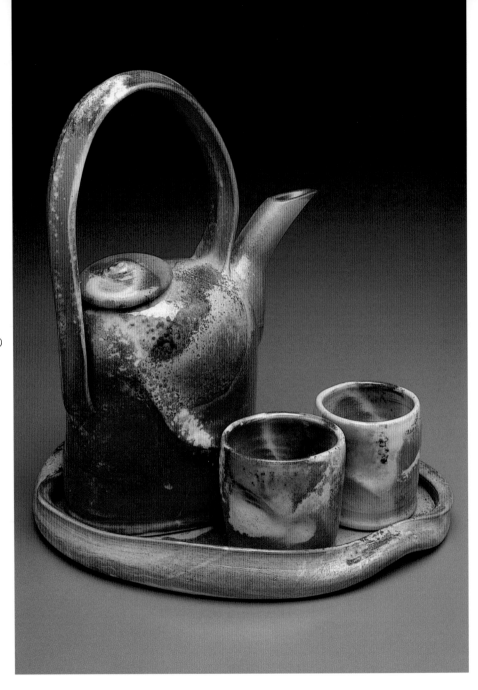

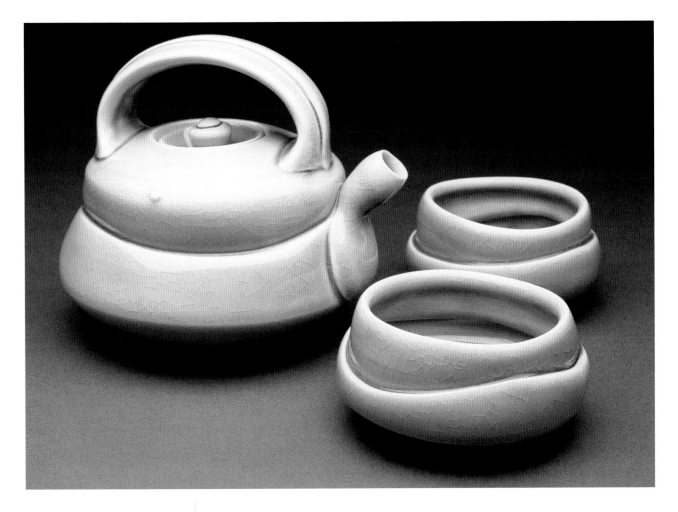

● **RYAN FITZER**
● *Teapot*, 1999
● 8 x 7 x 8 ½ in. (20.3 x 17.8 x 20.3 cm)
● Wheel-thrown porcelain;
 celadon glaze; cone 10 soda
● Photo by artist

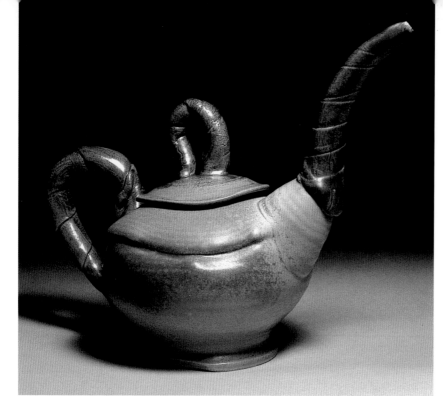

CATHRYN LEE SCHROEDER
Blue Fruit Teapot, 1999
10 x 12 ½ x 6 ½ in. (25.4 x 31.8 x 16.5 cm)
Thrown and altered; cones 5–6 stoneware;
hand-built spout and handles; sprayed glazes;
bisque cone 06; glaze cone 5
Photo by artist

These teapots are part play and part hard work.
The challenge is getting all the parts to work
together as a unified statement.

DENISE WOODWARD-DETRICH
Teapot, 2000
6 ½ x 11 x 6 ¼ in. (16.5 x 27.9 x 15.8 cm)
Thrown and altered, carved;
cone 10 electric
Photo by artist

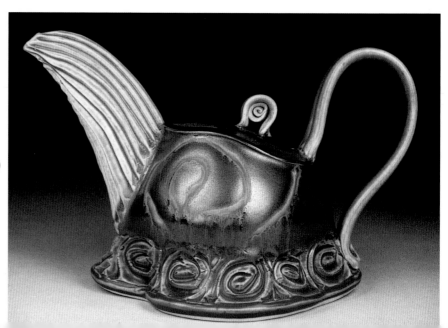

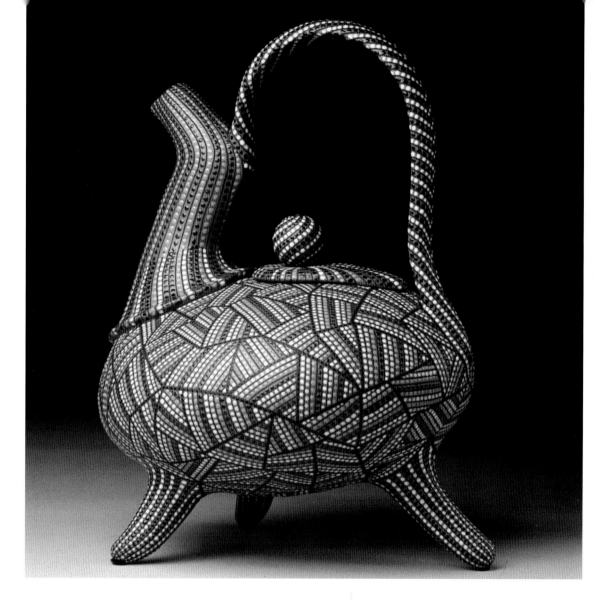

● **RICKY MALDONADO**
● *Magdalena*, 2001
● 11 x 13 x 10 in. (27.9 x 33 x 25.4 cm)
● Coil-built; dotted glaze over slip design
over terra sigillata; burnished; single
fired to cone 06
● Photo by Imag-Ination

MALCOLM DAVIS

Flat Teapot, 2000

6 x 9 ½ x 9 ½ in. (15.2 x 24.1 x 24.1 cm)

Thrown porcelain with red shino-type carbon trap glaze; bisque cone 010; glaze cone 10 gas with heavy reduction

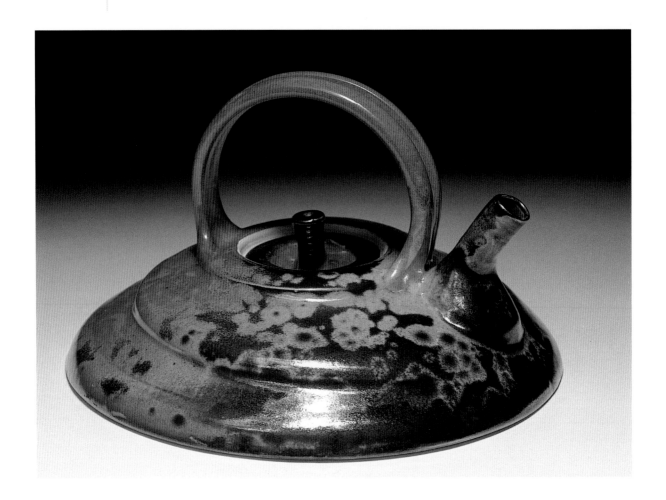

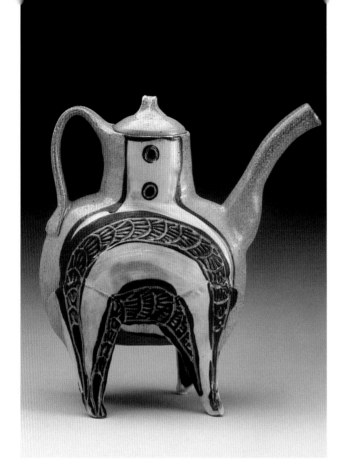

SUZE LINDSAY
Footed Teapot, 2001
8 x 7 x 3 in. (20.3 x 17.8 x 7.6 cm)
Thrown, hand-built, and assembled
stoneware elements; slips and
glazes; cone 10 salt
Photo by Tom Mills

ARDIS BOURLAND
Dr. Seuss Meets Picasso, 2000
8 x 8 x 4 in. (20.3 x 20.3 x 10.2 cm)
Thrown and altered white clay;
clear satin glaze over underglazes;
hollow handle; cone 6
Photo by Fareed al Mashat

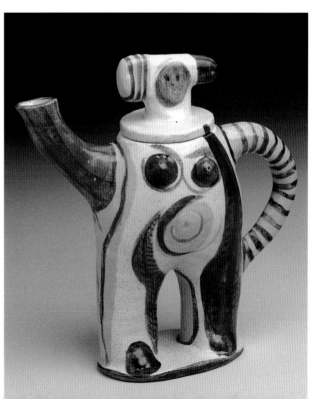

BARBARA KNUTSON

The Opera Singer Teapot, 2000

8 ½ x 10 ½ x 5 in. (21.6 x 26.7 x 12.7 cm)

Slab-built white stoneware, textured with stamps and rollers before construction; hollow handle; bisque cone 06; glaze cone 10 reduction

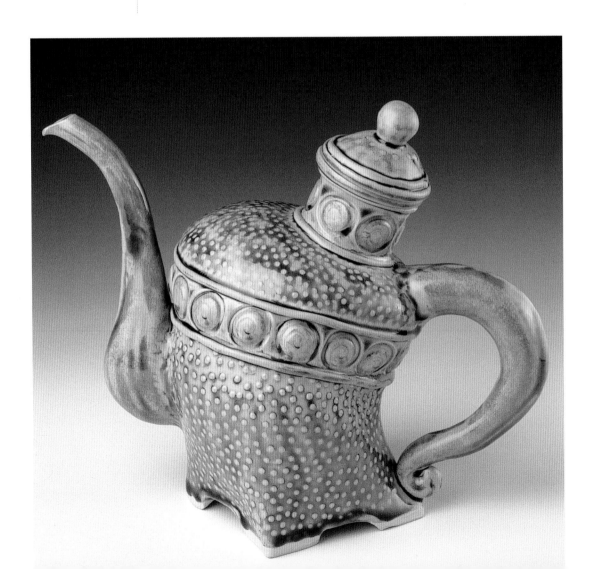

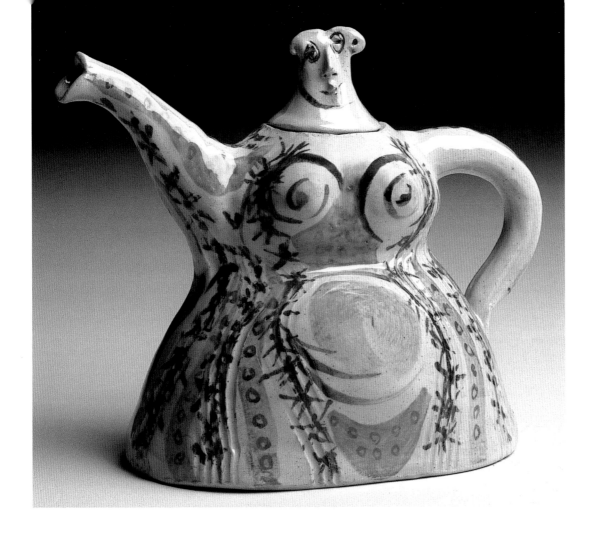

ARDIS BOURLAND
Vertical Stripes are Slimming, 2000
7 ½ x 8 x 4½ in. (19 x 20.3 x 11.4 cm)
Thrown and altered white clay; transparent glaze over underglazes; hollow handle; cone 6

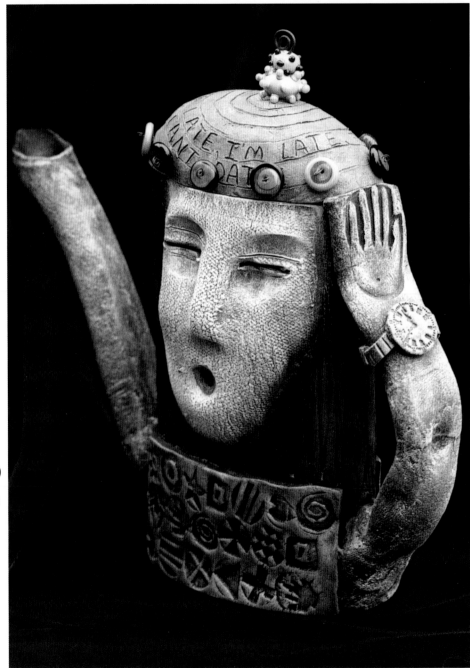

PATTY EARL-BARON

Tea Time, 2001

11 x 12 ½ x 3 in. (27.9 x 31.8 x 7.6 cm)

Slab-built, low-fire white clay; hand stamped; bisque cone 02; cold finished with acrylics

Photo by Corky Baron

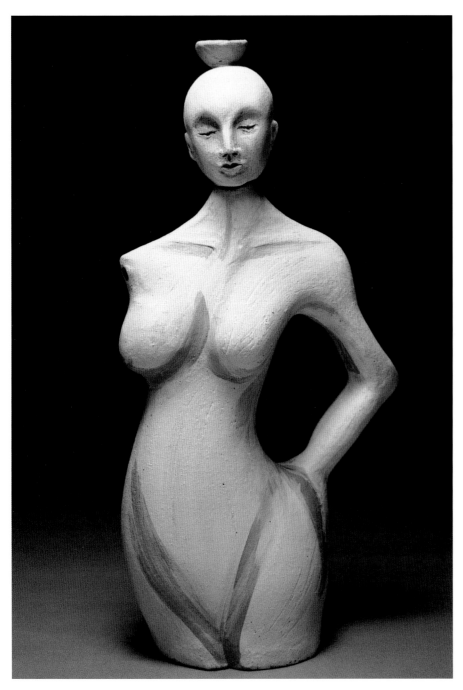

● **LINDA GANSTROM**
● *Balancing Act*, 1996
● 16 x 6 x 3 in. (40.6 x 15.2 x 7.6 cm)
● Hollow slab stoneware construction; pinched-head lid; terra sigillata; cone 04
● Photo by Sheldon Ganstrom

This teapot refers to the juggling needed to create balance in contemporary life.

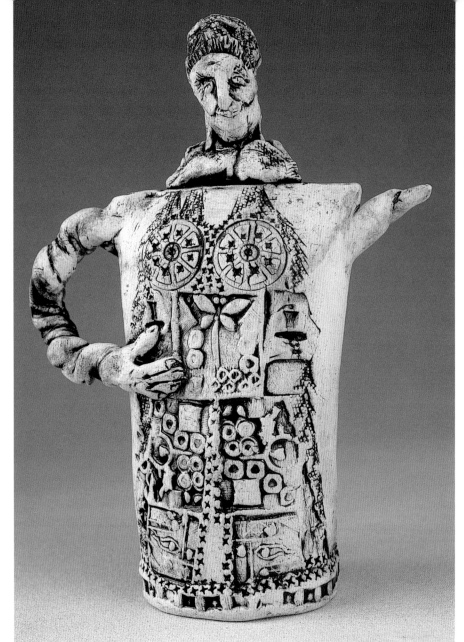

JEWELL GROSS BRENNEMAN
Yadda, Yadda, Yadda: Butterfly, 2001
9 ¼ x 7 x 3 in. (23.5 x 17.8 x 7.6 cm)
Hand-built raku clay body;
stamps/glaze inlay; cone 04
Photo by Gregory Staley

I am interested in marrying good form to lively surface decoration. I want the surface to contribute to meaningful content with a push/pull from two to three dimensions.

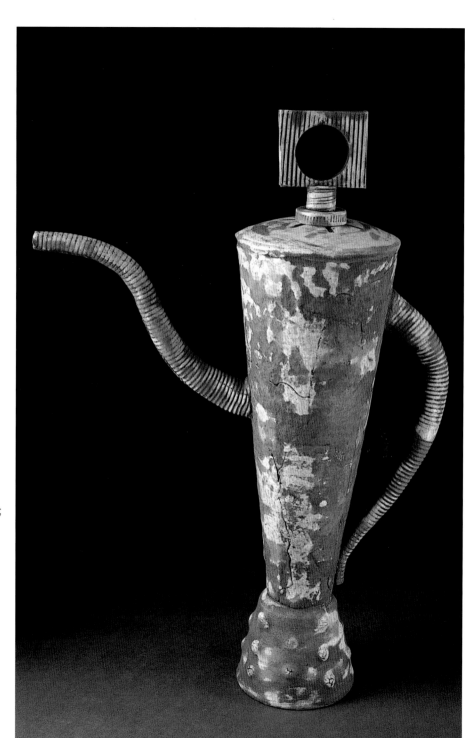

● **BEBE ALEXANDER**
● *Techno Salvage Teapot*, 2000
● 18 in. (45.7 cm) tall
● Hand-built and thrown earthenware;
 underglazes and layered 04 glazes
● Photo by John Bonath

My goal is to make my work seem
both ancient and futuristic. I think of
my pieces as "relics from the future."

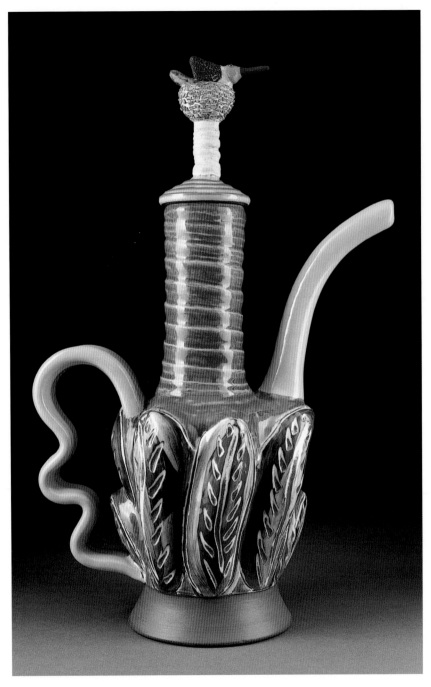

● **LORI MILLS**
● *Tall Teapot with Nested Hummingbird*, 2001
● 15 x 10 x 5 in. (38.1 x 25.4 x 12.7 cm)
● Thrown and altered; low-fire slips and glazes; bisque cone 05; glaze cone 06

My work combines the visual and tactile language of pottery with childhood recollections of secret garden environments.

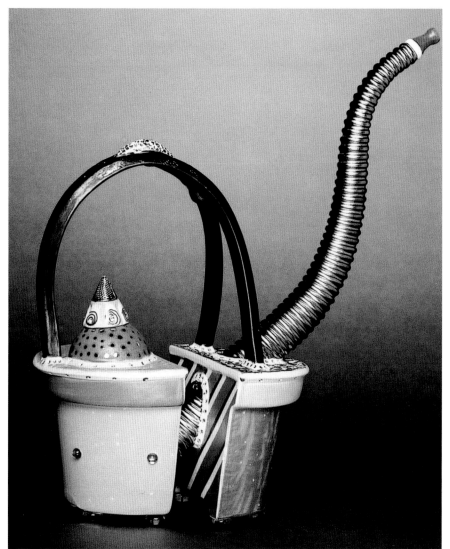

GARY MERKEL

Shift-Tea, 2001

15½ x 14 x 7 in. (39.4 x 35.6 x 17.8 cm)

Slab-built, high-fire porcelain; cone 8; cast components; coil- and hand formed, then assembled; color underglazes, clear glaze overall cone 8; low-fire glaze accents cone 05; 22 k gold and platinum lusters cone 018; small found metal and antique Austrian crystal additions

Photo by Karen Benedict

● **BRIAN HIVELEY**
● *Swirl Teapot*, 2001
● 17 x 17 x 7 in. (43.2 x 43.2 x 17.8 cm)
● Slab-built earthenware; underglazes and
 glazes; cone 6 multi-fired oxidation
● Photo by artist

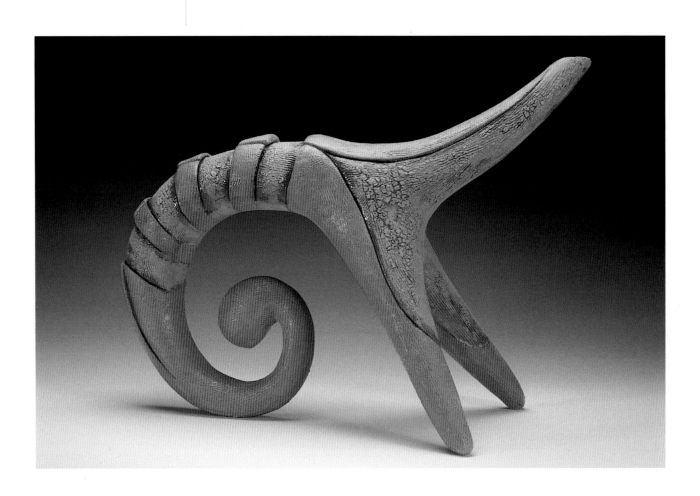

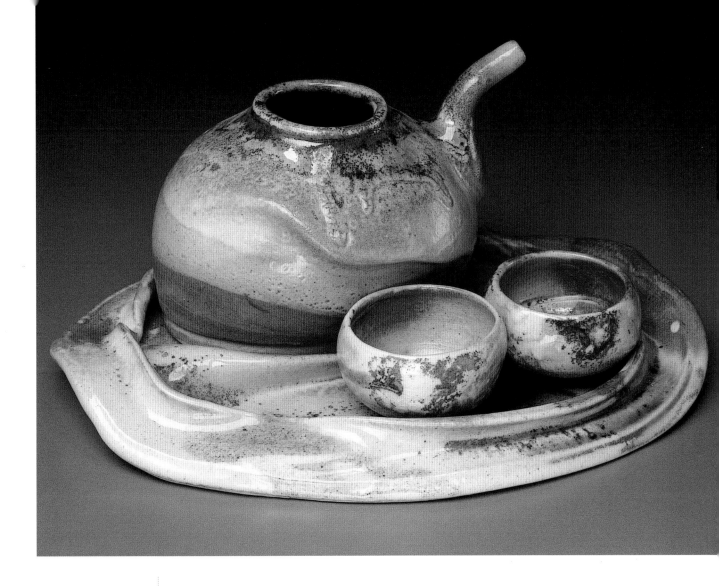

● **MEIRA MATHISON**
● *Untitled*, 2000
● 4 x 3 x 5 in. (10.2 x 7.6 x 12.7 cm)
● Thrown and altered porcelain; cone
 10 reduction; layered shino glazes
 and sprinkled ash
● Photo by Janet Dwyer

EILEEN P. GOLDENBERG

Purple Teapot, 2001

10 x 7 x 4 in. (25.4 x 17.8 x 10.2 cm)

Thrown porcelain; purple matte glaze; copper handle; cone 10

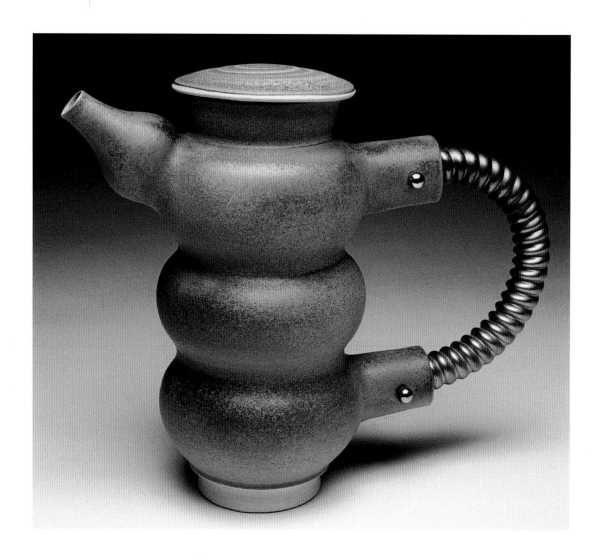

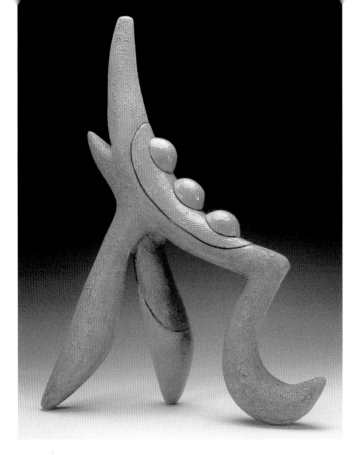

● **BARBARA FREY**
● *Let's Go Teapot #15*, 2001
● 7 ¼ x 6 ½ x 6 ½ in. (18.4 x 16.5 x 16.5 cm)
● Slab-built porcelain and colored porcelain; slips, powdered clays and oxides; hand-textured; cone 6
● Photo by Harrison Evans

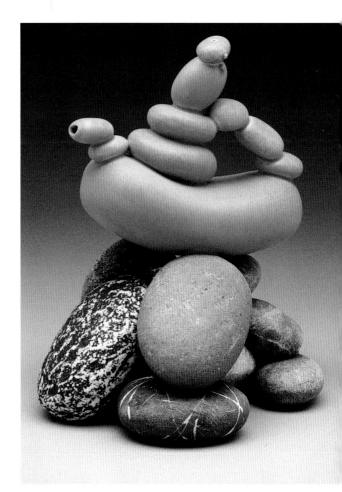

● **BRIAN HIVELEY**
● *Biomorphic Teapot*, 2001
● 19 x 14 x 6 in. (48.3 35.6 x 15.2 cm)
● Slab-built earthenware; underglazes and glazes; multi-fired cone 6 oxidation
● Photo by artist

The natural world has always been the driving force in my creation of art. My goal is not to directly mimic specific objects in nature, but rather to suggest universal biomorphic forms.

CARRIANNE HENDRICKSON

Tea Time for the Poisoned Souls, 1999

16 x 12 x 8 in. (40.6 x 30.5 x 20.3 cm)

Hand-built; textured surface with red brown stains; glaze and clay cone 5

Photo by Carol Townsend

My goal in this tea set design was to challenge ideas of how a teacup functions and what a teapot could look like. The teacups are designed so that the person must hold the cup until all the "tea" is gone. The teapot pours from the bee's stinger.

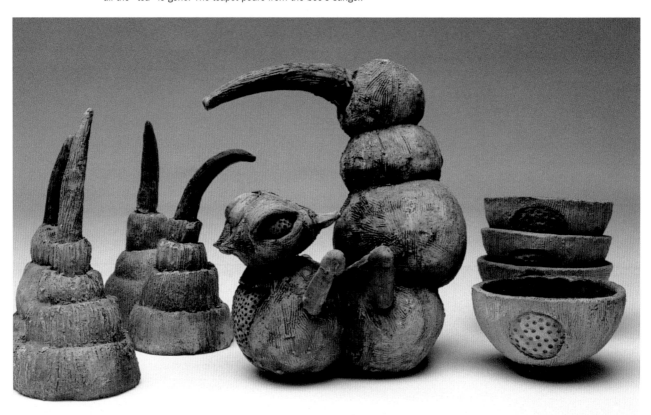

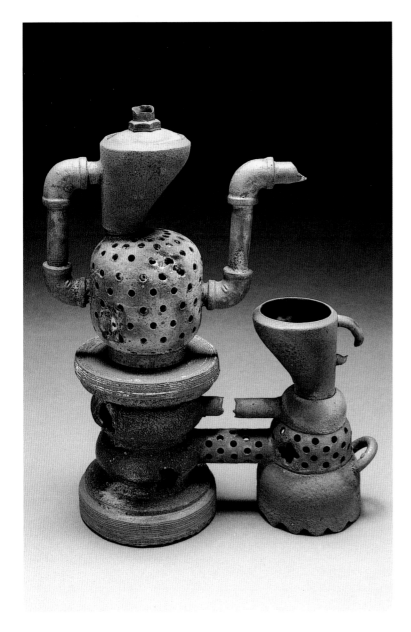

● **MATT WILT**
● *Refined*, 1996
● 13 x 10 x 6 in. (33 x 25.4 x 15.2 cm)
● Slipcast, wheel-thrown, and assembled stoneware; cone 8
● Photo by artist

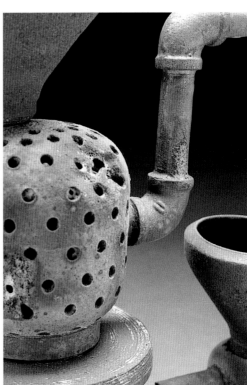

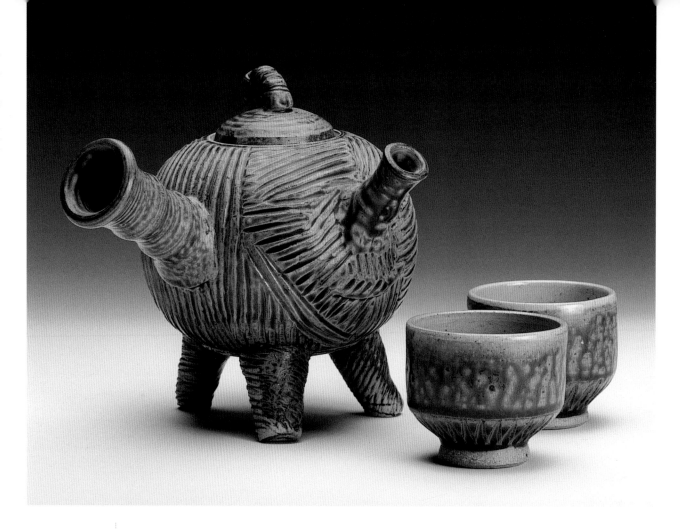

● **ANDREW P. LINTON**
● *"Blau Hai,"* 2000
● 8 x 7 x 6 in. (20.3 x 17.8 x 15.2 cm)
● Thrown with hand-built additions; hand carved;
 blue ash glaze; cone 10 reduction
● Photo by Jim Kammer

I have been fortunate to have had many Japanese pottery
students. Some of them have brought in pots for me to study,
which has helped me to develop this style in my own work.

● **MATT WILT**
● *"SAP,"* 1998
● 13 x 11 x 11 in. (33 x 27.9 x 27.9 cm)
● Wheel-thrown, slipcast, and assembled
 stoneware; cone 8
● Photo by Joe Painter

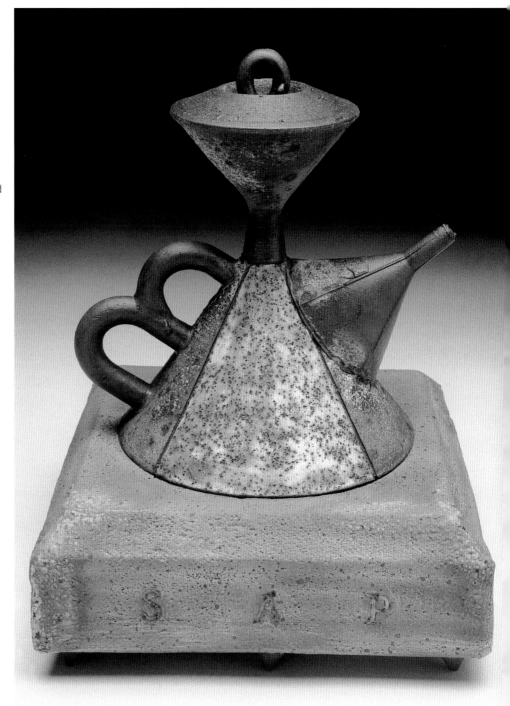

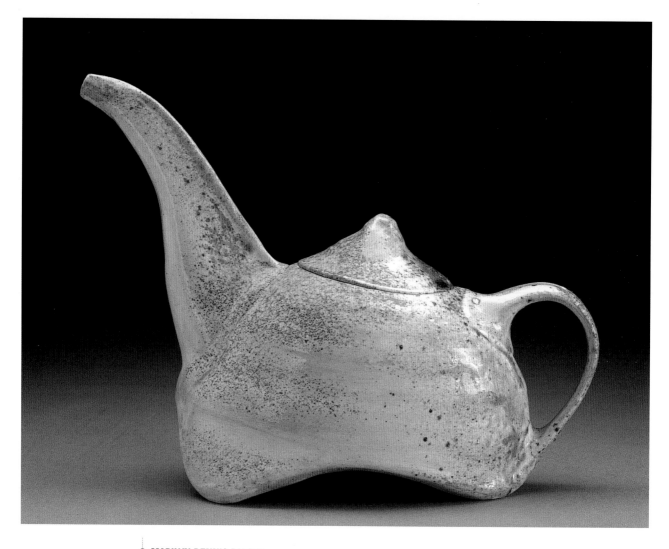

● **MARILYN DENNIS PALSHA**
● *Wood Fired Teapot*, 2001
● 7 x 9 x 4 in. (17.8 x 22.9 x 10.2 cm)
● Thrown and altered stoneware with slab spout;
　shino glaze; wood fired with natural ash deposits
● Photo by Tom Mills

JUDY TRYON

Very High Tea, 1998

16 x 16 ¾ x 3 ¾ in. (40.5 x 42.5 x 9.8 cm)

Wheel-thrown mid-fire white stoneware with extruded spout and handle; airbrushed, trailed, and painted underglazes and glaze; bisque cone 06; glaze cone 6 electric

Photo by A. K. Photos

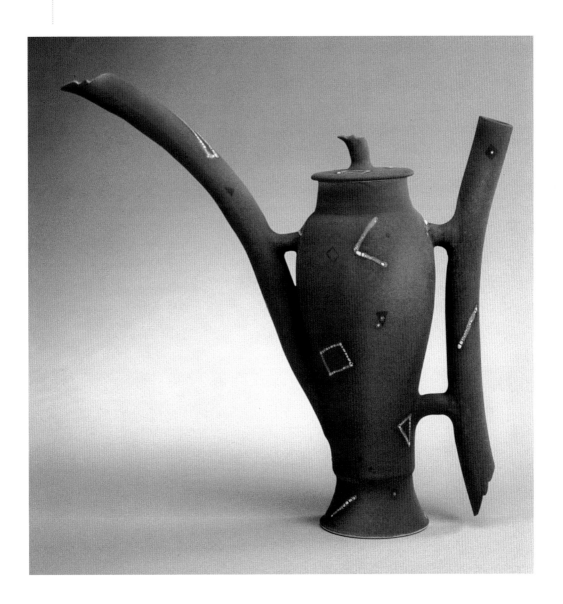

MARKO FIELDS

A Teapot for the Tactile Impaired, No. 2, 2001

Stoneware with porcelain applied as slip; cast and fabricated bronze from oak and sea urchin; thrown and altered with hand-built elements; cone 10 reduction

Photo by artist

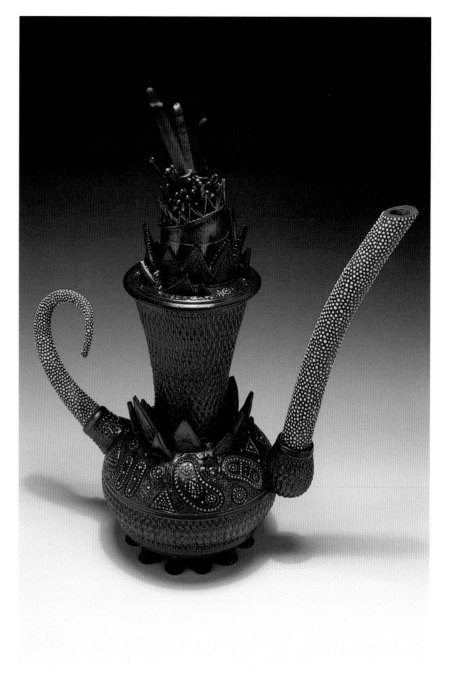

- **SUSAN FARRAR PARRISH**
- *Tea in the Garden II*, 2001
- 18 ½ x 16 x 3 ½ in. (47 x 40.6 x 8.9 cm)
- Slab-built; underglaze painting; carved; clear glaze cone 6
- Photo by Seth Tice-Lewis

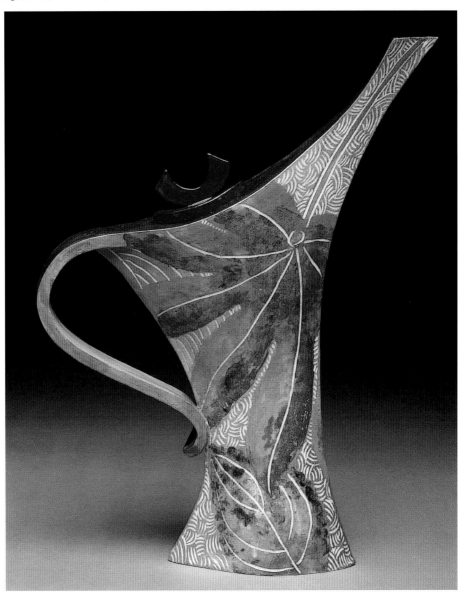

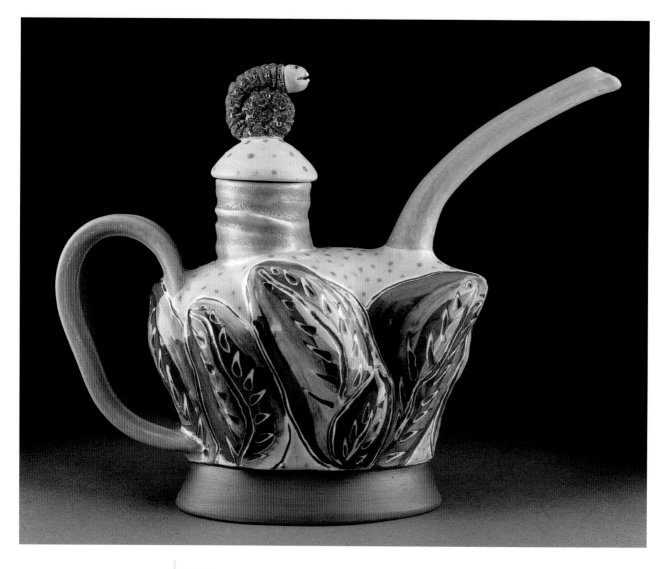

LORI MILLS

Teapot with Perched Caterpillar, 2000

9 ¾ x 12 x 4 ¼ in. (24.7 x 30.5 x 10.8 cm)

Thrown and altered; low-fire slips and glazes; bisque cone 05; glaze cone 06

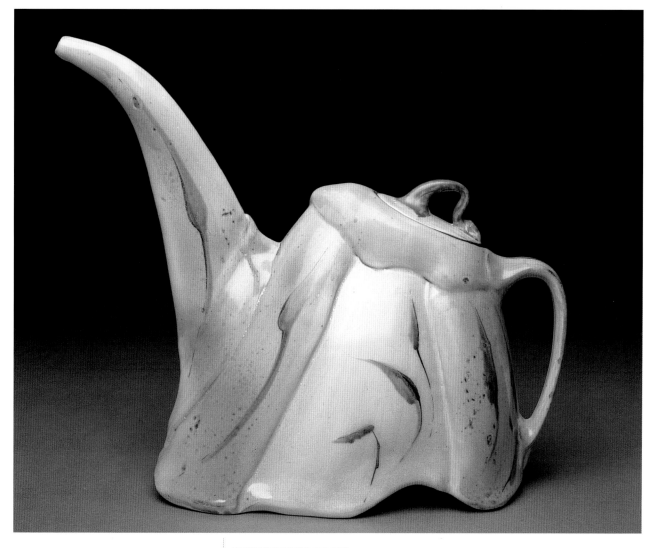

MARILYN DENNIS PALSHA

Garden Teapot, 2001

12 x 14 x 5 in. (30.5 x 35.6 x 12.7 cm)

Slab-built red earthenware; bisque cone 03;
majolica glaze cone 02

Photo by Seth Tice-Lewis

DIANE C. DUVALL
Soda Fired Teapot, 1998
16 x 15 x 4 in. (40.6 x 38.1 x 10.2 cm)
Hand-built stoneware; soda fired;
bisque cone 05

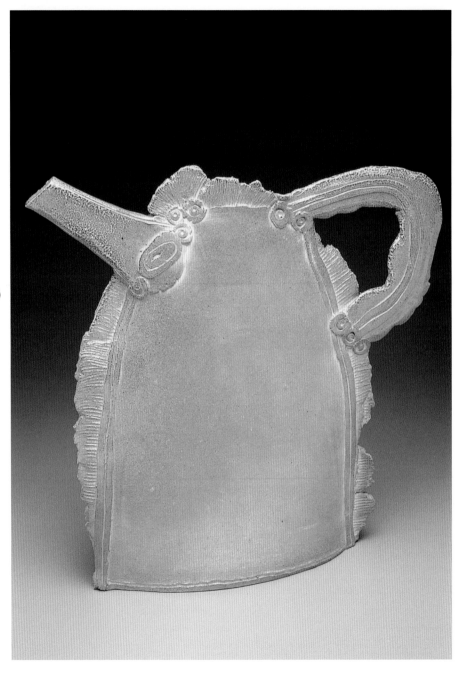

● **ERKUTER LEBLEBICI**
● *Untitled*, 1999
● 8 ¼ x 8 x 4 in. (21 x 20 x 10.5 cm)
● Slip cast; low-fire glaze; bisque cone 04;
 glaze cone 06
● Photo by Mustafa Rekfo

Since systemic botany is my original profession,
I was inspired by the appearance of the peristome
of mosses during the design process.

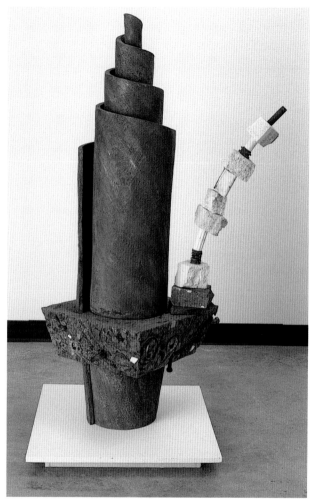

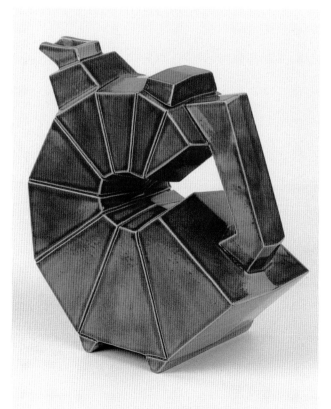

● **ROBERT L. WOOD**
● *The Odds Are Stacked*, 1998
● 51 x 30 x 22 in. (129.7 x 76.2 x 55.8 cm)
● Slab-built earthenware clay and steel; slip with
 oxide and frit, textured surface embedded with
 broken pottery shards, and pieces of brick and
 steel bolts; single-fired cone 1 gas

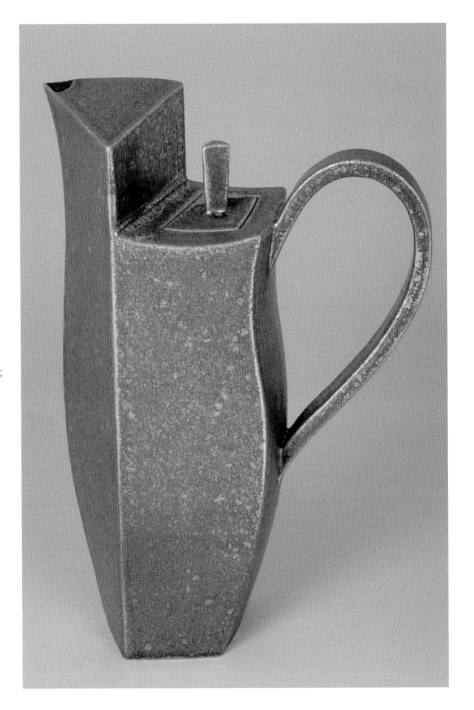

● **ELEONORE CAMSTRA**
● *Teapot*, 2000
● 11 x 6 x 3 ¼ in. (28 x 15 x 8 cm)
● Sheets of English stoneware; gold lustre over glaze; bisque cone 05a; glaze cone 5; gold lustre cone 018

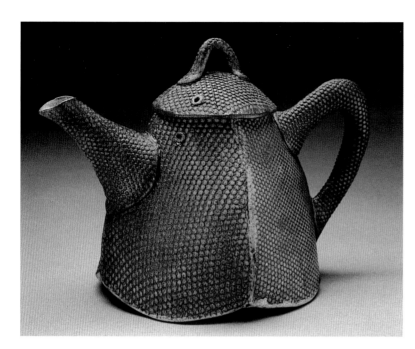

C J HAYS

Untitled, 2001

5 x 6 ½ x 3 ½ in. (12.7 x 16.5 x 8.9 cm)

Slab-built stoneware; oxide washes over textured surface; cone 10 reduction

Photo by Al Surratt

BACIA EDELMAN

Teapot, 2000

11 x 14 ½ x 4 in. (27.9 x 36.8 x 10.2 cm)

Slab-built stoneware, underglazes and terra sigillata painted over textured surfaces; bisque cone 05; sprayed white lichen glaze; cone 6

Photo by artist

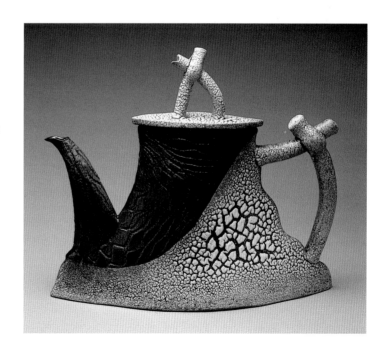

RICKY MALDONADO

Fire Plum, 2001

15 x 13 x 8 in. (38.1 x 33 x 20.3 cm)

Coil-built; dotted glaze over slip design over terra sigillata; burnished; single fired to cone 06

Photo by Imag-Ination

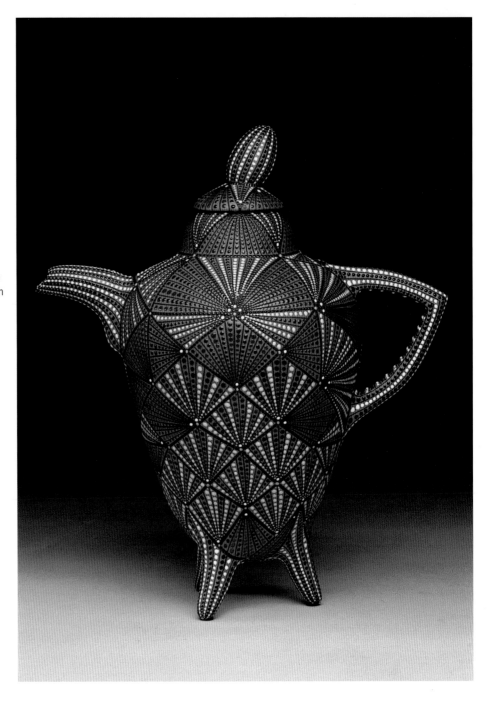

KATHRYN SHARBAUGH

Parachutes, 1999

8 x 5 x 2 in. (20.3 x 12.7 x 5 cm)

Stiff porcelain slab construction; underglaze; bisque cone 04; sprayed overglaze cone 10

Photo by Jane Hale

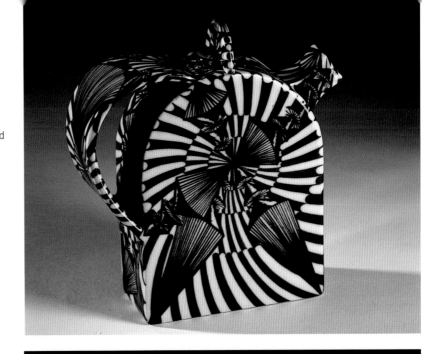

GINGER TOMSHANY

Raku Teapot No. 81, 2000

8 x 10 ¾ in. (20.3 x 21 cm)

Thrown and hand-built raku with bamboo handle

Photo by artist

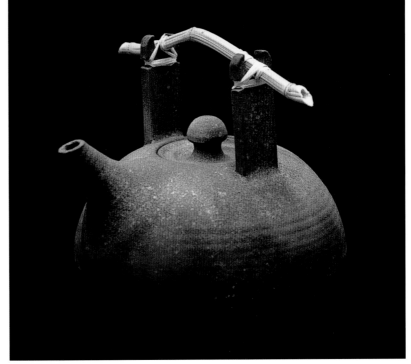

ELEONORE CAMSTRA

Teapot, 2000

8 ¼ x 8 ¾ x 3 ¼ in. (21 x 22 x 9 cm)

Sheets of English stoneware; gold lustre covers the glaze; bisque cone 05A; glaze cone 5; lustre cone 018

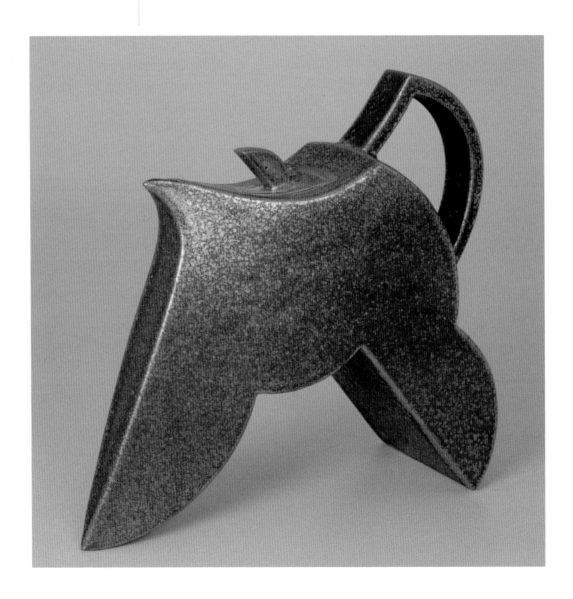

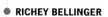 **RICHEY BELLINGER**

● *Teapot 1*, n.d.

● 14 x 9 x 8 in. (35.6 x 22.9 x 20.3 cm)

● Wheel-thrown porcelain; slip patterns; high-calcium glazes; cone 10 reduction

● Photo by Bill Bachuber

I find great satisfaction in producing simple but strong pottery forms that are enhanced by thick slip relief patterns and glazes that move.

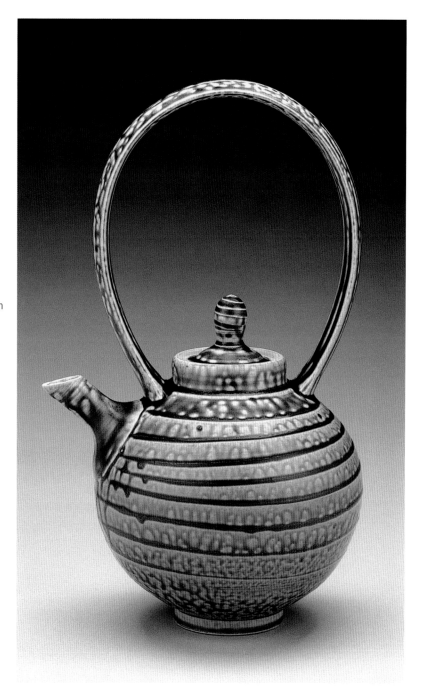

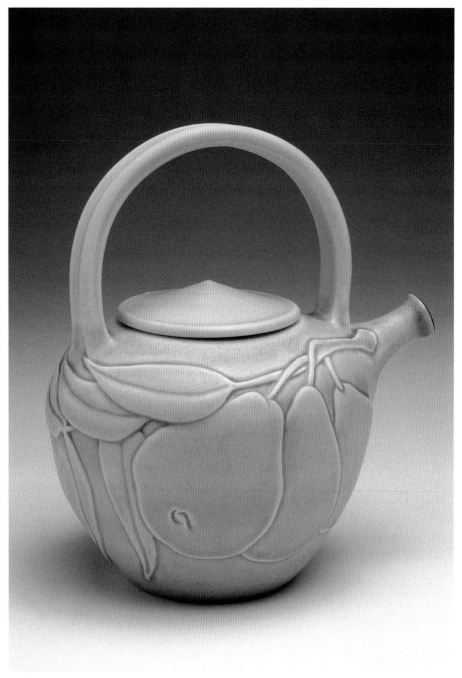

KATHYRN E. NARROW
Sorb Apple Teapot #3, 2000
8 ½ x 8 x 6 ¼ in. (21.6 x 20.3 x 15.8 cm)
Thrown porcelain; carved at greenware
stage; glaze cone 6 oxidation
Photo by John Carlano

- **VIRGINIA PIAZA**
- *Spiral Teapot*, 1998
- 6 ½ x 6 x 5 ½ in. (16.5 x 15.2 x 14 cm)
- Wheel-thrown and assembled gray stoneware; wax-resist design; shino and copper matte glazes; bisque cone 06; cone 10 gas reduction
- Photo by John Bessler

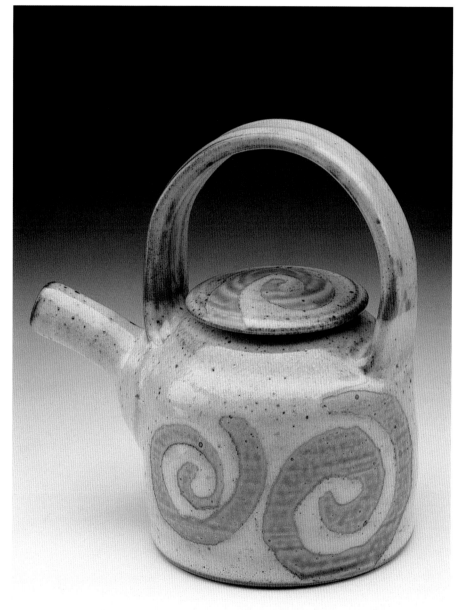

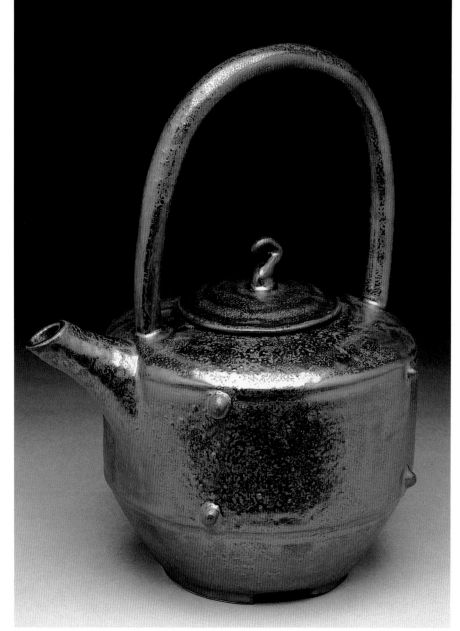

KATHLEEN NARTUHI
Teapot with Studs, 2001
12 x 9 ½ x 6 in. (30.5 x 24.1 x 15.2 cm)
Wheel-thrown porcelain with hand-built additions; sgraffito; bronze glaze; bisque cone 06; glaze cone 6
Photo by George Post

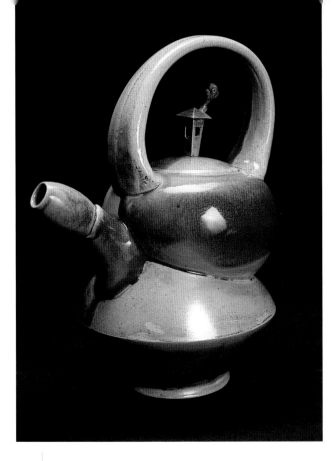

DOUGLAS E. GRAY
Gothic Teapot, 2000
10 x 6 x 5 in. (25.4 x 15.2 x 12.7 cm)
Thrown stoneware; fake yellow ash
glaze; cone 10 reduction
Photo by Walter Sallenger

I enjoy the inherent design challenge in making teapots. Each element is constructed with the knowledge that it must ultimately be combined with several others, so when I want to incorporate a simple architectural reference, like an arch, its form helps dictate the shape and proportion of every other element.

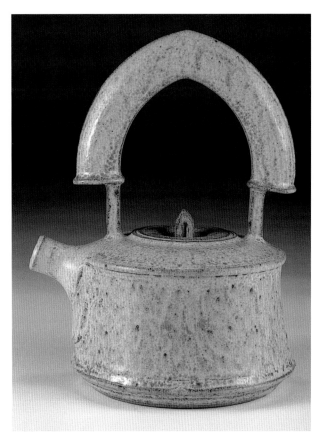

SCOTT D. CORNISH
House on the Hill, 2001
12 x 9 x 6 in. (30.5 x 22.9 x 15.2 cm)
Wheel-thrown and assembled porcelain; cast sterling silver; sprayed glaze with wax resist; cone 10 soda
Photo by artist

CHRISTA ASSAD

Teaworks I, 1999

8 x 10 x 6 ½ in. (20.3 x 25.4 x 16.5 cm)

Wheel-thrown and constructed stoneware; cone 10 reduction

Photo by Todd Burns

Learning to improvise within a system comes through repeated performance and familiarity with the subject matter.

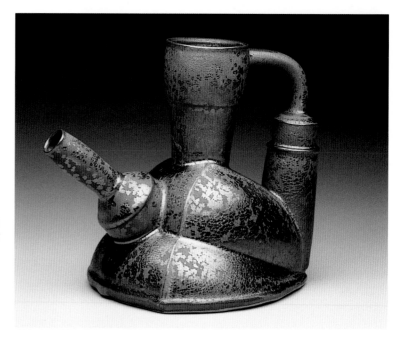

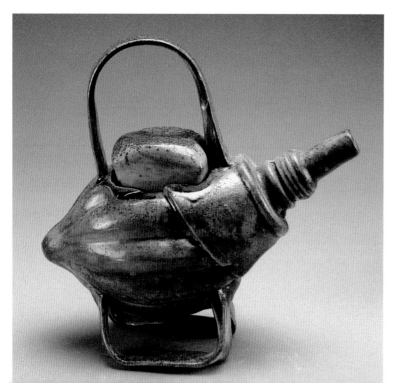

HARRY WONG

The Other One, 2000

7 x 7 ½ x 4 ½ in. (17.8 x 19 x 11.4 cm)

Slip-cast, hand-built, and wheel-thrown clay with slip surface; bisque cone 07; cone 10 wood

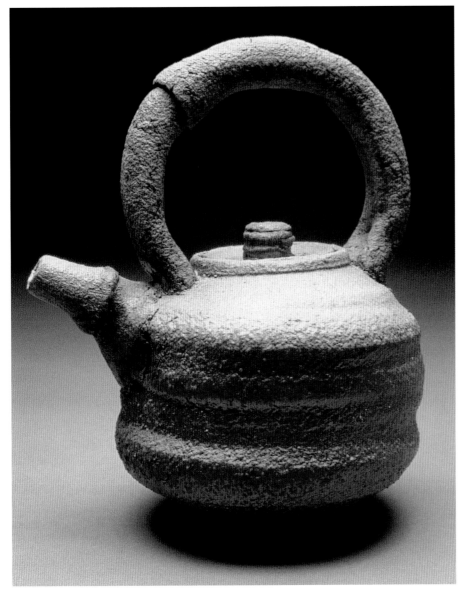

CHRIS DONIERE

Cover Story 2, 2000

14 x 7 ¾ x 5 ½ in. (35.6 x 19.6 x 14 cm)

Thrown; slab-built handle; wash; cone 10 anagama, natural wood ash

Photo by artist

To create texture and volume, I pushed the clay to its breaking point.

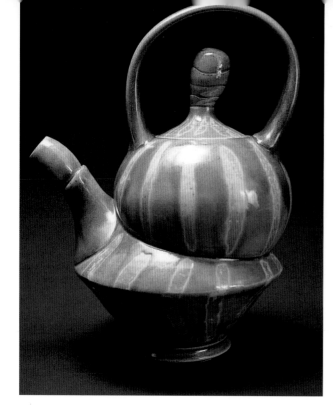

SCOTT D. CORNISH

Stripey Green Teapot, 2001

12 x 9 x 7 in. (30.5 x 22.9 x 17.8 cm)

Wheel-thrown and assembled porcelain; sprayed glaze with wax resist; cone 10 soda

Photo by artist

MACY DORF

Untitled, 2001

10 x 7 ½ x 5 ¼ in. (25.4 x 19 x 13.3 cm)

Thrown form with extruded and altered handles; glazes; cone 10

Photo by Paul Gillis

The extruded teapot handle becomes a dynamic sculptural element, while its organic nature responds to the natural contours of the hand.

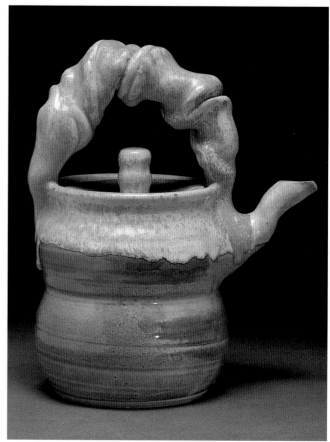

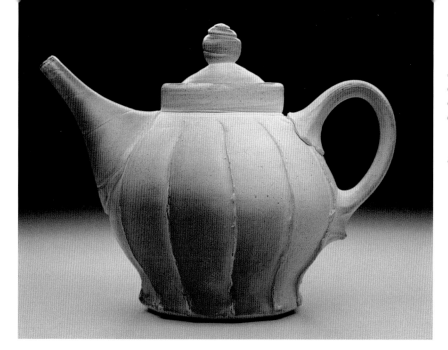

● **GAY SMITH**
● *Fluted Teapot*, 2000
● 7 ½ x 6 x 3 in. (19 x 15.2 x 7.6 cm)
● Wheel-thrown porcelain; surface manipulated on the wheel; raw glazed and single-fired; cone 10 soda
● Photo by Tom Mills

● **DIANE ROSENMILLER**
● *Teapot*, 2001
● 10 x 10 x 6 in. (25.4 x 25.4 x 15.2 cm)
● Thrown porcelain with hand-built spout; carved; glazed; cone 10 soda
● Photo by Nicholas Seidner

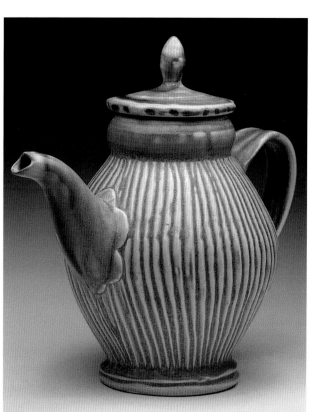

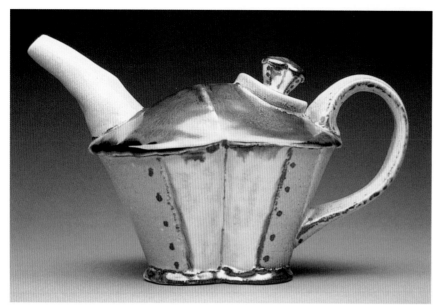

● **CHRIS DONIERE**
● *Riveting*, 2001
● 5 ½ x 8 x 4 ¼ in. (14 x 20.3 x 10.8 cm)
● Thrown, altered, and slab construction porcelain; high-fire glazes; cone 10 soda
● Photo by artist

With this pot I concentrated on bringing the two-part body together to form one unit and continued that idea through the glazing process.

● **KATHRYN FINNERTY**
● *Twig Teapot*, 2001
● 6 ½ x 9 in. (16.5 x 22.9 cm)
● Wheel-thrown and slab terra cotta composition; pressed relief, white slip; cone 04

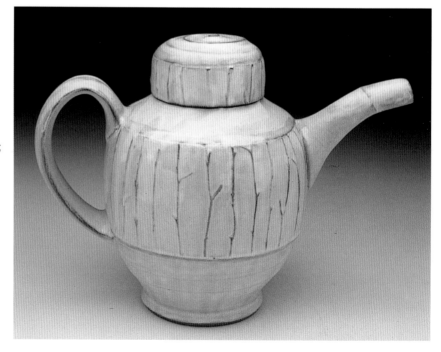

MARK PETERS

Teapot, 2000

8 x 8 x 5 in. (20.3 x 20.3 x 12.7 cm)

Wheel-thrown and altered stoneware; wood fired

Photo by artist

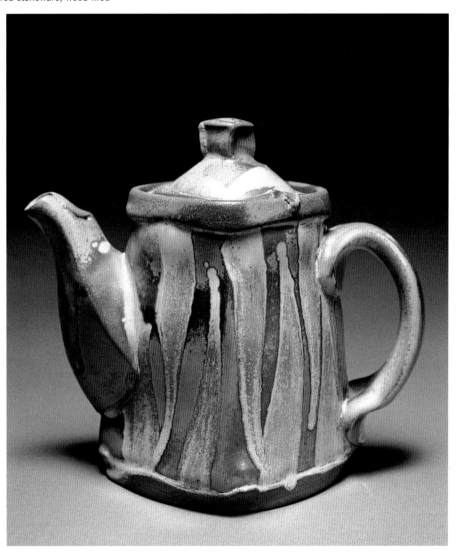

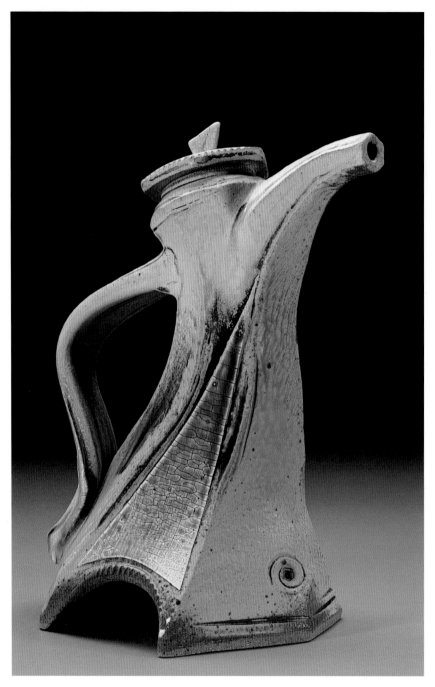

TONY WINCHESTER
Teapot, 2000
11 x 7 x 5 in. (27.9 x 17.8 x 12.7 cm)
Wheel-thrown, altered, faceted, and assembled stoneware; reduction-fired
Photo by Larry Sanders

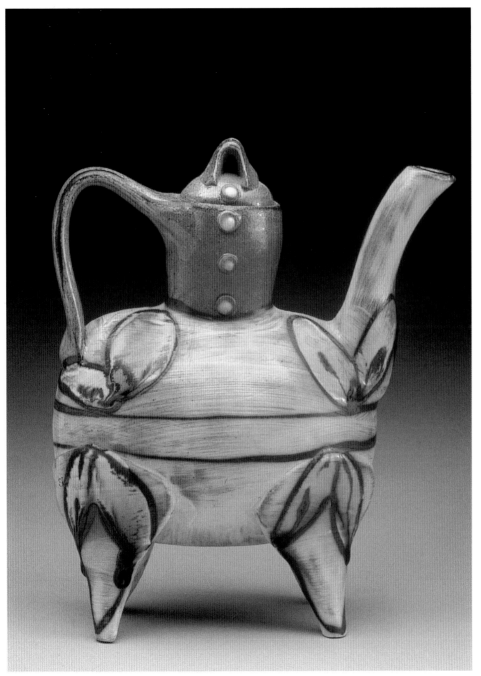

● **SUZE LINDSAY**
● *Footed Teapot*, 2001
● 8 x 7 x 3 in. (20.3 x 17.8 x 7.6 cm)
● Thrown, hand-built, and assembled stoneware elements; slips and glazes; cone 10 salt
● Photo by Tom Mills

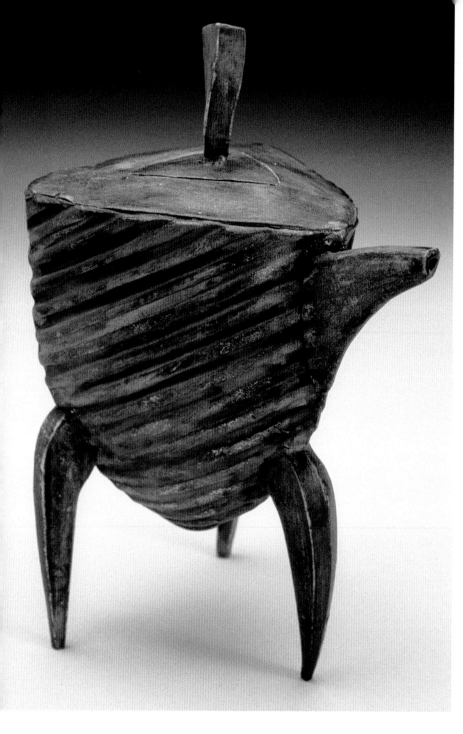

● **MARGARET PATTERSON**
● *Ca. 2000*, 2000
● 6 ½ x 4 ½ x 3 ½ in. (16.5 x 11.4 x 8.9 cm)
● Hand-built with textured slabs; terra sigillata
 and cobalt oxide wash patina; bisque cone
 06; patina cone 04; sandblasted
● Photo by Bart Kasten

- **RICKY MALDONADO**
- *Aria*, 2001
- 16 x 14 x 9 in. (40.6 x 35.6 x 22.9 cm)
- Coil-built; dotted glaze over slip design over terra sigillata; burnished; single fired to cone 06
- Photo by Imag-Ination

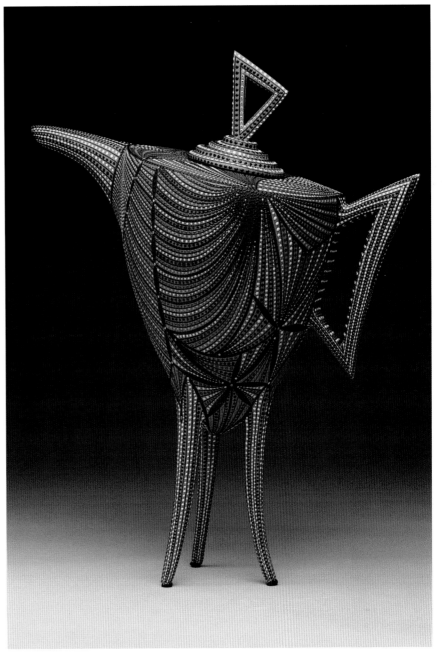

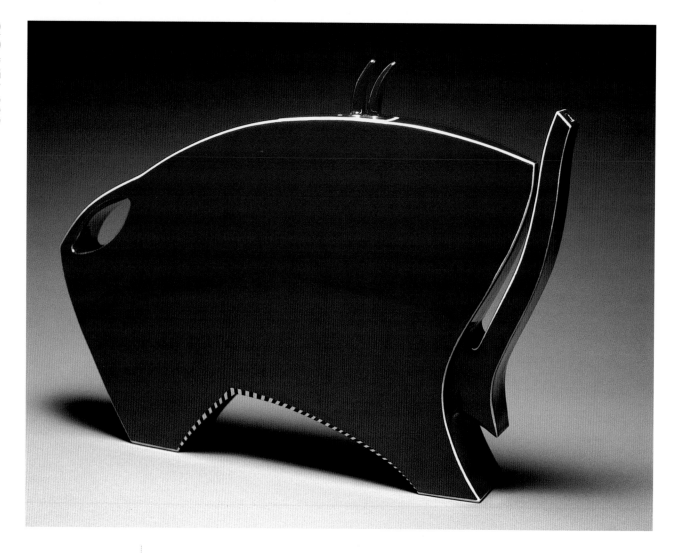

● **JOHN GLUMPLER**
● *Red Variation*, 2001
● 14 x 20 x 3 in. (35.6 x 50.8 x 7.6 cm)
● Slab-built white earthenware with
engobes and glazes

I find it interesting that the teapot is fast becoming an icon of sorts. It's
amazing that, like typography, the structure of the teapot can be pushed to
the point of abstraction and beyond, yet remain visually readable.

MARGARET PATTERSON

Catch Me If You Can..., 1998

5 x 9 x 3 ½ in. (12.7 x 22.9 x 8.9 cm)

Hand-built with textured slabs; terra sigillata and cobalt oxide wash patina; bisque cone 06; patina cone 04

Photo by Bart Kasten

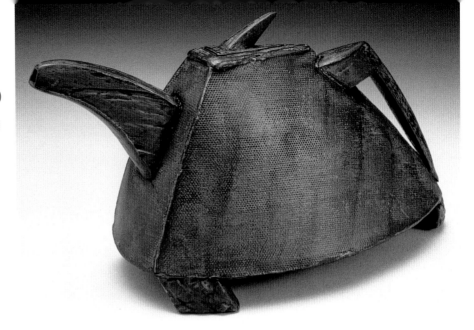

MARK PETERS

Teapot, 2001

8 x 8 x 5 in. (20.3 x 20.3 x 12.7 cm)

Wheel-thrown and altered stoneware; wood fired

Photo by artist

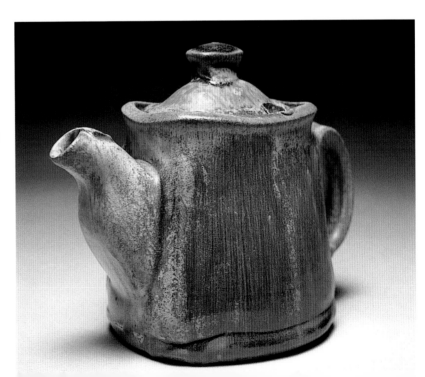

DAVEN HEE

Sammy's Teapot, 2000

10 x 4 ½ x 4 in. (25.4 x 11.4 x 10.2 cm)

Wheel-thrown and altered; ash glazes with oxides; cone 10 reduction

Photo by Brad Groda

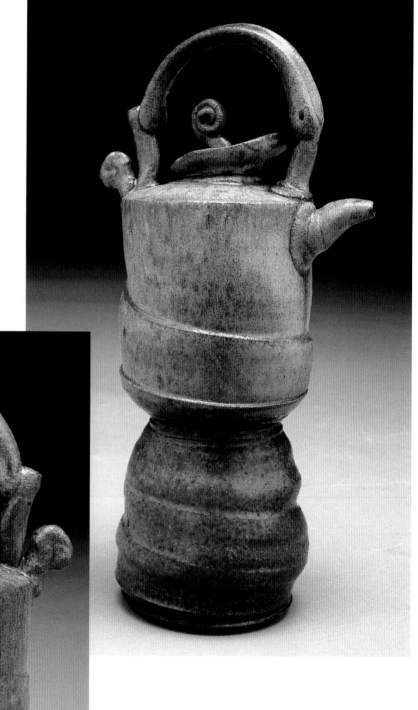

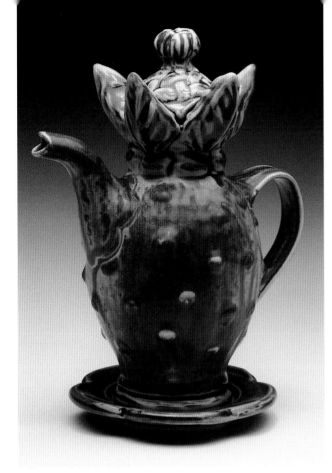

ANN M. PERRY SMITH
Batea, 2000
15 x 12 x 10 in. (38.1 x 30.5 x 25.4 cm)
Slab-built body; hand-carved surface with hand-carved applique; sculptural lid construction; pulled handles and spout; copper red raku glaze with black reduction; raku fire

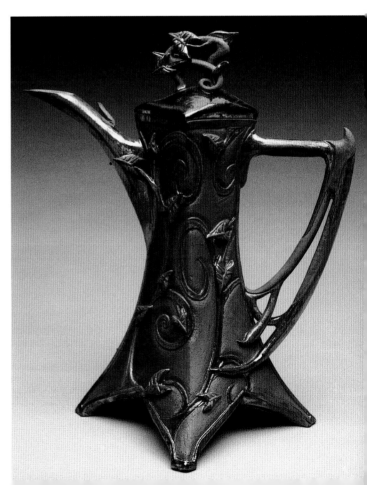

DIANE ROSENMILLER
Ewer, 2001
8 x 7 x 4 in. (20.3 x 17.8 x 10.2 cm)
Thrown and altered porcelain; press-molded top attachments and hand-built spout; glaze cone 10 soda
Photo by Nicholas Seidner

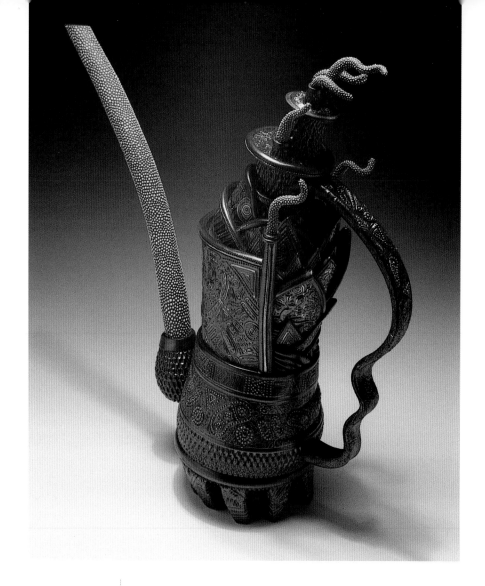

MARKO FIELDS
Gaia's Teapot of Dalliance and Fertility, 2001
20 x 14 x 7 in. (50.8 x 35.6 x 17.8 cm)
Stoneware; porcelain (applied as slip); thrown and altered with hand-built elements, including coils; press-molded slabs; cone 10 reduction; lustre cone 018
Photo by artist

BARBARA NEWELL

Tall Teapot, 2000

23 x 13 ½ x 6 ½ in. (58.4 x 34.3 x 16.5 cm)

Slab-built white stoneware with impressed
design; slip and glaze; bisque 06; cone 10 wood

The colors and textures in my work are influenced
by the natural beauty of the desert, the mountains,
and the lakes where I have lived.

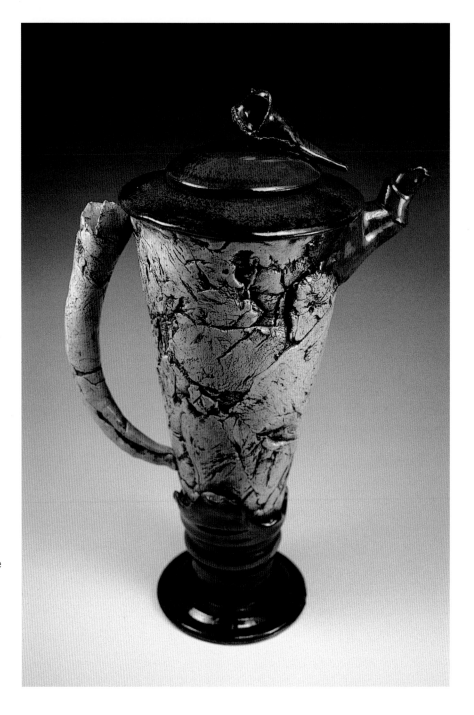

DALE DUNCAN

Textured Teapot, 2001

17 x 10 x 7 in. (43.2 x 25.4 x 17.8 cm)

Combination wheel-thrown, press-molded, and hand construction; clear and saturated iron glaze over iron wash, rubbed into body textures; bisque cone 06; glaze cone 6 oxidation

Photo by artist

I love the different textures created by pressing objects into wet clay. The crevasses and textures in this piece are created by molds and stamps taken from the bark of oak trees.

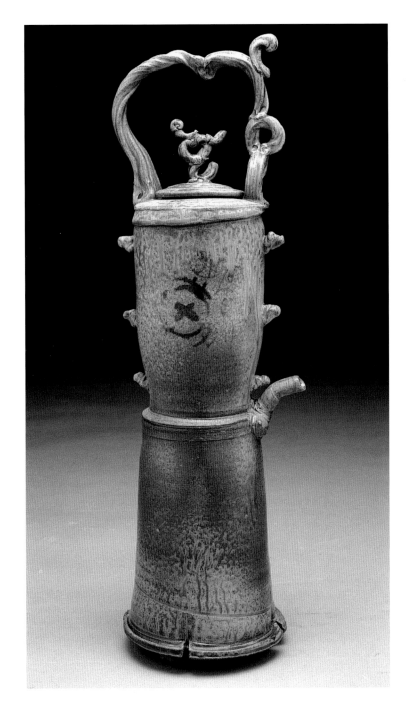

DAVEN HEE

Teapotish, 2000

20 x 7 x 5 ½ in. (50.8 x 17.8 x 14 cm)

Wheel-thrown and altered; ash glazes with oxides; cone 10 reduction

Photo by Brad Groda

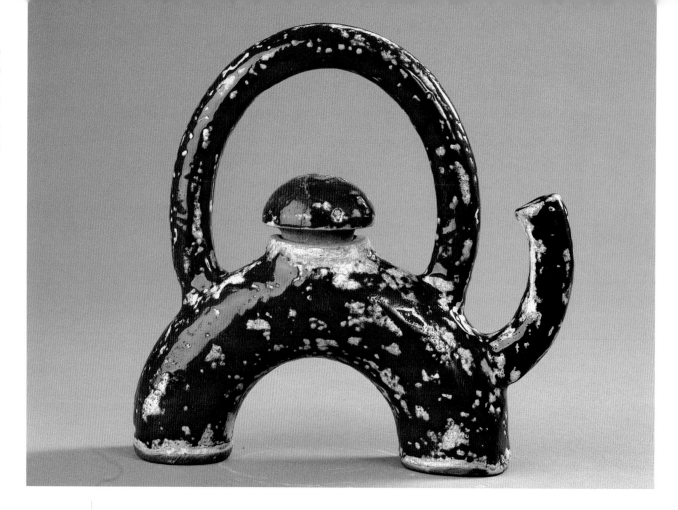

- **LEENA BATRA**
- *Half-Doughnut Teapot*, 2000
- 7 x 8 x 3 in. (17.8 x 20.3 x 7.6 cm)
- Thrown and hand-built stoneware; bisque cone 06; white dolomite glaze; cone 9 gas, reduction; cadmium orange overglaze; refired in oxidation cone 06
- Photo by Hari Laxman

I'm mad about pottery—there is simply no life without it. I love to experiment with just about everything: form, clay bodies, glazes, different techniques; there is no limit!

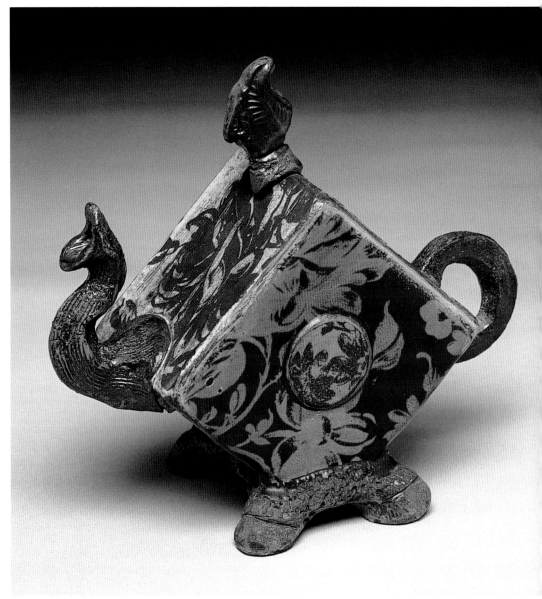

ANN M. PERRY SMITH
On His Advice, 2000
18 x 22 x 12 in. (45.7 x 55.8 x 30.5 cm)
Wheel-thrown terra cotta clay body; hand-carved surface with hand-carved appliqué; sculptural construction of lids and pulled handles; pulled spout; glaze cone 6 on leaves and body; glaze cone 04 on vine carving, handles, lids; patina-finished handles and lid

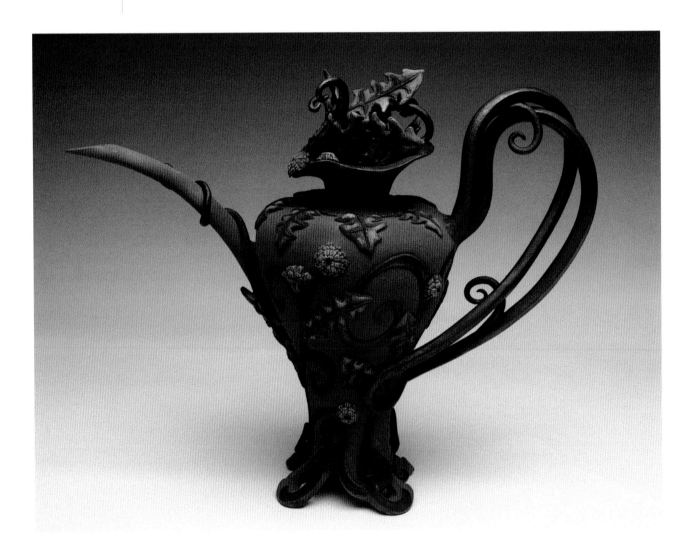

BRIAN HIVELEY

Yellow Spot Teapot, 2001

15 x 17 x 7 in. (38.1 x 43.2 x 17.8 cm)

Slab-built earthenware; underglazes and glazes; cone 6 multi-fired oxidation

Photo by artist

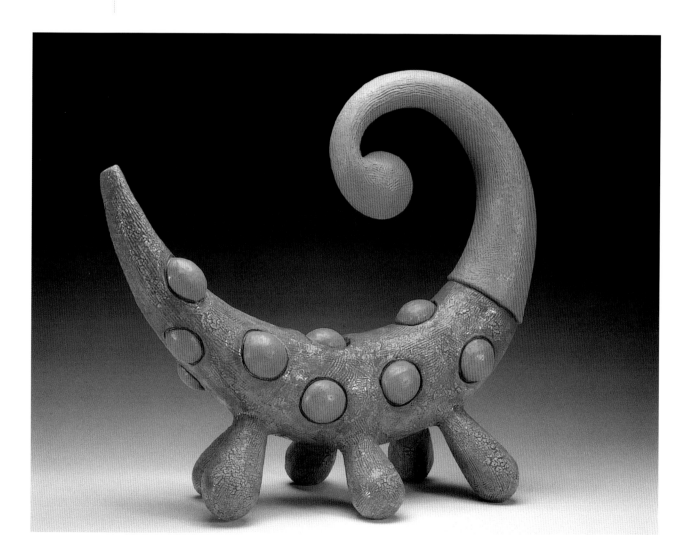

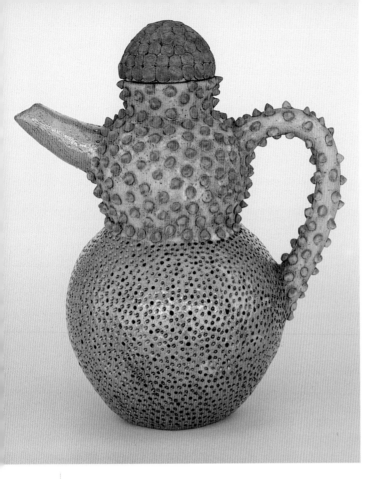

PRISCILLA HOLLINGSWORTH

Teapot: Double Gourd with Purple Nubs, 2001

10 x 8 ½ x 6 in. (25.4 x 21.6 x 15.2 cm)

Hand-built (coiled and paddled with pinched texture) from terra cotta; bisque cone 06; glaze cone 04, then cone 08

Photo by artist

This textured teapot series is a playful variation on Chinese gourd-shaped teapots and West African pots made for sacred purposes, which are patterned in nubs and pocks to distinguish them from pots made for ordinary uses.

IAN STAINTON

Flat-Sided Teapot, 2000

9 ½ x 9 ½ x 3 ½ in. (24.1 x 24.1 x 8.9 cm)

Hand-thrown without base; bead glaze over black slip; cone 10 reduction

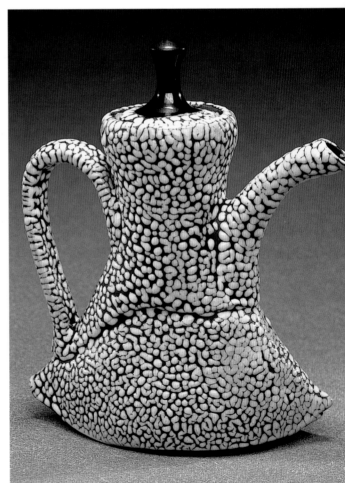

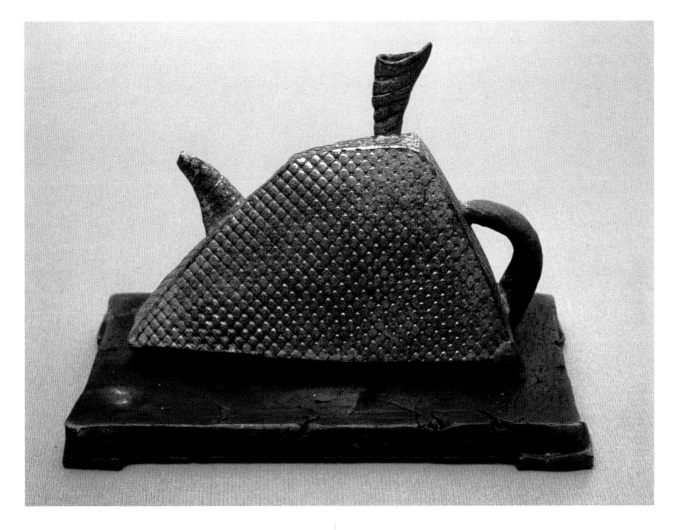

● **MARGARET PATTERSON**
● *Teapot Form with Stand*, 1999
● 6 x 2 ½ x 7 ½ in. (15.2 x 6.4 x 19 cm)
● Hand-built with textured slabs; raku fired
● Photo by artist

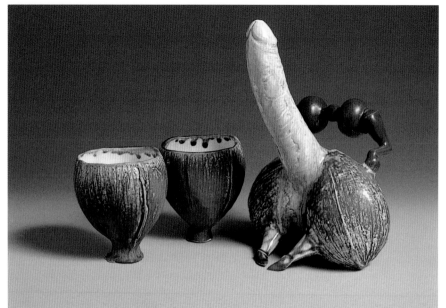

TAMMY TOMCZYK
Tea for Two, 2001
10 x 7 ½ x 5 ½ in. (25.4 x 19 x 14 cm)
Slip-cast parts; bisqued; glaze cone 04
Photo by artist

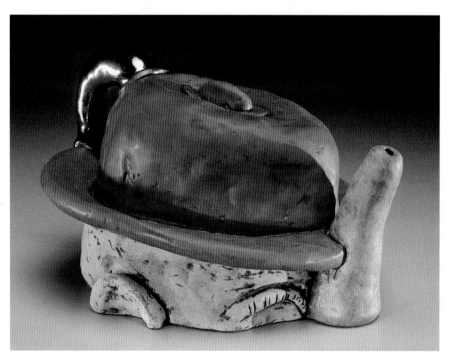

ALLAN ROSENBAUM
Red Bowler Teapot, 2001
6 x 10 x 8 in. (15.2 x 25.4 x 20.3 cm)
Coil-built earthenware; oxide wash;
underglaze and layered glazes; cone 05
Photo by Katherine Wetzel

In this piece I focused on a small section
of the figure to create a sculptural teapot
that humorously refers to the anthropo-
morphic qualities of a classical teapot.

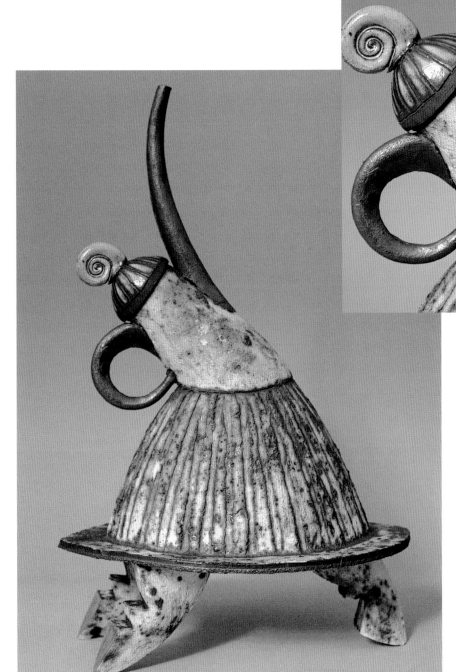

● **HENNIE MEYER**
● *Teapot on the Run*, 2001
● 16 ½ x 11 ¾ x 8 ¾ in. (42 x 30 x 22 cm)
● Slab-built, press-molded earthenware; slip and gold luster; glaze cone 1
● Photo by artist

I find that the challenge of making teapots lies in their composite nature—in creating a balance of elements between lid, handle, spout, and feet—to form an aesthetically pleasing vessel that combines humor and a recognizable signature style.

HENNIE MEYER

Triangular T-Pot, 2001

6 ¾ x 6 x 3 ½ in. (17 x 15 x 9 cm)

Hand-built slab and press-molded; low-fire glazes and underglaze; glaze cone 01; lustre 1436°F (780°C)

Photo by artist

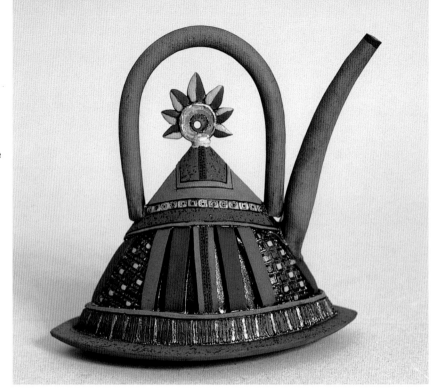

MARKO FIELDS

Basket Teapot with Fruit Indigenous to My Planet, 2001

12 x 16 x 8 in. (30.5 x 40.6 x 20.3 cm)

Thrown and altered stoneware and porcelain with hand-built elements; sgraffito and incised; underglazed; clear glaze cone 6 oxidation

Photo by artist

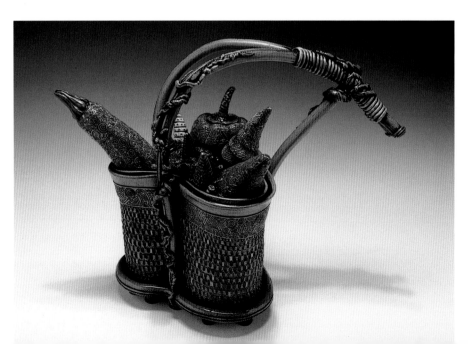

SCOTT DOOLEY
Teapot, 2001
16 x 8 x 5 in. (40.6 x 20.3 x 12.7 cm)
Hand-built and textured porcelain slabs;
oxide and glaze; cone 5 electric

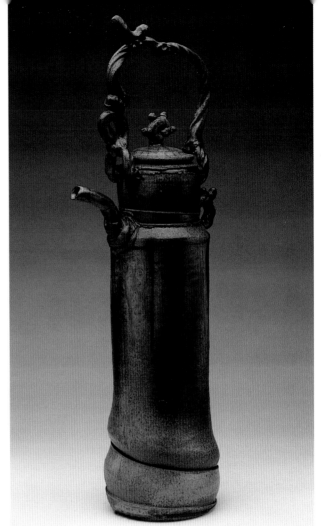

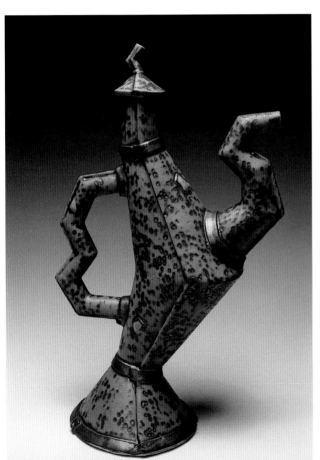

DAVEN HEE
Industrial Tea, 2000
18 x 6 ½ x 4 ½ in. (45.7 x 16.5 x 11.4 cm)
Wheel-thrown and altered; cone 10 reduction; ash glaze and oxides
Photo by Brad Groda

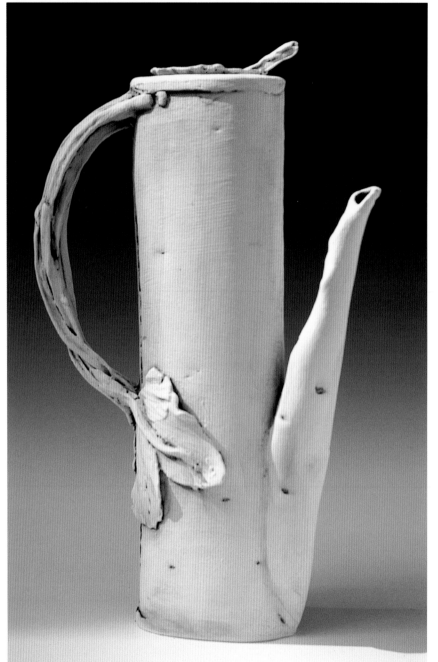

UNA MJURKA
Garden Vegetable Pot #2, 2001
14 x 9 x 2 ½ in. (35.6 x 22.9 x 6.4 cm)
Hand-built, low-fire clay; layered engobes with oxide and glaze washes; multi fired cone 06–04 range
Photo by artist

SHAY AMBER

Phasma, 2000

14 x 4 x 5 in. (35.6 x 10.2 x 12.7 cm)

Slab and coil construction; oxide and underglaze washes; glaze cone 04

Photo by Neil Picket

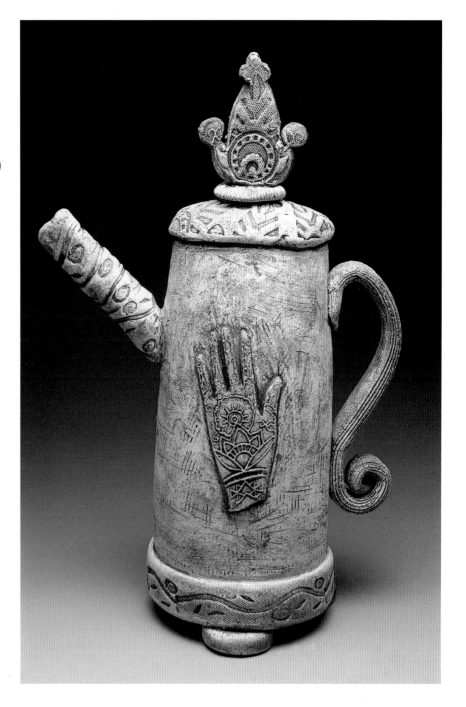

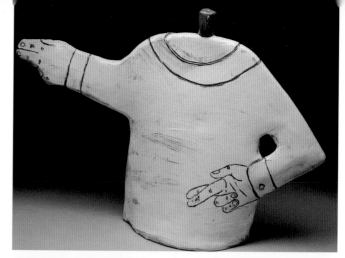

CHRIS DAVENPORT

Self-Portrait, 2000

11 x 3 x 13 in. (27.9 x 7.6 x 33 cm)

Slab-built earthenware; slips and glaze over incised drawing; cone 04 oxidation

I created this self-portrait in reaction to Renaissance sensibilities being applied to a craft medium.

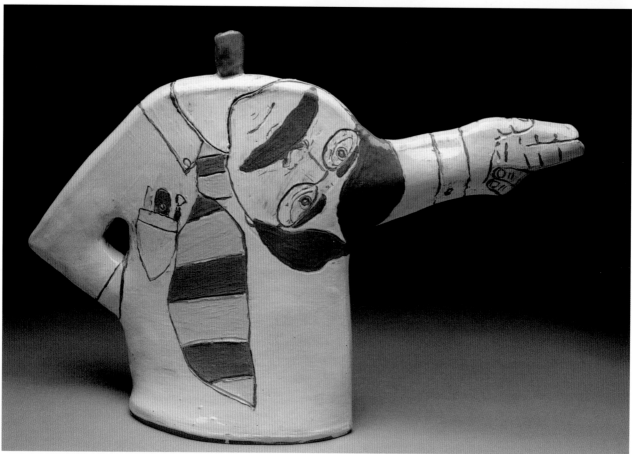

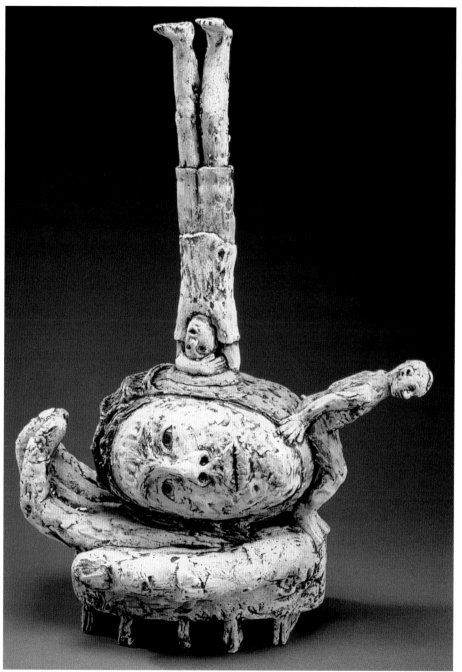

DEBRA W. FRITTS
Head First, 1999
25 x 15 x 9 in. (63.5 x 38.1 x 22.9 cm)
Slab-built, coiled, and modeled terra cotta;
bisque cone 02; multifired cone 04; slips,
oxides, glazes, and underglazes
Photo by Michael Noa

- **MANDY WOLPERT**
- *Oh No You Don't!*, 2000
- 19 x 13 x 6 ½ in. (48.3 x 33 x 16.5 cm)
- Earthenware slab base with thrown additions; glass beads and metal bells; underglaze decoration; clear glaze; bisque 04, glaze 06
- Photo by Ian Hobbs

The jester has his hands on his hips, the wisdom of the heavens on his garb. He is laughing at human behavior on the subject of temptation.

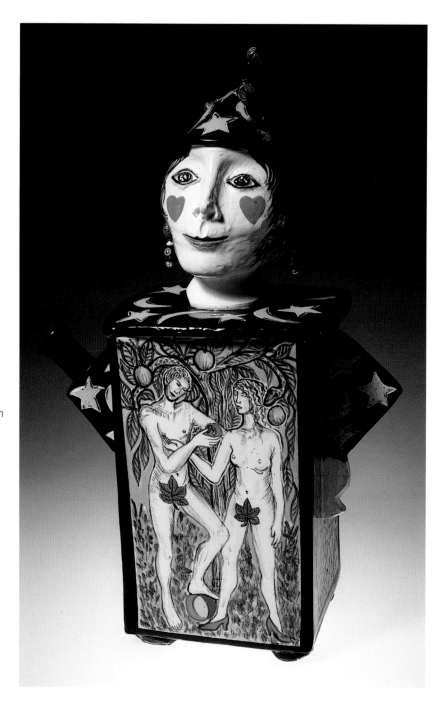

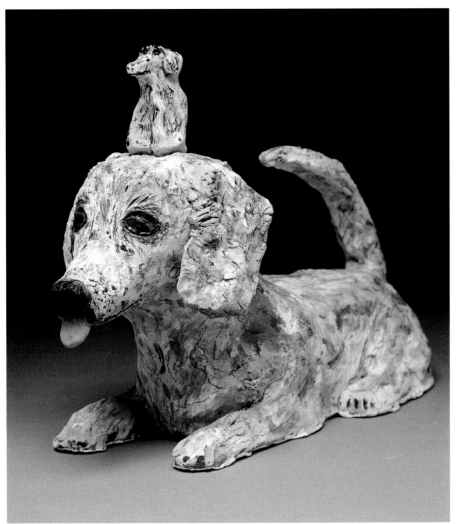

SYLVIA LAMPEN
Doxie Teapot, 2000
10 x 14 x 8 in. (25.4 x 35.6 x 20.3 cm)
Coil-built red clay; all firings cone 04
Photo by Michael Noa

ILONA ROMULE
The Games of Chameleons, 2000
7 ½ x 9 x 8 in. (19 x 22.9 x 20.3 cm)
Slip-cast porcelain from self-made plaster molds with cork lids; bisque cone 07; interior glaze cone 10; hand polished; china paint and gold lustre; two cone 08 firings
Photo by Aigars Jukna

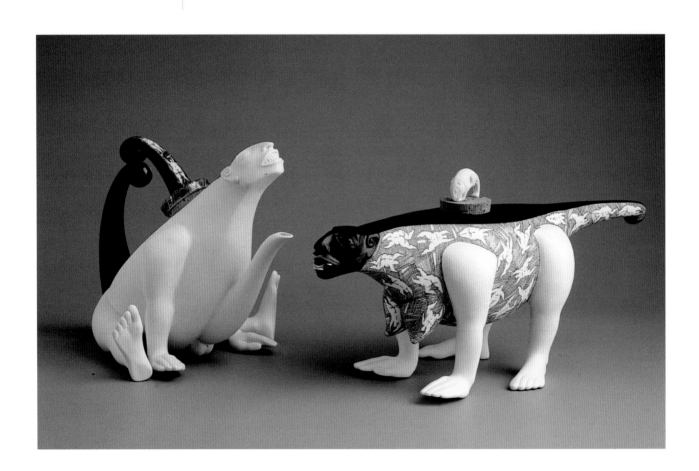

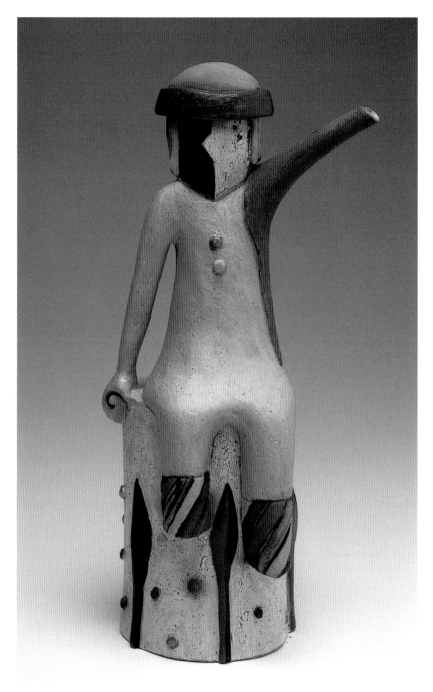

ELYSE SAPERSTEIN
Pointer, 2000
17 x 8 ½ x 6 in. (43.2 x 21.6 x 15.2 cm)
Slab-built earthenware; layered low-fire glazes, slip, and wash; bisque cone 06; glaze cone 06
Photo by John Carlano

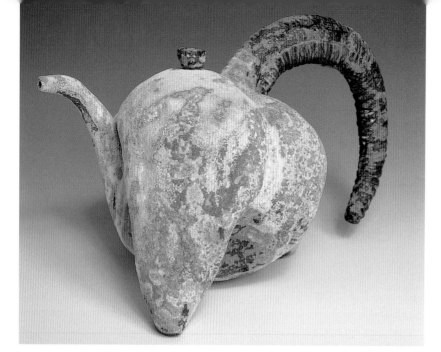

● **ROBERT MUELLER**
● *Horney Teapot*, 1999
● 7 x 8 x 6 in. (17.8 x 20.3 x 15.2 cm)
● Wheel-thrown and altered stoneware; glaze cone 10 reduction; reglazed and refired cone 06 oxidation
● Photo by Joe Guinta

Sometimes my involvement with the many facets of the ceramic process overwhelms me. I start out to throw a simple form, which leads to altering the form, then cutting it up and reconstructing it. Even the glazing and firing processes are reinvestigated several times in making a single piece.

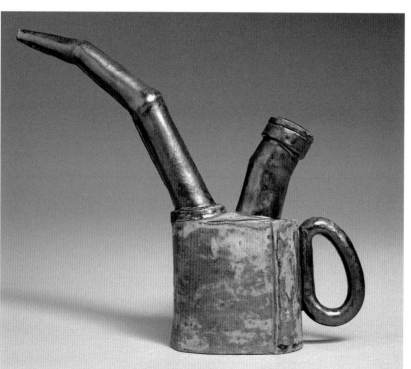

● **JOSEPH LYON**
● *Teapot* , 2001
● 12 x 14 x 3 $7/16$ in. (30.5 x 35.6 x 8.7 cm)
● Slab-built; brushed-on glazes; bisque cone 07; cone 10 soda
● Photo by artist

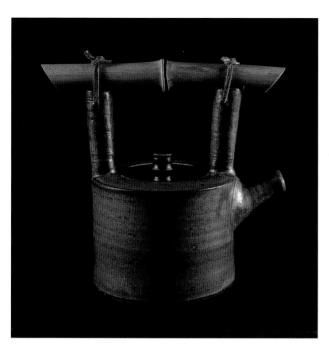

JOE COMEAU
Tea Pot, 2000
12 x 7 x 6 in. (30.5 x 17.8 x 15.2 cm)
Wheel-thrown white stoneware with bamboo handle; spodumene glaze; cone 10 gas reduction

DINA ANGEL-WING
Teapot with Tall Bamboo Handle, 2000
18 x 10 x 8 in. (45.7 x 25.4 x 20.3 cm)
Wheel-thrown stoneware clay; bisque cone 08; raku fired
Photo by Frank Wing

I am strongly inspired by age-old Asian tea traditions, which I combine with the need for my work to express playfulness.

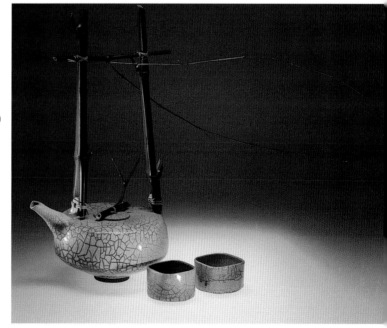

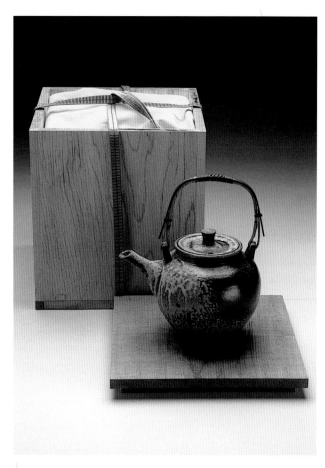

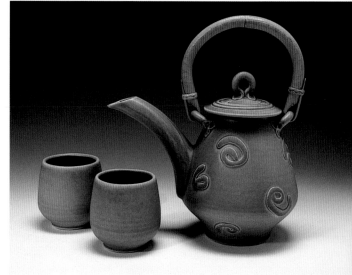

BONNIE K. MORGAN
Untitled, 1999
12 x 11 x 7 in. (30.5 x 27.9 x 17.8 cm)
Wheel-thrown porcelain with applied
clay design; cone 5 electric
Photo by Elizabeth Ellingson

RAFAEL MOLINA
Teapot, 2001
9 x 8 x 6 in. (22.9 x 20.3 x 15.2 cm)
Wheel-thrown stoneware;
glaze cone 13 wood
Photo by artist

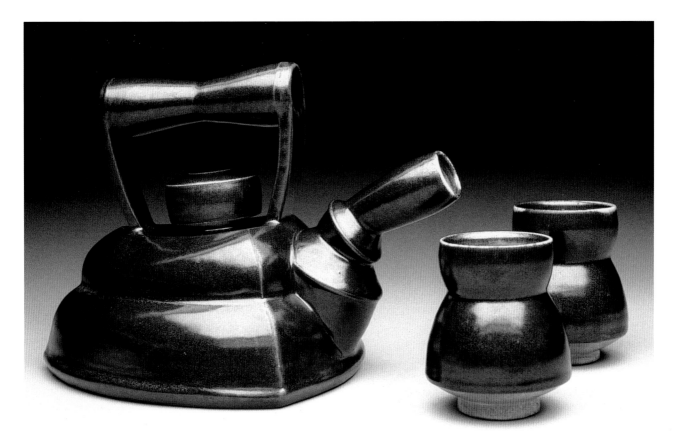

● **CHRISTA ASSAD**
● *Iron Teapot and Cups*, 1999
● 10 x 12 x 7 in. (25.4 x 30.5 x 17.8 cm)
● Wheel-thrown and constructed stoneware;
 cone 6 soda
● Photo by artist

Much like learning to play a musical instrument, throwing clay on the wheel requires methodical practice and refinement of technique. Just as scales provide a vocabulary with which musicians can speak to each other, so there are "rules" for making functional pots.

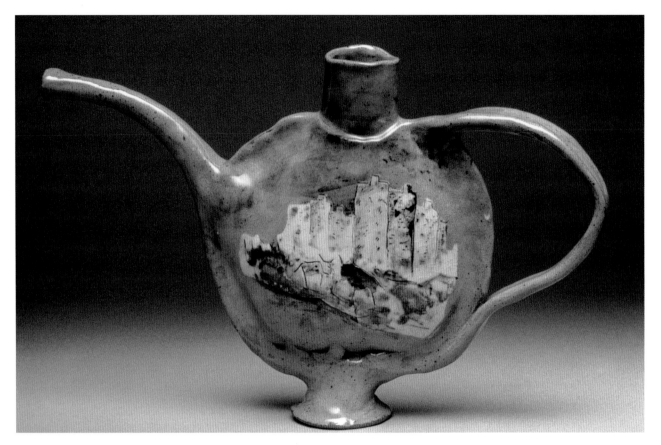

ELAINE WOLDORSKY
City Tea Pot, 2000
10 x 15 x 3 ½ in. (25.4 x 38.1 x 8.9 cm)
Slab-built porcelain; inlay and brushwork;
cone 10 red fired
Photo by Peter Lee

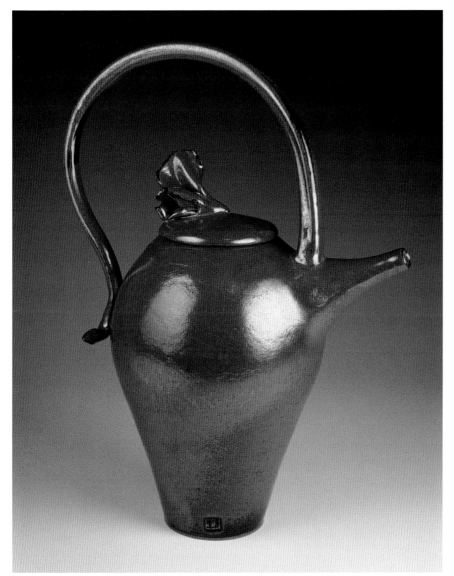

DALE DUNCAN
Iron Red Teapot, 2001
12 ½ x 8 x 6 in. (31.8 x 20.3 x 15.2 cm)
Wheel-thrown; saturated iron glaze; bisque cone 06; glaze cone 6 oxidation
Photo by artist

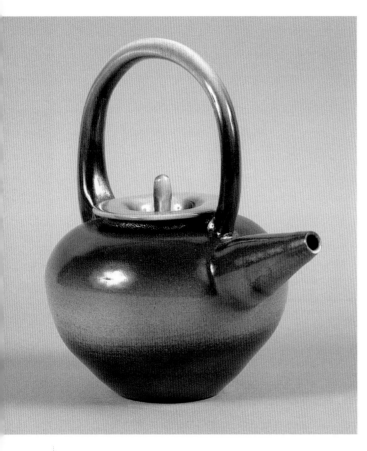

TYLER GULDEN

Teapot, 2001 (cover)

8 x 6 ½ x 7 ½ in. (20.3 x 16.5 x 19 cm)

Wheel-thrown porcelain; wheel-thrown and
altered hollow handle; glaze cone 10 soda

One of my favorite books is *The Way Things Work,* by
D. Macaulay (Scholastic, 1988), because it illustrates the
complex inner workings of fairly ordinary tools and
machines. Making pots provides an opportunity for me to
explore, examine, and illustrate the not-so-common intrica-
cies and complexities of everyday, useful objects. How parts
and pieces connect and relate tells a lot about how a pot
was made, giving insight to the user, and making the use of
the pot not only pleasurable but engaging.

ERIK HANSEN

Teapot, 2001

8 x 5 x 4 ½ in. (20.3 x 12.7 x 11.4 cm)

Wheel-thrown; pulled handle; sprayed oxides under clear glaze;
bisque cone 06; glaze cone 9

Photo by Doug Thompson

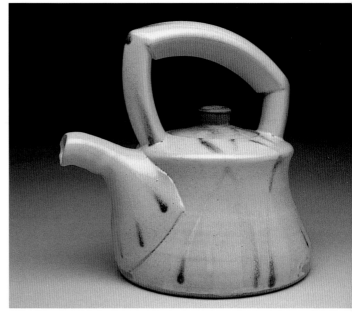

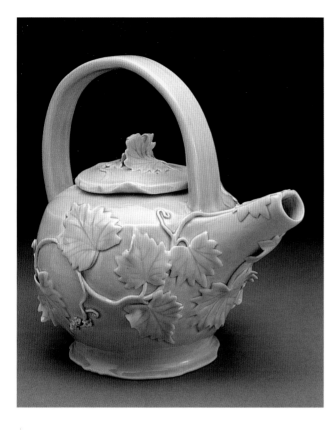

KATHRYN E. NARROW
Sweet Pea Teapot #1, 2000
8 ½ x 7 ¼ x 5 ¾ in. (21.6 x 18.4 x 13.3 cm)
Thrown porcelain; carved at greenware stage;
glaze cone 6 oxidation
Photo by John Carlano

MARY-HELEN HORNE
Muscadine Teapot, 2001
8 x 7 ½ x 5 in. (20.3 x 19 x 12.7 cm)
Wheel-thrown porcelain; bisque cone 04;
glaze cone 6 electric
Photo by Bart Kasten

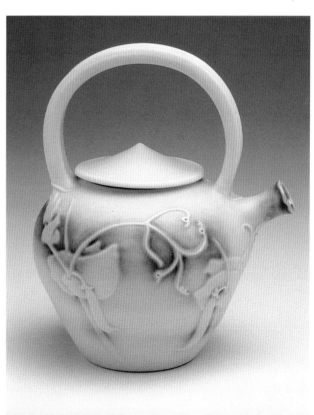

RON BOLING

Raku Tea Pot - Alluding to Function, 2000

19 x 12 in. (48.3 x 30.5 cm)

Wheel-thrown raku clay with extruded handle; Piepenburg Patina glaze; bisque cone 07; glaze cone 07

Photo by John Hooper

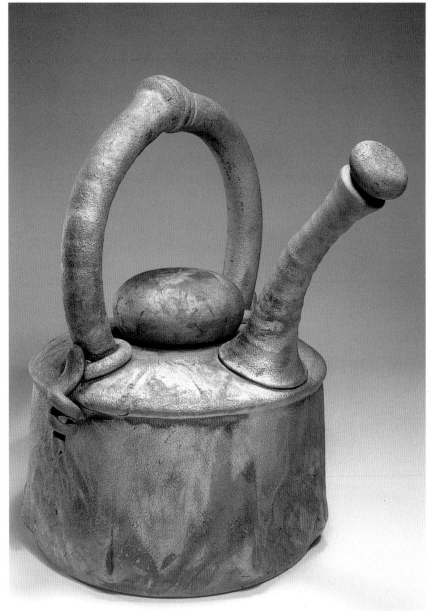

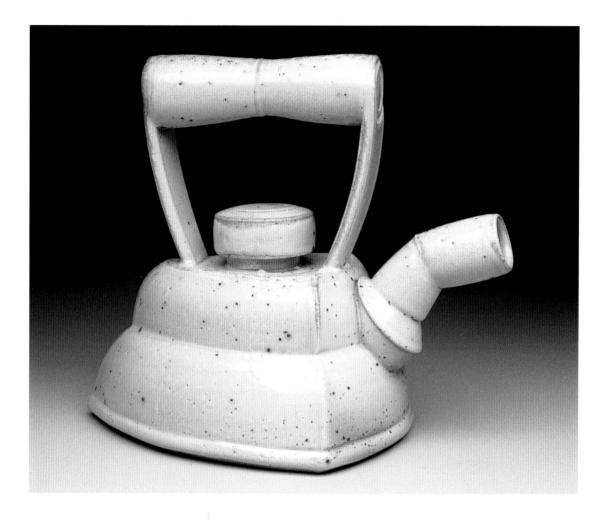

● **CHRISTA ASSAD**
● *Iron Teapot*, 1999
● 8 x 8 x 6 in. (20.3 x 20.3 x 15.2 cm)
● Wheel-thrown and constructed stoneware;
 cone 6 soda
● Photo by artist

I like to think that my work reflects a system of parts that "strike a chord." Clarity, as well as harmony, is essential in the attachment of handles, the fit of lids, the curve of spouts.

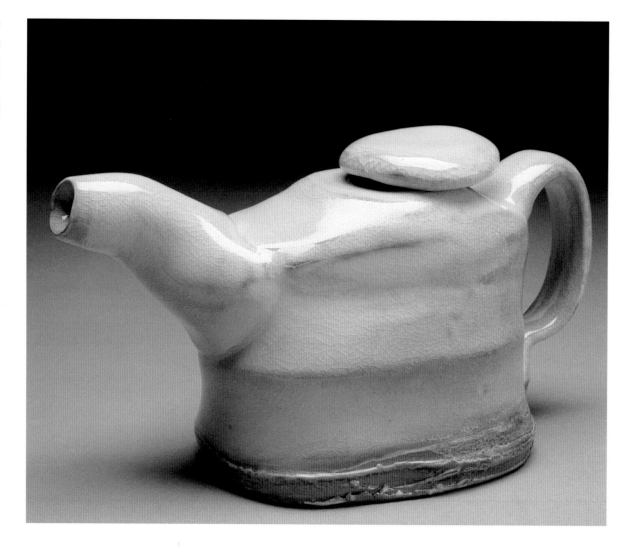

● **CHRIS DAVENPORT**
● *Soda-Fired Teapot*, 2001
● 6 x 4 ½ x 9 in. (15.2 x 11.4 x 22.9 cm)
● Thrown grolleg porcelain; Pinnel's Clear
Glaze; cone 10 soda

GEOFFREY SWINDELL

Teapot, 2001

4 ½ x 3 ½ x 5 in. (11.4 x 8.9 x 12.7 cm)

Wheel-made porcelain; cone 8

Photo by Tom Swindell

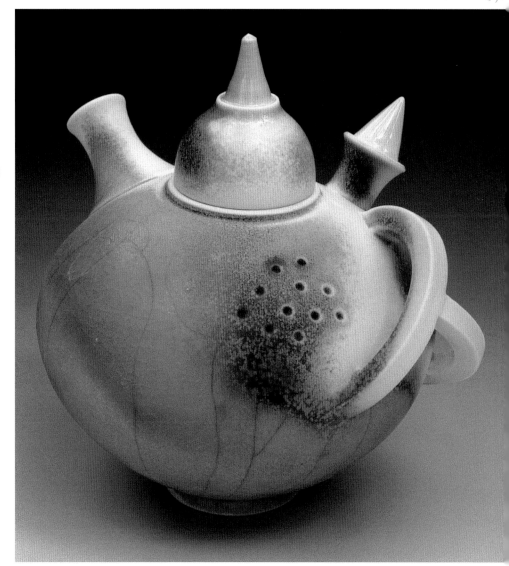

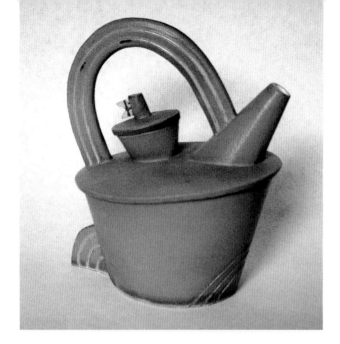

● **ROBERT DARK**
● *Flagship Teapot*, 2001
● 7 ½ x 7 ½ x 5 ½ in. (19 x 19 x 14 cm)
● Altered and thrown stoneware; white slip and new turquoise glaze; bisque cone 06; glaze cone 8

This teapot is a tribute to my father and grandfather, who worked on ships. I like dynamic forms generated from real objects.

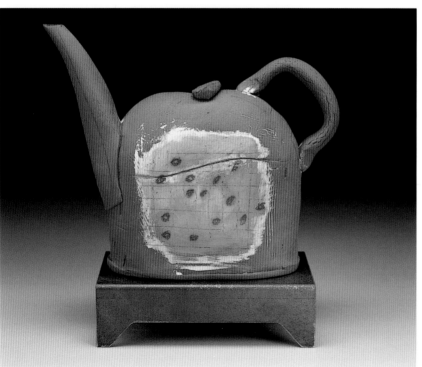

● **NANCY SELVIN**
● *Teapot #9805*, 1998
● 10 x 10 x 4 in. (25.4 x 25.4 x 10.2 cm)
● Hand-built terra cotta over foam armature; brushed and sponged underglaze color; underglaze pencil; cone 1
● Photo by Charles Frizzell

PAT DABBERT
DAVE DABBERT

t-Totaler, 2000

12 x 15 x 3 in. (30.5 x 38.1 x 7.6 cm)

Slab construction; extruded handle and spout; incised line drawing; clear glaze cone 6; lusters and gold cone 016

Currently we are using a porcelain clay body. Even though it is not forgiving, we love the bright white color. The teapot is functional and actually pours.

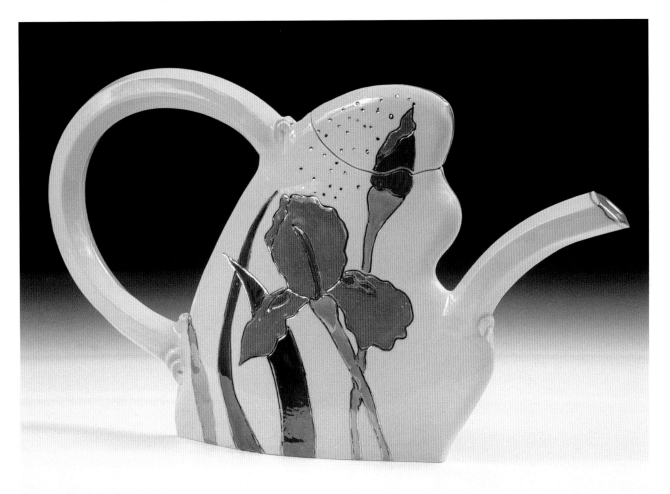

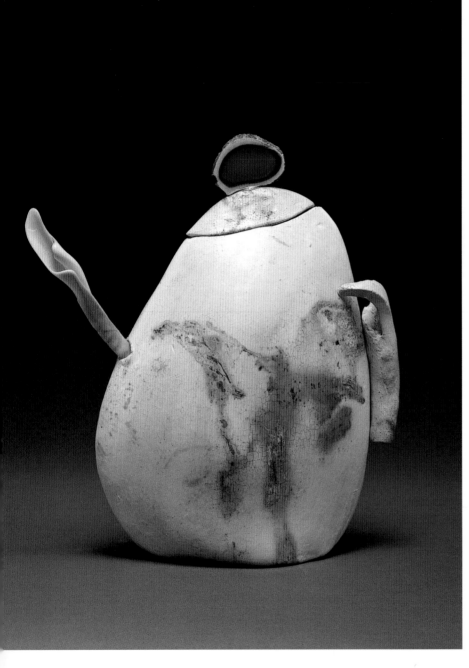

LYNNE MCCARTHY
Untitled, 2000
10 x 9 ½ x 4 in. (25.4 x 24.1 x 10.2 cm)
Slab-built and paddled raku clay; terra sigillata;
single-fire cone 04 saggar fired in electric kiln
Photo by Michael Noa.

Fired pieces are always a surprise, and I can
always come up with a spout, handle, or lid
decoration from my collection of natural found
objects to enhance these organic pieces.

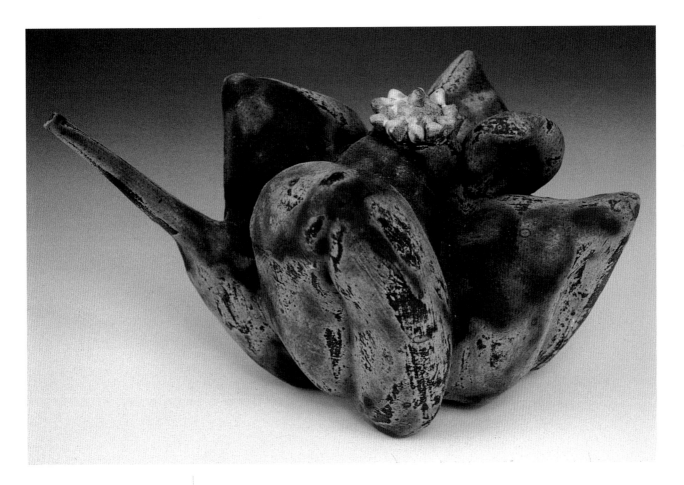

- **ROBERT MUELLER**
- *Blue Velvet*, 2000
- 5 x 6 x 5 in. (12.7 x 15.2 x 12.7 cm)
- Wheel-thrown and altered stoneware; glaze cone 10 reduction
- Photo by Joe Guinta

● **VIRGINIA PIAZA**
● *Bull's Eye Teapot*, 1999
● 7 x 6 ½ x 5 in. (17.8 x 16.5 x 12.7 cm)
● Wheel-thrown and assembled gray stoneware; wax resist design; shino and copper matte glazes; bisque cone 06; cone 10 gas reduction
● Photo by James Dee

I am drawn to the teapot form. It offers a fresh challenge each time I consider a new approach because the history of tea spans many cultures, rituals, and ideas.

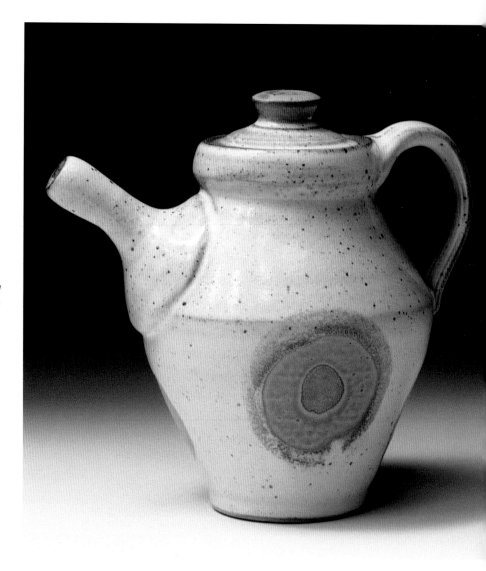

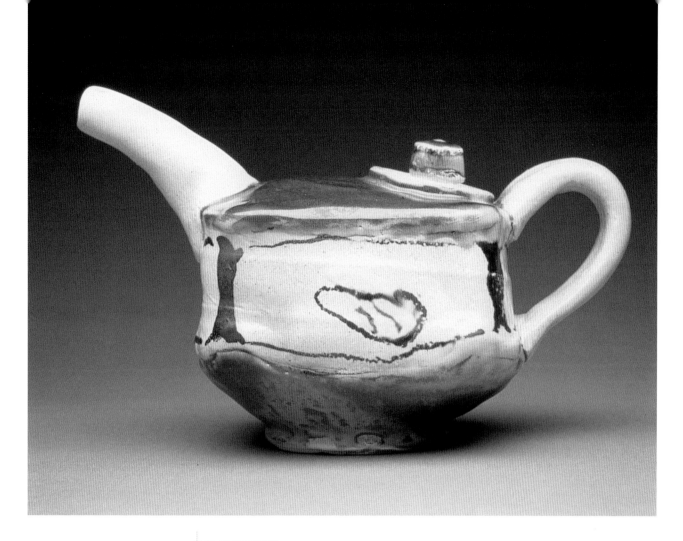

- **CHRIS DONIERE**
- *Feather*, 2001
- 5 x 7 ¾ x 4 in. (12.7 x 19.6 x 10.2 cm)
- Thrown, altered, and hand-built porcelain;
 high-fire glazes cone 10 soda
- Photo by artist

Concentrating on the connections of the rough edges, I created a contrast
between the top and bottom against the smooth white body.

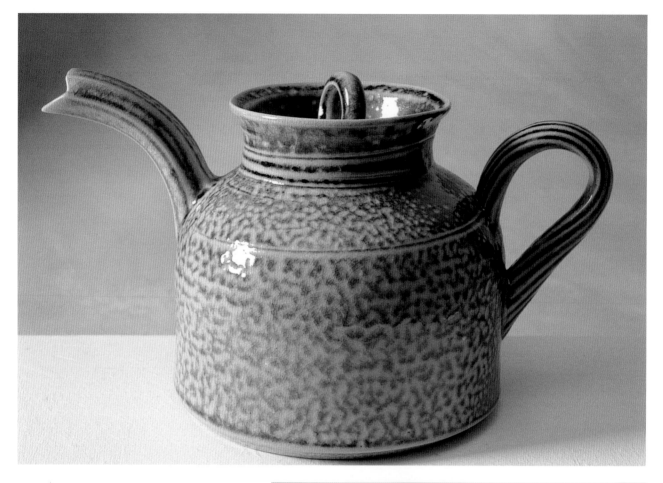

- **REBECCA HARVEY**
- *Teapot Recess Lid*, 2001
- 6 ¾ x 6 ¼ x 5 ½ in. (17 x 16 x 14 cm)
- Wheel-thrown body and lid with extruded handle and spout; cobalt slip 2372°F (1300°C) soda

The work has evolved from studies of 18th-century creamware, Japanese ceramics, and architectural designs. I translate the strong but simple sense of form in these traditions into a range of highly practical and individual pieces.

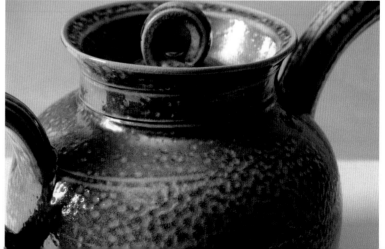

HODAKA HASEBE

Teapot, 2000

8 x 6 x 9 in. (20.3 x 15.2 x 22.9 cm)

Wheel-thrown stoneware;
cone 10 reduction

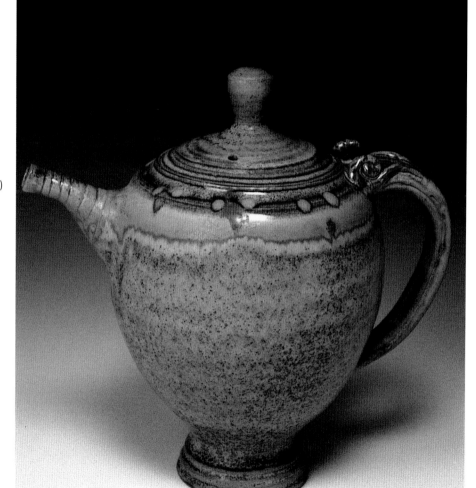

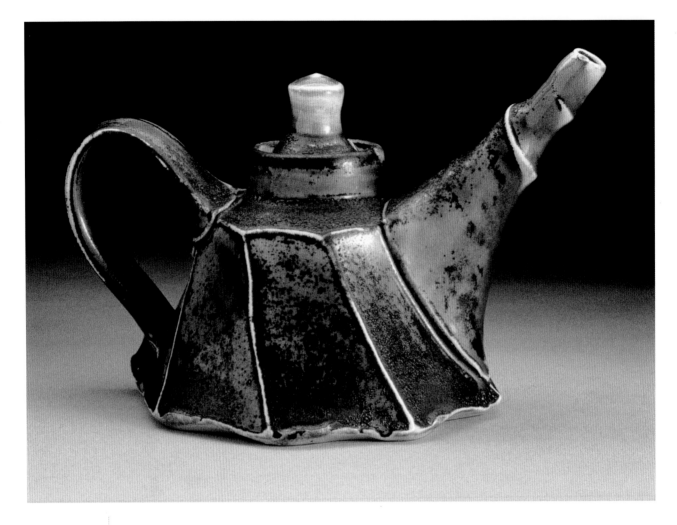

● **GAY SMITH**
● *Faceted Teapot*, 1997
● 6 x 6 in. (15.2 x 15.2 cm)
● Wheel-thrown porcelain manipulated and altered on
 the wheel; raw glazed and single-fired; cone 10 soda
● Photo by Tom Mills

People say that my teapots look like a Mad Hatter's tea party. I take this as a great compliment, especially because I take pots seriously. I imagine my pots playing around in the pottery during my absence, then quickly arranging themselves into stillness upon my return, as if I wouldn't notice.

LYNNE MCCARTHY
Teapot Dome Scandal (You Can't Put That on Top of a Teapot), 2000
10 x 10 x 3 ½ in. (25.4 x 25.4 x 8.9 cm)
Slab-built and paddled raku clay with found-object handle, spout, and lid decoration; raku glaze fire in raku kiln; reduced
Photo by Michael Noa

I enjoy raku, salku, and saggar/pit firings because the results are so natural and organic in appearance, and work so nicely with my forms. This style also gives me the opportunity to use some of the unusual natural objects my children, husband, and I have collected on our travels.

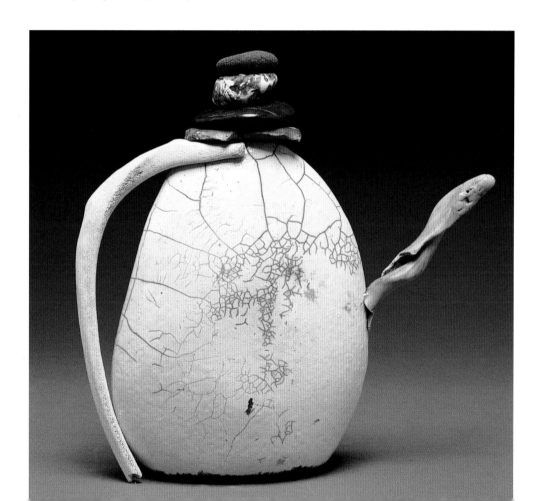

MARK BURLESON
Champa, 2000
24 x 18 in. (61 x 45.7 cm)
Hand-built earthenware; photographic silkscreen; enameled wooden box
Photo by Tom Mills

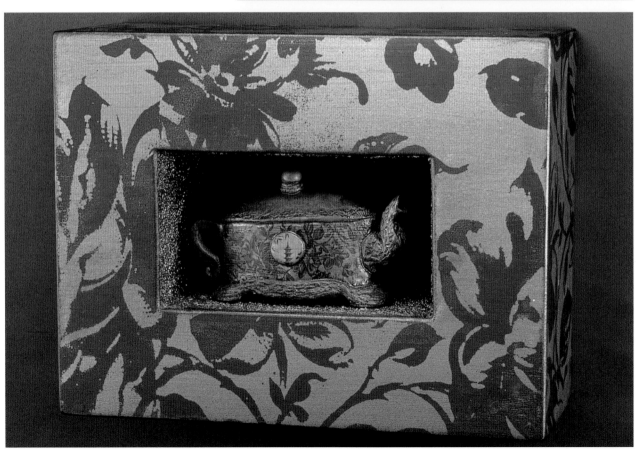

● **ERIN YAROSH**
● *The Saddler Reborn*, 2001
● 12 x 10 x 2 in. (30.5 x 25.4 x 5 cm)
● Slab-built low-fire red clay body; black
 copper oxide glaze cone 03

The idea of "home" has been a central concept in my recent ceramic works. Home is where many people first start to develop their personal feelings, vulnerabilities, memories, and emotions. I continue to use the concept of "home" in conjunction with my ceramics in order to explore and depict the process of how personality can be influenced and informed through relationships with domestic objects.

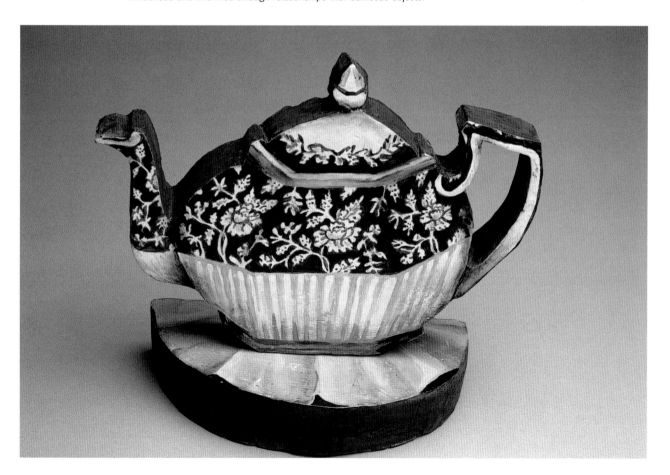

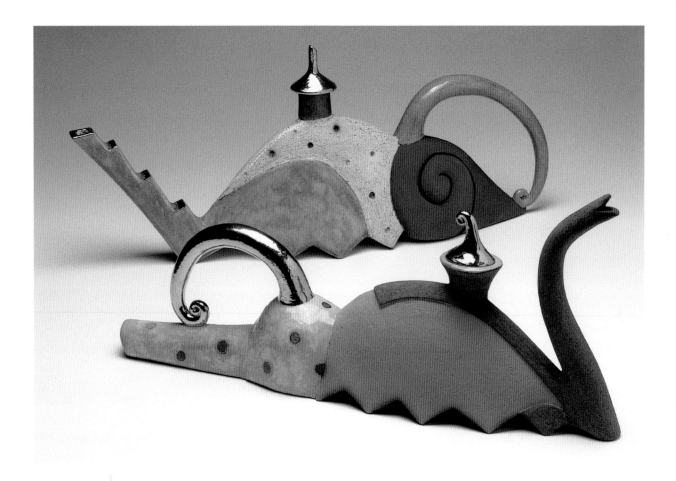

ELYSE SAPERSTEIN

Pulsation (front), The City Never Sleeps (back), 2000

11 x 25 ½ x 6 in. (27.9 x 64.8 x 15.2 cm) and 10 ½ x 24 x 5 in. (26.7 x 61 x 12.7 cm)

Slab and coil earthenware construction; low-fire glazes, slip, and luster; bisque cone 06; glaze cone 06

Photo by John Carlano

I enjoy creating teapots from slab because I can focus particular attention on the relationship of positive and negative elements to form and space. I use divisions of textured, colored surfaces against one another, to enhance the composition. Highly personal narratives are at the core of my work. As a long-time admirer and collector of folk art, I have adopted a symbolic, naive style that suggests both an inherent meaning and the inaccessibility of that meaning to the viewer. My work is defined by the intersection of functional, historical, representational, and symbolic codes.

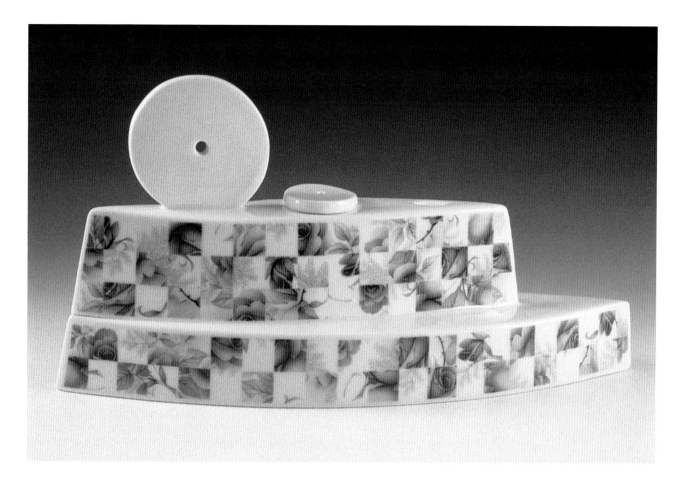

● **BILLIE JEAN THEIDE**

● *Butte # Czech-4*, 1997

● 3 ¼ x 9 ½ x 2 ¼ in. (8.2 x 24.1 x 5.6 cm)

● Slip-cast, altered porcelain; cone 15 gas reduction; clear glaze; vintage ceramic decals low-fired cone 015 electric

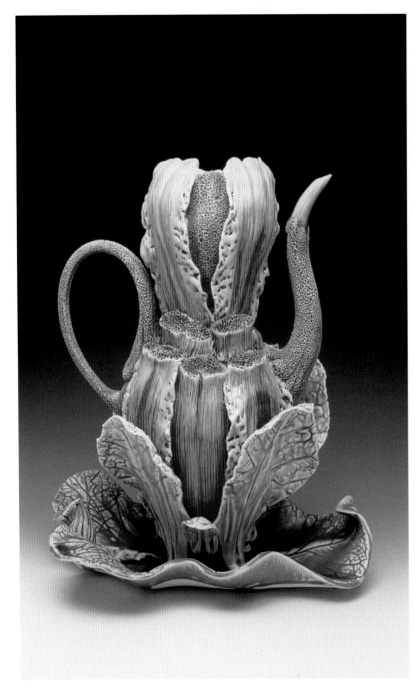

● *Untitled*, 2001
● 10 x 7 x 8 in. (25.4 x 17.8 x 20.3 cm)
● Wheel-thrown and hand-built porcelain; drawn and carved texture; bisque 1873°F (1023°C); glaze cone 10 oxidation
● Photo by artist

The designs of my teapots are influenced by European porcelains and Yixing teapots from China. The subject matter of my work is heavily influenced by my environment. I use plants, sea forms, and human anatomy to talk about life, disease, and the struggle for survival.

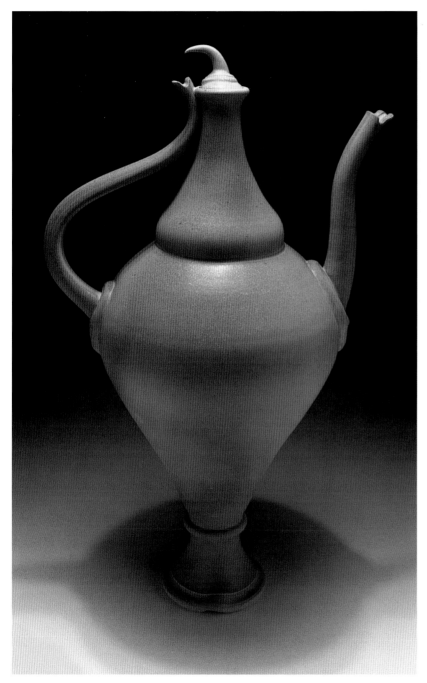

JOHN MCCLUGGAGE
Fairly Tall Tea, 2001
23 x 13 x 10 in. (58.4 x 33 x 25.4 cm)
Wheel-thrown stoneware; glaze cone 10
Photo by Marko Fields and artist

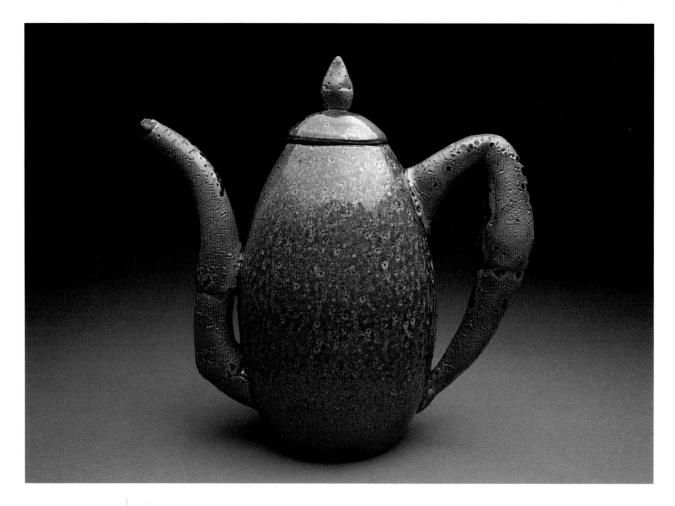

KATHY HOFFMAN

Teapot, 2000

10 x 10 x 6 in. (25.4 x 25.4 x 15.2 cm)

Thrown body with hand-built parts; shino glaze with carbon trapping; bisque cone 08; cone 10 gas

The inspiration for this teapot came as I examined the segmentations of insects' bodies and legs.

SHELLEY SCHREIBER

Teapot , 2001

5 x 8 x 4 ½ in. (12.7 x 20.3 x 11.4 cm)

Wheel-thrown porcelain with hand-built spout and handle; blue celadon glaze; cone 10 reduction

Photo by artist

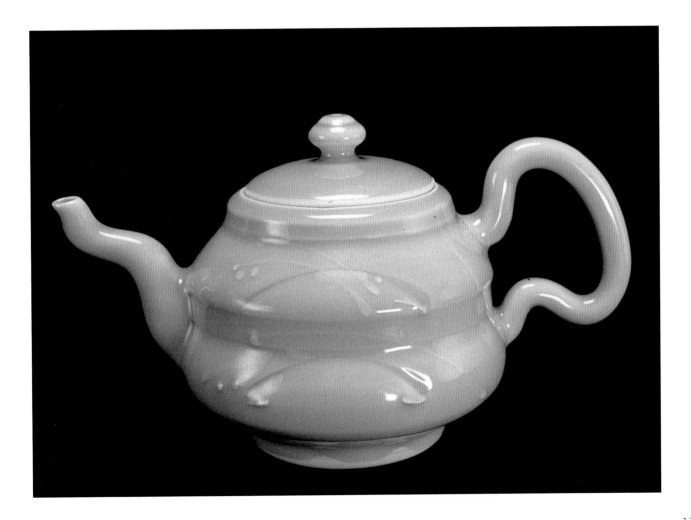

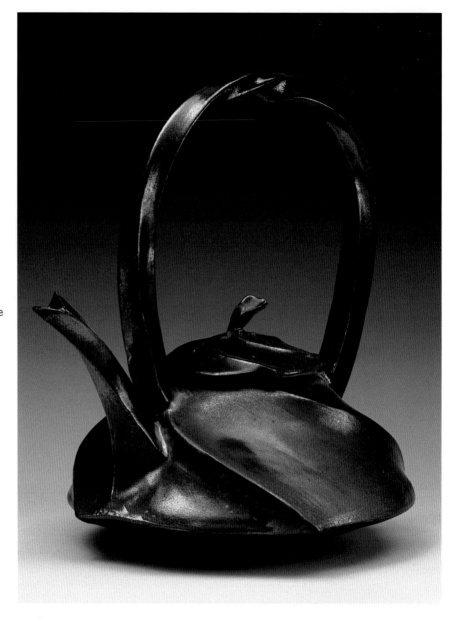

- **ROBERT PUTNAM**
- *Teapot*, 1998
- 11 x 10 x 6 ½ in. (27.9 x 25.4 x 16.5 cm)
- Thrown, altered, and hand-built stoneware; poured glaze with sprayed highlights; bisque cone 06; glaze cone 9 reduction
- Photo by Janet Ryan

All of my work is a reaction to human movement, primarily dance.

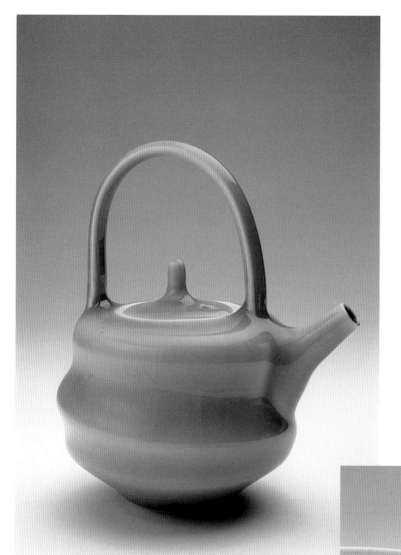

VICTOR GREENAWAY

Porcelain Spiral Teapot, 1999

6 ¾ x 6 ¾ in. (16 x 16 cm)

Thrown porcelain; celadon glaze; 2372°F (1300°C) reduction

Photo by Terrance Bogue

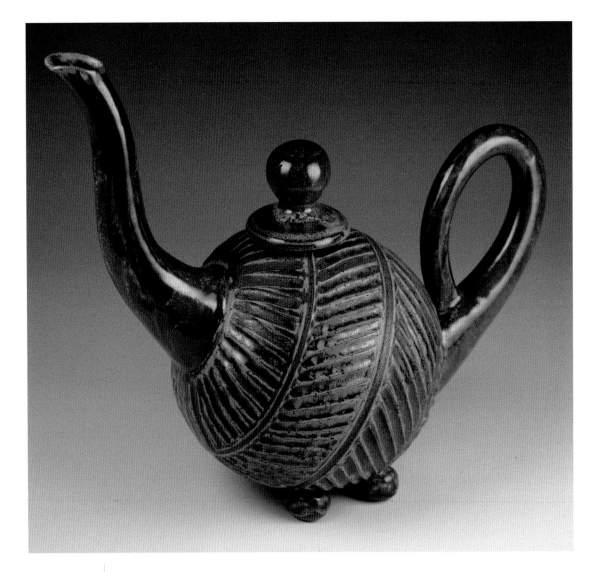

● **SANDY SINGLETARY**
● *Carved Teapot*, 2001
● 7 x 10 x 6 in. (17.8 x 25.4 x 15.2 cm)
● Thrown; carved; cone 6 oxidation
● Photo by Dale Duncan

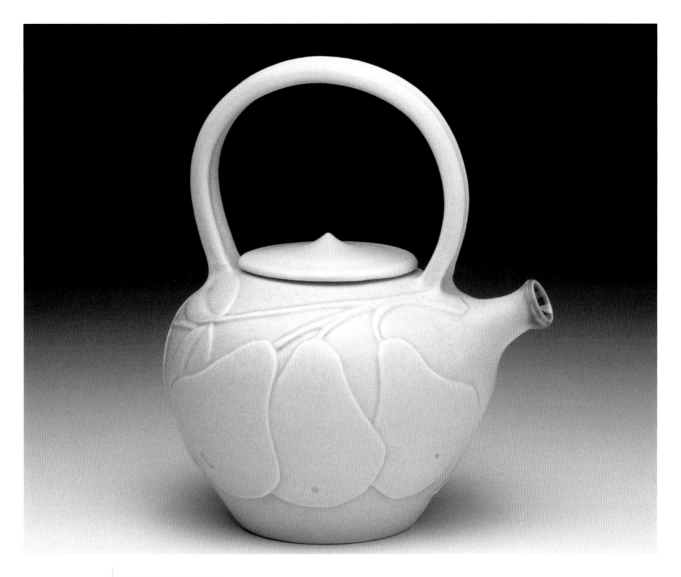

KATHRYN E. NARROW

Sorb Apple Teapot #1, 1999

8 ½ x 7 ½ x 6 ¼ in. (21.6 x 19 x 15.8 cm)

Thrown porcelain; carved at greenware stage;
glaze cone 6 oxidation

Photo by John Carlano

- **WILL HAMILTON**
- *handT-pot*, 2001
- 7 ½ x 7 x 2 ½ in. (19 x 17.8 x 6.4 cm)
- Slab-built St. Thomas clay; textured surfaces; glazes; fired at medium stoneware temperature

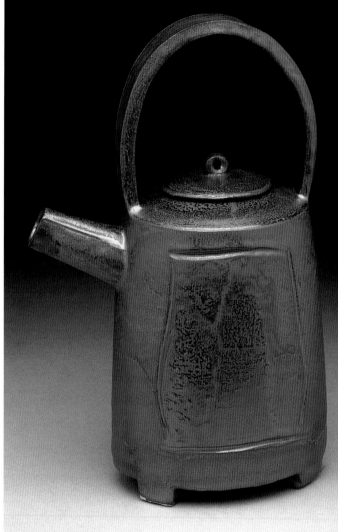

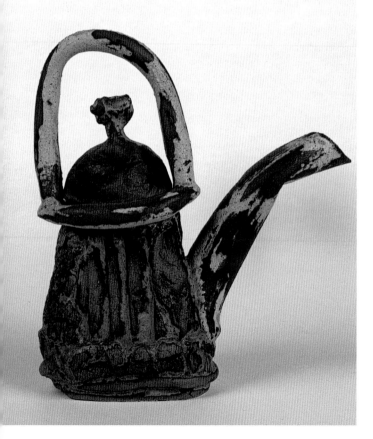

- **KATHLEEN NARTUHI**
- *Teapot with Rectangle*, 2000
- 10 ½ x 6 x 4 ¼ in. (26.7 x 15.2 x 10.8 cm)
- Wheel-thrown porcelain with hand-built additions; sgraffito; bronze glaze; bisque cone 06; glaze cone 6
- Photo by George Post

As a ceramic artist inspired by Shang Dynasty bronzes, I am intrigued by the difficult challenges of creating a balanced functional and sculptural piece of art.

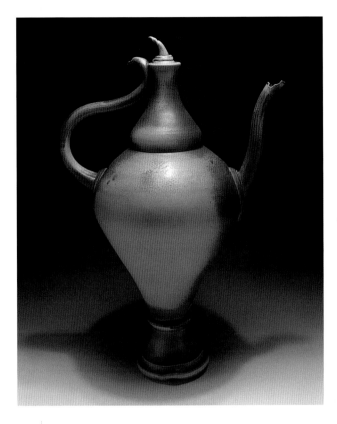

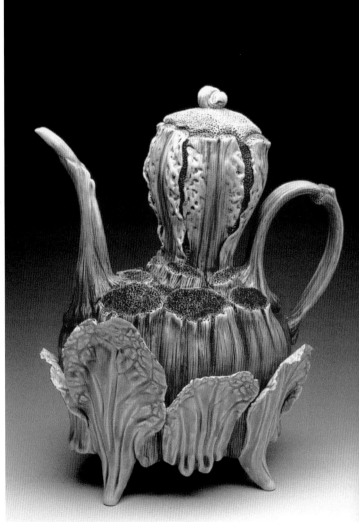

- **JOHN MCCLUGGAGE**
- *Green Tea*, 2001
- 21 x 14 x 9 in. (53.3 x 35.6 x 22.9 cm)
- Wheel-thrown stoneware; glaze cone 10
- Photo by Marko Fields and artist

- **BONNIE SEEMAN**
- *Teapot Untitled*, 2001
- 10 x 6 ½ x 9 in. (25.4 x 16.5 x 22.9 cm)
- Wheel-thrown and hand-built porcelain; drawn and carved texture; bisque 1873°F (1023°C); glaze cone 10 oxidation
- Photo by artist

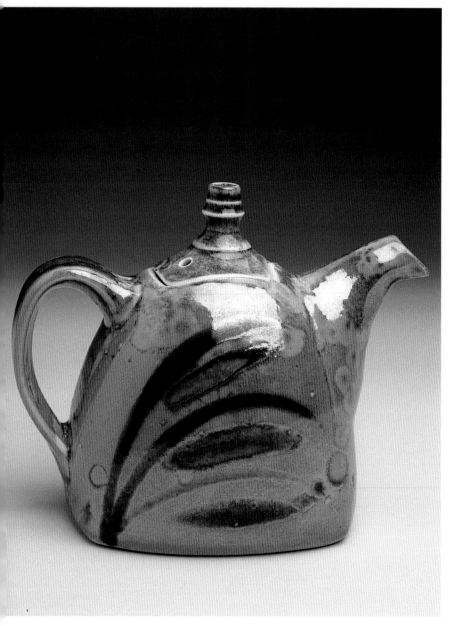

GERBI TSESARSKAIA
Shino III, 2001
5 x 8 x 5 in. (12.7 x 20.3 x 12.7 cm)
Wheel-thrown and altered; bisque cone 06;
cone 10 gas reduction
Photo by artist

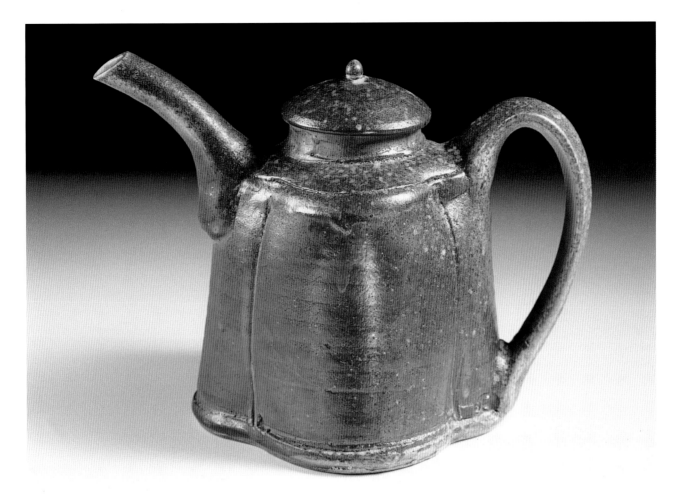

JOHN ELDER
Teapot, 2001
6 x 8 ¼ x 5 in. (15 x 21 x 13 cm)
Thrown and altered; flashing slip applied;
cone 12, 40-hour wood firing
Photo by Dale Gould

ANDREW P. LINTON
Tea Decanter (Tea for One), 2000
8 x 4 ½ x 3 in. (20.3 x 11.4 x 7.6 cm)
Thrown and altered with hand-built additions; hand carved; blue ash glaze; cone 10 reduction
Photo by Jim Kammer

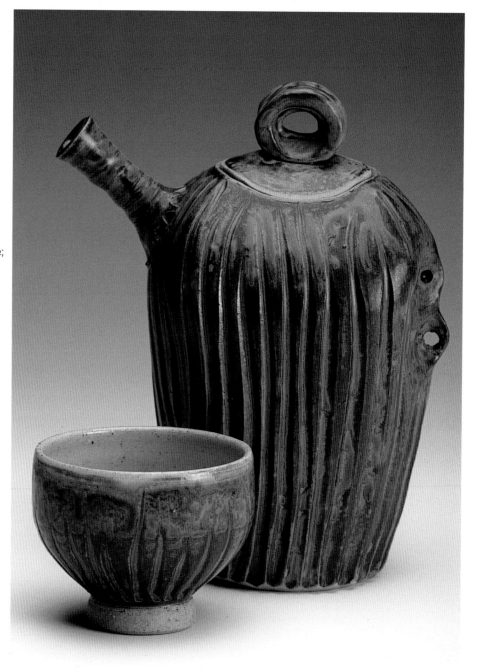

CAROL-ANN MICHAELSON

Four-Piece Tea Set, 2000

8 in. (20.3 cm) tall

Thrown and hand-built slab porcelain; sprayed with combination of ash glazes; stamped details on handle; bisque cone 06; cone 8 oxidation

Photo by Craig Parker

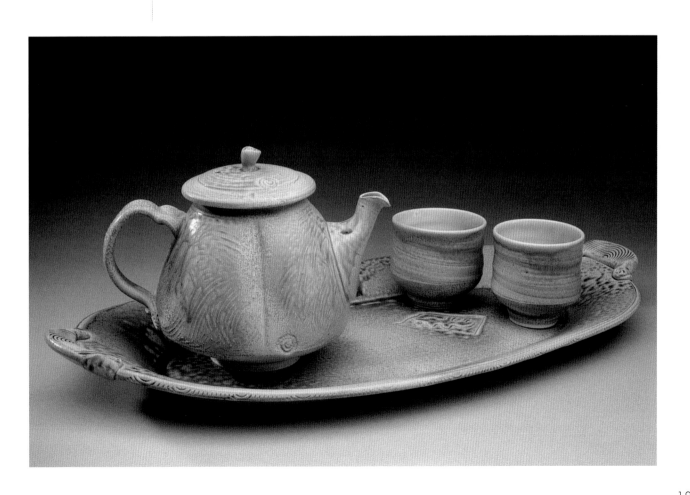

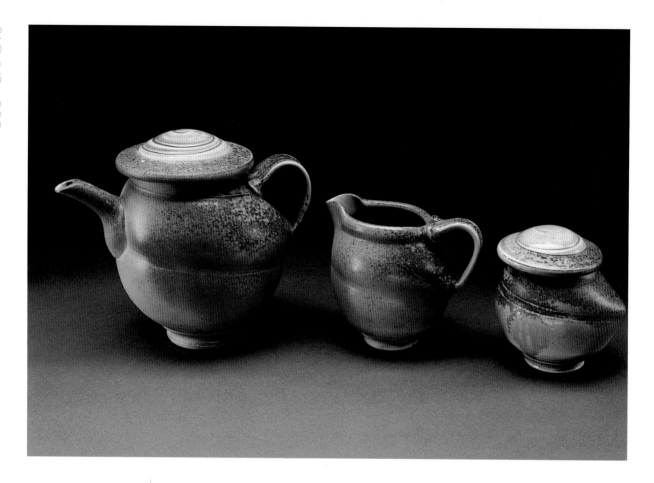

CONNIE CHRISTENSEN
● *Tea Set*, 1999
● 6 x 7 x 4 ½ in. (15.2 x 17.8 x 11.4 cm)
● Thrown and altered porcelain; wood fired

With this teapot set I strive to create a sense of physical motion, as
if captured in mid-stride walking across the table.

- **RAE DUNN**
- *Grandma Belle*, 2000
- Hand-built, high-fire stoneware; oxide, clear glaze and engobe; cone 10 reduction
- Photo by Charles Ingram

I want my work to elicit a physical response, that it ask to be touched, and provide a sense of reassurance.

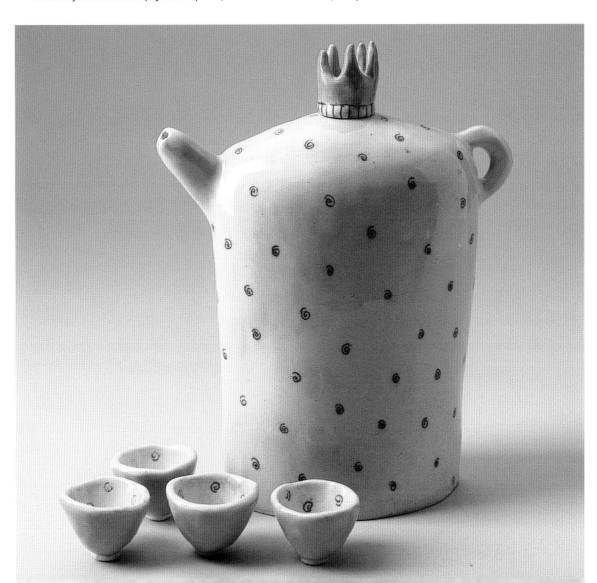

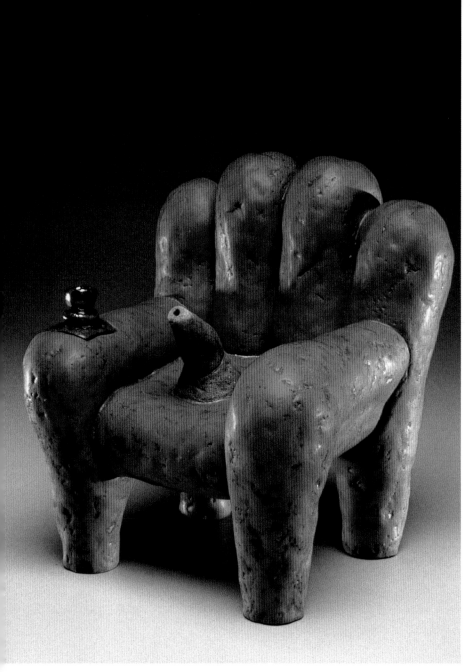

● **ALLAN ROSENBAUM**
● *Easy Chair Teapot*, 2001
● 10 x 9 x 9 in. (25.4 x 22.9 x 22.9 cm)
● Coil-built earthenware; oxides wash; layered glazes; cone 05
● Photo by Katherine Wetzel

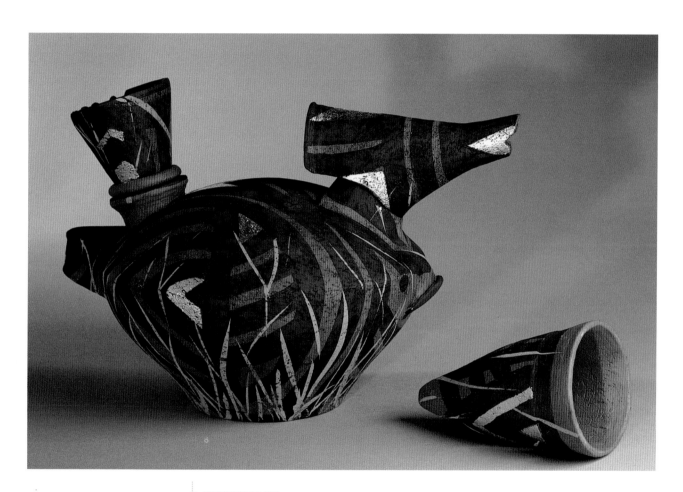

JENNIE BIRELINE
Celebration Teapot with Companion Cup, 2000
7 ¾ x 10 ¼ x 6 in. (19.6 x 26 x 15.2 cm)
Assembled from wheel-thrown earthenware
elements; terra sigillata; 22k gold leaf; cone 04
Photo by Michael Zirkle

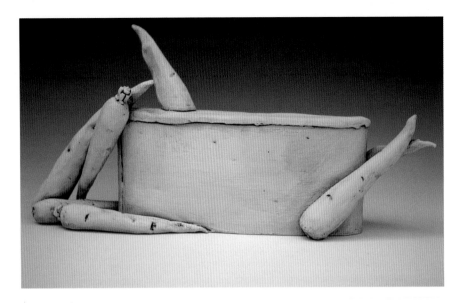

● **UNA MJURKA**
● *Garden Vegetable Pot #3,* n.d.
● 9 x 19 x 3 in. (22.9 x 48.3 x 7.6 cm)
● Hand-built, low-fire clay; layered engobes
 with oxide and glaze washes; multi-fired
 cone 06–04 range
● Photo by artist

● **DINA ANGEL-WING**
● *Celestial Ciel Teapot,* 2000
● 20 x 12 x 3 in. (50.8 x 30.5 x 7.6 cm)
● Slab-built with sterling silver handle and
 gilded lid; bisque cone 08; raku approx-
 imately cone 4
● Photo by Frank Wing

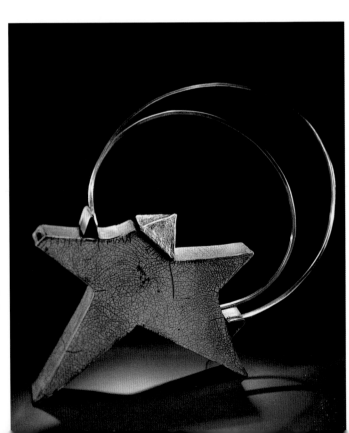

RICHARD SWANSON
Proud Catch II (edition of 22), 2001
9 ¼ x 3 ½ x 9 in. (23.5 x 8.9 x 22.9 cm)
Fine-grained, high-iron clay; cast and sanded
after each firing; bisque cone 06; fired until
vitreous, cone 5

My teapots are informed by historical examples–Inuit carvings, pre-Columbian ceramics, African sculpture, Japanese netsuke carvings, and Yixing teapots. I admire the concise vocabulary of these pieces, their use of everyday life as subject matter, their compact format, and their straightforward but unique way of relating figurative elements.

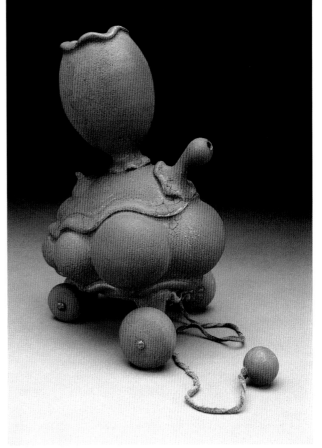

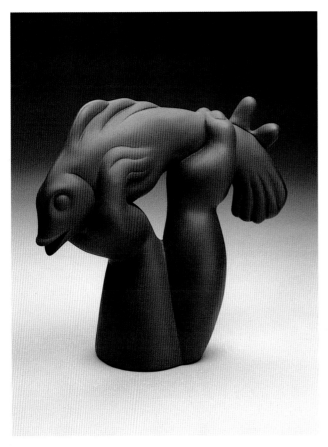

ROBERT "BOOMER" MOORE
Pull Tea, 2001
12 x 6 x 8 in. (30.5 x 15.2 x 20.3 cm)
Assembled wheel-thrown and altered
parts; bisque cone 08; glaze cone 10
gas reduction; sandblasted

Working to find a balance between a love
for clay and ceramic processes, and a fas-
cination for toys and animation, I strive to
create pieces that are somehow descriptive
of my personality.

191

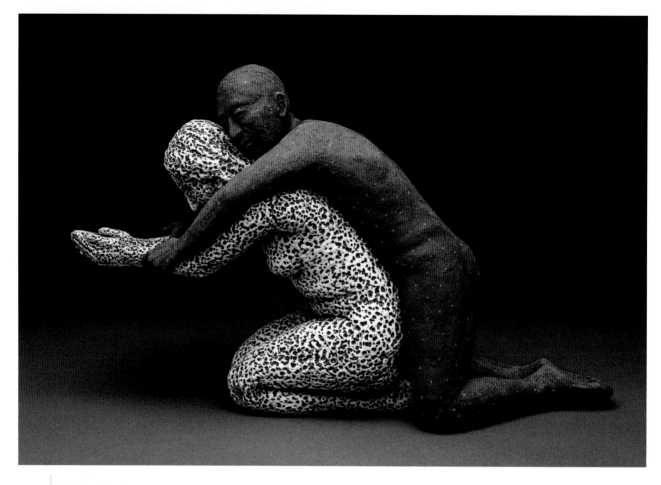

● **ADRIAN ARLEO**
● *Leaning Brown Figure with Blue Spots*, 2001
● 11 ½ x 19 x 6 in. (29.2 x 48.3 x 15.2 cm)
● Hand-built low-fire clay; glaze cone 05
● Photo by Chris Autio

My teapots are small-scale narrative dramas. The teapot form and size encourages a playfulness and spontaneity, in contrast to my larger sculpture. I enjoy composing the pieces—figuring out which parts of the human anatomy will make up the lid, the handle, the spout, and how much volume to give the "belly." This scale creates an intimacy that draws the viewer into the drama to explore the tension that develops between the figures and the ambiguity of the relationship. There are active and passive players: some are more sexually charged, others more domestic; some appear humorous, while others appear slightly menacing. Like a form of short story, the openendedness of the narrative causes one to wonder, and invites interpretation.

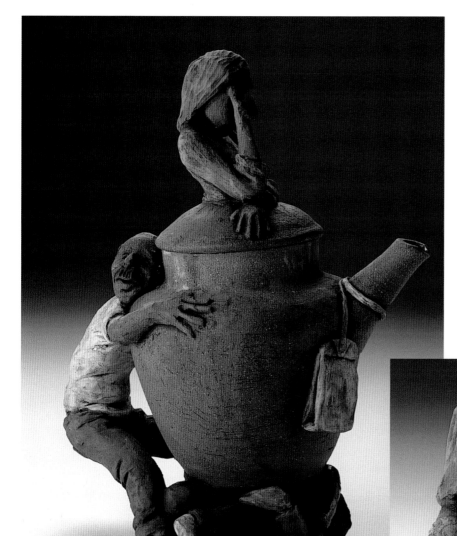

MARLENE FERRELL PARILLO
Dysfunctional Teapot II, 2001
8 x 8 x 6 in. (20.3 x 20.3 x 15.2 cm)
Wheel-thrown and sculpted; Mason stains; cone 6
Photo by Howard Goodman

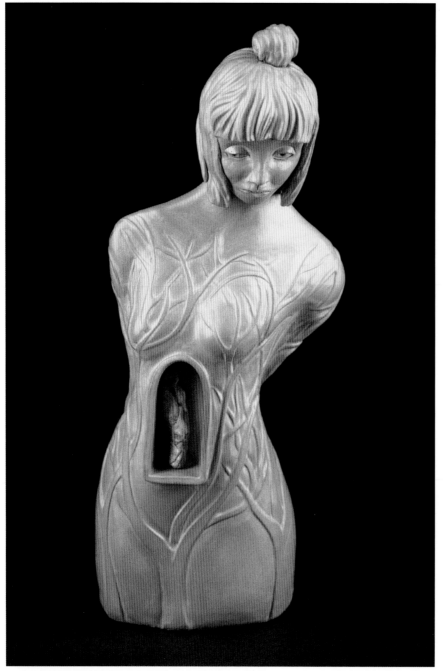

LINDA GANSTROM
Mother of Fear Heart/Home Teapot, 1997
17 x 7 x 4 in. (43.2 x 17.8 x 10.2 cm)
Hollow slab construction; pinched head lid; carved; burnished terra sigillata; cone 04
Photo by Sheldon Ganstrom

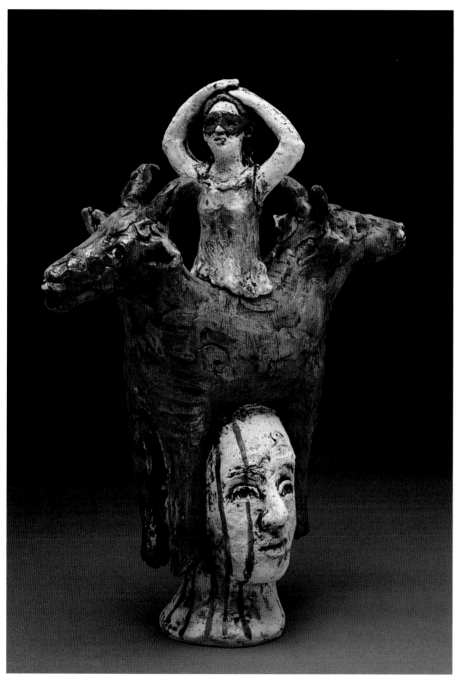

DEBRA W. FRITTS
Night Games, 2001
12 ½ x 10 x 3 in. (31.8 x 25.4 x 7.6 cm)
Pinched, coiled, and modelled terra cotta; bisque cone 2; glaze cone 04; multi-fired cone 04; slips, oxides, glazes, and underglazes
Photo by Michael Noa

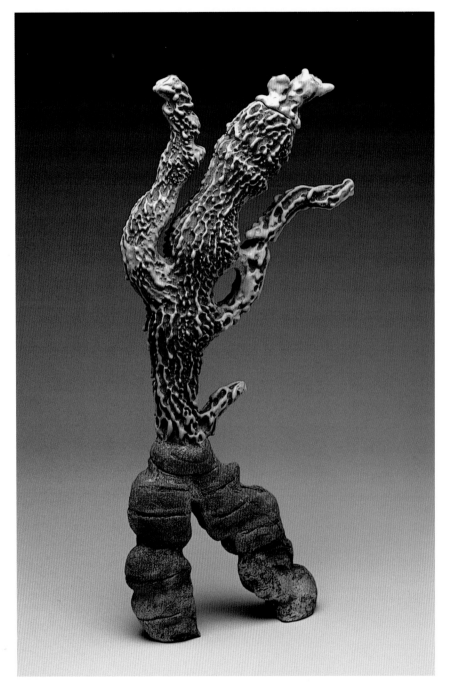

● **SHANE M. KEENA**
● *Porifera Teapot*, 2001
● 19 x 9 x 3 in. (48.3 x 22.9 x 7.6 cm)
● Hand-built, wheel-thrown, and cast
 porcelain and stoneware; cone 10
 reduction; additional multi-fired cone
 06 oxidation
● Photo by David Calicchio

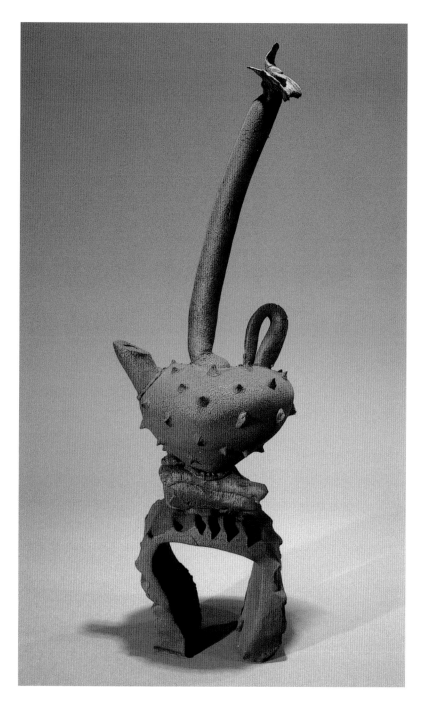

● **KEVIN A. MYERS**
● *Untitled*, 2001
● 17 ¼ x 9 ½ x 4 ¾ in. (43.8 x 24.1 x 12.1 cm)
● Thrown and altered earthenware; chome red
glaze and sprayed application; cone 05

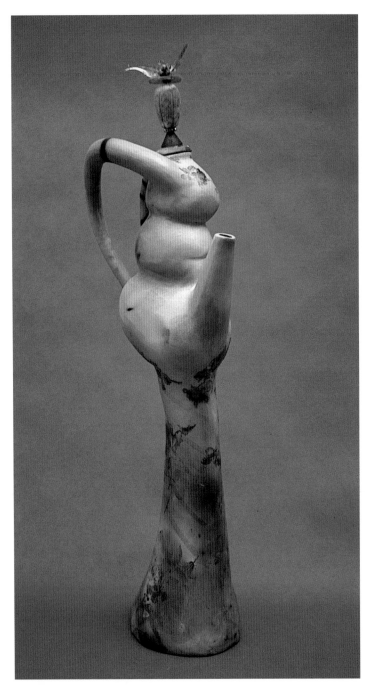

LISA KRIGEL
Untitled, 2000/2001
19 x 4 ½ x 3 in. (48.3 x 11.4 x 7.6 cm)
Slab- and coil-built white earthenware; transfer appliqué and mixed media; bisque cone 05; saggar cone 07; transfers cone 016

I've been making teapots based on the female form exclusively for the last five years. I explore the form as object and the object as form and investigate a fine line between form and function.

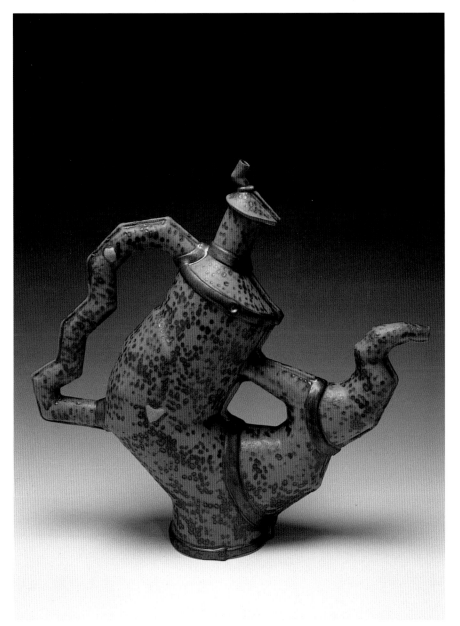

SCOTT DOOLEY
Teapot, 2000
14 x 15 x 4 in. (35.6 x 38.1 x 10.2 cm)
Hand-built and textured porcelain slabs;
oxide and glaze; cone 5 electric

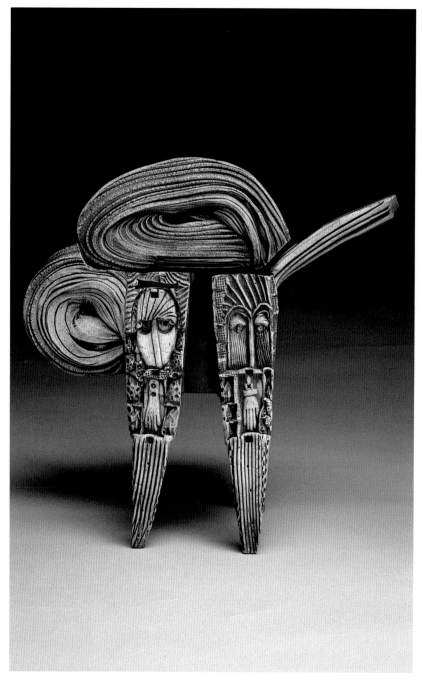

LANA WILSON
Ritual Teapot, 2000
14 x 17 x 5 in. (35.6 x 43.2 x 12.7 cm)
Slab-built, stamped white stoneware;
bisque cone 06; glaze cones 6 and 04

CYNTHIA BRINGLE

Teapot, 1999

8 x 8 x 6 in. (20.3 x 20.3 x 15.2 cm)

Wheel-thrown and altered; carved; cone 10 gas

Photo by Tom Mills

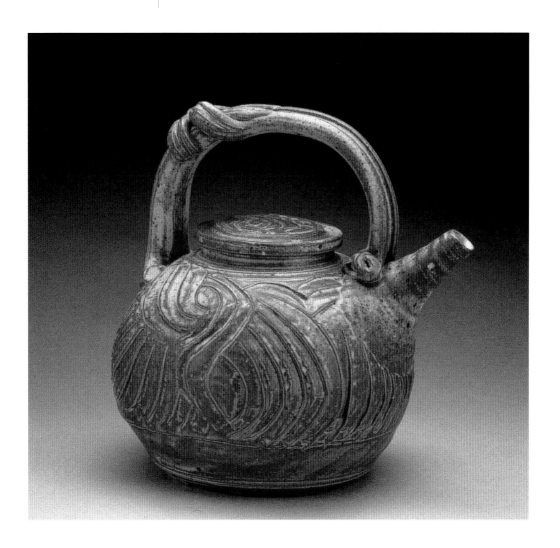

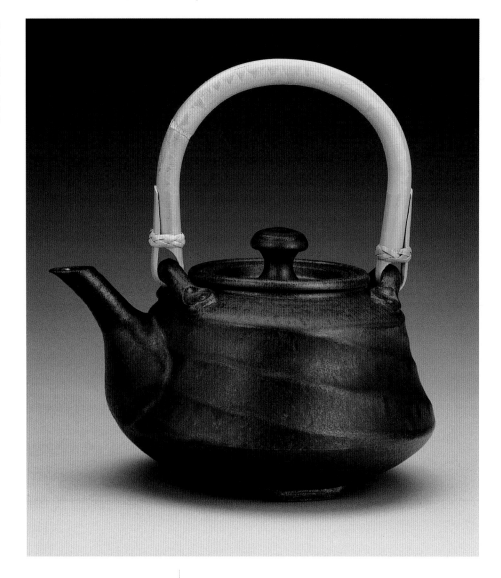

HSIN-YI HUANG
Teapot, 2001
8 ½ x 8 ½ x 7 in. (21.6 x 21.6 x 17.8 cm)
Wheel-thrown stoneware; hand-faceted; iron
matte glaze; cone 10 reduction
Photo by Bill Buchaber

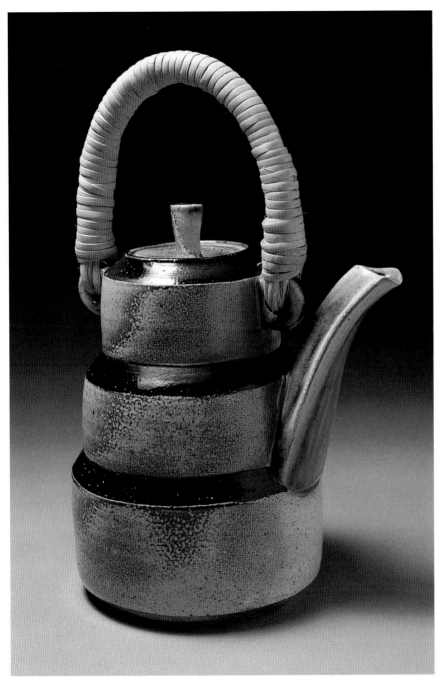

● **MARK JOHNSON**
● *Teapot*, 2001
● 14 x 6 x 6 in. (35.6 x 15.2 x 15.x cm)
● Thrown white stoneware; glaze, wax resist, and black underglaze; handmade cane handle; cone 10 soda
● Photo by artist

NICK JOERLING

Untitled, 2001

8 x 8 ½ x 5 in. (20.3 x 21.6 x 12.7 cm)

Wheel-thrown and altered stoneware; wax resist over shino glaze; cone 10

Photo by Tom Mills

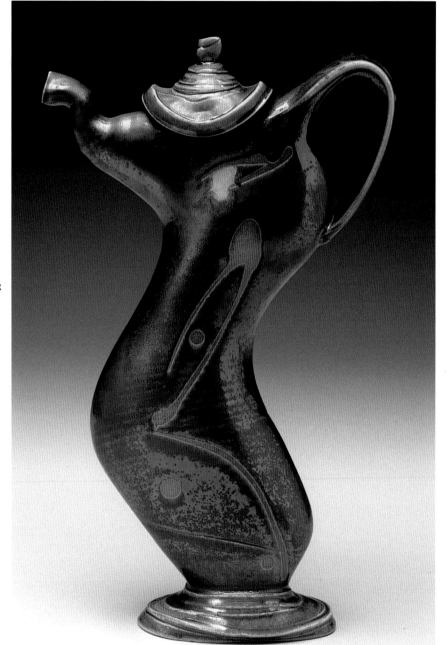

MICHAEL SHERRILL
Black Wave, 1993
26 x 11 x 14 in. (66 x 27.9 x 35.6 cm)
Wheel-thrown white stoneware with extruded parts; copper saturate glaze; cone 05
Photo by Tim Barnwell

I was influenced by the rhythms and patterns of form I saw in industrial forms that surrounded me as a kid.

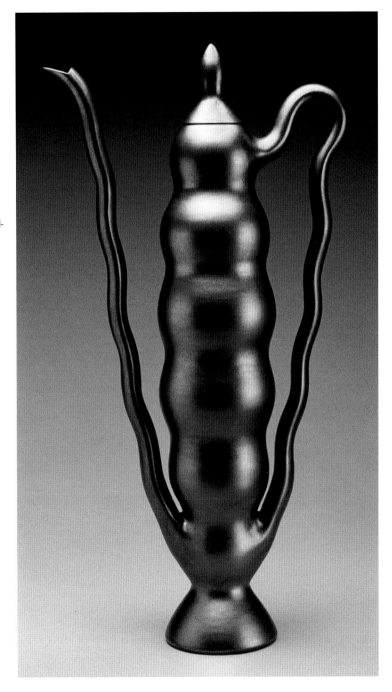

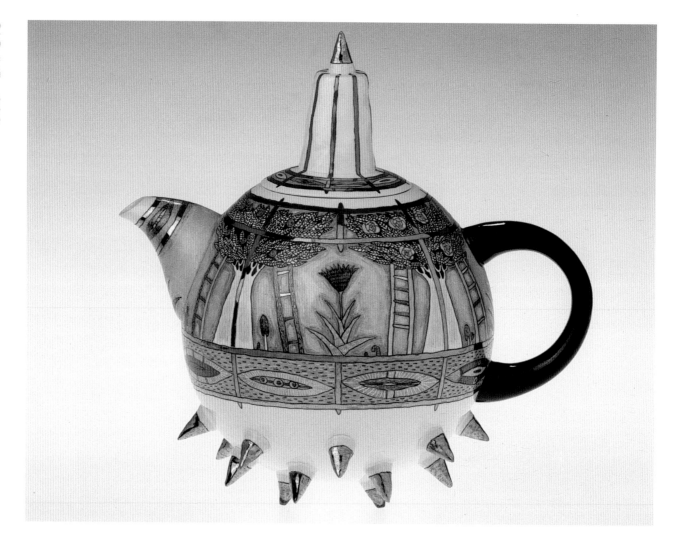

● **MARUTA RAUDE**
● *Four Trees, Eight Ladders, and Flower of Agave*, 2000
● 9 x 10 ¼ x 6 ¾ in. (22.9 x 26 x 17.1 cm)
● Porcelain; bisque at 1652°F (900°C); firing, 2336°F
 (1280°C); surface painting, 1382°F (750°C)
● Photo by Aigars Jukna

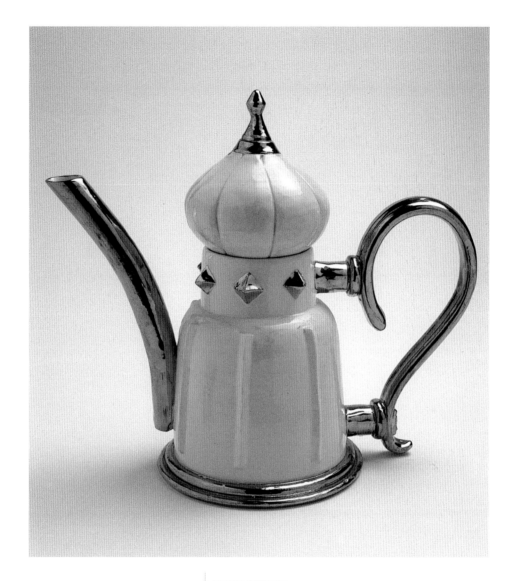

● **SONJE HIBBERT**
● *St. Basus Cathedral*, 2001
● 10 x 11 ½ x 5 in. (25.4 x 29.2 x 12.7 cm)
● Thrown white earthenware teapot with thrown
 lid, pulled handle, rolled spout; silver luster
 finish; sprig decoration; bisque cone 01; glaze
 cone 05; lustre cone 017
● Photo by artist

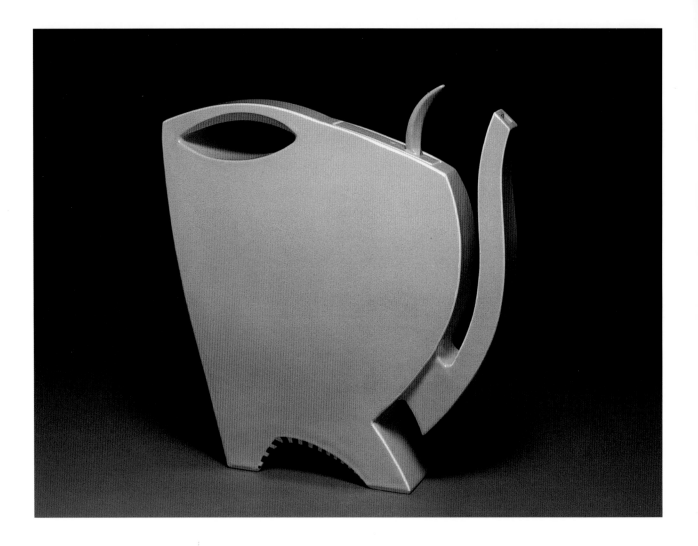

● **JOHN GLUMPLER**
● *Yellow Variation*, 2001
● 12 x 11 x 2 ½ in. (30.5 x 27.9 x 6.4 cm)
● Slab-built white earthenware with engobes
and glazes

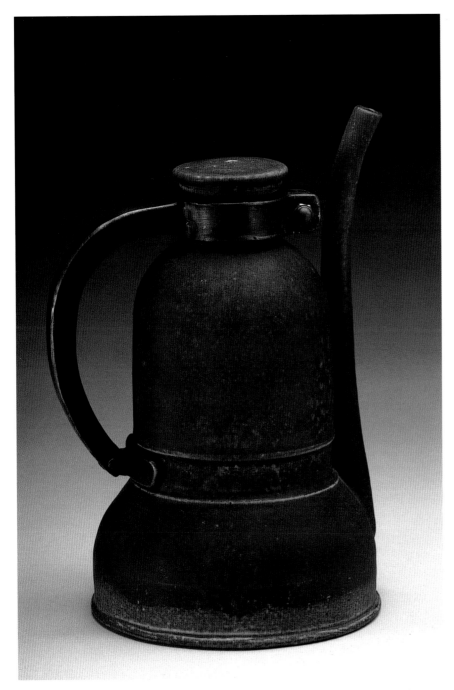

TED NEAL

Oilcan Teapot #5, 1999

7 x 5 x 5 in. (17.8 x 12.7 x 12.7 cm)

Wheel-thrown stoneware; sandblasted; cast bronze handle; cone 10 soda

Photo by Jeff Bruce

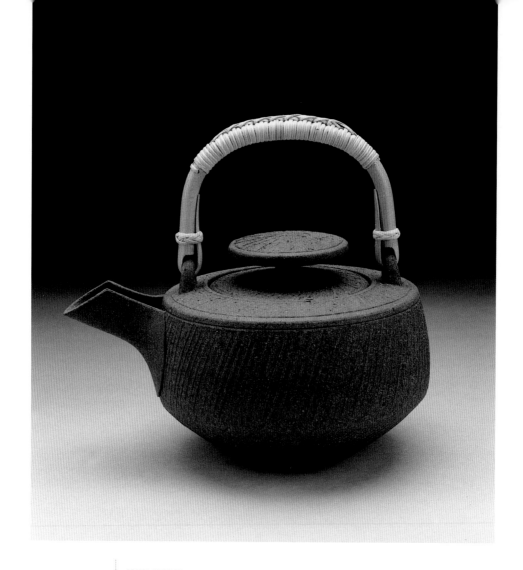

● **JOHN NEELY**
● *Combed Grey Teapot with Braided Cane Handle,* 1997
● 7.5 x 6 x 6 in. (19 x 15 x 15 cm)
● Thrown and assembled stoneware; combed
● Photo by artist

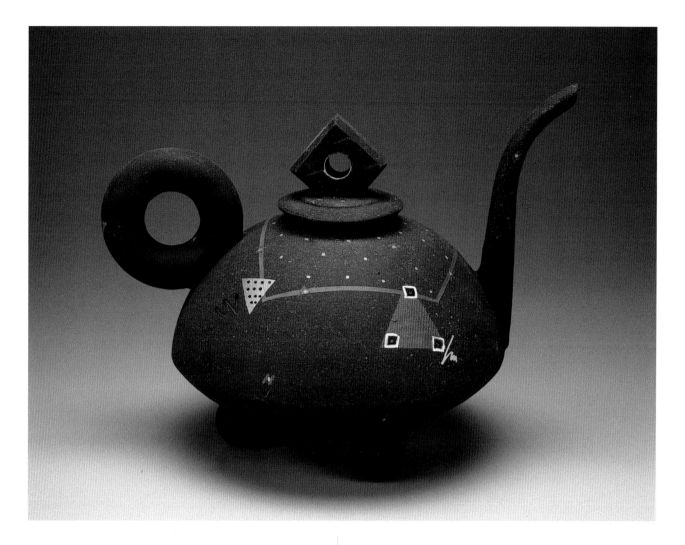

● **JONATHAN KAPLAN**
● *Ball Foot Teapot*, 1999
● 9 x 10 in. (22.9 x 25.4 cm)
● Slip-cast terra cotta; glaze, underglaze,
 and non-fired pigments; cone 4
● Photo by David C. Holloway

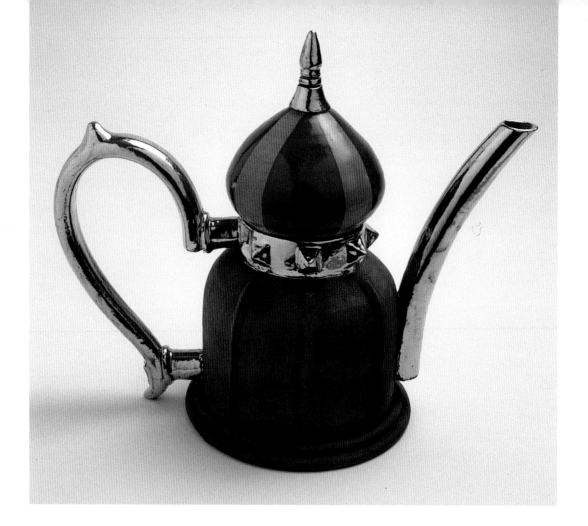

● **SONJE HIBBERT**
● *St. Basus Cathedral*, 2001
● 10 x 11 ½ x 5 in. (25.4 x 29.2 x 12.7 cm)
● Thrown terra cotta with thrown lid, pulled han-
 dle, and rolled spout; underglaze finish on lid;
 gold lustre; sprig decoration; bisque cone 01;
 glaze cone 05; lustre cone 017
● Photo by artist

This teapot series was inspired by St. Basus Cathedral in Moscow, which I photographed
in 1990 while traveling through Russia.

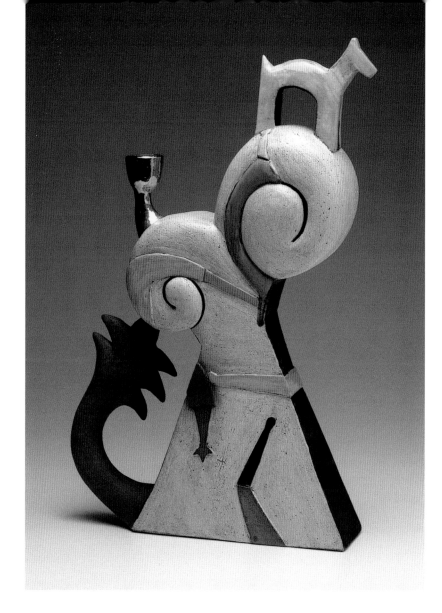

● **ELYSE SAPERSTEIN**
● *Life Line*, 2000
● 23 ½ x 14 ½ x 5 ½ in. (59.7 x 36.8 x 14 cm)
● Slab-built earthenware; low-fire glazes, slip, wash, and luster; bisque cone 06; glaze cone 06
● Photo by John Carlano

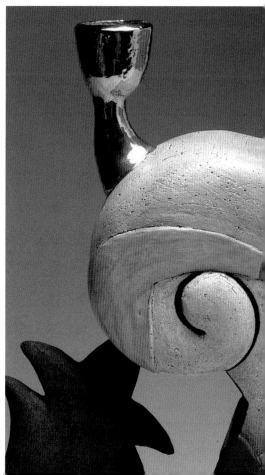

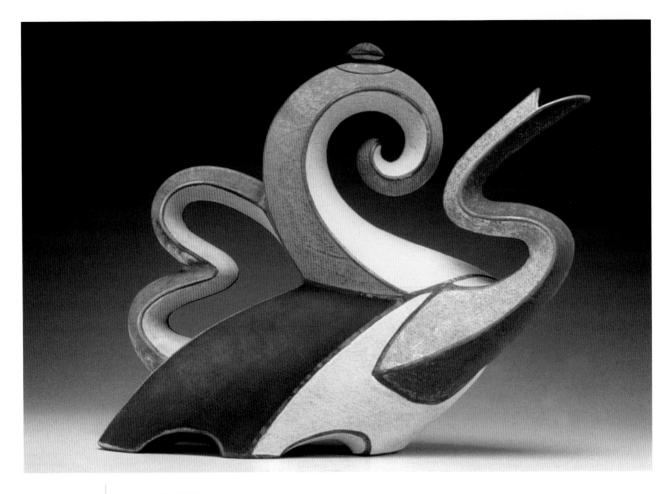

● **MICHAEL SHERRILL**
● *Sauras Tea*, n.d.
● 16 x 21 x 7 in. (40.6 x 53.3 x 17.8 cm)
● Wheel-thrown white stoneware with extruded and altered parts; applied color to alkaline base; cone 06
● Photo by Tim Barnwell

This piece is in a modernist vein, but it's an animated form that nearly walks off the table. I wanted to create an object with physical energy similar to dance.

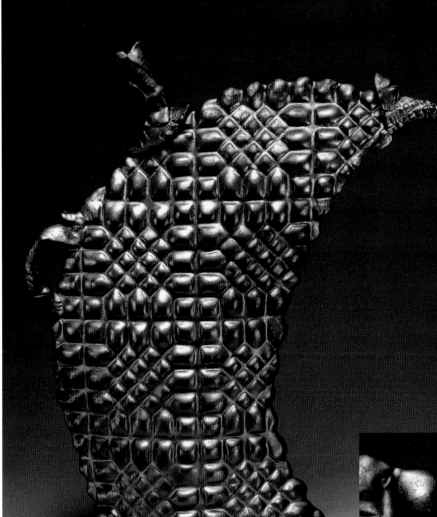

● **O'BRIEN TYRRELL**
● *Into the Wind*, 2000
● 22 x 18 x 5 ½ in. (55.8 x 45.7 x 14 cm)
● Slab-built mid-range stoneware; glaze over surfaces textured by pressing into antique architectural artifacts; bisque cone 06; glaze cone 6 oxidation
● Photo by Peter Lee

I enjoy using turn-of-the-century images on my contemporary tea pot forms. I worked very hard to create a "backbone" where the seams join.

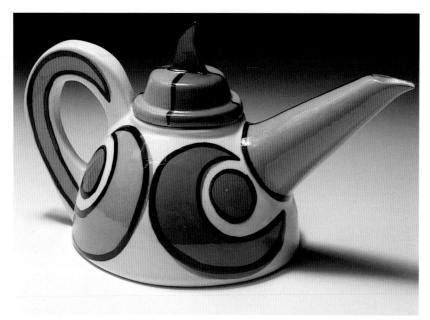

MATTHEW A. YANCHUK
Horn Teapot, 2000
5 ½ x 6 x 10 ½ in. (14 x 15.2 x 26.7 cm)
Slip-cast construction; wax-resist decoration;
bisque cone 04; glaze cone 06
Photo by D. James Dee

My work is inspired by Southwestern Mimbres
pottery and fabric design.

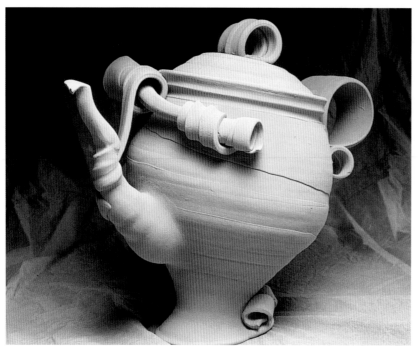

PATSY COX
Mother, 1999
18 x 23 x 17 ½ in. (45.7 x 38.4 x 44.5 cm)
Wheel-thrown with thrown and pulled
additions; glazed interior, engobe
exterior; cone 10
Photo by Tom Stilts

My work is about process. It is founded in the tra-
dition and craft of ceramics but focuses on taking
functional forms into sculpture realms.

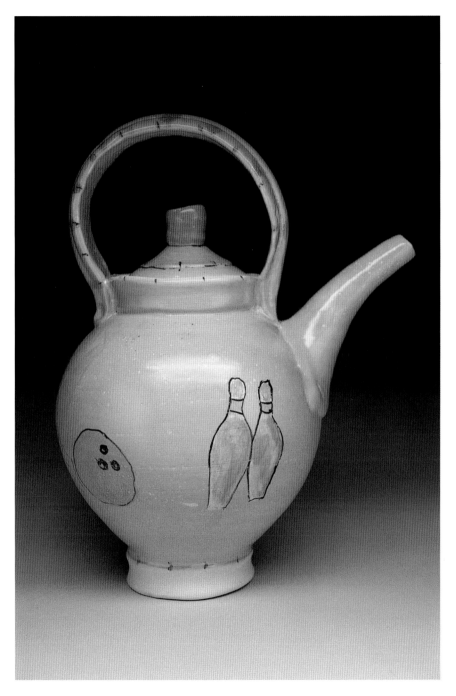

SCOTT LYKENS

Tea in Akron Ohio, 2001

14 x 9 x 6 in. (35.6 x 22.9 x 15.2 cm)

Thrown, altered, and hand-built white earthenware; brushed overglaze hand-crafted from personal chemistry; cone 3

Photo by artist

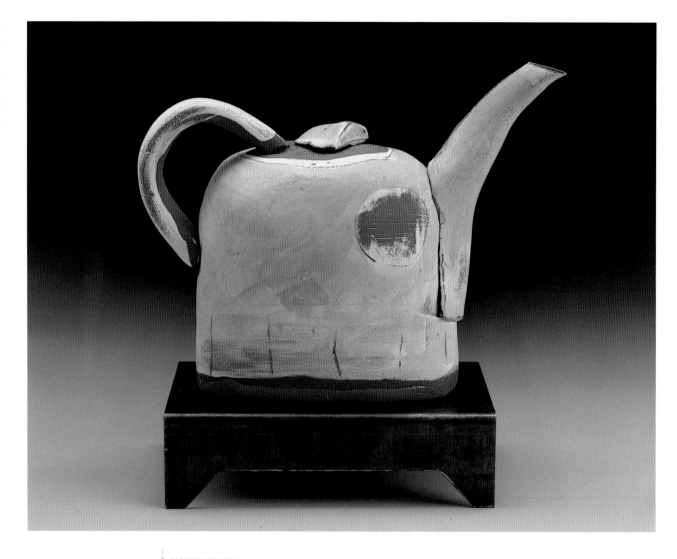

● **NANCY SELVIN**
● *Teapot #9819*, n.d.
● 10 x 10 x 4 in. (25.4 x 25.4 x 10.2 cm)
● Hand-built terra cotta over foam armature;
 brushed and sponged underglaze color;
 underglaze pencil; cone 1

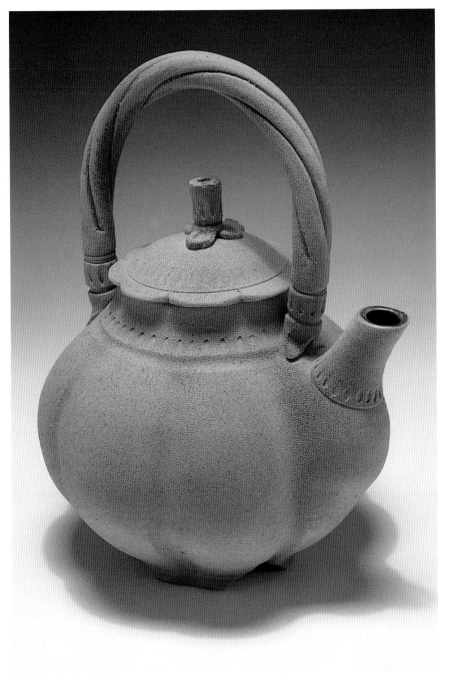

● **MARK BRANSTINE**
● *Ozymandias*, 1999
● 12 x 10 x 7 ¼ in. (30.5 x 25.4 x 18.4 cm)
● Thrown and altered porcelain stoneware;
 sprayed sandstone-like texture; glaze cone 10;
 bisque cone 06
● Photo by Marko Fields and artist

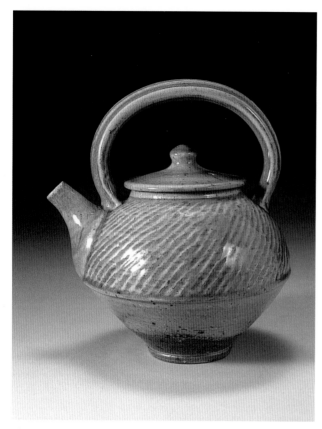

● **CAROL SELFRIDGE**
RICHARD SELFRIDGE
● *Quiet Comfort Teapot*, 2000
● 9 x 8 x 8 in. (22.9 x 20.3 x 20.3 cm)
Thrown Helmer stoneware; rolled rope;
ash chun glaze; cone 11 wood
● Photo by Richard Selfridge

● **NESRIN DURING**
● *Untitled*, 2001
● 9.5 x 7 x 6 ¼ in. (24 x 18 x 16 cm)
● Hand-built; ash-glazed interior;
2372°F (1300°C) wood
● Photo by Stephan During

This teapot is made from German Westerwalder clay,
a clay that is responsive to wood firing. The inside is
ash-glazed, for extra sheen. I place small containers
of salt in the wood kiln, and sometimes I place a
small piece of crystal glass on the shoulder of a pot,
beside the handle, to let it flow and run with the
form of the pot. The pot pours beautifully, because I
place a little sausage-roll of clay under the edges of
my spouts.

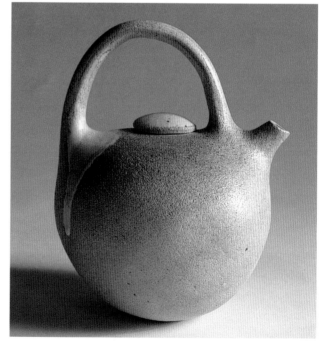

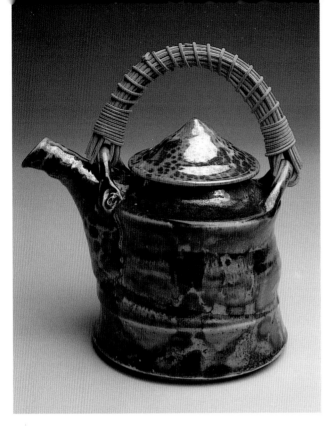

DALE NEESE

Stoneware Teapot, 2001

6 ½ x 5 ½ x 8 in. (16.5 x 14 x 20.3 cm)

Hand-thrown, altered stoneware; matte black, shino glazes with wood ash applications; cone 10 reduction

Photo by D. Seale

I have developed my skills to a point where I can explore in-depth forms, textures, and materials that evolve from the earth itself. There is no better feeling of creative satisfaction for me than to see and hold warm, beautiful pots as they are taken from the kiln.

GERBI TSESARSKAIA

Shino II, 2001

8 x 6 ½ x 5 ½ in. (20.3 x 16.5 x 14 cm)

Wheel-thrown porcelain; bisque cone 06; cone 10 gas reduction

Photo by artist

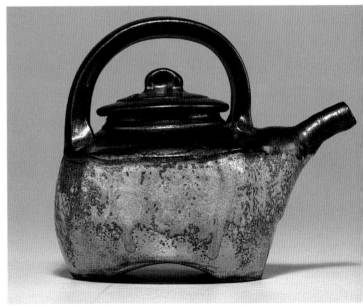

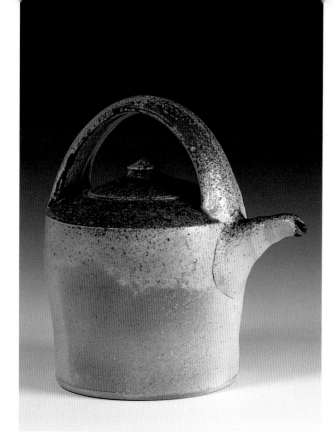

BILL VAN GILDER
Tea Pot with Top Handle, 2001
10 x 9 x 7 in. (25.4 x 22.9 x 17.8 cm)
Wheel-thrown, cut, and assembled stoneware; slip coated and glazed interior; bisque cone 010; light salt glaze, cone 11 wood
Photo by C. Kurt Holter

BEN KRUPKA
Teapot, 2001
8 x 5 ½ x 6 ½ in. (20.3 x 14 x 16.5 cm)
Wheel-thrown porcelain; cone 10 wood

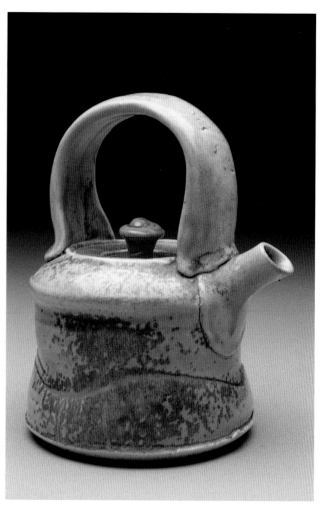

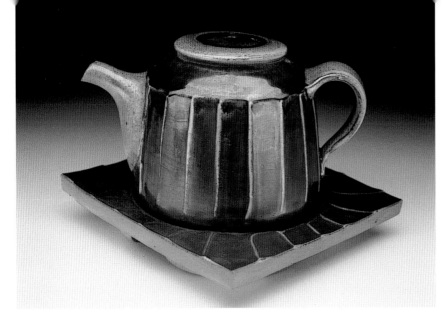

THOMAS ROHR

Teapot with Trivet, 1998

8 x 8 x 6 in. (20.3 x 20.3 x 15.2 cm)

Thrown porcelain; cone 12 wood

Photo by artist

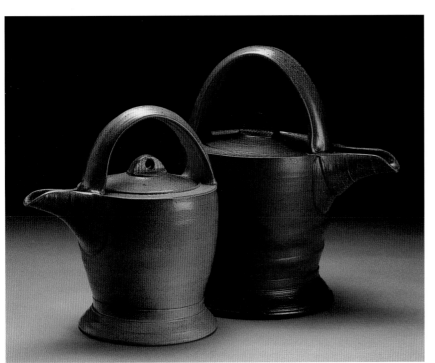

BILL VAN GILDER

Tea Pots with Top Handles, 2000

(left) 9 x 8 x 6 in. (22.9 x 20.3 x 15.2 cm)
(right) 12 x 10 x 7 ½ in. (30.5 x 25.4 x 19 cm)

Wheel-thrown, cut, and assembled stoneware;
dipped in clay slips; light salt glaze, cone 010
wood; bisque- and high-fired cone 11

Photo by C. Kurt Holter

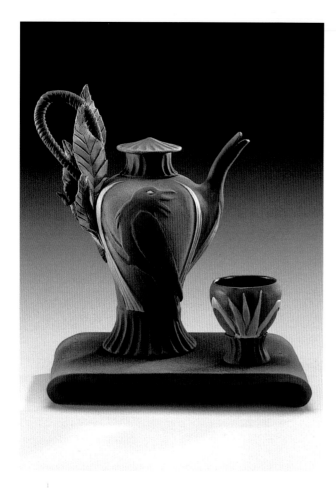

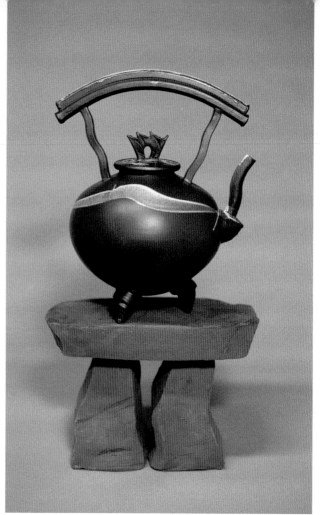

NANCY Y. ADAMS
Raven Fetish Tea, 2001
7 x 10 x 5 in. (17.8 x 25.4 x 12.7 cm)
Wheel-thrown earthenware with handcarved and hand-modeled flora and fauna motifs; airbrushed low-fire glazes; cone 06

DON DAVIS
Teapot with Stand, 1992
18 x 10 x 7 in. (45.7 x 25.4 x 17.8 cm)
Thrown porcelain clay with hand-built additions; engobe and glaze trail; cone 7
Photo by Tim Barnwell

I like teapots because they are composed from various parts and that creates so many possibilities. It is important to me that they actually function, even if the form is elevated to "art."

224

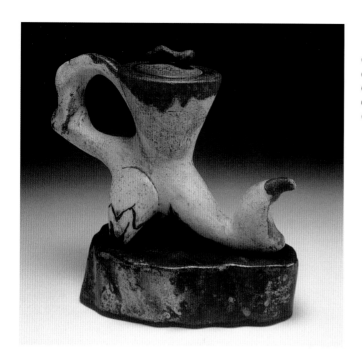

● **MARVIN SWEET**
● *Teapot Couture*, 2001
● 10 ¾ x 9 x 5 ½ in. (27.3 x 22.9 x 14 cm)
● Slab-built; raku-fired glazes; sand blasted
● Photo by David Powell

● **CHUCK HINDES**
● *Woodfired Teapot*, 2001
● 5 ¼ x 9 x 6 in. (13.3 x 22.9 x 15.2 cm)
● Slab-built stoneware; pressed surface;
 unglazed; single-fired cone 11
● Photo by artist

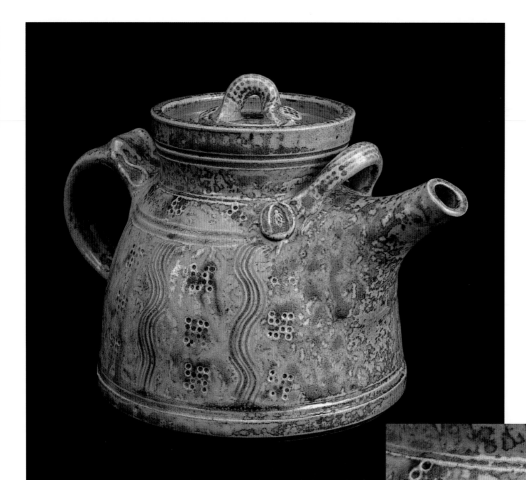

ROBERT JOHNSON
Salt-Glazed Teapot for Two, 2000
5 x 6 ¼ x 6 ¼ in. (13 x 16 x 16 cm)
Wheel-thrown white stoneware clay; cobalt and copper washes on raw ash glaze over impressed and scored decoration; salt glaze cone 10
Photo by Barbara Berkowitz

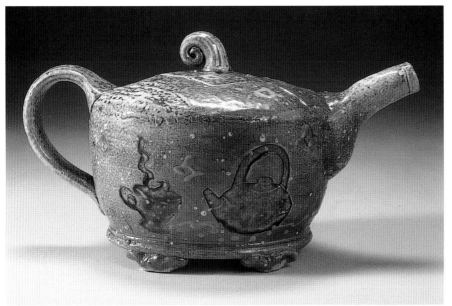

CAROL SELFRIDGE
RICHARD SELFRIDGE

Tea Party Teapot, 2001

5 ½ x 9 ½ x 4 ¾ in. (14 x 24.1 x 10.8 cm)

Thrown, altered, and constructed stoneware with feldspathic stones; rubber stencils; trailed glaze; salt glaze cone 11 wood

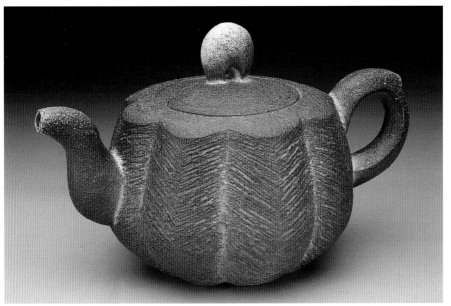

PETE PINNELL

Teapot in Winter Colors, 2001

7 x 6 x 6 in. (17.8 x 15.2 x 15.2 cm)

Wheel-thrown and altered stoneware; cone 8 soda

Photo by artist

Much of the color, form, and texture of this work is inspired by the winter landscape of the American Midwest.

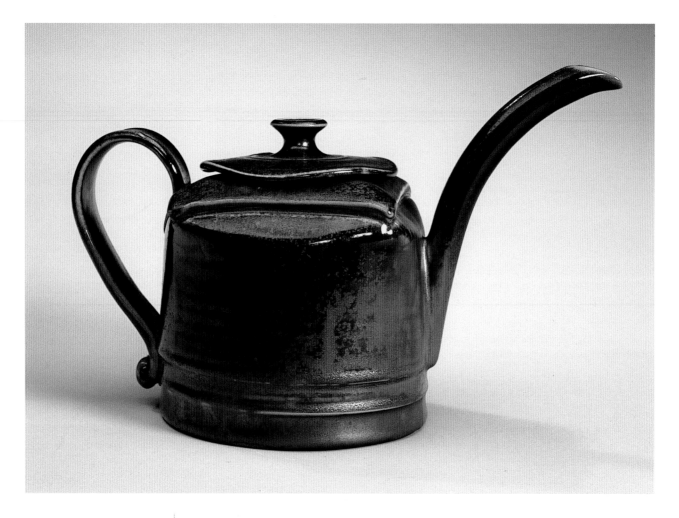

JUDY TRYON
"T" Square, 2000
7 ¼ x 12 ½ x 5 ½ in. (18.5 x 32 x 14 cm)
Wheel-thrown and altered high-fire brown
stoneware with hand-built additions and extru-
sions; wood fired with sprayed salt/soda solution;
bisque cone 06; glaze cone 10–11
Photo by A. K. Photos

SUSAN BEINER
"Openwork" Teapot, 2001
8 x 11 x 6 in. (20.3 x 27.9 x 15.2 cm)
Slip-cast and hand-built porcelain; bisque cone 06; layered glazes multi-fired cone 6, cone 06, and cone 017
Photo by Susan Einstein

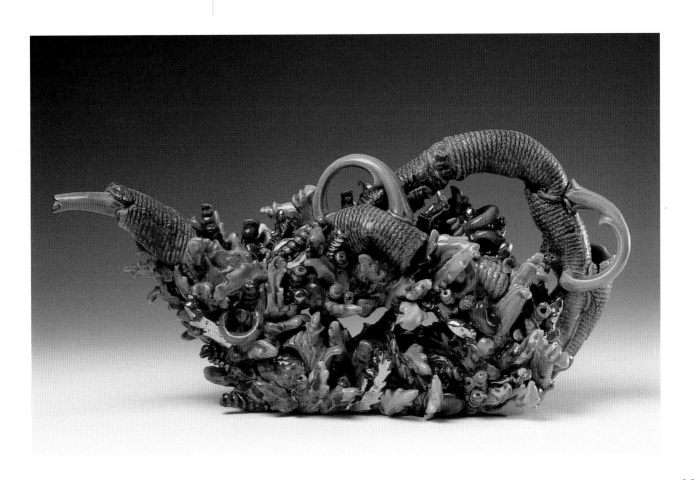

TOM HUBERT

Long Legged Teapot, 1998

36 x 21 x 13 in. (91.4 x 52.6 x 33 cm)

Wheel-thrown whiteware clay; extruded, slab built, and cast hemisphere low fire; multiple-fired underglazes and clear glaze; hardwood legs; oil paint and clear lacquer; cone 02 bisque; cone 03 underglaze firings; cone 04 glaze

Photo by artist

I enjoy making large, non-functional teapots because of the complex form possibilities and the extensive amount of surface available for decoration.

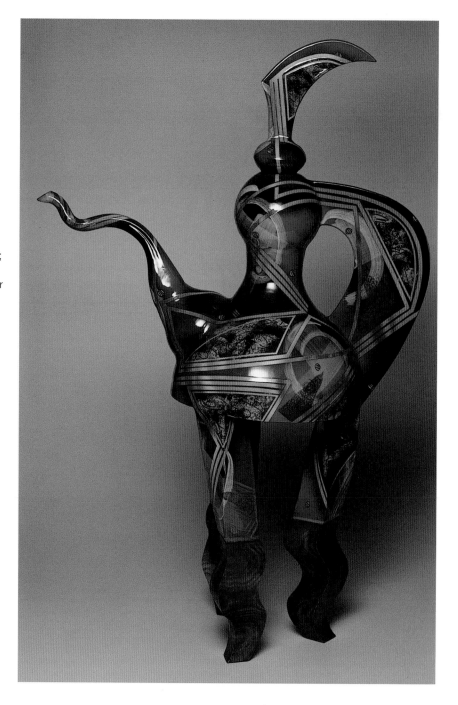

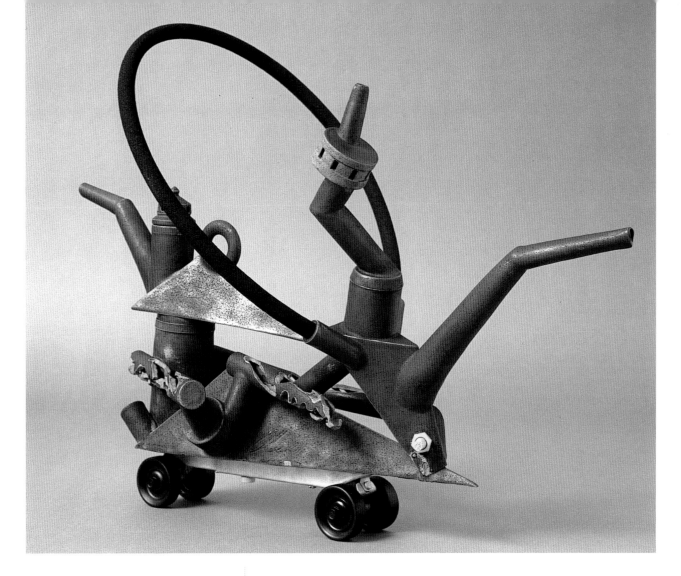

● **OLE MORTEN ROKVAM**
● *"478,"* 2001
● 18 ¼ x 11 ¾ x 25 ½ in. (46 x 30 x 65 cm)
● Reduction-fired stoneware to cone
 10, 2336°F (1280°C); sandblasted; metal and
 rubber hosing attachments
● Photo by Halvard Haugerud

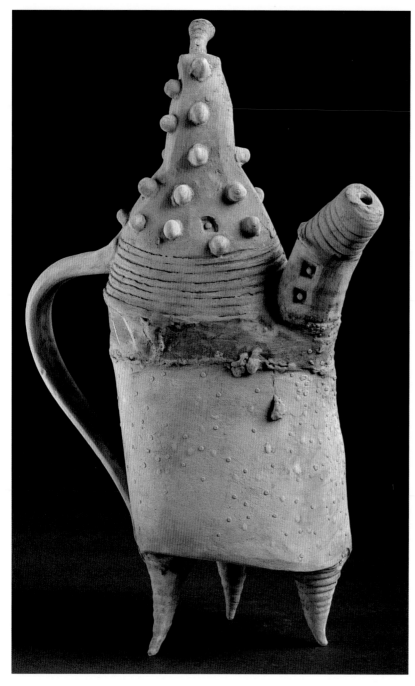

SIGRID K. ZAHNER
If Eva Were a Teapot, 2000
20 x 10 x 8 in. (50.8 x 25.4 x 20.3 cm)
Hand-built; low-fire slips and stains (brushed, rubbed, sprayed); bisque cone 09, glaze cone 06
Photo by Joe Vondesaar

● **RAE DUNN**
● *Mr. Wong*, 2000
● 10 x 8 x 2 in. (25.4 x 20.3 x 5 cm)
● Hand-built high-fire stoneware; oxides and engobe; cone 10 reduction
● Photo by Charles Ingram

My work is not a reaction against the complexity of life today, but rather a way for me to embrace the joyful, spontaneous elements of daily living.

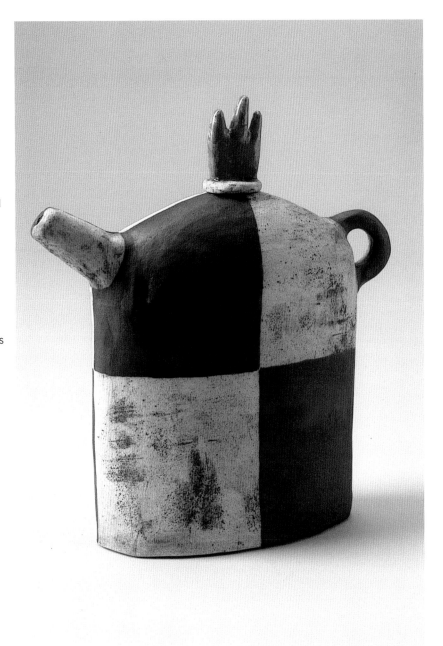

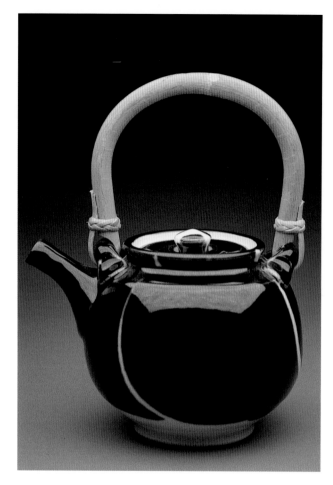

● **KATHLEEN GUSS**
 STEPHEN ROBISON
● *Teapot*, 2001
● 9 x 8 x 4 ½ in. (22.9 x 20.3 x 11.4 cm)
● Wheel-thrown and hand-built porcelain with
 terra sigillata; woven copper handle; glaze
 cone 6 oxidation

Kathleen and I are interested in the interplay of
form, surface, context, and utility.

● **STEPHEN MICKEY**
● *Blue and White Teapot*, 2001
● 6 x 6 x 6 in. (15.2 x 15.2 x 15.2 cm)
● Wheel-thrown porcelain; wax resist
 decoration; cone 10
● Photo by Rhue Bruggeman

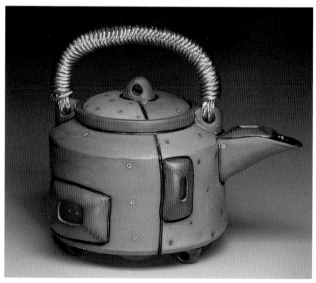

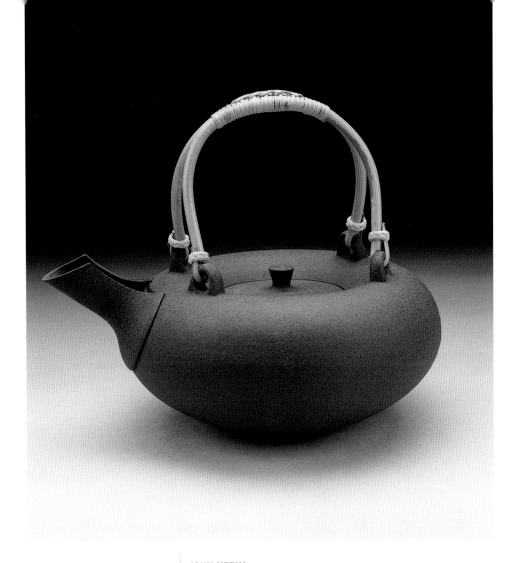

● **JOHN NEELY**
● *Black Flat Oval Teapot with Double Cane Handle*, 1997
● 7 ½ x 8 x 8 in. (19 x 20 x 20 cm)
● Wheel-thrown and assembled stoneware
● Photo by artist

The teapot is a machine for brewing tea. Mechanical precision is the starting point; utility is the by-product of an aesthetic investigation.

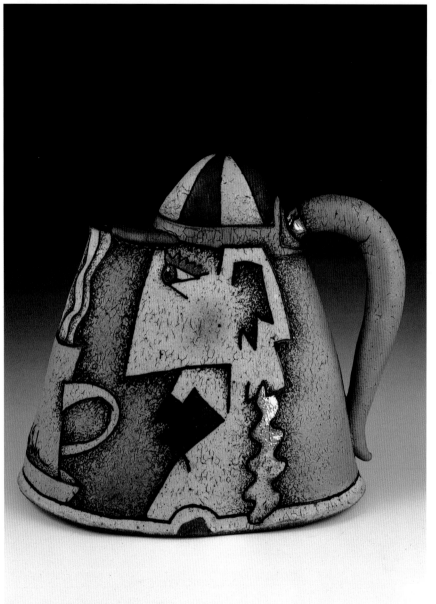

● **RIMAS VISGIRDA**
● *"Two cups"*, 1999
● 9 x 10 x 5½ in. (22.9 x 25.4 x 14 cm)
● Wheel-thrown and altered stoneware;
 bisque cone 010; white engobe, wax inlay
 black line, and interior glaze cone 10; black
 underglaze (in texture), underglaze pencil,
 and selected areas of exterior glaze cone
 05; lusters and china paints, cone 018
● Photo by artist

JILL J. BURNS

Coffee Pot with Biggin, 2001

9 x 8 x 5 in. (22.9 x 20.3 x 12.7 cm)

Wheel-thrown stoneware with slab handle; copper matte crystalline glaze; bisque cone 05; glaze cone 10 reduction

Photo by Steve Briggs

Coffee is often the preferred beverage in America, so I choose to make coffee pots rather than teapots. This piece is inspired from tinware; I try to express the spirit of its straightforward utilitarian nature.

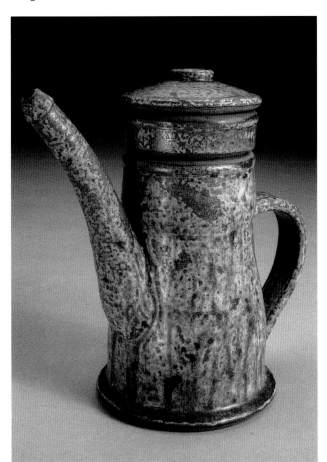

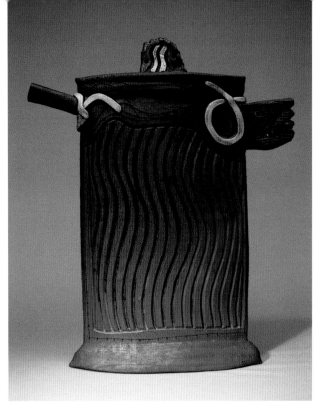

DOUG EUBANK

Black/Gold Teapot, 2001

18 x 15 x 5 in. (45.7 x 38.1 x 12.7 cm)

Slab-built stoneware; cobalt carbonate wash; cone 10 salt; gold paint applied

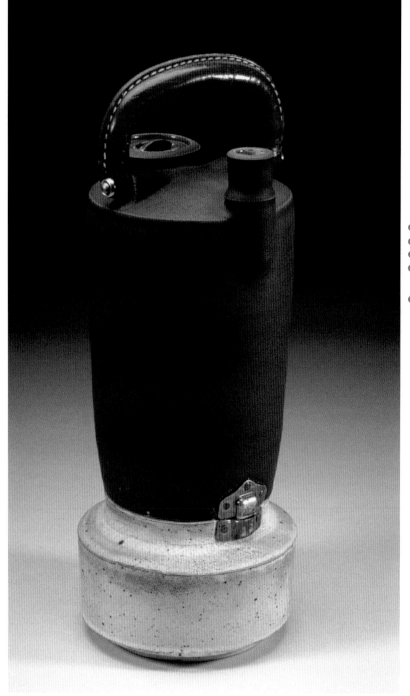

● **TED NEAL**
● *Portable Teapot with Storage Base*, 1999
● 17 x 7 x 7 in. (43.2 x 17.8 x 17.8 cm)
● Wheel-thrown stoneware; sandblasted;
 found objects; cone 10 reduction
● Photo by Jeff Bruce

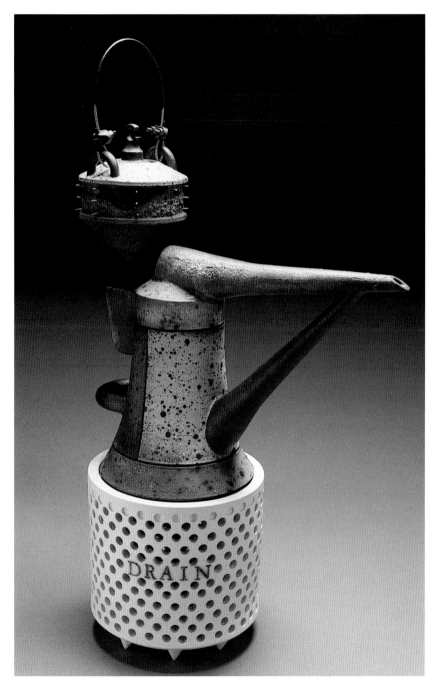

MATT WILT

BlowTorch II, 2001

21 x 16 x 9 in. (53.3 x 40.6 x 22.9 cm)

Wheel-thrown, slip-cast, and hand-built stoneware and porcelain; cone 8

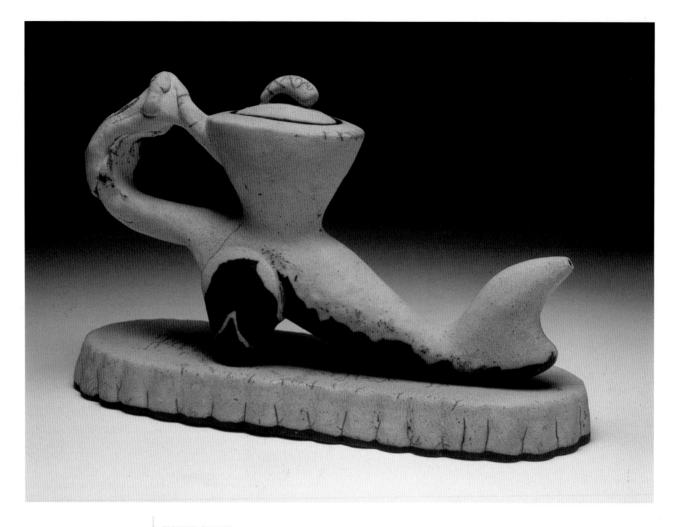

- **MARVIN SWEET**
- *Teapot and Trivet*, 2001
- 7 ¾ x 12 ¾ x 4 in. (19.6 x 31.1 x 10.2 cm)
- Slab-built; sandblasted; glaze raku-fired
- Photo by David Powell

ROBERT "BOOMER" MOORE
Long Tea, 2001
12 x 8 x 20 in. (30.5 x 20.3 x 50.8 cm)
Assembled, wheel-thrown, and altered parts; multiple sprayed layers high-fire copper-bearing glazes; bisque cone 08; glaze cone 10 salt; sandblasted

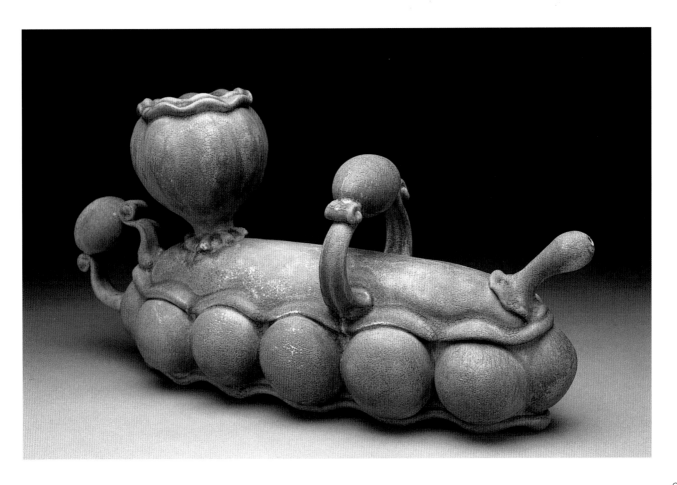

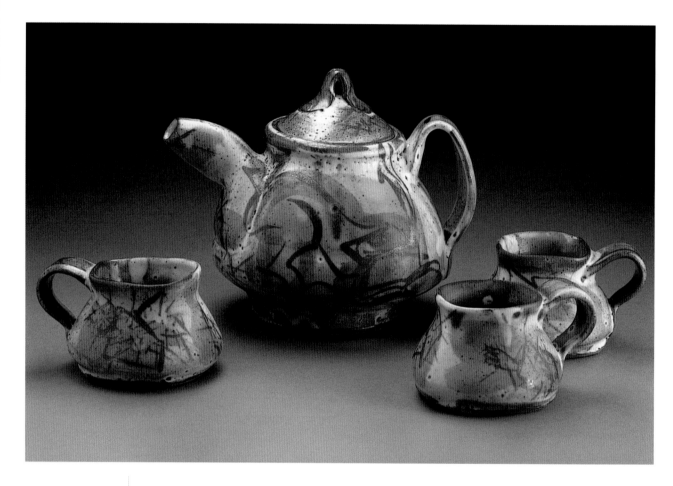

● **BECCA FLOYD**
● *Stoneware Teapot with Shino and Rabbit Design*, 2001
● Wax resist with brushed-on coloring oxides; celadon, and ohatra
 with brushed-on triaxial blend of oxides; reduction fired
● Photo by Tom Mills

Making teapots forces me to consider all aspects of the three-dimensional form and its uses. Teapots are the ultimate potter's challenge; it is a form that tests all aspects of functionality and design.

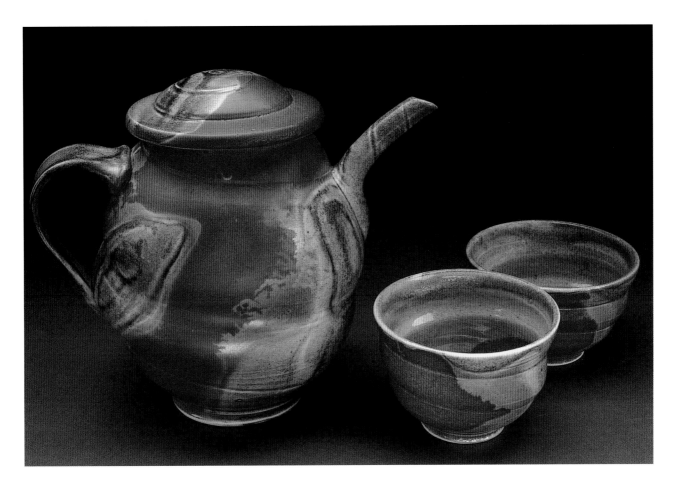

CONNIE CHRISTENSEN
Untitled, 2001
6 ½ x 7 x 4 ½ in. (16.5 x 17.8 x 11.4 cm)
Wheel-thrown porcelain, shino glaze;
cone 10 reduction

Wrapping plastic over parts of the shino-glazed form slows the drying
process, leaving orange flashes that record the path of the plastic.

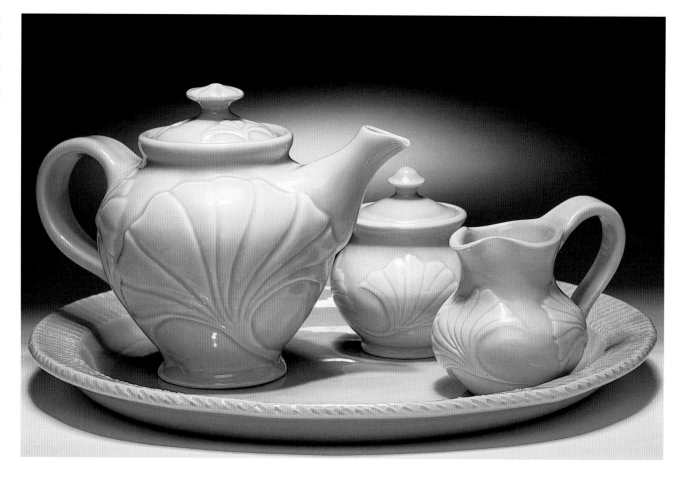

CHERI YARNELL
Porcelain Teaset, 1999
8 x 9 x 8 in. (20.3 x 22.9 x 20.3 cm)
Wheel-thrown; carved ginkgo design;
celadon glaze cone 9 reduction

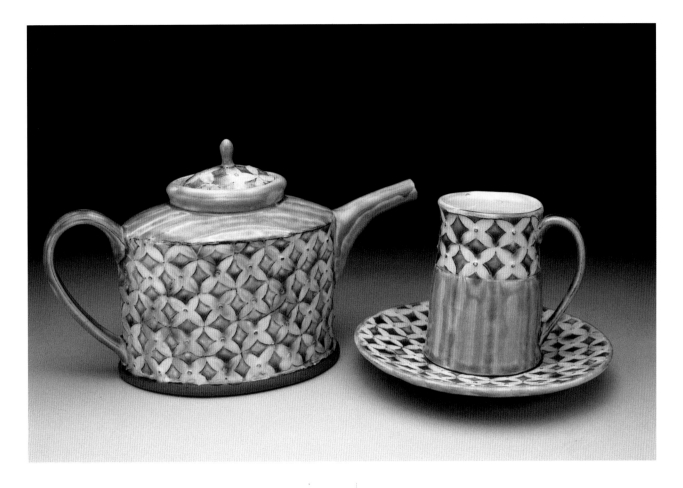

KATHRYN FINNERTY

Oval Teapot, 2001

6 ½ x 9 in. (16.5 x 22.9 cm)

Slab construction with raised-line relief; white slip over terra cotta; cone 04

I make wheel-thrown and slab-constructed functional pottery. The decorative wares of 19th-century English pottery have played an important part in influencing my work.

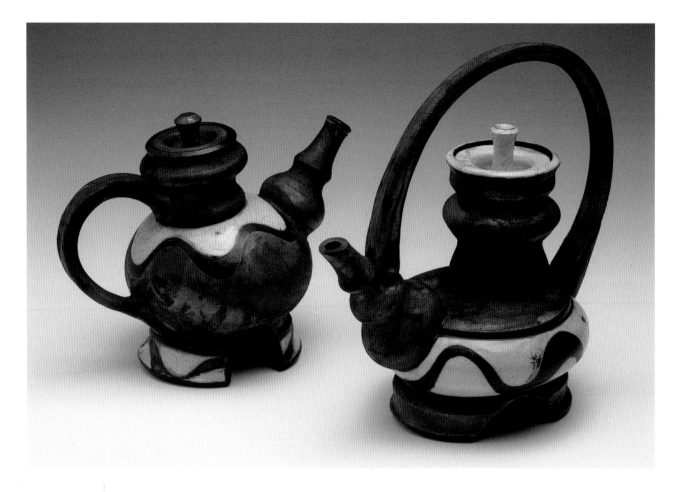

● **SHARI SIKORA**
● *The Pair*, 2001
● 9 ½ x 7 ½ x 5 ½ in. (24.1 x 19 x 14 cm)
● Wheel-thrown and altered raku clay; copper and
 clear glazes; bisque cone 06; raku with reduction
● Photo by John Carlano

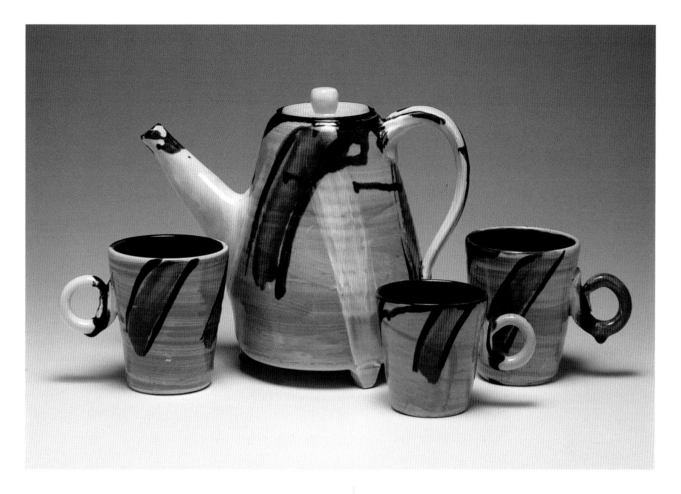

STEVEN GLASS

Teapot with Cups, 2000

9 ½ x 9 ½ x 6 ¾ in. (24.1 x 24.1 x 17.1 cm)

Wheel-thrown white stone; slips and underglazes; clear overglaze; bisque 1800°F (982°C); glaze 2280°F (1249°C)

Photo by Mike Pocklington

I try to create work that is energetic and fresh. All of my work is oxidation fired, so it is challenging to make engaging surface phenomena.

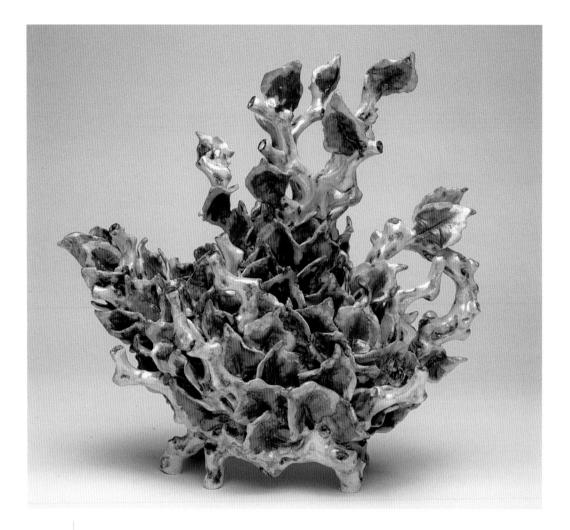

- **JANET KORAKAS**
- *Dragon*, 2001
- 9 ¾ x 9 ½ x 5 in. (25 x 24 x 13 cm)
- Coiled, press-molded, and hand-sculpted stoneware; glazes and lustres; bisque cone 06; glaze cone 8; lustre cone 017

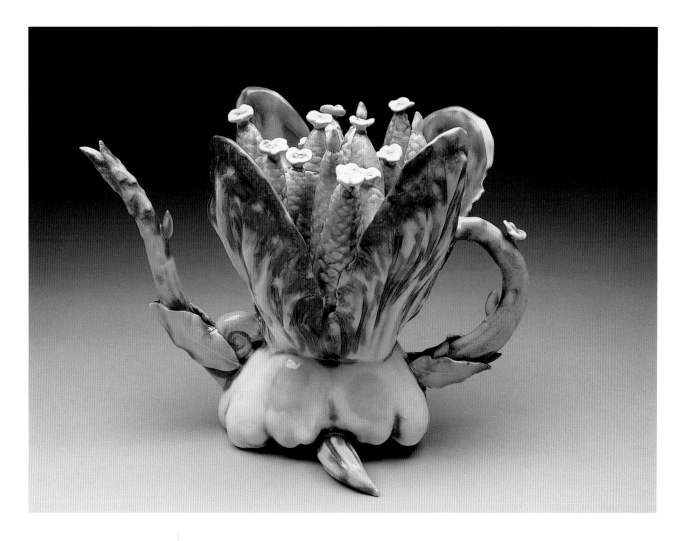

EUNJUNG PARK
Telopea, 2001
8 x 9 ½ x 5 in. (20.3 x 24.1 x 12.7 cm)
Slip-cast porcelain; glaze cone 9

My teapots, constructed from organic forms, seek to bring out the intimacy between human nature and the wilderness as it exists in my culture. Seeing tea as a gift from the natural world, I make vessels that inspire enchantment between humans and other living creatures.

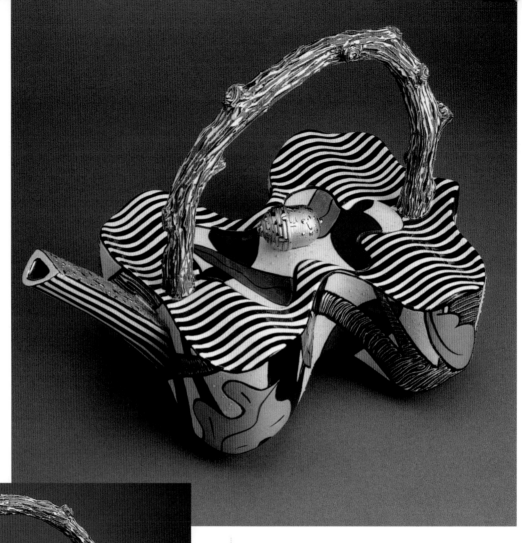

● **CAROL GOUTHRO**
● *Teapot*, 1999
● 9 ½ x 13 ½ x 7 in. (24.1 x 34.3 x 17.8 cm)
● Slip-cast terra cotta with hand-built
 additions; low-fire underglazes, glazes,
 and lusters; bisque cone 04; glaze cone 05;
 luster cone 022
● Photo by Roger Schreiber

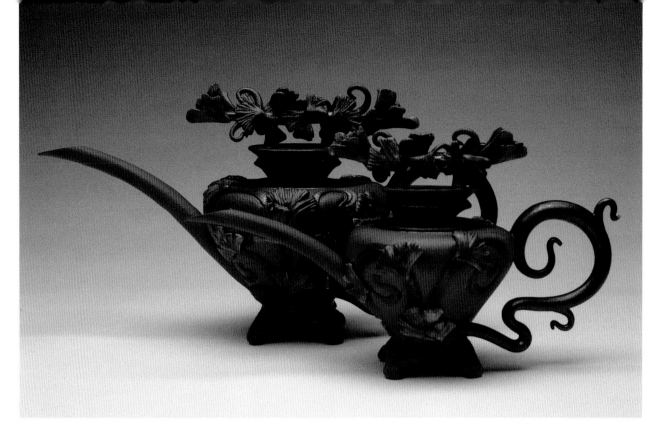

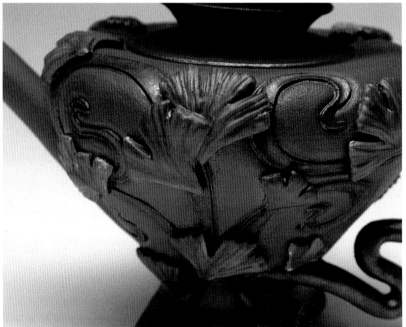

ANN M. PERRY SMITH

Gingko Green Tea I and II, 1999

14 x 18 x 10 in. (35.6 x 45.7 x 25.4 cm) and 12 x 14 x 8 in. (30.5 x 35.6 x 20.3 cm)

Wheel-thrown terra cotta; hand-carved surface with hand-carved appliqué; sculptural construction of lids, pulled handles and spout; leaves glaze cone 6; vine, handles, and lids cone 04

I have always carried part of the past inside of me. When I began to create this body of work, memories surfaced as part of my inherited culture—a wonderful gift from my parents and grandparents. As I incise each curve onto a piece I feel I'm integrating history, belief, attitude, and desire into each image.

251

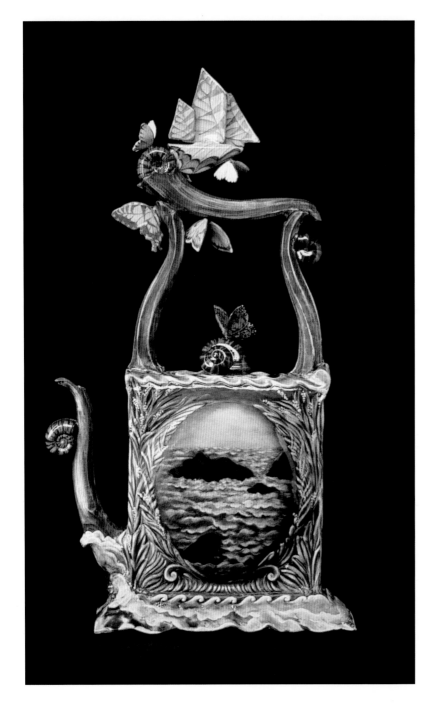

● **SUSAN THAYER**
● *Zephyr*, 2001
● 14 ½ x 8 x 2 ¾ in. (36.8 x 20.3 x 7 cm)
● Assembled from slip-cast parts; carved;
glazed; china paints

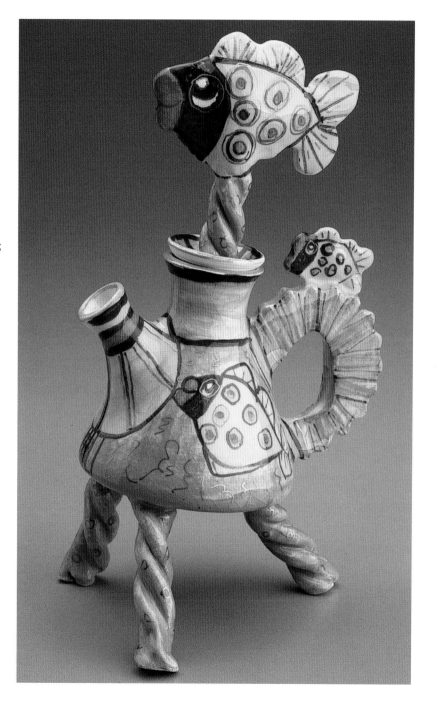

MAGGIE SMITH

Fish, 2000

11 x 6 in. (28 x 15 cm)

Wheel-thrown; add-ons and colored slips; glaze 2048°F (1120°C); luster 1382°F (750°C)

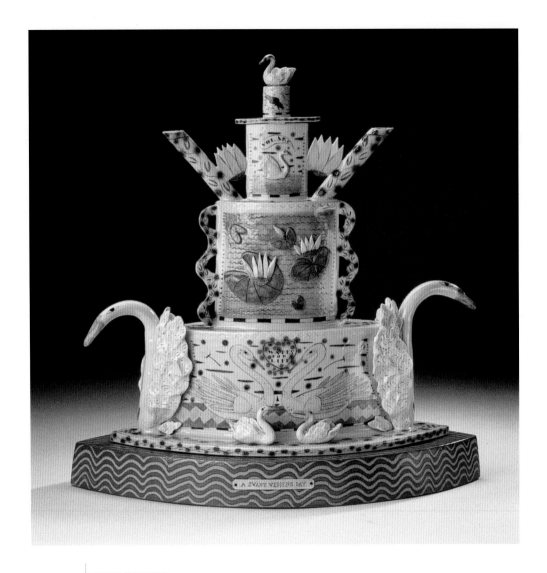

● **MARA SUPERIOR**
● *A Swan's Wedding Day*, 2001
● 19 x 20 x 10 in. (48.3 x 50.8 x 25.4 cm)
● Slab-built porcelain; relief surface painted
 with ceramic oxides and underglazes;
 cone 10 reduction

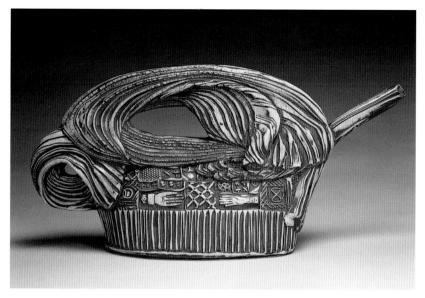

LANA WILSON

Artifact Teapot, 1999

8 x 16 x 4 in. (20.3 x 40.6 x 10.2 cm)

Slab-built white stoneware; stamped; bisque cone 06; glaze cones 6 and 04

I am inspired by old ritual objects, like yak-butter ceremonial teapots used in Bhutan.

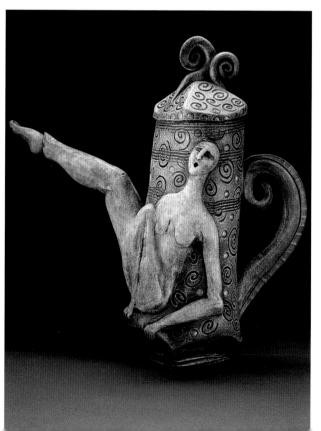

MARIE E.V.B. GIBBONS

Sirens, 2001

15 x 13 x 6 in. (38.1 x 33 x 15.2 cm)

Hand-built slabs, coils, and repoussé; cone 04 electric; cold finishes of acrylic paints, colored pencil, and sealant

Photo by John Bonath/Maddog Studio

My work often speaks through metaphor. The vessel (in this case, the teapot) can speak of human experience: the filling or emptying of its contents, the comfort of sharing a warm moment, or the ceremony of existence.

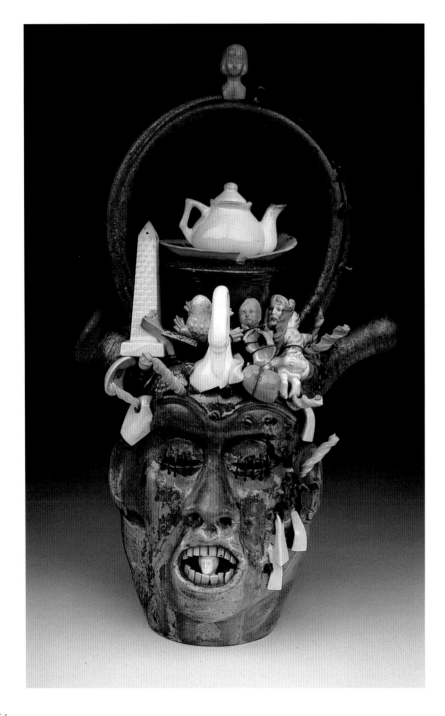

● **PETER LENZO**
● *Tea for the Dead (Face Jug Fetish)*, 2001
● 18 x 9 x 7 in. (45.7 x 22.9 x 17.8 cm)
● Wheel-thrown and slip-cast with hand-built
 and recycled components; slips applied to
 wet greenware; single-fire cone 11 salt
● Photo by Craig Wactor

I collect small clay objects from a variety of
sources, such as yard sales, flea markets,
antique stores, and gift shops. What I can-
not find I slip cast. These objects are then
stabbed into and/or wired onto the wet clay
of wheel-thrown and altered face jugs.

KAREN MARIE PORTALEO
Nurse (Fetish Series 1), 2001
9 x 6 ½ x 6 in. (22.9 x 16.5 x 15.2 cm)
Slab- and coil-built low-fire clay;
bisque cone 04; glaze cone 06
Photo by Joseph Bronzino

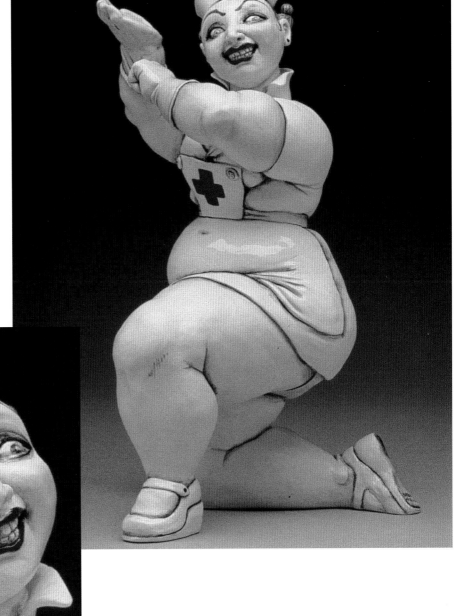

257

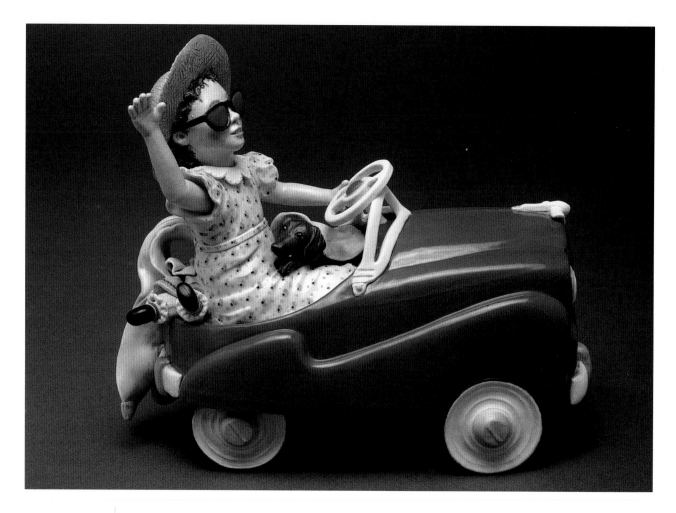

● **KATHRYN MCBRIDE**
● *Arriving in Style*, 2001
● 8 x 9 x 6 in. (20.3 x 22.9 x 15.2 cm)
● Hand-built (pinch, coil, and slab)
 porcelain; engobe and underglaze
 decoration; bisque cone 06; glaze
 cone 8 oxidation
● Photo by Tony Grant

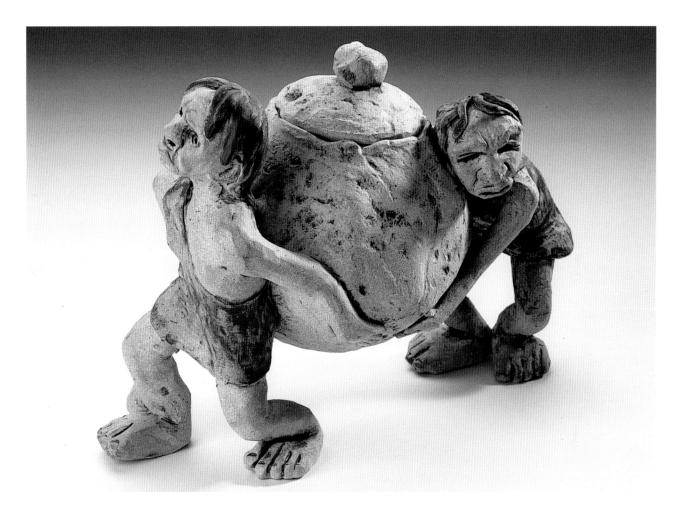

- **MARLENE FERRELL PARILLO**
- *Workingman's Teapot*, 1999
- 8 x 6 x 10 in. (20.3 x 15.2 x 25.4 cm)
- Wheel-thrown and sculpted stoneware clay; cone 10 reduction; decorated with Barnard slip and Mason stain
- Photo by Howard Goodman

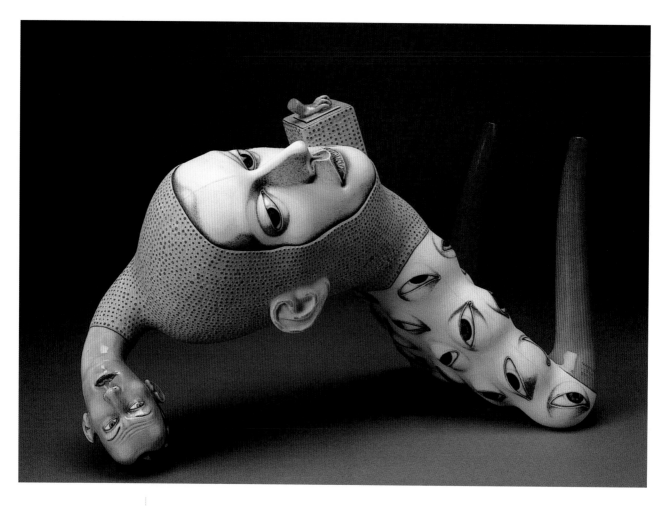

SERGEI ISUPOV
● *Awakening*, 2000
● 8 x 13 x 7 ½ in. (20.3 x 33 x 19 cm)
● Hand-built porcelain; Mason stains; cone 7

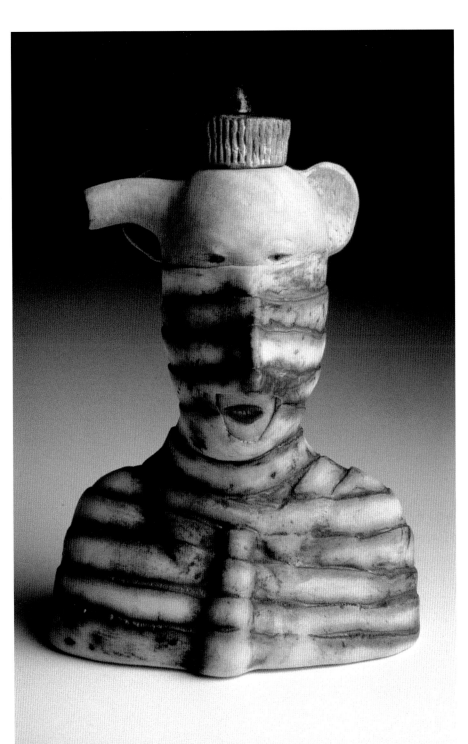

● **LESLIE ROSDOL**
● *Mysterious Figure in Business Suit*, 2001
● 6 x 4½ x 2¾ in. (15.2 x 11.4 x 7 cm)
● Coiled porcelain; stains and glazes;
 multi-fired cone 5 and cone 05
● Photo by Susan Einstein

● **CINDY GIBSON**
● *Sisters*, 2000
● 7 x 10 ½ x 5 ½ in. (18 x 27 x 14 cm)
● Wheel-thrown porcelain; slips and under-glazes; clear glaze; bisque cone 06; glaze cone 10 oxidation
● Photo by artist

A teapot is the ideal surface for my narrative paintings. Because it is used daily, its paintings are personal conversations or bits of well known stories, its meaning revealed during the acts of brewing, pouring, and contemplating (drinking).

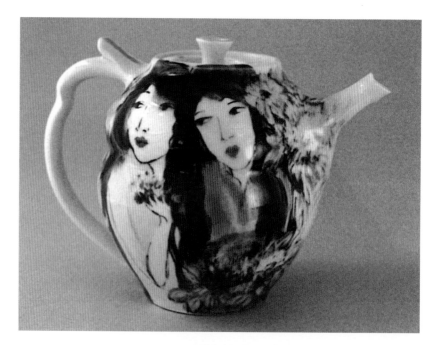

● **BARBARA FREY**
● *Let's Go Teapot #13*, 2001
● 7 x 7 ¼ x 5 in. (17.8 x 18.1 x 12.7 cm)
● Slab-built porcelain and colored porcelain; slips, powdered clays, and oxides; hand-textured surfaces; cone 6

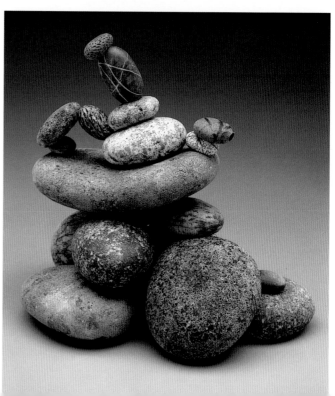

● **STEPHEN MICKEY**
● *Squared T-Pot*, 2000
● 9 x 7 x 4 ½ in. (22.9 x 17.8 x 11.4 cm)
● Wheel-thrown stoneware; squared; white
 slip with finger swipes; cone 12 anagama
● Photo by Rhue Bruggeman

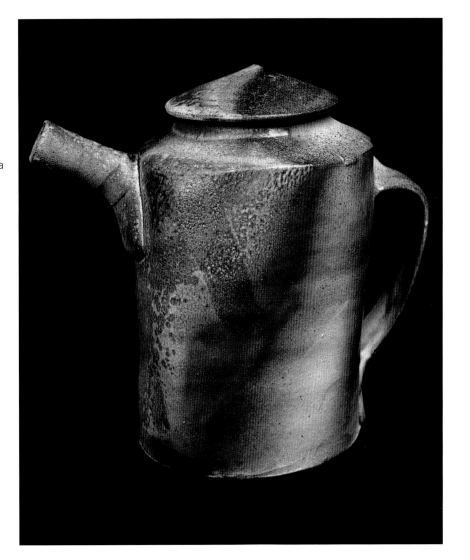

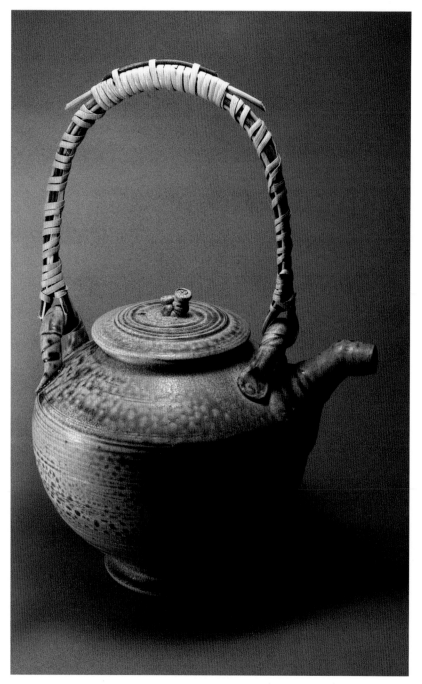

CAROL-ANN MICHAELSON
Untitled, 2000
12 x 6 x 8 in. (30.5 x 15.2 x 20.3 cm)
Wheel-thrown and altered porcelain;
sprayed ash glazes; bisque cone 06;
glaze cone 8

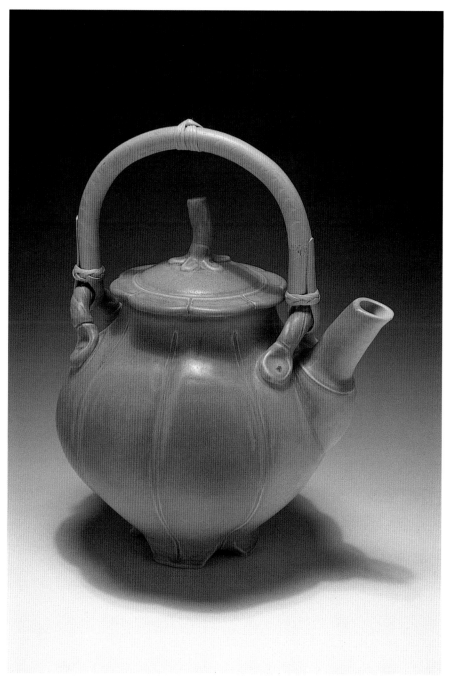

MARK BRANSTINE
Pretty in Pink, 2001
11 x 9 ½ x 7 in. (27.9 x 24.1 x 17.8 cm)
Wheel-thrown and altered porcelain stoneware; glaze with copper overspray; bisque cone 06; glaze cone 10
Photo by artist and Marko Fields

265

MAGGIE SMITH
Sun Moon and Stars, 2000
11 x 6 in. (28 x 15 cm)
Wheel-thrown with add-ons; colored slips; glaze 2048°F (1120°C); luster 1382°F (750°C)

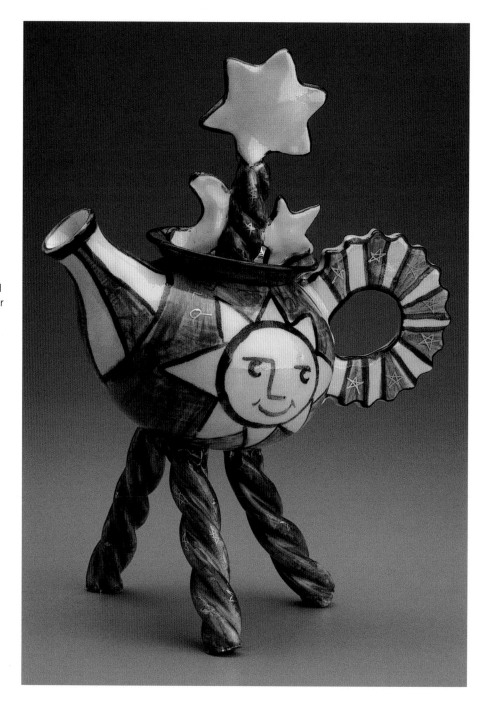

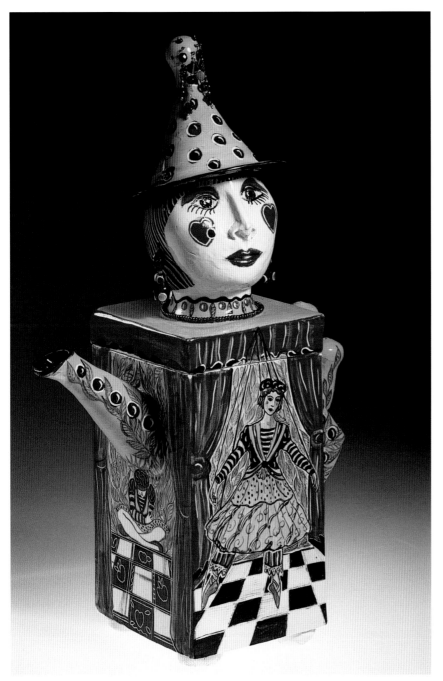

● **MANDY WOLPERT**
● *No. 3 With Strings Attached – A Feminist Statement*, 2000
● 21 x 13 x 6 ½ in. (53.3 x 33 x 16.5 cm)
● Slab base with wheel-thrown earthenware additions; underglaze decoration; glass beads; bisque cone 04; glaze cone 06; clear glaze

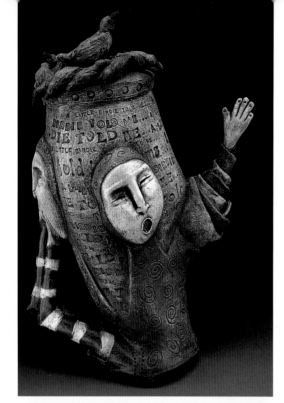

MARIE E.V.B. GIBBONS
A Little Bird Told Me, 2001
16 x 11 x 5 ½ in. (40.6 x 27.9 x 14 cm)
Hand-built slab construction; pinched and molded birds; repoussé figures; cone 04 electric; cold finishes of acrylic paints, colored pencil, and sealant
Photo by John Bonath/Maddog Studio

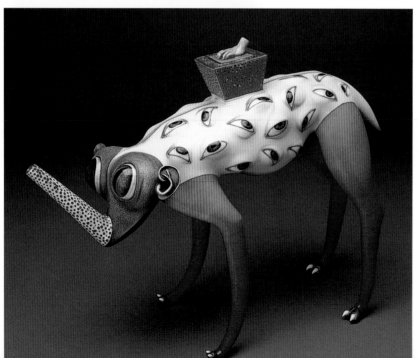

SERGEI ISUPOV
Passive Observer, 2000
11 ½ x 13 ½ x 5 in. (29.2 x 34.3 x 12.7 cm)
Hand-built porcelain; Mason stains; cone 7

ILONA ROMULE

The Golden End, 1999

7 x 5 x 8 ½ in. (17.8 x 12.7 x 21.6 cm)

Slip-cast porcelain in hand-made plaster molds; bisque cone 07; partly glazed cone 10; hand polished; china painted and gold luster, two firings cone 08

I think of my art as a three-dimensional story in colors. Porcelain is the expressive means, or language, of my "literature," and the events in my everyday life, as well as my imagination about them, are reflected in it.

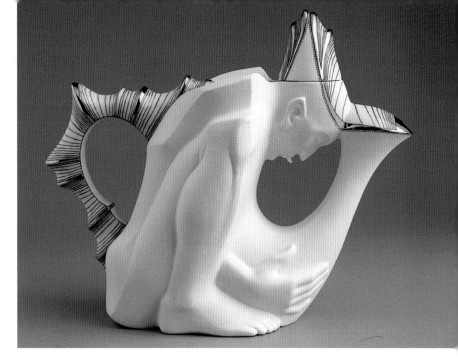

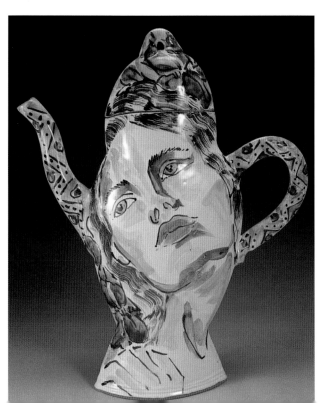

CAROL SELFRIDGE
RICHARD SELFRIDGE

Astarte Remembers Spring Flowers, 2000

20 ½ x 17 x 4 ½ in. (51.4 x 43.2 x 11.4 cm)

Slab-constructed terra cotta; majolica cone 04

Photo by Richard Selfridge

These pieces are flattened illusionistic vessels that combine figurative painting and mythological narrative.

269

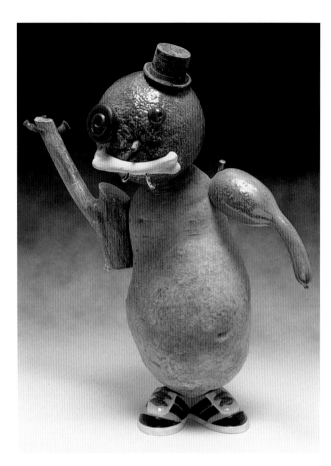

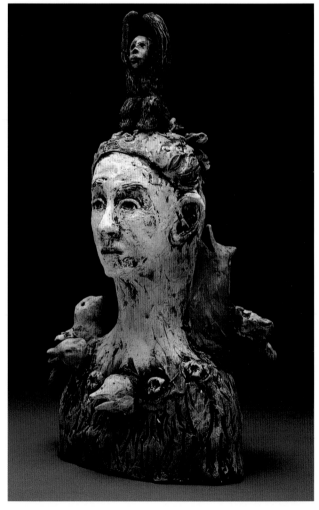

DEBRA W. FRITTS
Wish On, 2001
17 x 10 ½ x 7 ½ in. (43.2 x 26.7 x 19 cm)
Coiled and modelled terra cotta; bisque
cone 2; multiple firings cone 04; slips,
oxides, glazes, and underglaze
Photo by Michael Noa

ROBIN CAMPO
Orange You Glad to See Me?, 2000
15 x 5 x 13 in. (38.1 x 12.7 x 33 cm)
Slip-cast and assembled white earthenware;
bisque cone 03; glaze cone 05; multi-fired
china paint and luster cone 018
Photo by artist

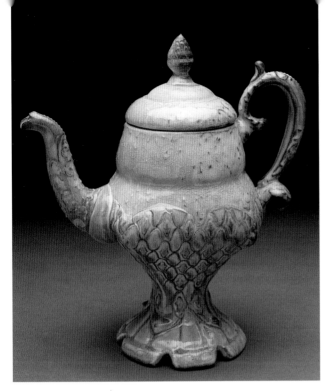

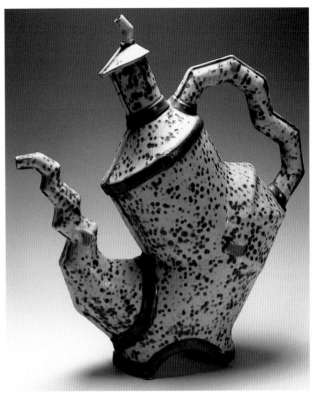

KRISTEN KIEFFER

Teapot, 2001

10 ½ x 5 x 10 in. (26.7 x 12.7 x 25.4 cm)

Wheel-thrown and darted porcelain; stamped and slip-trailed; multiple glazes; cone 10 soda

Photo by artist

SCOTT DOOLEY

Teapot, 2000

16 x 13 x 5 in. (40.6 x 33 x 12.7 cm)

Hand-built and textured porcelain slabs; oxide and glaze; cone 5 electric

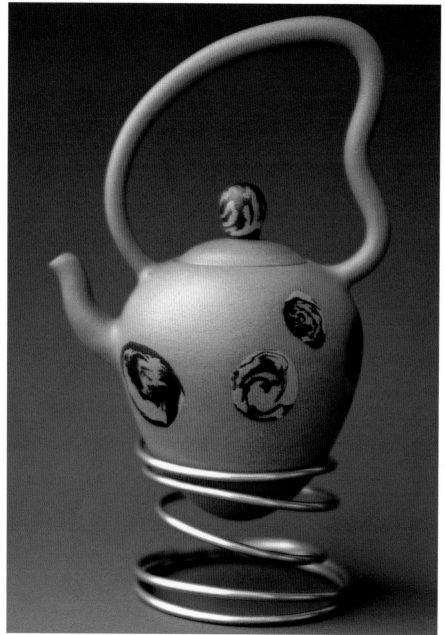

HWANG JENG-DAW
Jumping Teapot, 2000
5 ¼ x 3 ½ x 2 ½ in. (13 x 9 x 6.5 cm)
Slab-built colored clay; cone 7 oxidation

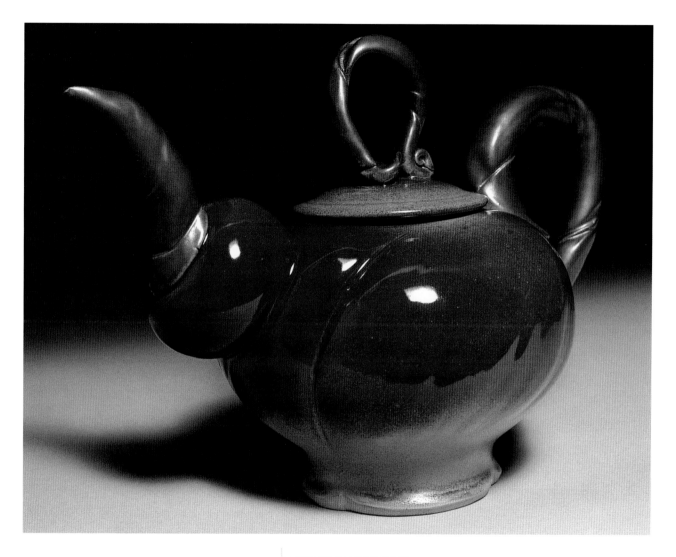

CATHRYN LEE SCHROEDER
Red Bulbous Teapot, 1998
9 x 10 x 6 ½ in. (22.9 x 25.4 x 16.5 cm)
Wheel-thrown and altered stoneware;
hand-built spout and handles; sprayed
glazes; bisque cone 06; glaze cone 5
Photo by artist

DIANE C. DUVALL
Smoked Teapot, 1999
12 x 13 x 4 in. (30.5 x 33 x 10.2 cm)
Hand-built stoneware; bisque cone
05; smoked

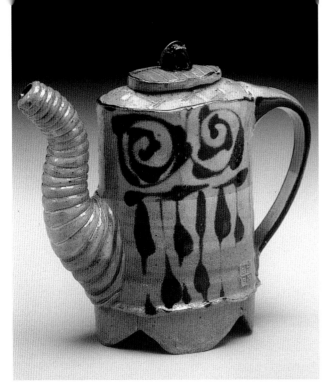

● **TERRY GESS**
● *Teapot With Stripes and Spirals*, 1998
● Wheel-thrown and hand-built porcelain; multi-layered brush work textures; lightly salted in atmospheric kiln; bisque cone 08; glaze cone 10

● **PHILLIP HARRIS**
ANNE SCHIESEL-HARRIS
● *Untitled*, 2001
● 10 x 15 x 4 in. (25.4 x 38.1 x 10.2 cm)
● Slab-built porcelain with textural imprints, stains, and glazes; cone 6 oxidation
● Photo by Bob Barrett

This piece represents the collaborative efforts of two artists. Anne's contribution is the form and construction; Phil works with pattern and the graphic quality of the surface.

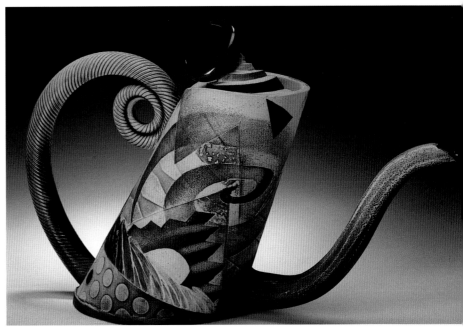

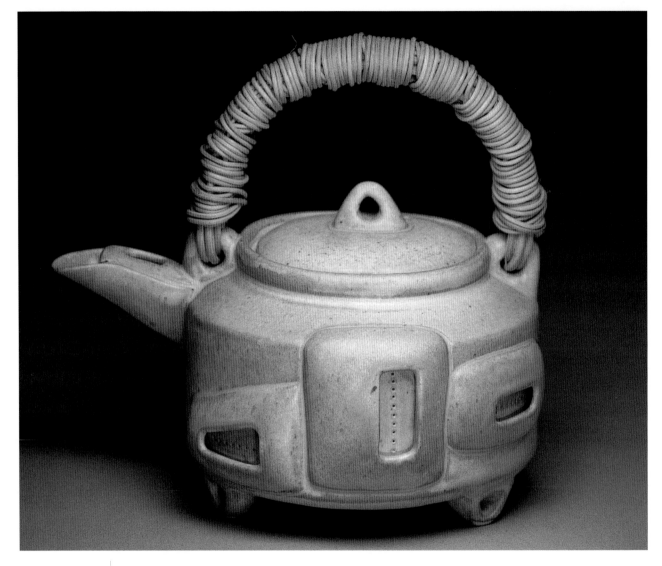

KATHLEEN GUSS
STEPHEN ROBISON

Teapot, 2001

8 x 8 x 5 in. (20.3 x 20.3 x 12.7 cm)

Wheel-thrown and hand-built porcelain; woven cane
handle; high spodumene glaze cone 10 reduction

CAROLINE CERCONE
Teapot, 2001
6 x 8 x 5 ½ in. (15.2 x 20.3 14 cm) without handle
Wheel-thrown; brushwork on slip; single-fired cone 10 wood
Photo by William Struhs

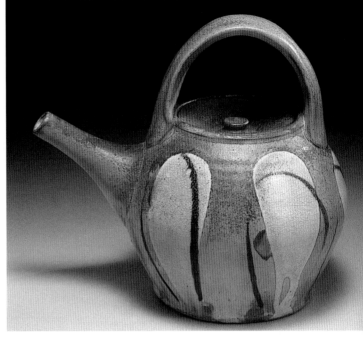

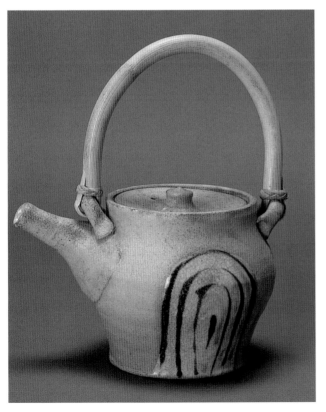

WILL RUGGLES
DOUGLASS RANKIN
Teapot, 2001
10 x 10 x 6 in. (25.4 x 25.4 x 15.2 cm)
Wheel-thrown white stoneware; slips and glaze;
salt/soda cone 9 wood
Photo by W. Ruggles

● **JOHN A. VASQUEZ**
● *Square Fish Teapot*, 2001
● 9 ½ x 7 x 5 in. (24.1 x 17.8 x 12.7 cm)
● Wheel-thrown and altered stoneware with
 Tile 6 and black slip resist decoration;
 copper glaze; cone 10 soda
● Photo by Tom Mills

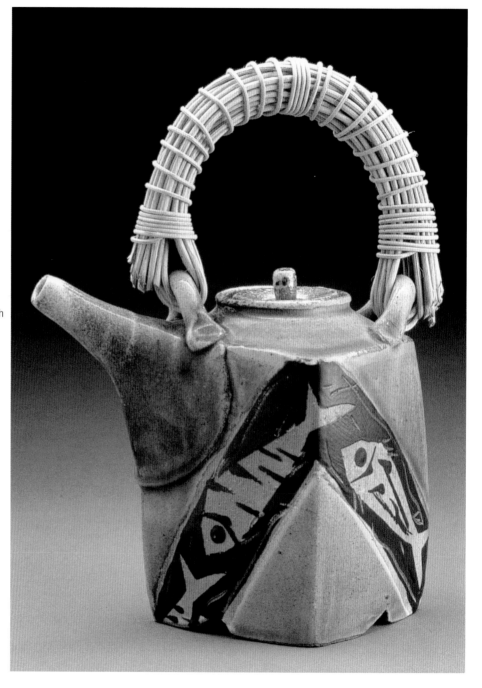

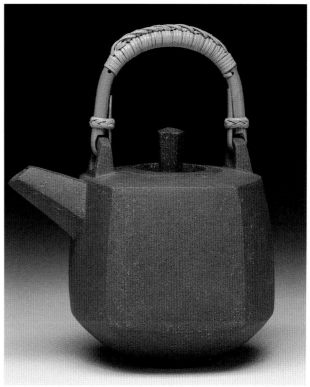

JOHN NEELY
Pentagonal Brown Teapot with Braided Cane Handle, n.d.
5 ¼ x 3 ½ x 3 ½ in. (13 x 9 x 9 cm)
Hand-built Yixing stoneware
Photo by artist

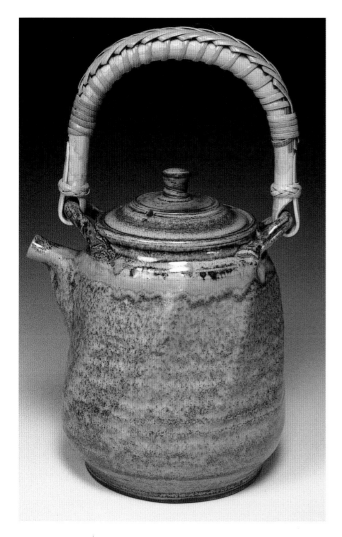

HODAKA HASEBE
Teapot, 2001
10 x 5 x 6 in. (25.4 x 12.7 x 15.2 cm)
Wheel-thrown and altered stoneware;
cone 10 reduction

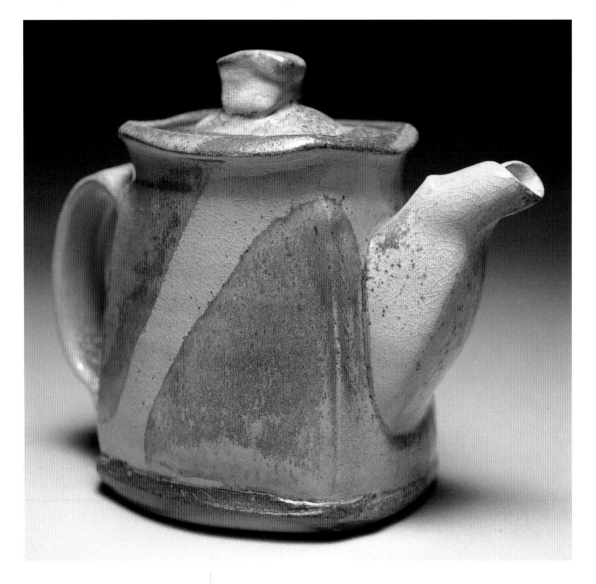

● **MARK PETERS**
● *Teapot*, 2001
● 8 x 8 x 5 in. (20.3 x 20.3 x 12.7 cm)
● Wheel-thrown and altered stoneware;
wood fired

CYNTHIA BRINGLE

Teapot, 2000

5 x 7 ½ x 4 in. (12.7 x 19 x 10.2 cm)

Wheel-thrown; wood/salt

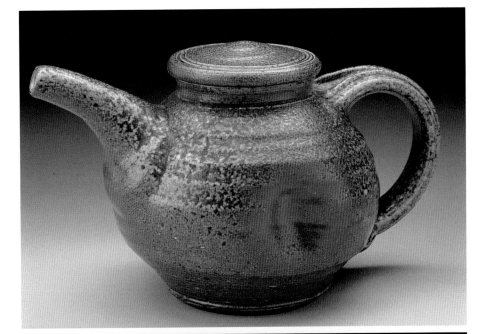

GAY SMITH

Faceted Teapot, 2000

6 x 6 x 6 in. (15.2 x 15.2 x 15.2 cm)

Wheel-thrown and altered; raw glazed; single-fire cone 10 soda

People say that my teapots look like they belong at a Mad Hatter's tea party. I imagine my pots playing around in the pottery during my absence and quickly arranging themselves innocently into stillness upon my return, as if I wouldn't notice.

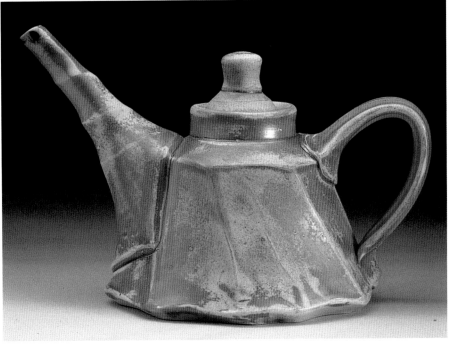

- **CONNOR BURNS**
- *Teapot*, 2000
- 4 x 7 x 3 ½ in. (10.2 x 17.8 x 8.9 cm)
- Wheel-thrown and altered components, assembled with slab components; ash glaze; single-fire cone 10 reduction
- Photo by Al Surratt

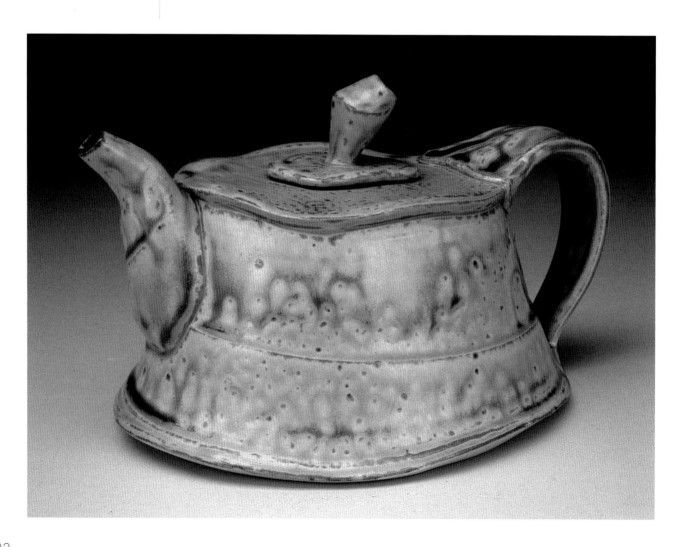

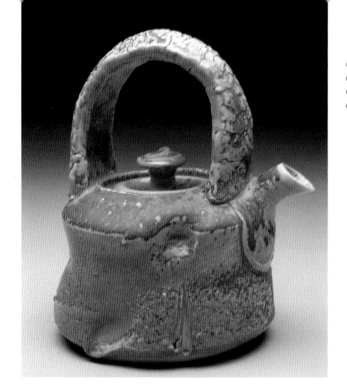

BEN KRUPKA
Teapot, 2001
8 x 5 ½ x 6 ½ in. (20.3 x 14 x 16.5 cm)
Wheel-thrown porcelain; cone 10 wood

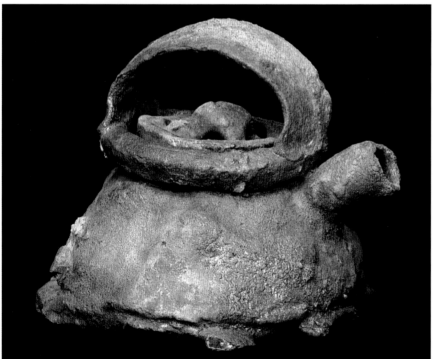

CHUCK HINDES
Wood-Fired Teapot, 2001
11 ½ x 10 x 11 ¾ in. (29.2 x 25.4 x 29.8 cm)
Hand-built unglazed stoneware; natural wood
ash cone 11, fired three times
Photo by artist

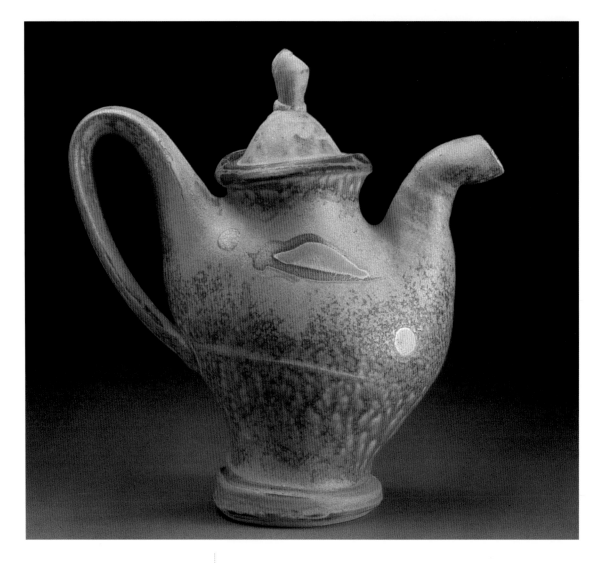

● **NICK JOERLING**
● *Untitled*, 2000
● 14 x 8 ½ x 3 in. (35.6 x 21.6 x 7.6 cm)
● Wheel-thrown and altered stoneware; wax
 resist over shino glaze; cone 10
● Photo by Tom Mills

● **GERBI TSESARSKAIA**
● *Shino I*, 2001
● 5 x 7 ½ x 5 in. (12.7 x 19 x 12.7 cm)
● Wheel-thrown and altered porcelain;
 bisque cone 06; gas cone 10 reduction
● Photo by artist

The teapot is the most intense and, at the same time, the most comforting clay form. It consists of several separately made parts which I try to unite in a harmonious whole.

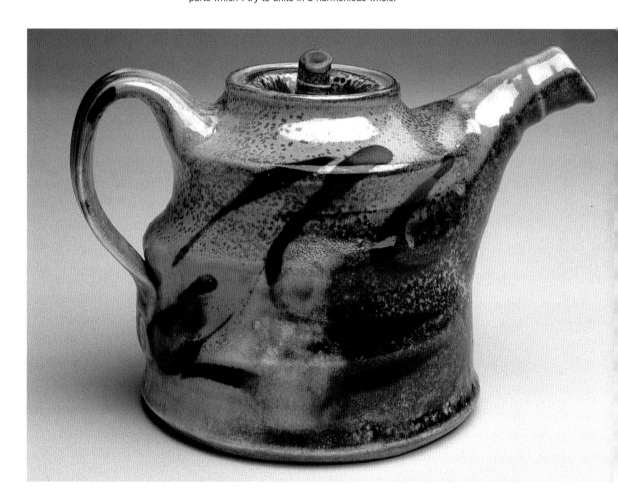

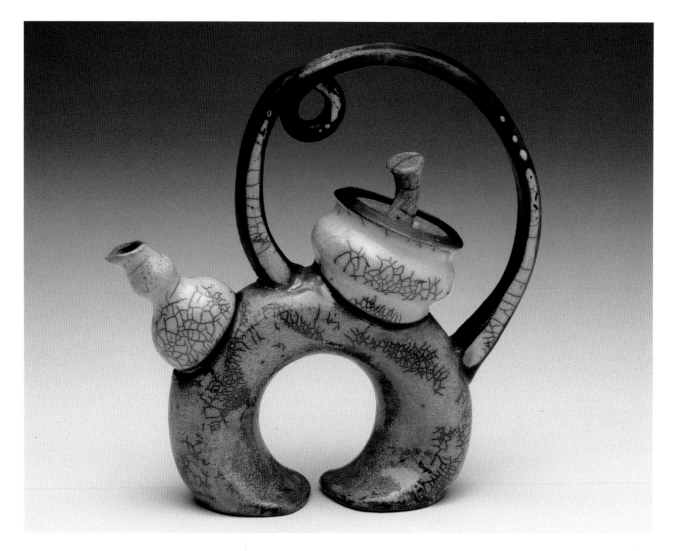

● **SHARI SIKORA**
● *Half-Moon Teapot*, 2001
● 11 x 9 x 4 in. (27.9 x 22.9 x 10.2 cm)
● Wheel-thrown and altered; bisque cone 06; raku
● Photo by John Carlano

● **PAUL DRESANG**
● *Untitled*, 2000
● 18 x 15 ½ x 14 in. (45.7 x 39.4 x 35.6 cm)
● Altered, wheel-thrown, and hand-built
 porcelain; glazes and lusters; cone 10
 residual salt fired; masked and sandblasted
● Photo by Joseph Gruber

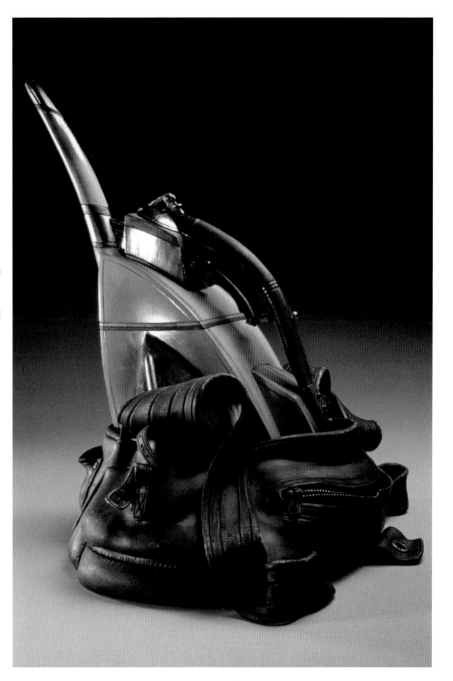

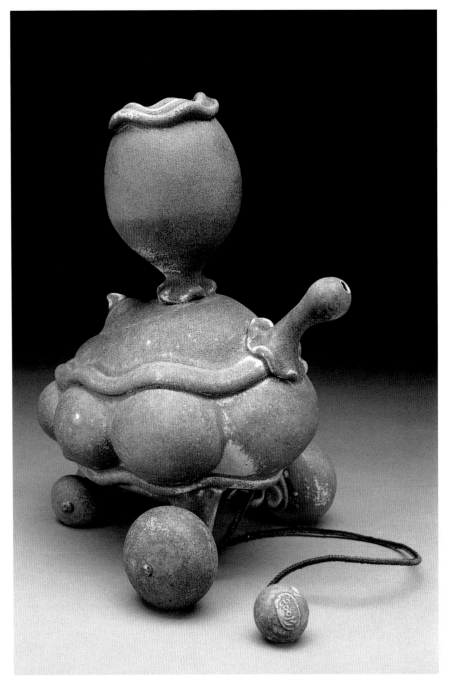

ROBERT "BOOMER" MOORE

Toy Tea, 2001

12 x 6 x 8 in. (30.5 x 15.2 x 20.3 cm)

Assembled, wheel-thrown and altered parts; multiple sprayed layers of high-fire copper-bearing glazes; bisque cone 08; glaze cone 10 gas reduction; sandblasted

● **VICTOR SPINSKI**
● *Red Teapot*, 2001
● 17 x 16 x 14 in. (43.2 x 40.6 x 35.6 cm)
● Slab-built and slip-cast; bisque-carved with
dental tools; glaze cone 06; luster cone 017

My teapot is made in the *trompe l' oeil* ("fool the eye") style. I try to imply that
the object is made of unlikely material and glazed in an unconventional way.

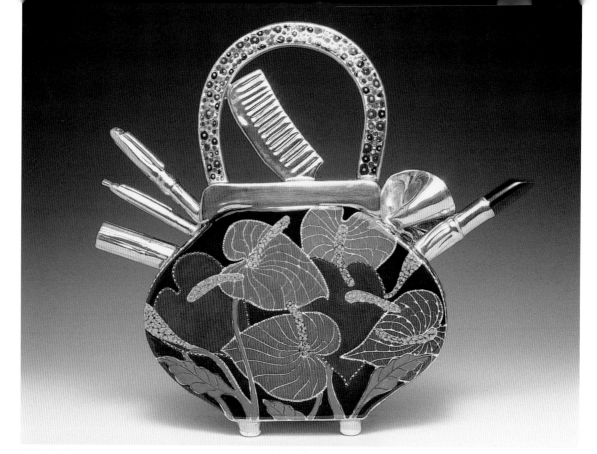

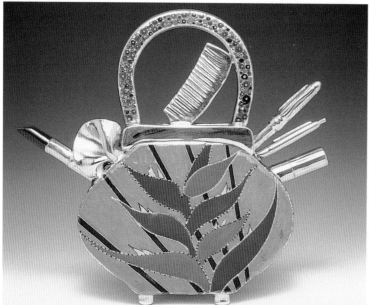

● **JOAN TAKAYAMA-OGAWA**
● *Anthurium Tea Bag*, 2001
● 12 x 13 x 4 in. (30.5 x 33 x 10.2 cm)
● Hand-built whiteware; low-fire glazes, gold lusters, gold beads; bisque cone 08; glaze cone 04; lusters/china paint fired three times at cone 019
● Photo by Steven Ogawa

The Tea Bags series explores social issues of beauty, privacy, femininity, seduction, hidden and exposed luxury, social status, and social values. The contents of the "Tea Bag" easily become spouts and handles, and tell us the personality of the female character that I imagined to be associated with this bag.

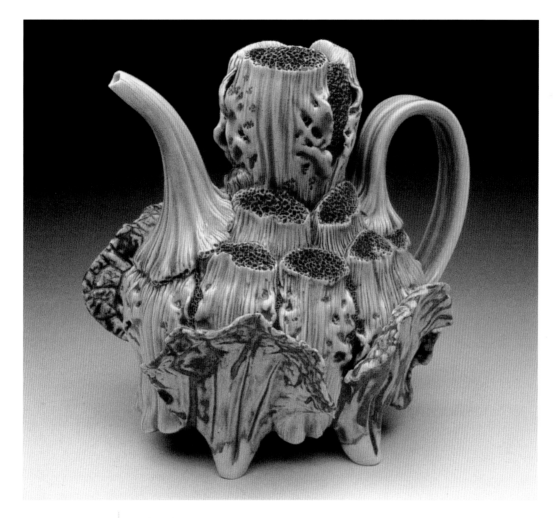

- **BONNIE SEEMAN**
- *Untitled*, 2001
- 5 x 3 ½ x 6 in. (12.7 x 8.9 x 15.2 cm)
- Wheel-thrown, altered, and hand-built porcelain; drawn and carved surface texture; bisque cone 06; glaze cone 10 oxidation
- Photo by artist

The designs of my teapots are influenced by European porcelains and Yixing teapots from China. The subject matter of my work is heavily influenced by my environment. I use plants, sea forms, and human anatomy to talk about life, disease, and the struggle for survival.

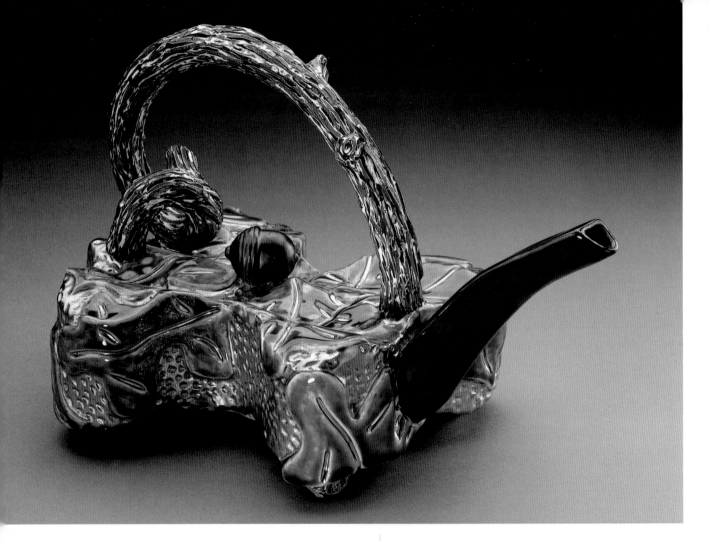

CAROL GOUTHRO
Teapot Gold/Oak Leaf, 1998
8 ½ x 13 x 7 in. (21.6 x 33 x 17.8 cm)
Slip-cast body; hand-built handle and spout; low-fire
glazes with lusters; bisque 04; glaze 05, luster 022
Photo by Roger Schreiber

I am interested in combining complicated forms with elaborately
embellished surfaces. Color is a very strong element in my work.

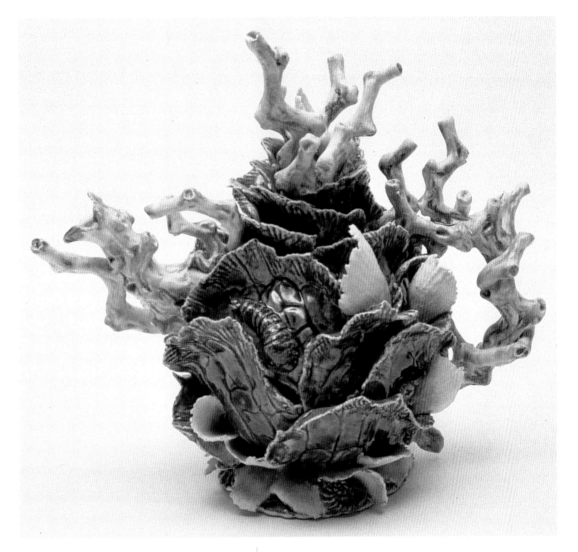

JANET KORAKAS
Grub Teapot, 2000
9 ¾ x 9 ¾ x 6 ¾ in. (25 x 25 x 17 cm)
Coiled, press-molded, and hand-sculpted stoneware;
bisque cone 06; glaze cone 8

This robust teapot is inspired by Australian Arts and Crafts pottery of the early 20th century. The fat grubs and snails adorning the body could offer a tasty treat to a bird or reptile foraging through the lush foliage.

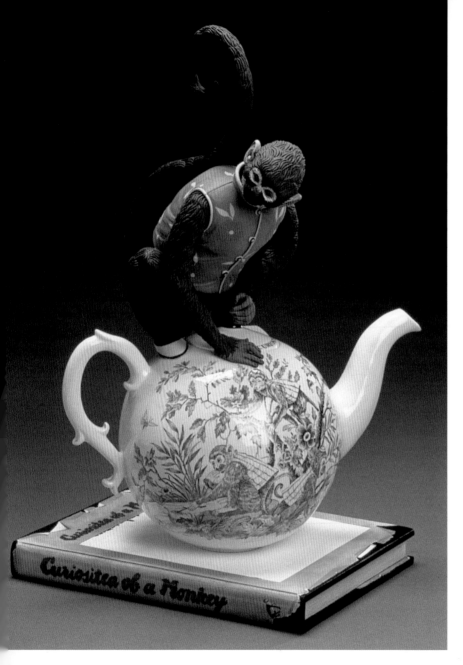

RED WELDON SANDLIN
Curositea of a Monkey, 2001
10 ½ x 5 ½ x 11 ¼ in. (26.7 x 14 x 28.6 cm)
Slab- and coil-built; wood and acrylic base; underglaze and black engobe; bisque cone 04; underglaze and glaze cone 06
Photo by Charlie Akers

I'm a Southerner, so it's only natural that I've become a visual storyteller using the medium of tea and teapots. Much like a writer, I interpret each book using character, illustration, and a plot with a twist.

KATHRYN MCBRIDE

A Clean Getaway, 2001

10 ¼ x 9 ¾ x 6 ½ in. (26 x 23.5 x 16.5 cm)

Hand-built (pinch, coil, and slab) porcelain; engobe and underglaze; bisque cone 06; glaze cone 8 oxidation

Photo by Tony Grant

VIPOO SRIVILASA
Mermaid's Pet Teapot No. 1, 1999
4 x 2 ¼ x 4 ¼ in. (10 x 6 x 11 cm)
Hand-built paper clay; layered low-fire glazes over hand-textured surfaces and decorated with diamonds; bisque 1000 °C; glaze 1120 °C
Photo by Michael Kluvanek

The shapes, colors, and texture of unique Australian rocks, shells, and marine life are extremely captivating, and they are represented in this little teapot.

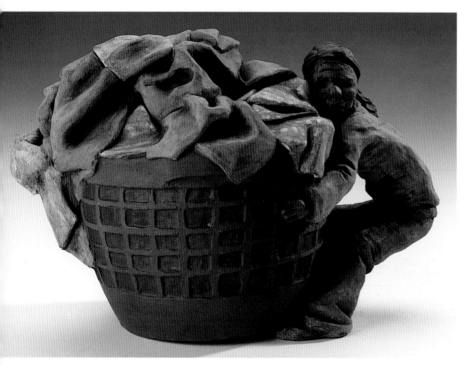

MARLENE FERRELL PARILLO
Working Mom's Teapot, 2001
8 x 8 x 10 in. (20.3 x 20.3 x 25.4 cm)
Wheel-thrown and sculpted mid-fire clay; Mason stains; glazed interior; glaze cone 6
Photo by Howard Goodman

MARIE E.V.B. GIBBONS
The Crane and I, 2001
15 x 12 x 6 ½ in. (38.1 x 30.5 x 16.5 cm)
Hand-built slabs and repoussé; cone 04 electric; cold finishes of acrylic paints, colored pencil, and sealant
Photo by John Bonath/Maddog Studio

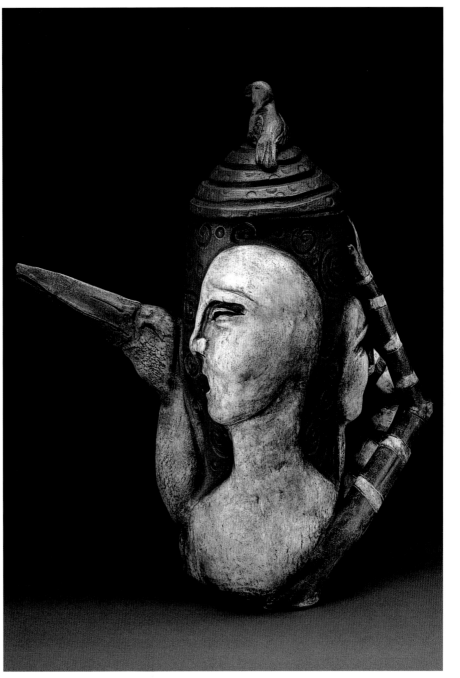

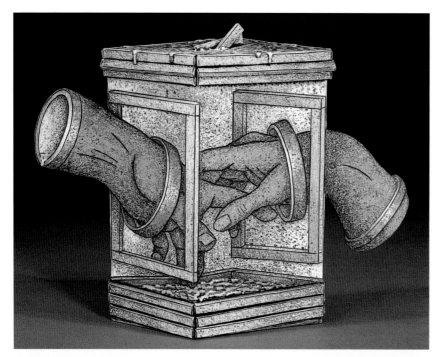

LOUIS MARAK
Touched Teapot, 2001
14 x 18 x 4 ½ in. (35.6 x 45.7 x 11.4 cm)
Hand-built earthenware; low-fire glaze and underglaze

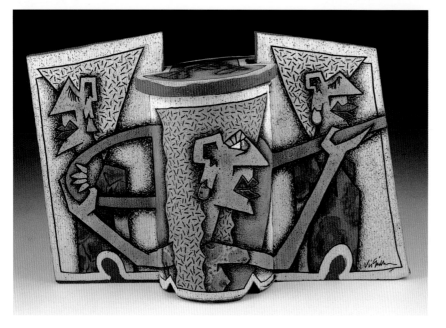

RIMAS VISGIRDA
"6 gals on a teapot", 1993
11 x 15 x 6 in. (27.9 x 38.1 x 15.2 cm)
Extruded and slab stoneware/earthenware mix; bisque cone 010; white engobe with black line wax inlay; cone 10; underglaze pencil, and glaze cone 05; lusters and china paints cone 018
Photo by artist

This series was about expanding the drawing surface. A hole through the thick slab functions as a spout.

- **MARDI WOOD**
- *"Asmara" Teapot*, 1999
- 9 ½ x 9 ½ x 4 in. (24.1 x 24.1 x 10.2 cm)
- Porcelain slab construction; relief from drawing; ceramic chalks; semi-matte translucent glaze; cone 11
- Photo by Richard Allen

My inspiration comes from the animals I draw. I plan my teapot with the animal in mind. I draw horses and cattle during time spent each year in Italy, going to the ancient sites, the ruins, where these animals are pastured.

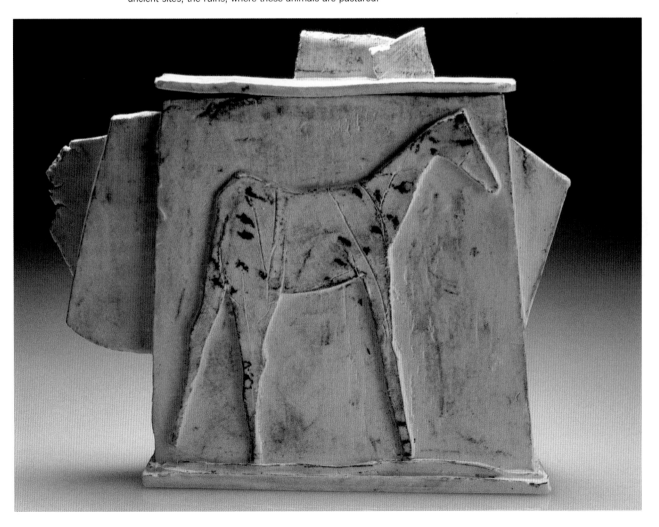

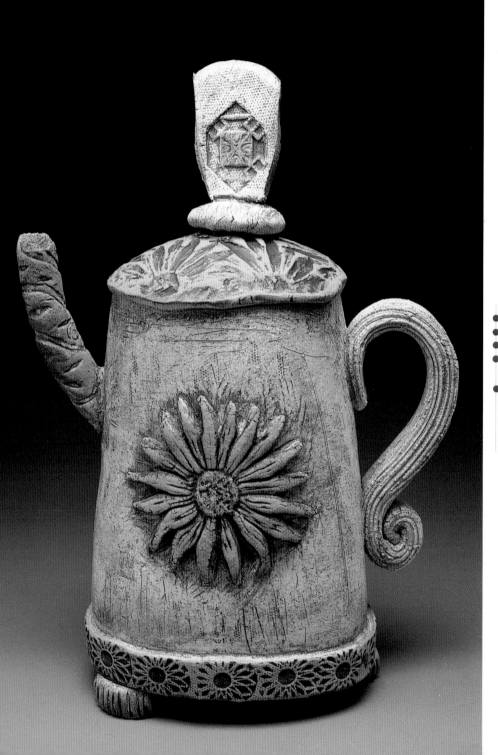

● **SHAY AMBER**
● *Floralis*, 2000
● 12 x 3 x 5 in. (30.5 x 7.6 x 12.7 cm)
● Slab and coil construction; oxide and underglaze washes; glaze cone 04
● Photo by Neil Picket

UNA MJURKA

Garden Vegetable Pot #1, 2001

13 ½ x 10 x 3 in. (34.3 x 25.4 x 7.6 cm)

Hand-built, low-fire clay; layered engobes with oxide and glaze washes; multiple firings cone 06–04 range

Photo by artist

Recently I have focused my attention on creating a series of complex still lives consisting of many objects. These pieces are directly influenced by 17th-century Dutch paintings. As a part of the exploration of different forms found in nature, I occasionally incorporate them in more simplified and laconic objects, such as teapots. These non-functional teapots usually have simple bodies with intricate, softly textured attachments in the shape of vegetables or fruit.

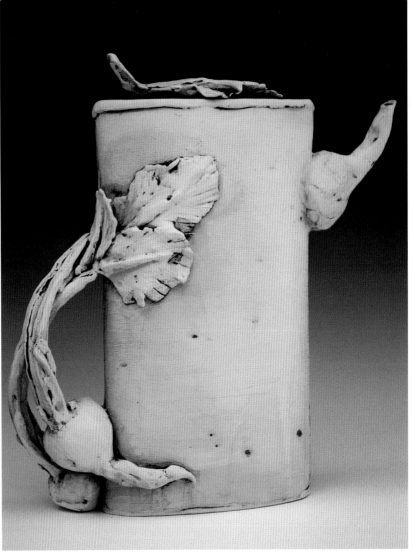

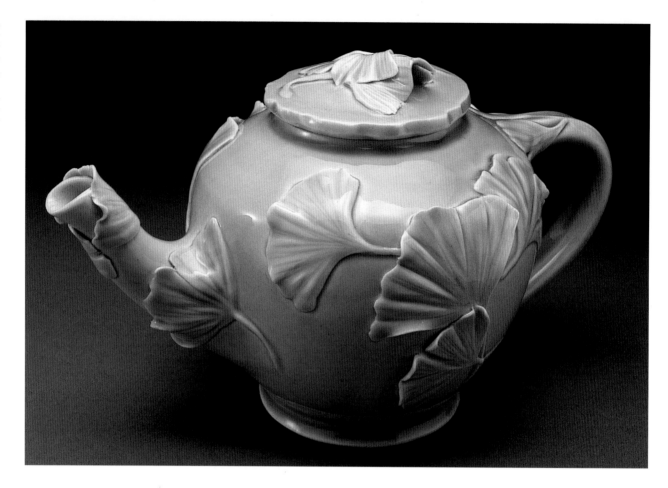

MARY-HELEN HORNE
Gingko Teapot, 2001
6 x 9 x 5 in. (15.2 x 22.9 x 12.7 cm)
Wheel-thrown porcelain; decoration modelled and attached when leather-hard; bisque cone 04; glaze cone 6 electric
Photo by Bart Kasten

In using a beautiful, handcrafted piece, I believe that the user conducts a daily conversation with its maker.

KATRINA CHAYTOR
"High Tea" Pot with Trivet, 2001
12 x 7 x 5 in. (30.5 x 17.8 x 12.7 cm) teapot
12 x 7 in. (30.5 x 17.8 cm) trivet
Hand-built with slabs, press-molded decoration, and sprigging; mid-range white clay body; glazes cone 6

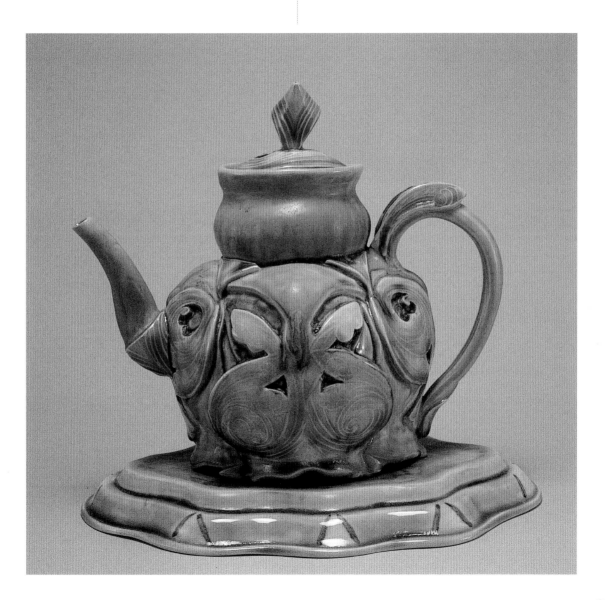

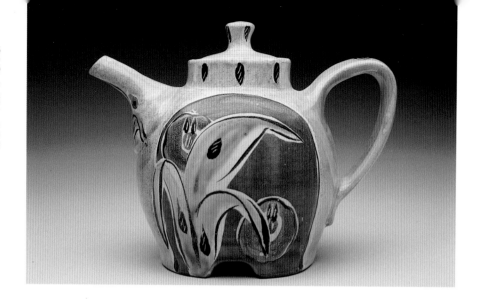

● **POSEY BACOPOULOS**
● *Oval Teapot*, 2001
● 7 ½ x 8 ½ x 5 ½ in. (19 x 21.6 x 14 cm)
● Wheel-thrown, altered, and assembled; majolica
 on terra cotta; bisque cone 06; glaze 04
● Photo by Kevin Noble

● **JO FORSYTH**
● *Festival*, 2001
● 12 x 6 x 6¾ in. (30 x 15 x 17 cm)
● Slip-cast white earthenware; resist decoration;
 bisque cone 06; glaze cone 02
● Photo by artist

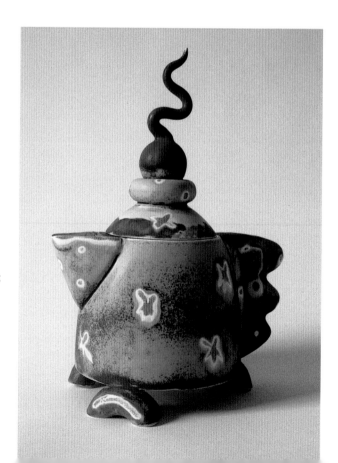

LORI MILLS

Teapot with Nested Hummingbird, 2001

12 x 14 x 4 ½ in. (30.5 x 35.6 x 11.4 cm)

Wheel-thrown and altered; low-fire slips and glazes;
bisque cone 05; glaze cone 06

My work combines the visual and tactile language of pottery with childhood recollections of secret garden environments.

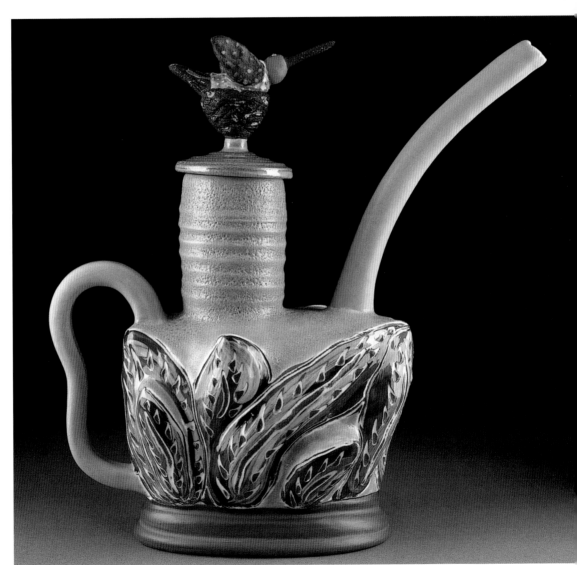

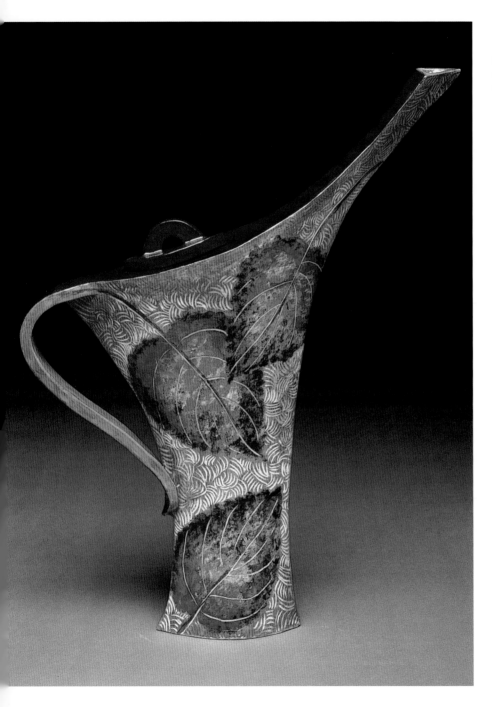

● **SUSAN FARRAR PARRISH**
● *Tea in the Garden III*, 2001
● Slab-built; painted with underglazes
 while leather-hard; carved; clear
 glaze; cone 6

I want my pots to reflect human forms
and to have a certain humor or attitude.
The interaction between the shapes of
the pots and the shapes and colors of
the decoration, which come from
nature, is very intriguing to me.

NANCY Y. ADAMS

Sweet Georgia Peach Tea, 2000

8 x 10 x 5 in. (20.3 x 25.4 x 12.7 cm)

Wheel-thrown earthenware; hand-carved and hand-modeled flora and fauna motifs; airbrushed low-fire glazes; cone 06

Photo by Hap Sakwa

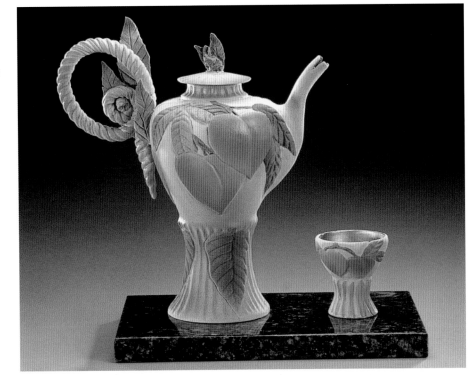

CONNOR BURNS

Tea for One, 2000

7 x 15 x 9 ½ in. (17.8 x 38.1 x 24.1 cm)

Wheel-thrown and altered components, assembled with slab components; white stoneware; single-fired cone 10 reduction

Photo by Al Surratt

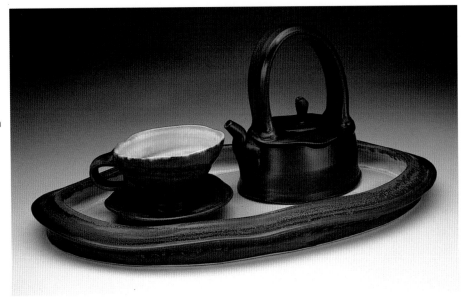

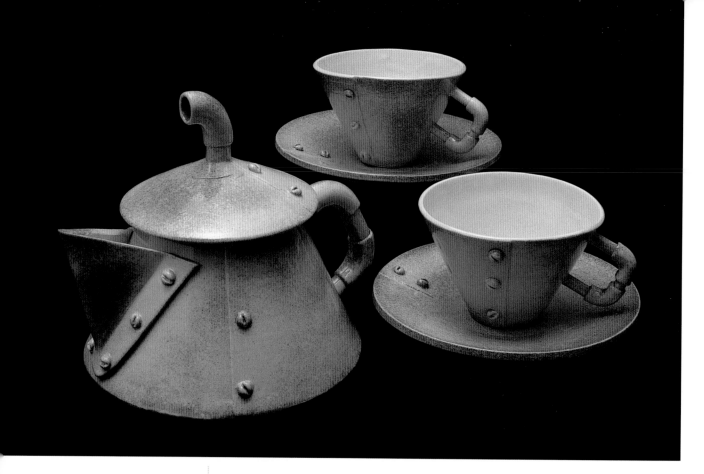

- **LARRY NELSON**
- *Tin Man Tea Set*, 2000
- 5 ½ x 6 x 7 in. (14 x 15.2 x 17.8 cm)
- Wheel-thrown, extruded, and slab-built porcelain; glaze cone 6 oxidation
- Photo by Loren Nelson

I try to contradict the malleable nature of clay—and its natural inclination towards elegant, organic shapes—with a hard, mechanic, tinsmith-created design. This incorporates lapped and "screwed-together" seams and pipe joint handles, combined with an uneven glaze, to create what might be an enameled tea set for the tinsmith's wife.

JOHN GOODHEART

Teapot for Virgin's Milk, 2001

14 x 8 x 6 in. (35.6 x 20.3 x 15.2 cm)

Wheel-thrown and press-molded low-fire whiteware with metal lid, wall mount; bisque cone 04; glaze cone 05

Photo by Kevin Montague and Michael Cavanaugh

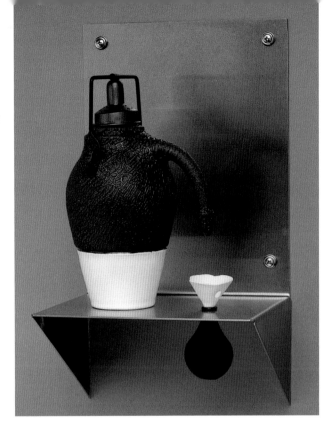

JONATHAN KAPLAN

Step Teapot with Cups 'n Saucers, 1999

10 x 9 in. (25.4 x 22.9 cm)

Slip-cast terra cotta; glaze, underglaze, and non-fired pigments; cone 4

Photo by David C. Holloway

My current work deals with geometric forms and assembled slip-cast components, airbrushed with multi-layered underglazes and glaze and using a variety of non-fired decorative pigments, such as gold leaf, Craypas, and paints.

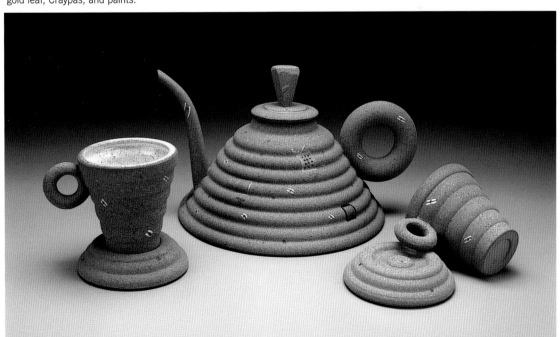

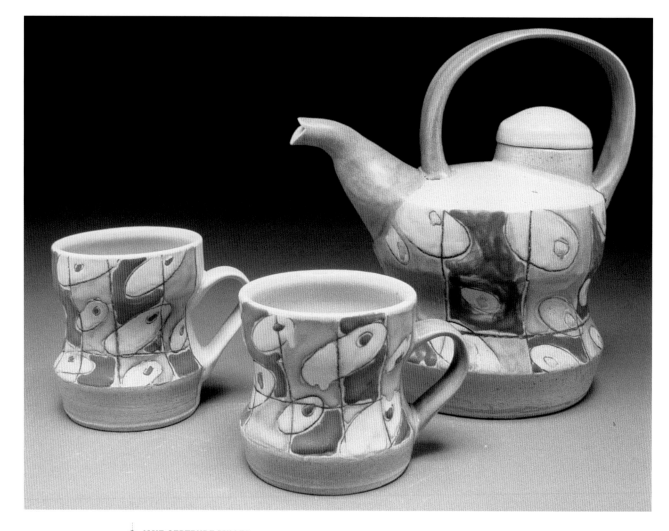

JANE GERTRUDE MILLER

Teapot Set, 1999

9 ½ x 12 ½ x 7 in. (24.1 x 31.7 x 17.8 cm)

Wheel-thrown and hand-built porcelain;
glaze, soda glaze, and glaze pencil; cone
10 reduction soda

Photo by artist

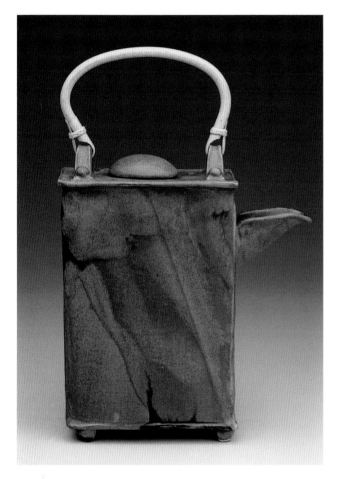

- **JEANETTE HARRIS**
- *Malachite Tea*, 1999
- 14 x 7 x 3 in. (35.6 x 17.8 x 7.6 cm)
- Slab-built stoneware teapot; cone 6 oxidation; copper/rutile glaze; cane handle
- Photo by Tom Holt

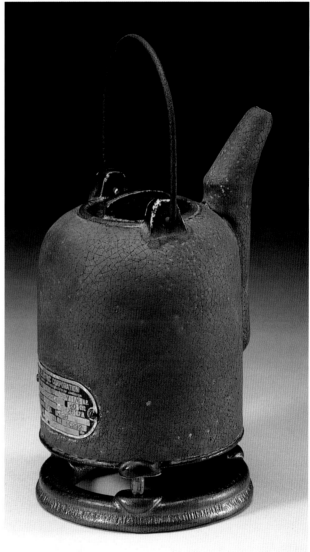

- **TED NEAL**
- *Teapot with Elevated Base*, 2000
- 10 x 6 x 6 in. (25.4 x 15.2 x 15.2 cm)
- Wheel-thrown stoneware; sandblasted; found objects and steel wire; soda fired
- Photo by Jeff Bruce

311

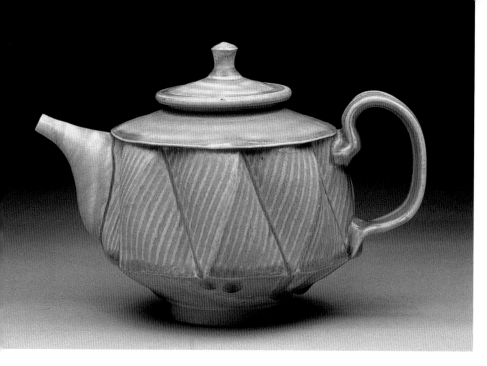

● **STEVEN ROBERTS**
● *Teapot*, 2000
● 5 ½ x 8 x 5 in. (14 x 20.3 x 12.7 cm)
● Thrown and altered porcelain; cone 10; soda fired

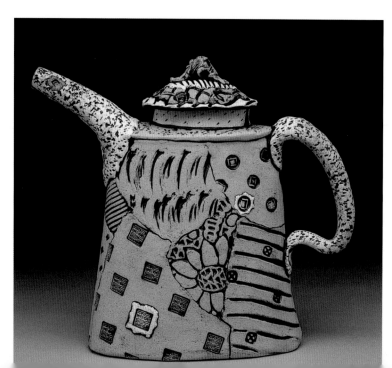

● **ELAINE PINKERNELL**
● *Ripped Up Teapot*, 1998
● 9 x 10 x 3 in. (22.9 x 25.4 x 7.6 cm)
● Slab-built stoneware; torn apart, textured, and reassembled; bisque cone 06; glaze cone 10
● Photo by George Post

I treat the clay as if it were fabric used in a quilt. Each piece begins as soft slabs of two different colors of clay which are torn apart and reassembled into a single sheet of clay. This sheet is used to create a boldly geometric shape made playful by its richly dressed-up surface. A dark glaze is sponged on, to highlight every rip and texture.

- **MEGAN LEIGH MULLINS**
- *Woodfired Teapot*, 2001
- 8 ½ x 7 x 4 in. (21.6 x 17.8 x 10.2 cm)
- Slab-built porcelain; high-fire glaze over part of surface; bisque cone 08; glaze cone 10 anagama wood reduction
- Photo by artist

My work is inspired by the home and the daily and ritual activities that make up everyday experiences. I work mainly with wheel-thrown, functional vessels that deal with the issue of containment.

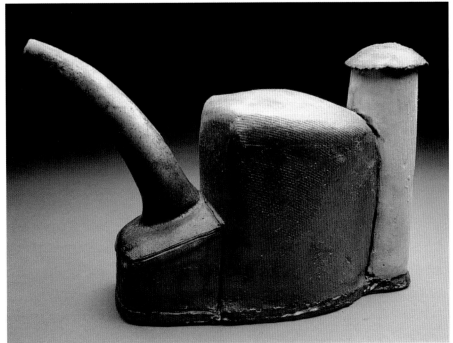

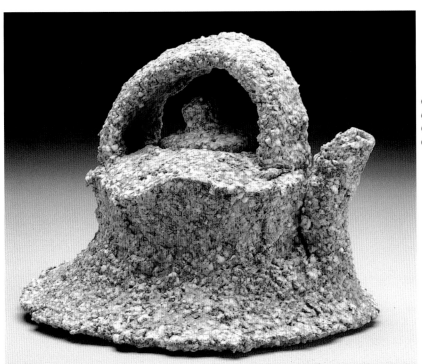

- **BEN KRUPKA**
- *Teapot*, 2001
- 7 x 6 x 9 in. (17.8 x 15.2 x 22.9 cm)
- Hand-built porcelain with feldspathic inclusions; cone 10 wood

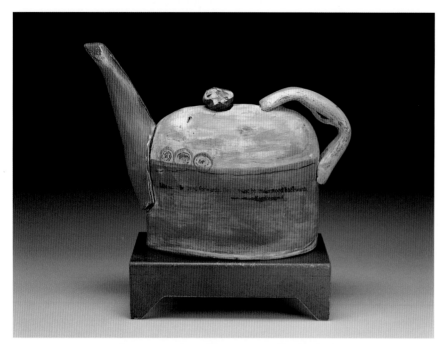

● **NANCY SELVIN**
● *Teapot #9806*, 1998
● 10 x 10 x 4 in. (25.4 x 25.4 x 10.2 cm)
● Hand-built terra cotta over foam armature; metal trivet; brushed and sponged underglaze color; silkscreened underglaze text; cone 1
● Photo by Charles Frizzell

Teapots are wonderful ceramic objects, so fun to make and pour all your ideas out onto one form.

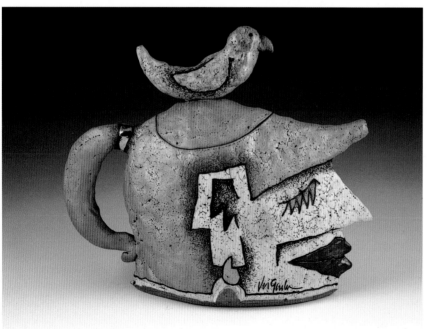

● **RIMAS VISGIRDA**
● *"Fred & Billie,"* 1996
● 9½ x 12 x 4 in. (24.1 x 30.5 x 10.2 cm)
● Coil-built stoneware; white engobe with black line wax inlay on greenware; bisque cone 010; interior glaze cone 10; underglaze pencil, black underglaze (in texture), and selected areas of exterior glaze cone 05; lusters and china paints, cone 018
● Photo by artist

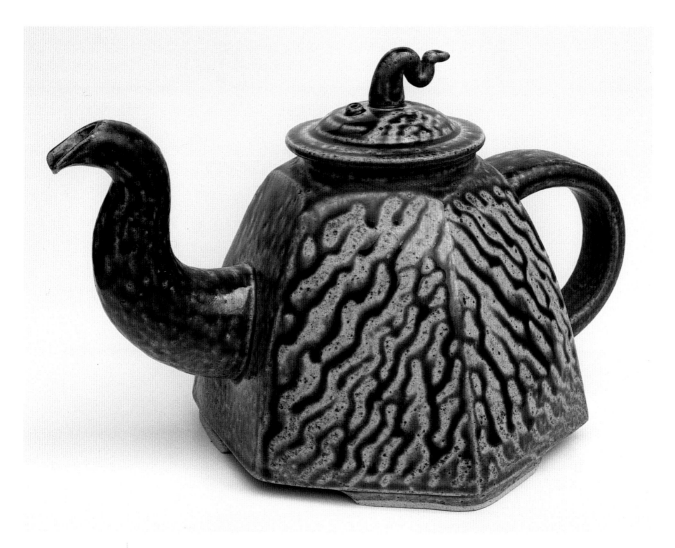

● **STEVE IRVINE**
● *Hand-Built Teapot*, 2000
● 7 x 9 ½ x 6 in. (18 x 24 x 15 cm)
● Wheel-thrown and altered; cobalt and
 wood ash glazes cone 10 reduction
● Photo by artist

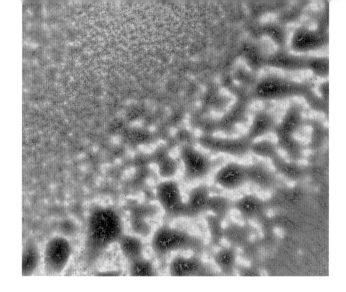

● **CAROL-ANN MICHAELSON**
● *Oval Thrown and Altered Teapot*, 1999
● 7 x 10 x 5 ½ in. (17.8 x 25.4 x 14 cm)
● Wheel-thrown and altered porcelain body; sprayed
 ash glazes; bisque cone 06; cone 8 oxidation

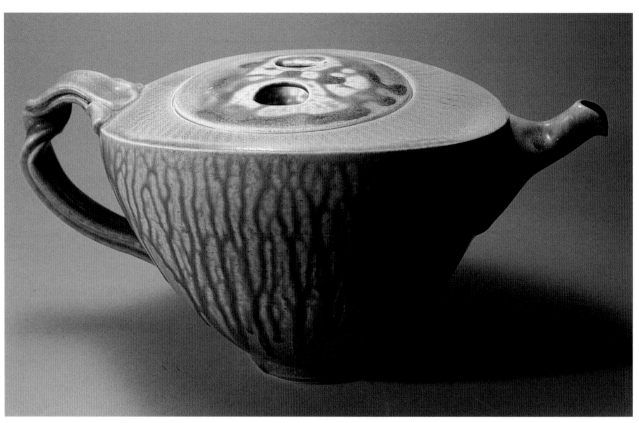

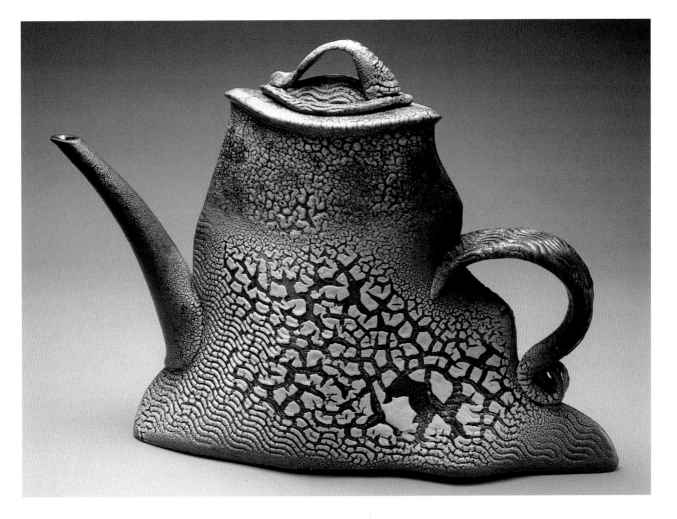

BACIA EDELMAN
Ice Floe Teapot, 1999
10 x 14 x 3 ½ in. (25.4 x 35.6 x 8.9 cm)
Slab-built stoneware; textured and underglaze painted;
bisque cone 04; sprayed lichen glaze; glaze cone 6
Photo by artist

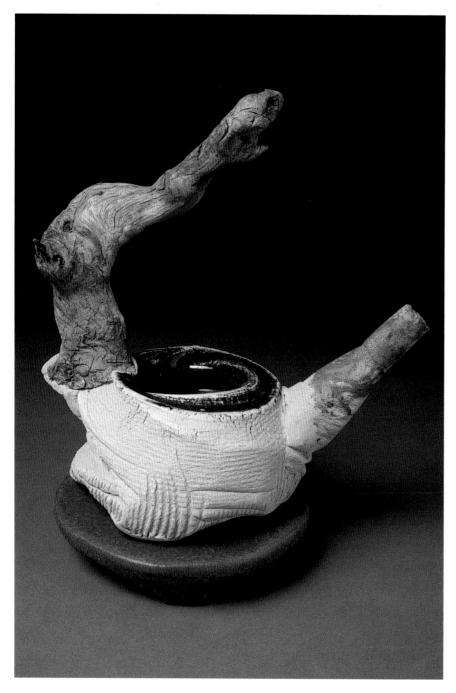

SCOTT PLACE
Teapot Form, 2001
12 x 10 x 7 in. (30.5 x 25.4 x 17.8 cm)
Wheel-thrown and altered low-fire
salt-firing body; stoneware base; cone 6

I enjoy the challenge of integrating a found object into the form of a vessel.

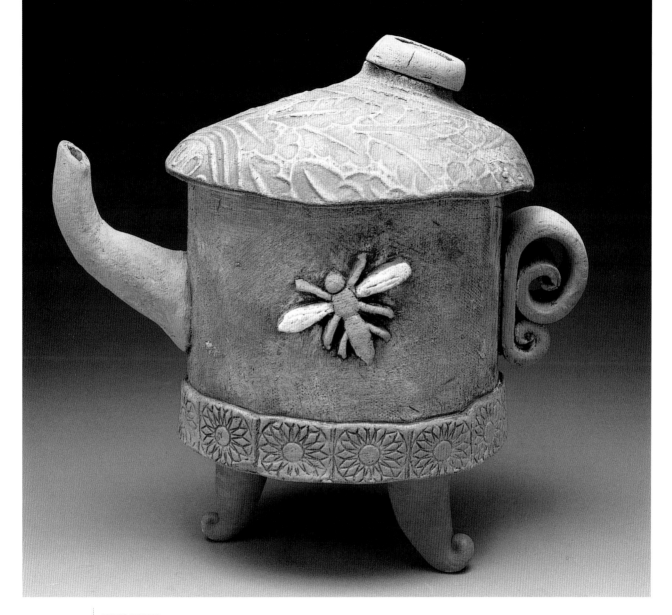

● **SHAY AMBER**
● *Vespa*, 2000
● 8 x 4 x 9 in. (20.3 x 10.2 x 20.3 cm)
● Slab and coil construction; oxide and underglaze washes; glaze cone 04
● Photo by Neil Picket

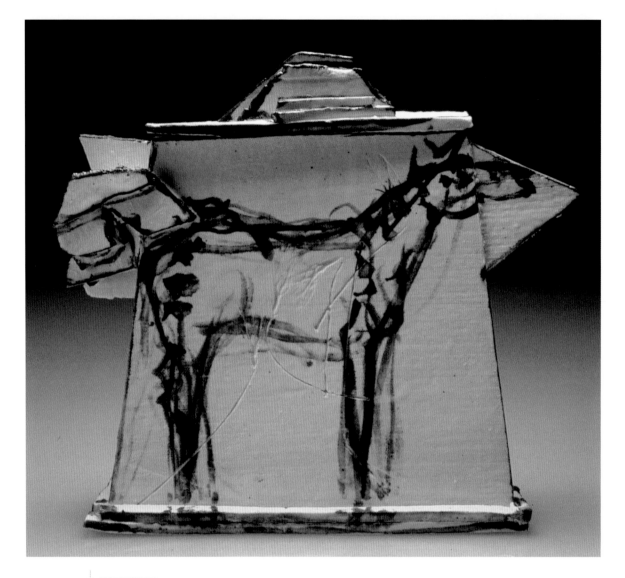

● **MARDI WOOD**
● *Flicking Tail Horse Teapot*, 1998
● 9 ½ x 9 ½ x 4 in. (24.1 x 24.1 x 10.2 cm)
● Slab porcelain construction; ceramic mineral stain drawing
 on bisque; cone 11; translucent semi-matte glaze
● Photo by Richard Allen

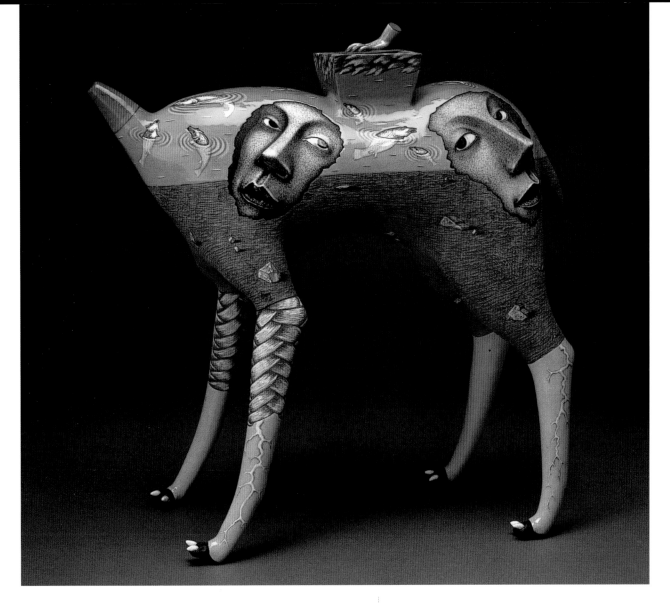

SERGEI ISUPOV
Mirage, 2000
11 ½ x 12 x 5 in. (29.2 x 30.5 x 12.7 cm)
Hand-built porcelain; Mason stains; cone 7

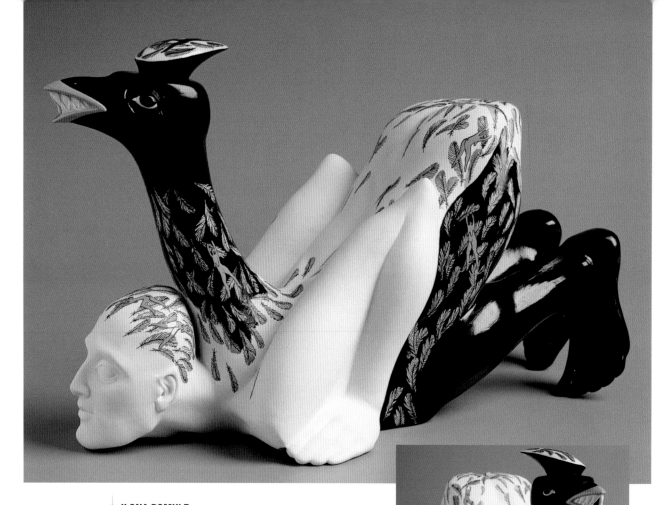

- **ILONA ROMULE**
- *Depending on Circumstances*, 2001
- 7 x 14 x 6 in. (17.8 x 35.6 x 15.2 cm)
- Slip-cast porcelain in self-made plaster molds; bisque cone 07; interior glaze cone 10; hand polished; china paint cone 08

NANCY Y. ADAMS
Bluebirds and Morning Glories Tea, 2001
8 ½ x 12 x 5 in. (21.6 x 30.5 x 12.7 cm)
Wheel-thrown earthenware with hand-carved and hand-modeled flora and fauna motifs; airbrushed low-fire glazes; cone 06

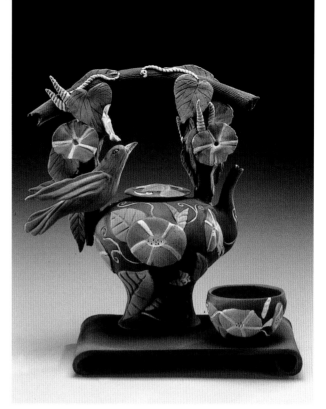

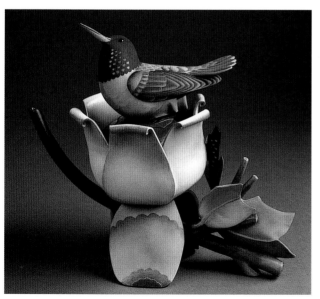

ANNETTE CORCORAN
Hummer With Blue Head, 2001
9 x 9 ½ x 5 ¼ in. (22.9 x 24.1 x 13.3 cm)
Wheel-thrown, altered, and slab-built porcelain; underglazes and overglazes; multi-fired glazes (cone 1 highest)

● **NICK WILSON**
 ELISE WILSON
● *Horse Teapot*, 2001
● 16 x 16 x 4 in. (40.6 x 40.6 x 10.2 cm)
● Slab-built stoneware; vitreous engobes; cone 5

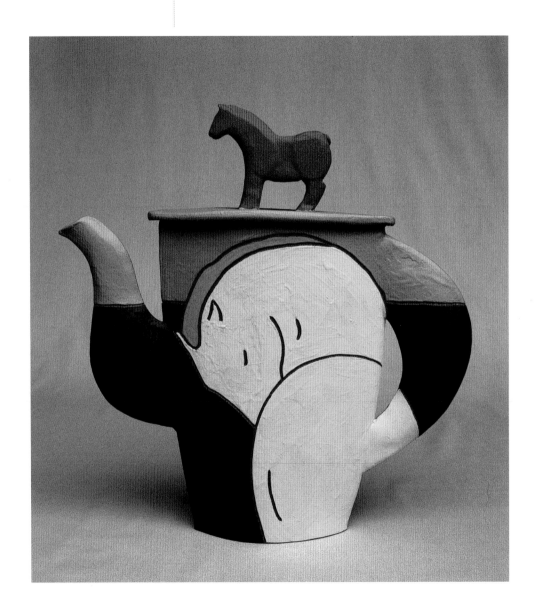

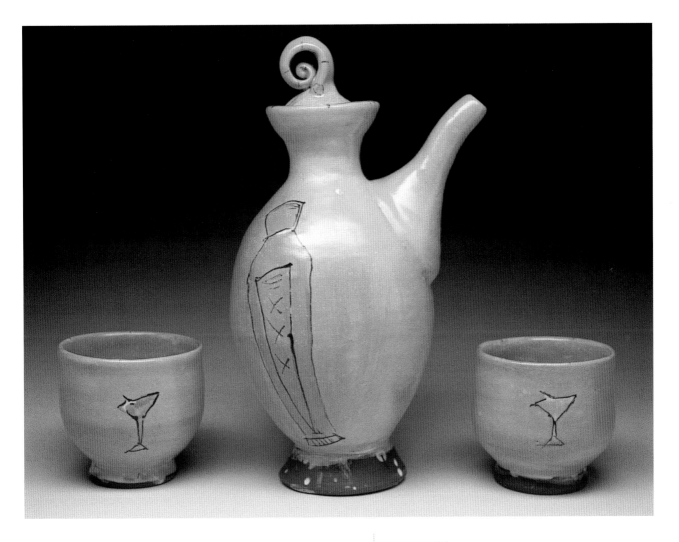

● **SCOTT LYKENS**
● *Mint Julep*, 2001
● 15 x 7 x 5 in. (38.1 x 17.8 x 12.7 cm)
● Wheel-thrown, altered, and hand-built; brush
 decorated; handcrafted personal chemistry
 glazes and overglazes; cone 02
● Photo by artist

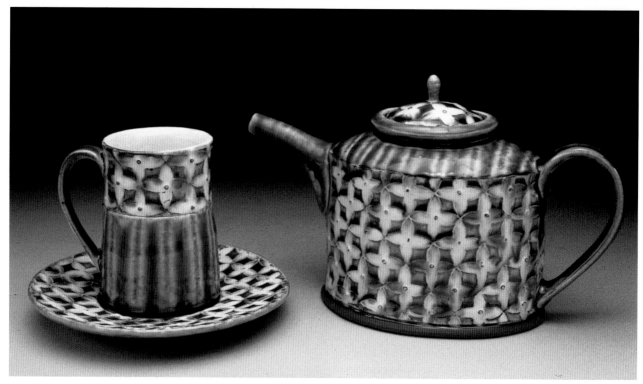

KATHRYN FINNERTY
Oval Teapot, 2001
6 ½ x 9 ½ in. (16.5 x 24.1 cm)
Slab construction with raised-line relief;
white slip over terra cotta; cone 04

The decorative wares of 19th-century English
pottery have influenced my wheel-thrown and
slab-constructed functional pottery.

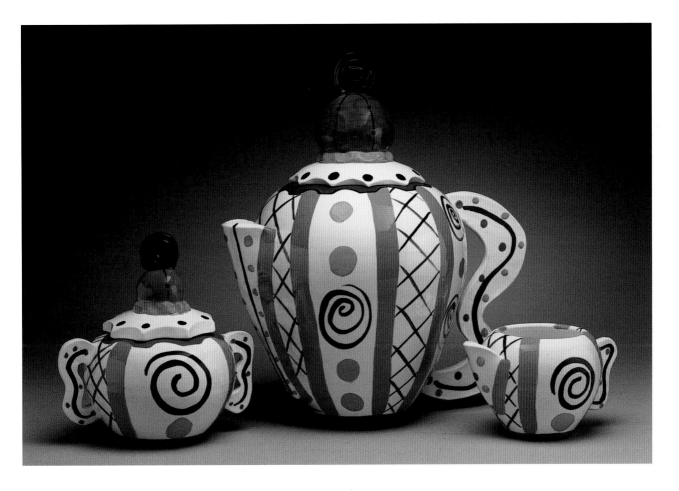

● **DORA STROTHER**
● *Funky Teapot (with Creamer and Sugar)*, 1999
● 12 ¾ x 9 ¾ x 7 in. (32.4 x 24.7 x 17.8 cm)
● Wheel-thrown earthenware with slab-built handle
 and spout; pinched and coiled handles on lids;
 low-fire underglazes and clear glaze; bisque
 cone 04; glaze cone 06
● Photo by Robert Strother

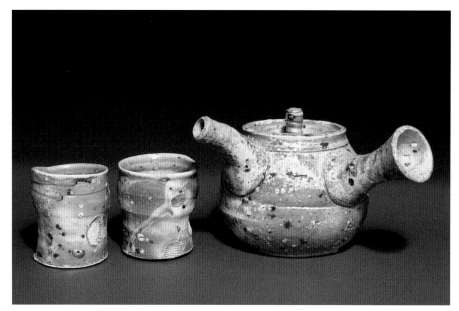

DALE HUFFMAN
Teapot with Yunomi, 2001
4 ½ x 6 x 7 in. (11.4 x 15.2 x 17.8 cm)
Wheel-thrown stoneware; natural ash glaze cone 12 wood

RAY CHEN
Tradition II, 2000
2 ½ x 5 x 4 ½ in. (6.4 x 12.7 x 11.4 cm)
Wheel-thrown; cone 10, 2280°F (1249°C) gas with strong reduction

From my traditional Chinese pottery background and serious training in the tea ceremonial, I find that making a teapot is a balanced and delicate process. The design is simple but the spirit is full of humility, to express the nature of dirt.

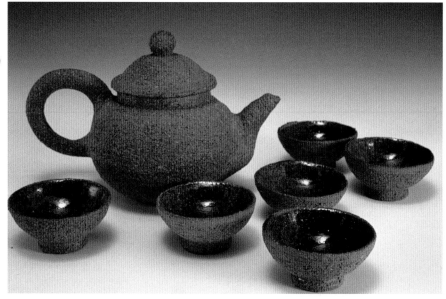

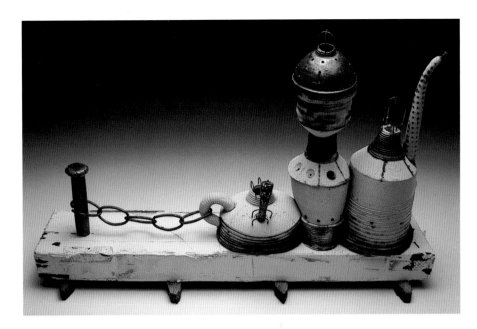

● **TODD SHANAFELT**
● *Filtered Apparatus*, 2001
● 10 x 12 x 4 in. (25.4 x 30.5 x 10.2 cm)
● Wheel-thrown altered stoneware; oxide
 and glaze; cone 3 oxidation
● Photo by artist

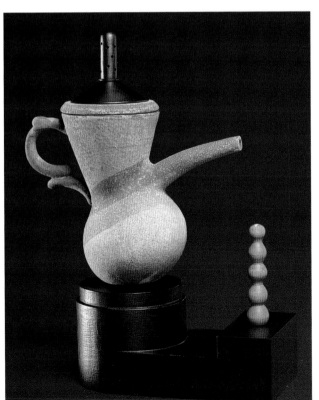

● **JOHN GOODHEART**
● *Three Sisters of Equal Rank: a teapot from the Retort Series*, 1999
● 13 x 4 x 7 in. (33 x 10.2 x 17.8 cm)
● Wheel-thrown and press-molded low-fire whiteware with metal lid,
 wood base; bisque cone 04; glaze cone 05
● Photo by Kevin Montague and Michael Cavanaugh

329

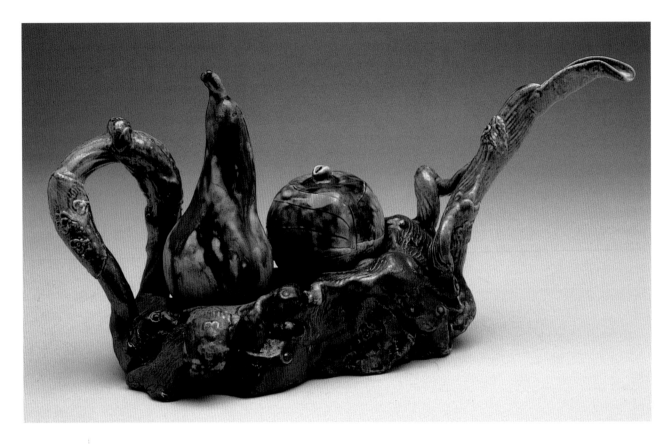

● **JOHN PARKER GLICK**
● *Fruit Teapot*, 1999
● 6 ½ x 10 x 4 in. (16.5 x 25.4 x 10.2 cm)
● Hand-built, press-molded stoneware; cone 10 soda

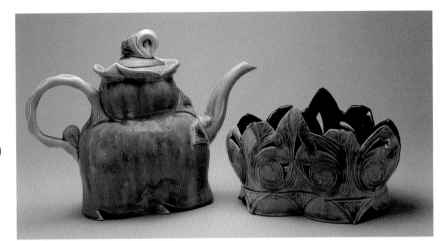

- **KATRINA CHAYTOR**
- *Nesting Pot with Cups*, 1999
- 10 x 6 x 5 in. (25.4 x 15.2 x 12.7 cm)
- Hand-built with slabs, press-molded decoration, and sprigging; mid-range white clay body; glazes cone 6

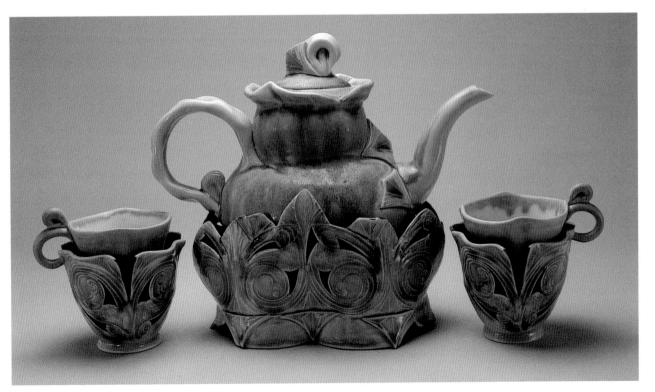

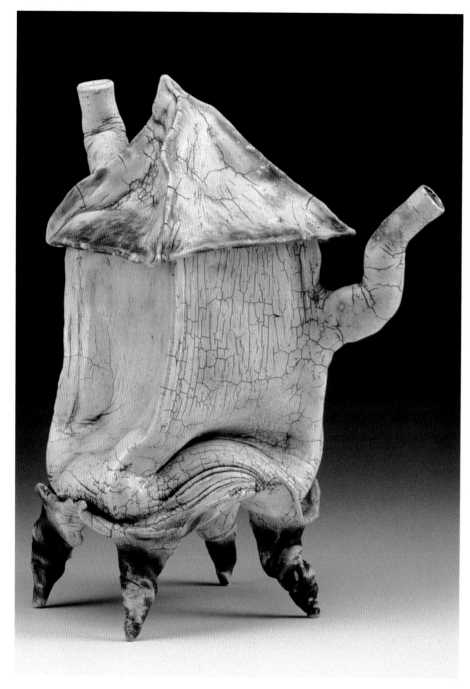

- **KATHLEEN KNEAFSEY**
- *Rusted Roof Teapot*, 2000
- 9 x 8 x 6 in. (22.9 x 20.3 x 15.2 cm)
- Wheel-thrown and altered porcelain base; slab-built lid with wheel-thrown elements; terra sigillata; bisque cone 06; saggar fired cone 04 salt
- Photo by Jeff Sabo

Houses—especially old ones—are filled with history and personality. Applying the parts of a house to the traditionally functional form of a teapot (such as a lid becoming a roof) seemed a natural way for me to express my interest in clay.

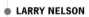 **LARRY NELSON**

Tall Tin Man Teapot #3, 2000

9 ½ x 5 ¼ x 7 ¾ in. (24.1 x 13.3 x 19.6 cm)

Wheel-thrown, extruded, and slab-built stoneware; cone 10 salt reduction

Photo by Loren Nelson

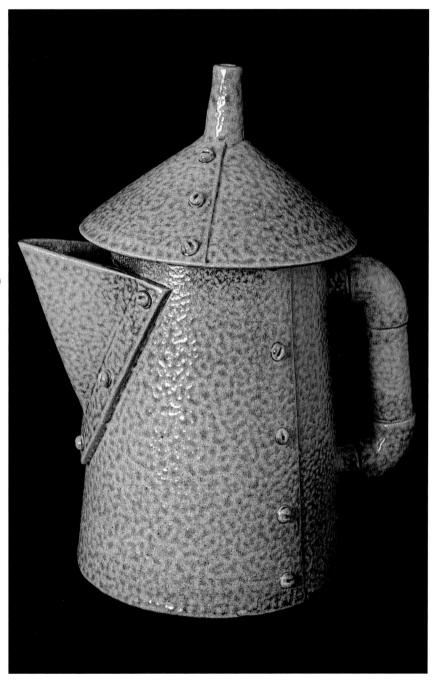

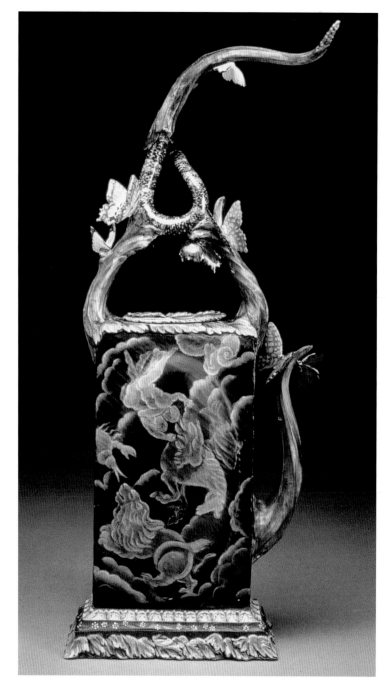

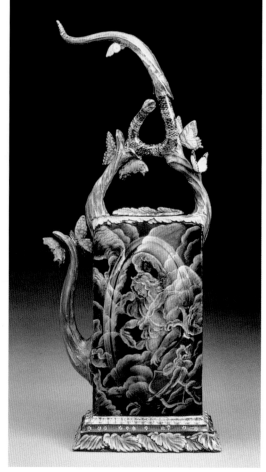

● **SUSAN THAYER**
● *Tempting Fate*, 2001
● 18 ¼ x 8 x 7 in. (46.4 x 20.3 x 17.8 cm)
● Assembled from slip-cast parts; carved;
glaze; china paints

My works are vessels; their contents, stories.

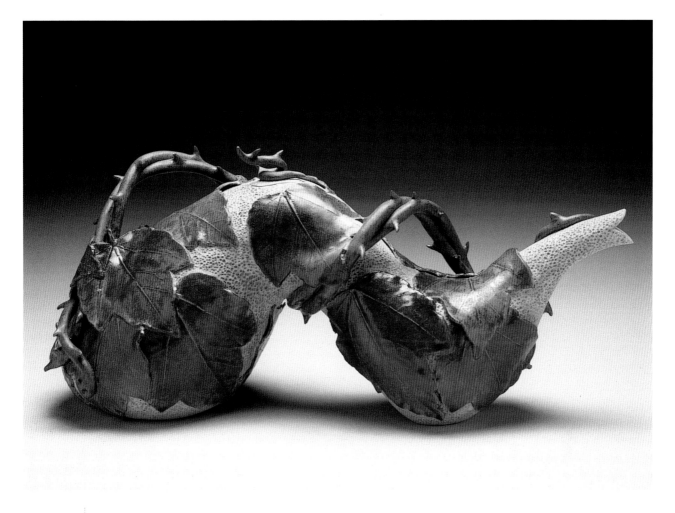

- **BETSY ROSENMILLER**
- *Teapot*, 1999
- Cast, hand-built, and assembled porcelain; carved texture; cone 5 glaze; china paint

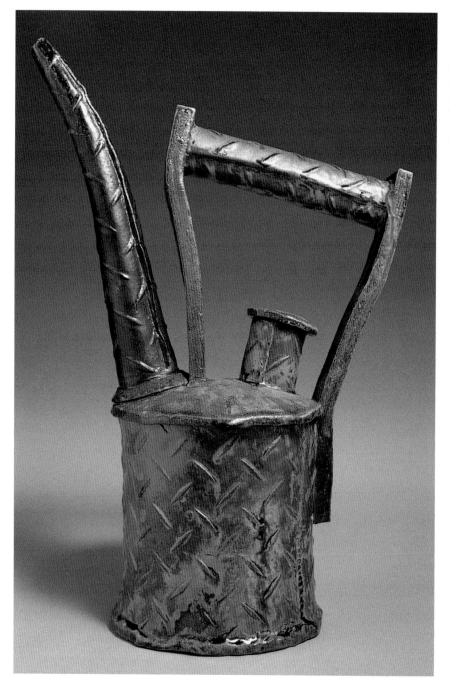

JOSEPH LYON

Teapot, 2001

16 ½ x 12 x 6 in. (41.9 x 30.5 x 15.2 cm)

Slab-built; press-molded textures; partially glazed; bisque cone 07; cone 10 wood/salt

Photo by artist

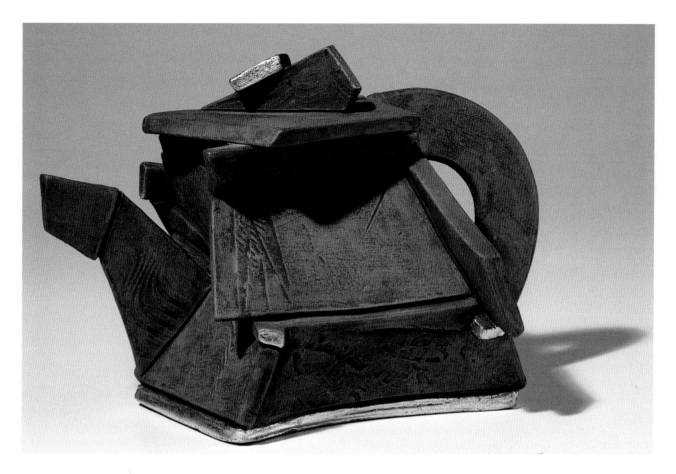

● **JENNIE BIRELINE**
● *Dozo Tea Pot*, 1998
● 5 ¾ x 9 x 5 ½ in. (13.3 x 22.9 x 14 cm)
● Earthenware slab construction; terra
 sigillata; 23k gold leaf; cone 04

● **O'BRIEN TYRRELL**
● *Capped Wedge Teapot*, 2000
● 14 ½ x 22 x 5 ½ in. (36.8 x 55.8 x 14 cm)
● Slab-built mid-range stoneware; layered glaze over surfaces
 textured by pressing into antique architectural artifacts;
 bisque cone 06; glaze cone 6 oxidation
● Photo by Peter Lee

I enjoy using turn-of-the-century images on my
contemporary teapot forms.

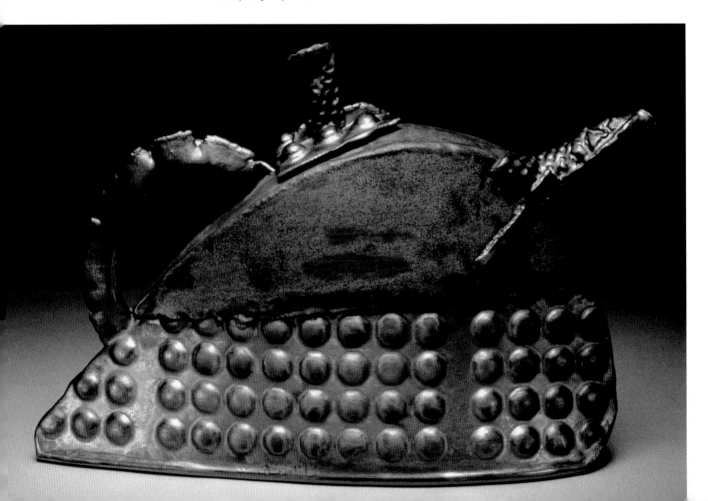

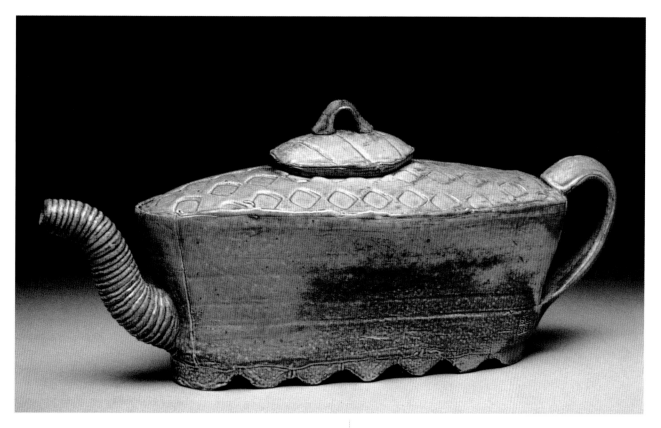

● **TERRY GESS**
● *Stretched Teapot*, 1997
● 7 x 15 x 5 in. (17.8 x 38.1 x 12.7 cm)
● Wheel-thrown and hand-built porcelain; multi-layered textures; lightly salted in atmosphere kiln; bisque cone 08; glaze cone 10
● Photo by Tom Mills. Yixing Factory #5 Collection, People's Republic of China.

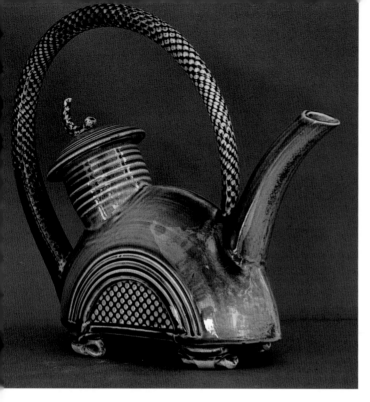

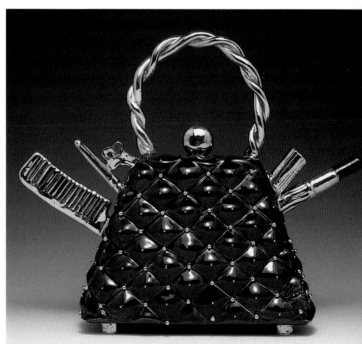

JOAN TAKAYAMA-OGAWA

Chanel Tea Bag, 2001

12 x 13 x 4 in. (30.5 x 33 x 10.2 cm)

Hand-built whiteware; low-fire glazes and gold lusters; gold beads; bisque cone 08; glaze cone 04; luster/china paint cone 019, fired three times

Photo by artist

STEPHEN C. CAPPELLI

Laid Back Low Rider Tea, 2001

8 x 10 ½ x 3 ½ in. (20.3 x 26.7 x 8.9 cm)

Wheel-thrown, cut, and assembled porcelain, with press-molded sides; hand-built feet; pulled spout and handle; amber celadon glaze cone 10 reduction

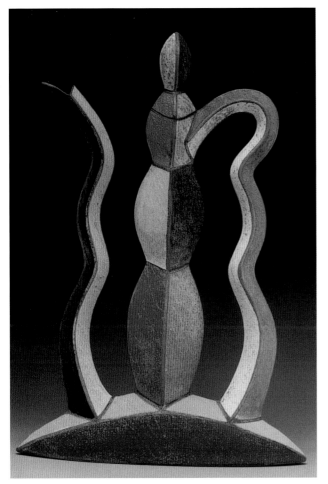

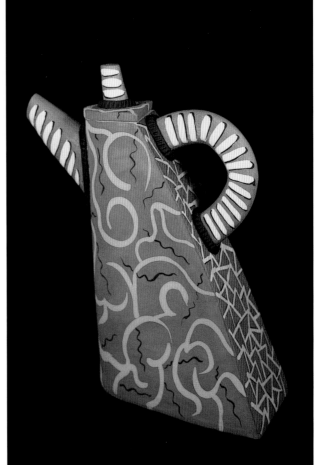

● **MICHAEL SHERRILL**
● *Incandescent Tea, 3*, 1996
● 27 x 18 x 6 in. (68.7 x 45.7 x 15.2 cm)
● Wheel-thrown, altered, and extruded white
 stoneware components; applied color to
 alkaline base; cone 06
● Photo by Tim Barnwell

This is one of my favorites; it embodies
my approach to modernism.

● **GLENDA GUION**
● *Teaparty #3*, 1996
● 12 ½ x 10 x 4 in. (31.8 x 25.4 x 10.2 cm)
● Slab-built red earthenware; underglaze cone 04

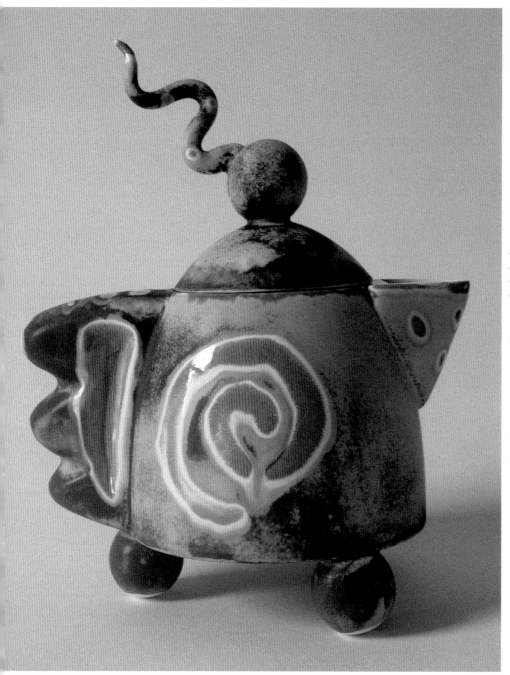

● **JO FORSYTH**
● *Jester*, 2001
● 11 ¾ x 6 x 6 ¾ in. (30 x 15 x 17 cm)
● Slip-cast white earthenware; glaze resist decoration; bisque cone 06; glaze cone 02
● Photo by artist

Inspired by the desire to animate objects, this piece is an investigation into the expression of character using simple component parts.

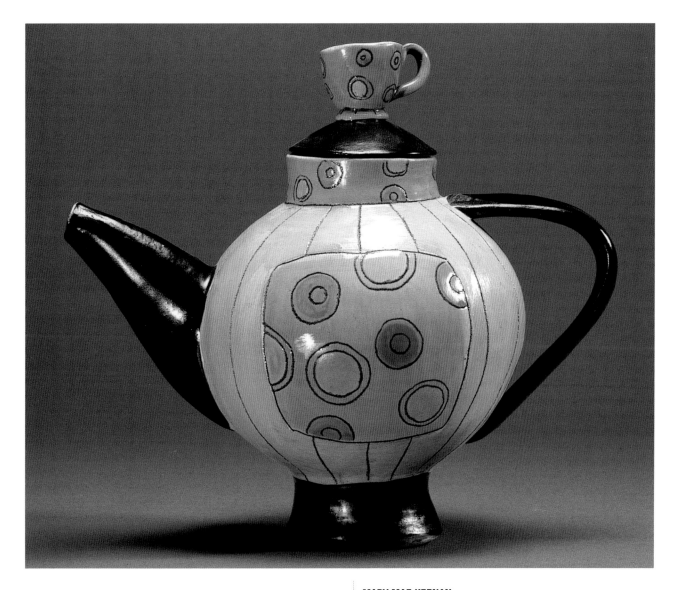

● **MARY MAE KEENAN**
● *Tea-Time*, 2001
● 8 x 6 x 5 in. (20.3 x 15.2 x 12.7 cm)
● Hand-built, low-fire earthenware; underglazes
and oxides; bisque cone 04; glaze cone 06

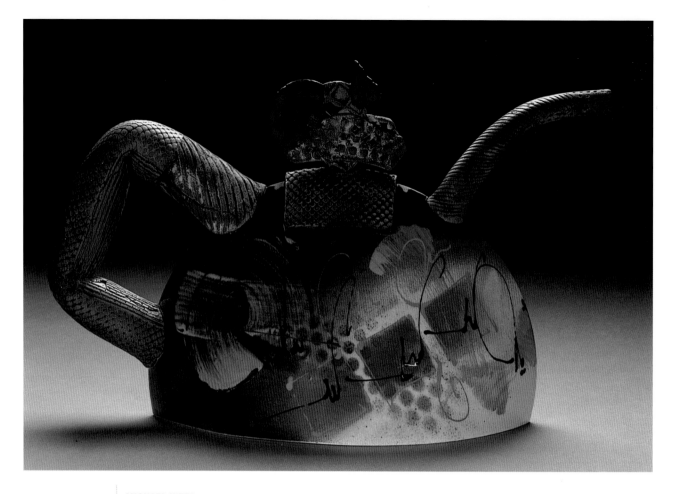

● **MICHAEL KIFER**
● *Teapot*, 2001
● 13 x 14 x 6 in. (33 x 35.6 x 15.2 cm)
● Hand-built white earthenware; underglaze
 slip trail; bisque cone 02; glaze cone 05
● Photo by Larry Sanders

I enjoy textured and painterly surfaces
that are juxtaposed for visual impact.

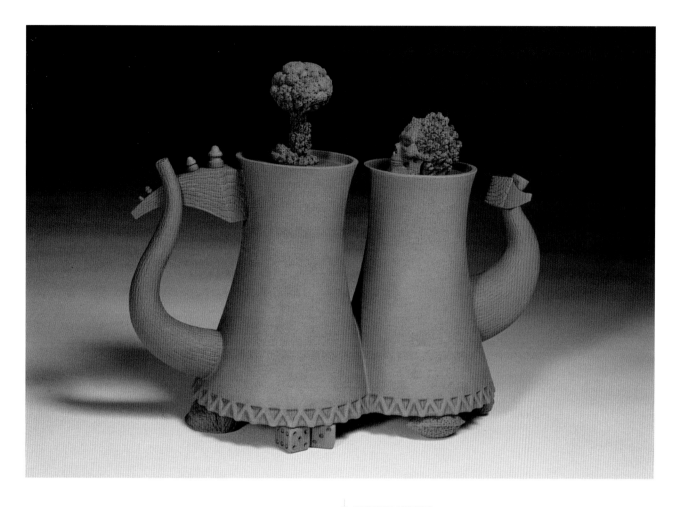

● **RICHARD NOTKIN**
● *Cooling Towers Teapot (Variation #32) – Yixing Series*, 1994
● 6 ¾ x 8 ⅜ x 3 ⅝ in. (17.1 x 21.3 x 9.2 cm)
● Slip-cast, hand-built, and assembled from multiple parts mid-range stoneware; carved; unglazed; cone 6
● Photo by artist

Although highly capable of dispensing tea, the messages conveyed by my teapots are of paramount importance to me.

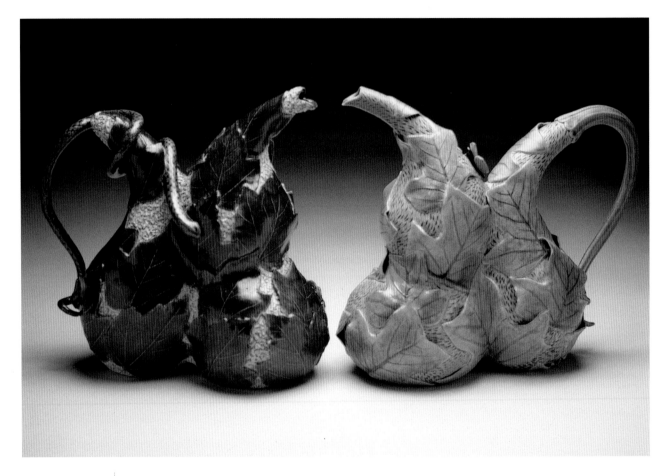

● **BETSY ROSENMILLER**
● *Pair of Teapots*, 1999
● 9 ½ x 10 x 5 in. (24.1 x 25.4 x 12.7 cm)
● Cast, hand-built, and assembled porcelain; slip-trailed
and carved texture; glaze cone 5; china paint

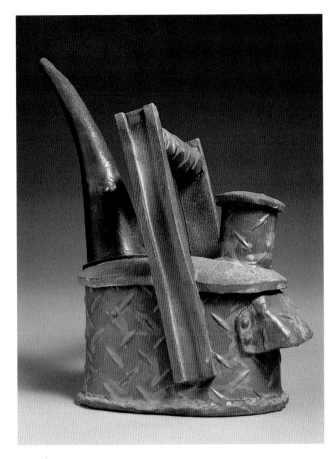

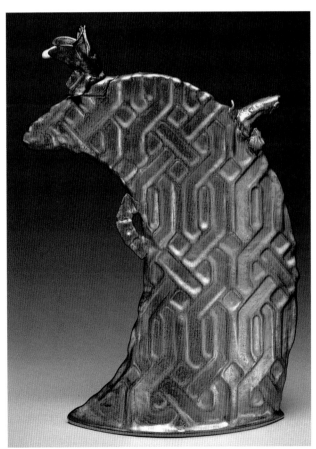

JOSEPH LYON
Teapot, 2001
13 ½ x 11 x 6 in. (34.3 x 27.9 x 15.2 cm)
Slab-built; press-molded textures; partially glazed; bisque cone 07; cone 10 wood
Photo by artist

O'BRIEN TYRRELL
Woa Mamma Hang On Here We Go, 2000
18 ½ x 13 ½ x 5 ½ in. (47 x 34.3 x 14 cm)
Slab-built mid-range stoneware; glaze over surfaces textured by pressing into a rubber floor mat; bisque cone 06; glaze cone 6 oxidation
Photo by Peter Lee

347

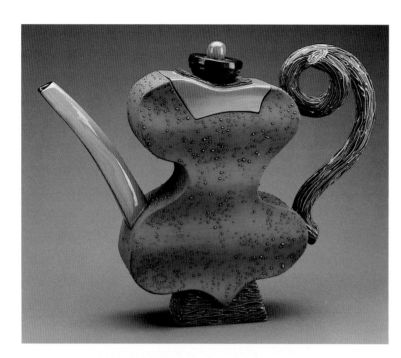

CAROL GOUTHRO

Teapot "Gold Dots," 1997

11 ½ x 14 x 3 ½ in. (29.2 x 35.6 x 8.9 cm)

Slip-cast body, hand-built handle, spout, and lid; low-fire underglazes, glazes, and lusters; sgraffito-carved handle and base; bisque cone 04; glaze cone 05; luster cone 022

Photo by Roger Schreiber

Color, elaborate surfaces, attention to detail, and sensuous forms are integral to my work.

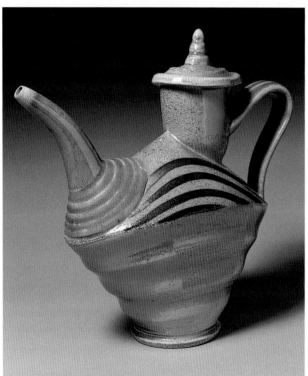

MARK JOHNSON

Teapot, 2001

12 x 12 x 6 in. (30.5 x 30.5 x 15.2 cm)

Wheel-thrown and assembled white stoneware; glaze, wax-resist, and black underglaze; cone 10 soda

Photo by artist

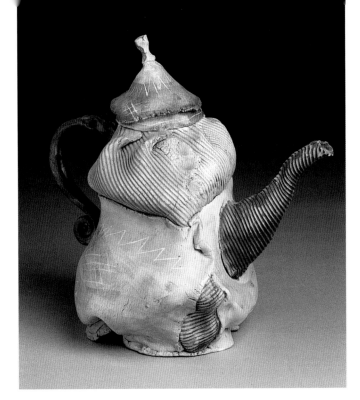

CHANDLER SWAIN
Primary Friend, 2000
10 ½ x 11 x 6 in. (26.7 x 27.9 x 15.2 cm)
Slab-built porcelain painted with watery underglazes; bisque cone 08; glaze cone 6
Photo by Tim Wickens

The inspiration for this teapot rests with abstract Impressionist painting and an attempt to recreate painterly looseness with clay.

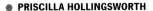

PRISCILLA HOLLINGSWORTH
Nubby Purple Teapot, 2001
7 x 9 x 5 ½ in. (17.8 x 22.9 x 14 cm)
Hand-built (coiled and paddled, with pinched texture) terra cotta; bisque cone 06; purple underglaze/black copper oxide/interior glaze cone 04; dark red and clear glaze on handle cone 08
Photo by artist

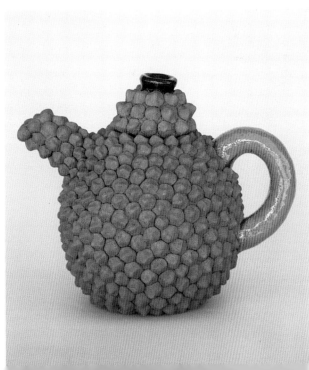

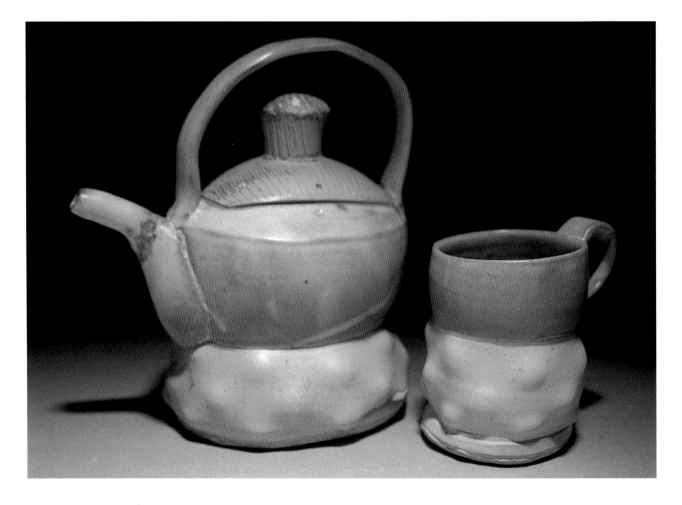

JANE GERTRUDE MILLER
Elbow Teapot Set, 2000
10 x 13 x 7 in. (25.4 x 33 x 17.8 cm)
Wheel-thrown, altered, and hand-built
porcelain; terra sigillata and glaze;
cone 10 reduction
Photo by artist

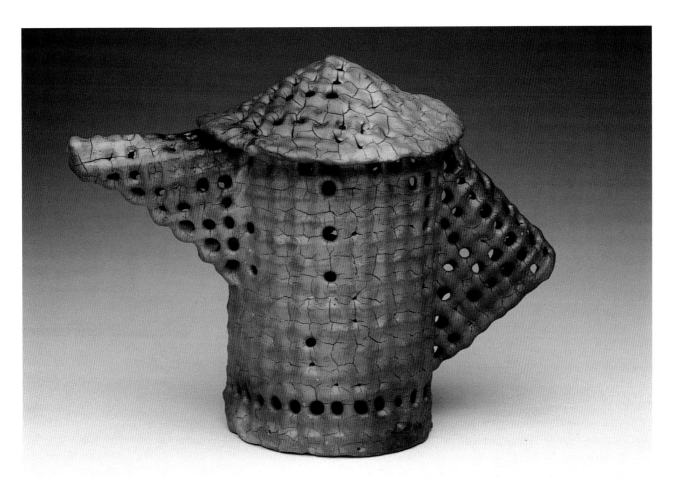

LINDA HANSEN MAU
Silo Series Teapot, 1997
9 x 12 x 7 in. (22.9 x 30.5 x 17.8 cm)
Porcelain paper clay on steel wire; Newman
Red terra sigillata; cone 04 electric; smoked
in open laundry tub with newspaper
Photo by Lynn Hunton

I love to experiment with new techniques; paper clay on
steel armatures was a real challenge!

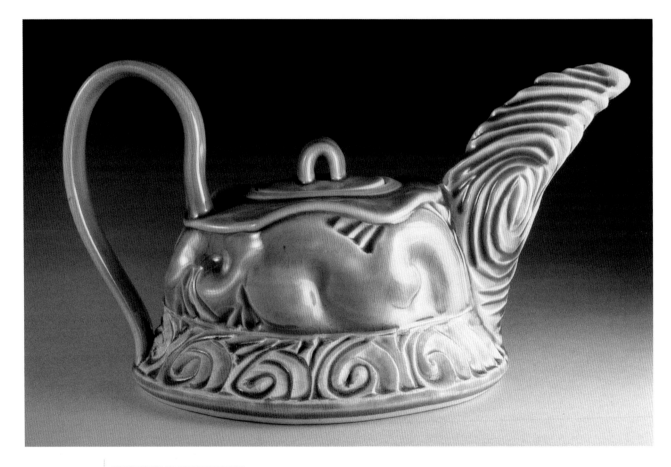

● **DENISE WOODWARD-DETRICH**
● *Teapot*, 1999
● 6 ½ x 11 x 6 ¼ in. (16.5 x 27.9 x 15.8 cm)
● Wheel-thrown and altered porcelain, carved;
 glaze cone 10 electric
● Photo by artist

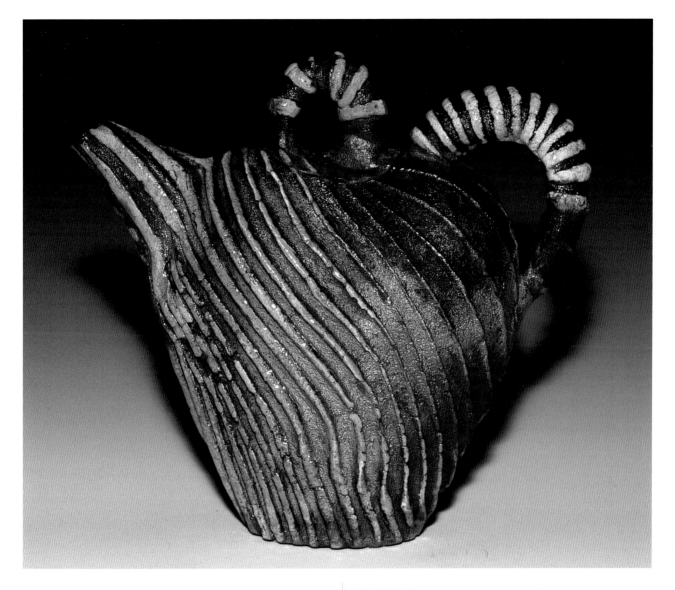

- **LESLIE GREEN**
- *Raku Teapot*, 2000
- 9 x 9 x 3 ½ in. (22.9 x 22.9 x 8.9 cm)
- Slabs cut with spring and formed on hump molds; raku

● **SUSAN FILLEY**
● *Feathered Wisp*, 2000
● 10 x 7 x 3 in. (25.4 x 17.8 x 7.6 cm)
● Wheel-thrown, altered, and combined parts; sprayed glazes; cone 10 reduction
● Photo by Tim Barnwell

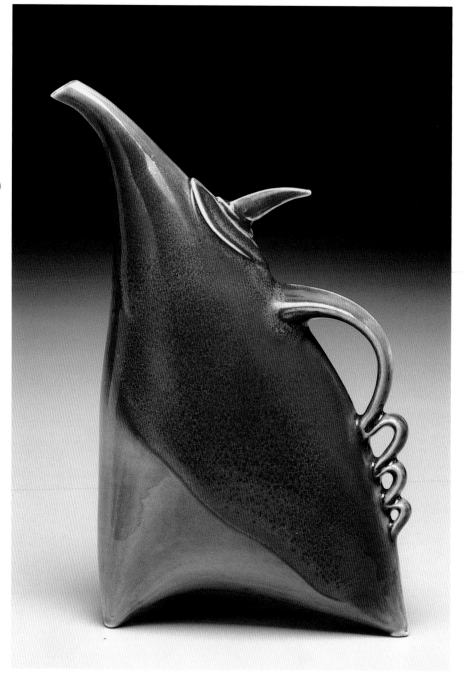

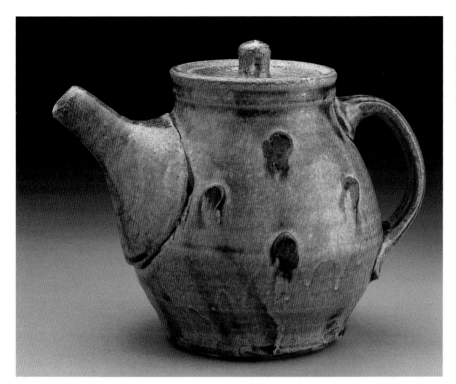

● **SHAWN IRELAND**
● *Teapot*, 2001
● 8 x 9 in. (20.3 x 22.9 cm)
● Wheel-thrown stoneware; cone 9 wood
● Photo by Tom Mills

I choose to make useful pots with a foundation in folk tradition. This involves digging clay, using local glaze materials, throwing on a treadle wheel, and firing with wood. These ingredients promote surprises.

● **JOHN A. VASQUEZ**
● *Fish Teapot*, 2000
● 6 x 8 ½ x 6 in. (15.2 x 21.6 x 15.2 cm)
● Wheel-thrown stoneware; slip with underglaze brushwork; copper green and amber celadon; cone 10 soda
● Photo by Tom Mills

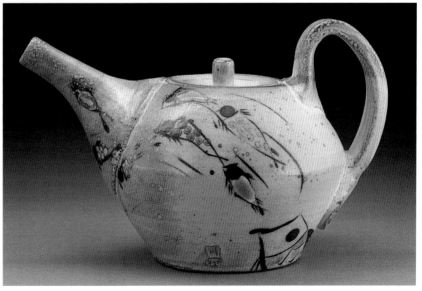

KATHRYN SHARBAUGH

Blue Belt, 2001

7 ½ x 4 ½ x 4 ½ in. (19 x 11.4 x 11.4 cm)

Wheel-thrown porcelain assemblage; underglaze painted; bisque cone 04; overglaze cone 10

Photo by Chuck Sharbaugh

I begin with a life experience, then abstract it geometrically to create a neutral ground, which in turn evolves the energy, the essence of the original experience. I make the clay subservient to the patterns of the finished product, creating illusions of depth and movement which hold the form, mirror it, and make it move.

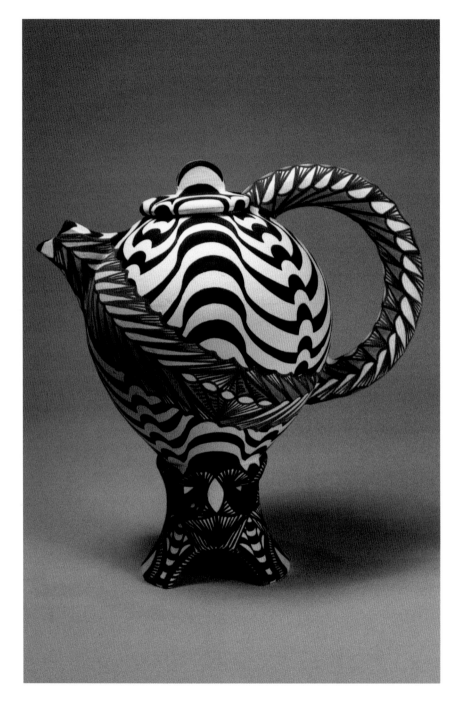

GLENDA GUION

Teaparty #5, 1997

12 x 9 x 5 in. (30.5 x 22.9 x 12.7 cm)

Slab-built red earthenware clay;
underglaze cone 04

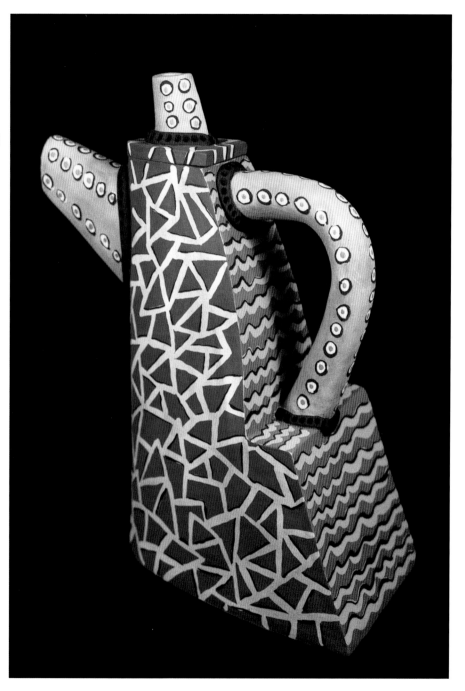

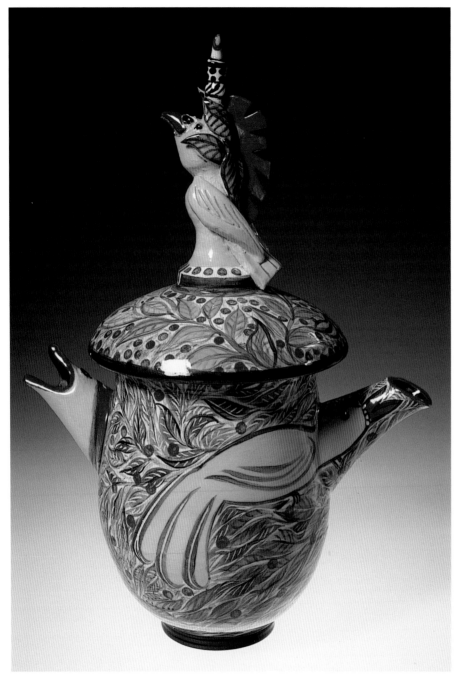

MANDY WOLPERT
Moe Hawk With Illumination, 2000
15 ½ x 11 in. (39.5 cm x 28 cm)
Wheel-thrown earthenware with
sculptural additions; underglaze; clear
glaze, bisque cone 04; glaze cone 06

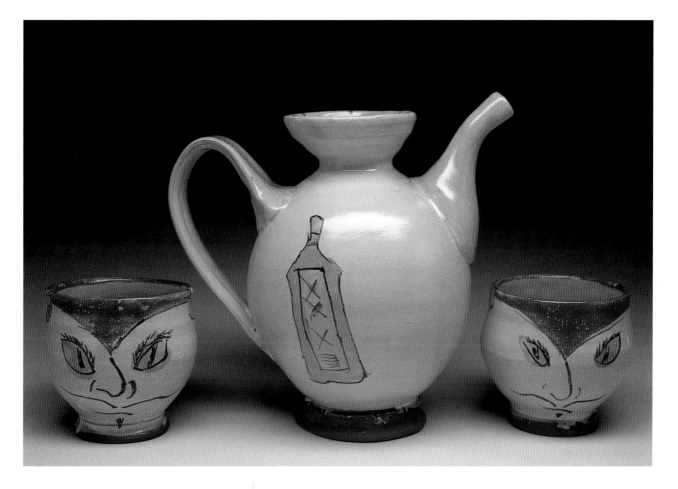

● **SCOTT LYKENS**
● *Hot Toddy*, 2001
● 15 x 11 x 7 in. (38.1 x 27.9 x 17.8 cm)
● Wheel-thrown; pulled handle; glazes and overglazes
 handcrafted from personal chemistry; cone 2
● Photo by artist

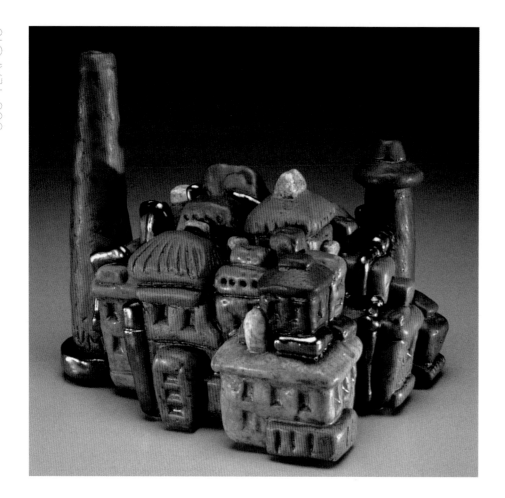

● **ALLAN ROSENBAUM**
● *Urban Teapot*, 2001
● 9 x 10 ½ x 8 in. (22.9 x 26.7 x 20.3 cm)
● Coil-built; oxide wash and low-fire glazes; cone 05

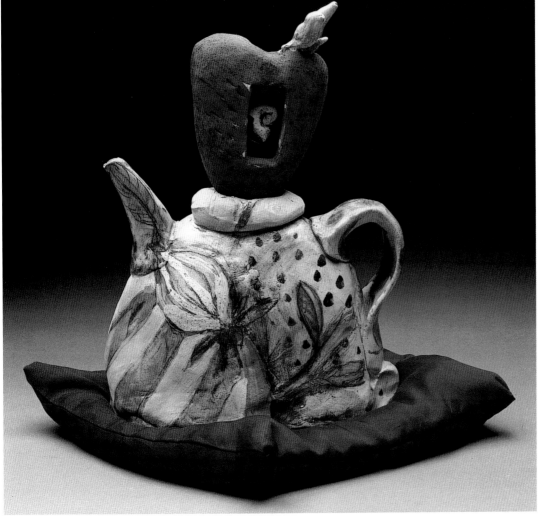

● **ANDREA FREEL**
● *Pressure,* 2000
● 9 x 6 x 5 in. (22.9 x 15.2 x 12.7 cm)
● Slab-constructed earthenware; underglazes, slips, and underglaze pencils; multiple firings, cone 04
● Photo by artist

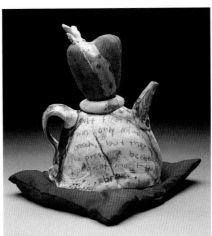

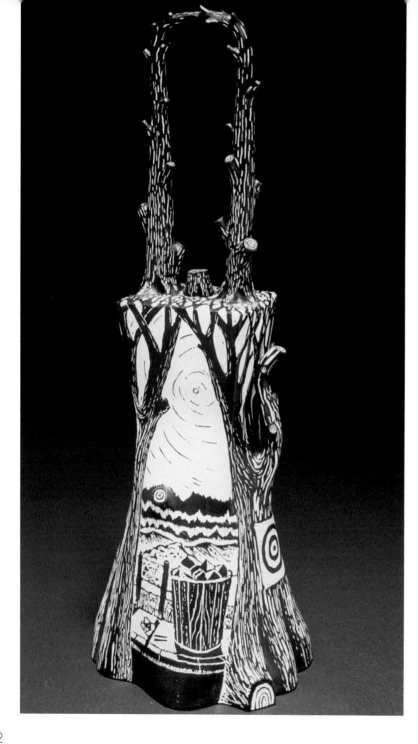

JEFF IRWIN
Take Out Trash Teapot, 1996
21 x 7 x 7 in. (52.6 x 17.8 x 17.8 cm)
Hand-built slab construction; earthenware; black and white vitreous engobe drawn in wax-resist method

My work deals with nature and its role as a resource. I like to use a mixture of humor and irony to discuss this issue.

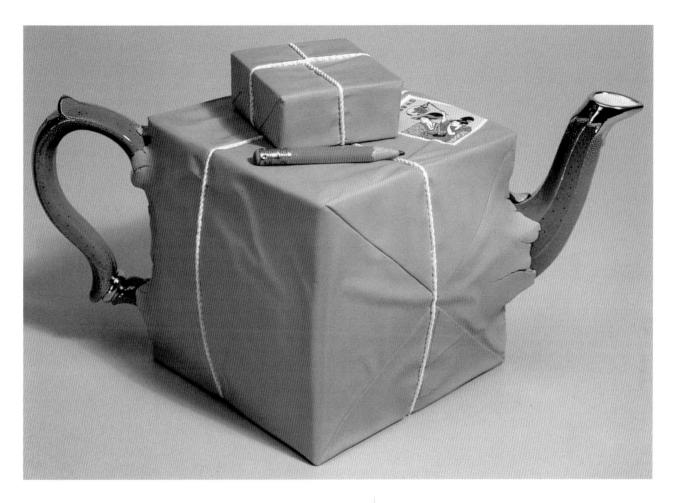

KAREN DAHL
Box to Small Teapot, 2000
17 x 16 ½ x 14 in. (43.2 x 41.9 x 35.6 cm)
Slip-cast white earthenware; underglazes, glazes, and luster; acrylic sealant; bisque cone 04; glaze cone 06
Photo by artist

This piece is an ode to the trials and tribulations of packing and shipping my fragile work.

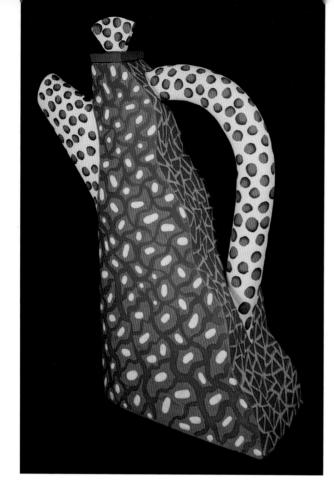

GLENDA GUION
Teaparty #6, 1997
13 x 10 x 5 in. (33 x 25.4 x 12.7 cm)
Slab-built red earthenware clay;
underglaze cone 04

JANETTE LOUGHREY
Carnival, 2001
6 ¾ x 11 ½ x 6 ¼ in. (17 x 29 x 16 cm)
Wheel-thrown white earthenware clay; Cesco underglaze and clear glaze with gold lustre; bisque cone 06; glaze cone 02

I love to take a "serious" form and have a lot of fun decorating it with dots, stripes, and heaps of color.

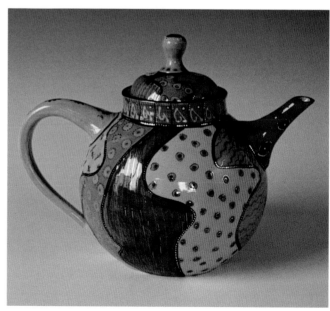

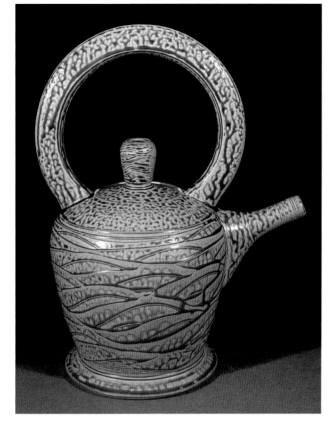

● **RICHEY BELLINGER**
● *Teapot 2*, n.d.
● 13 x 9 x 7 ½ in. (33 x 22.9 x 19 cm)
● Wheel-thrown porcelain clay; slip pattern; high calcium glaze at cone 10 reduction

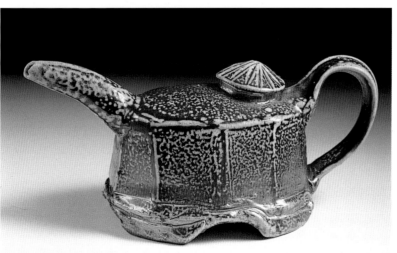

● **JOHN ELDER**
● *Teapot*, 2001
● 4 ¾ x 10 ¼ x 4 ¾ in. (12 x 26 x 12 cm)
● Wheel-thrown, altered, and faceted; hand-built spout and lid; cone 10 salt

● **DONNA COLE**
● *Seapot*, 2001
● 15 x 10 ½ x 6 in. (38.1 x 26.7 x 15.2 cm)
● Wire-cut slab construction; copper glaze;
 cone 6 oxidation

Moist wire-cut slabs were wrapped and
stretched into playful yet functional forms.
These teapots (called "seapots") express
rhythm and motion inspired by dance,
wind, sand, and sea.

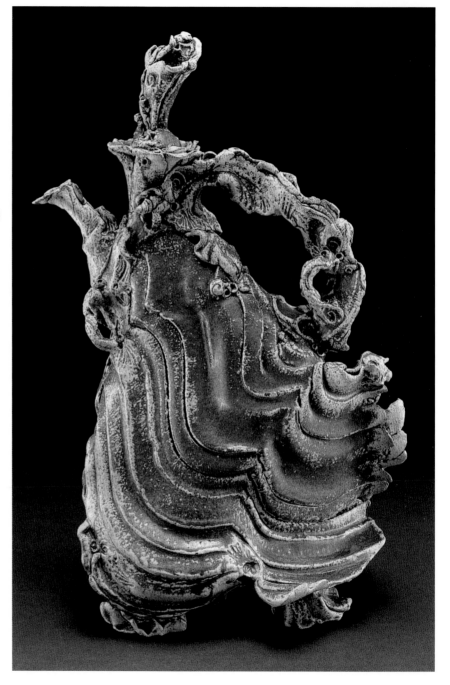

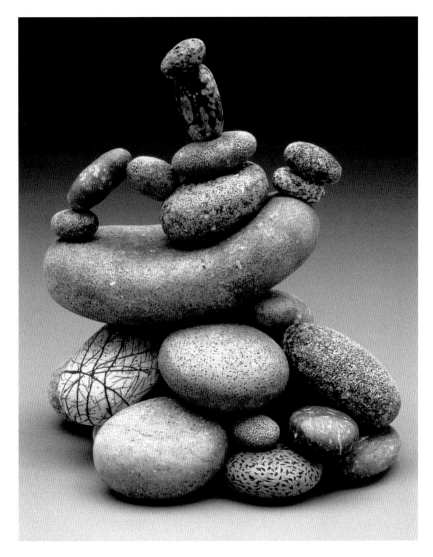

BARBARA FREY

Let's Go Teapot #12, 2001

7 x 6 ¼ x 6 ½ in. (17.8 x 15.8 x 16.5 cm)

Slab-built colored porcelain; slips, powdered clays, and oxides; hand-textured surfaces; cone 6

The smooth, rounded stones I have long admired and collected on the shores of Lake Ontario are themselves sculpture. This boat teapot is made from porcelain rocks created in homage to those wonderful naturally sculpted forms.

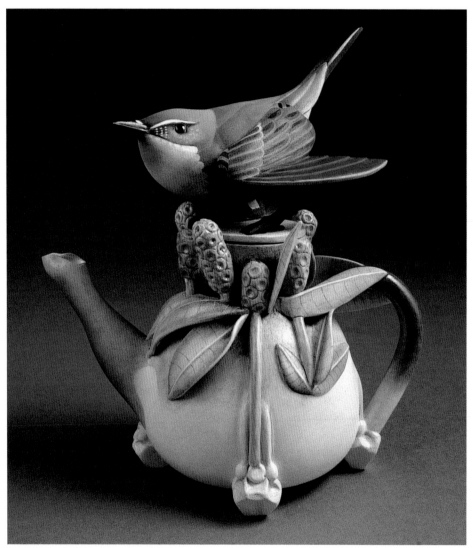

● **ANNETTE CORCORAN**
● *Tennessee Warbler*, 2001
● 7 ⅞ x 7 x 4 in. (20 x 17.8 x 10.2 cm)
● Wheel-thrown and altered porcelain; underglazes, glazes, and overglazes at multiple firings (cone 1 highest)
● Photo by Bob Kohlbrener

The teapot has captured my imagination for more than 20 years, and birds have been the focus of these teapots for nearly all that time.

● **DAVID KIDDIE**
● *Red Rocket*, 2000
● 13 x 21 x 9 in. (33 x 53.3 x 22.9 cm)
● Wheel-thrown and hand-built stoneware;
carved; high-fire glaze cone 10; red and
gold lusters cone 018

My work involves the juxtaposition of serious and
light themes; they are at once teapots, toys, war
machines, and sculptures; complacent, yet often
politically charged, as if toys for grown-ups.

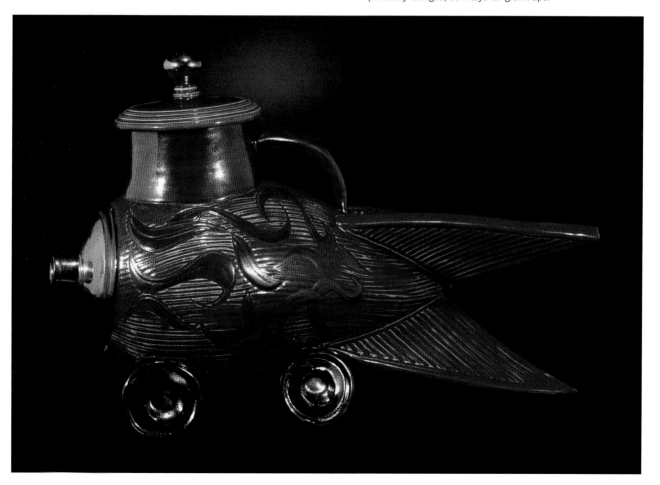

MARA SUPERIOR
Les Jardin des Papillons, 2001
15 x 19 x 9 in. (38.1 x 48.3 x 22.9 cm)
Slab-built porcelain; relief surface painted
with ceramic oxides and underglazes;
cone 10 reduction

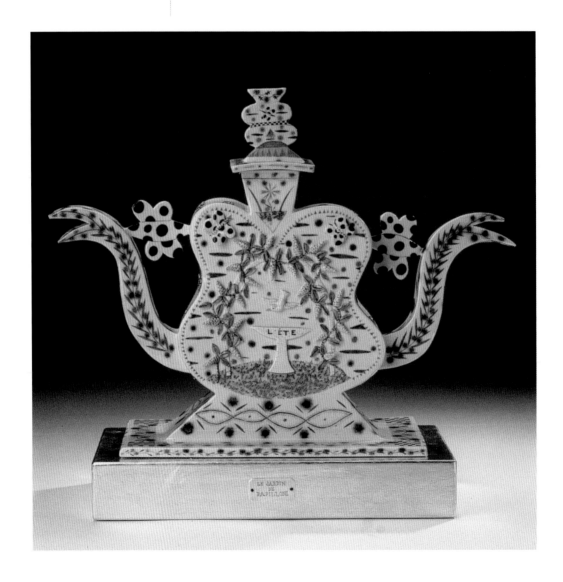

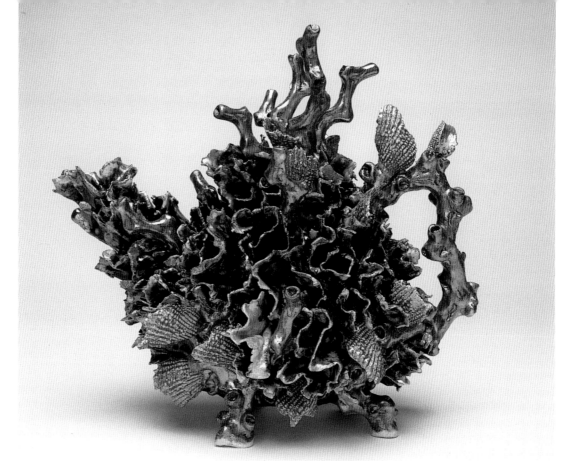

- **JANET KORAKAS**
- *Blue Oyster Teapot*, 2001
- 9 ½ x 10 ¼ x 6 ¾ in. (24 x 26 x 17 cm)
- Coil-built, press-molded, and hand-sculpted stoneware; glazes and lustres; bisque cone 06; glaze cone 8; lustre cone 017

The flamboyance and natural beauty of Australian aquatic plant and animal life served to inspire this piece.

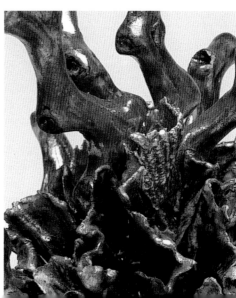

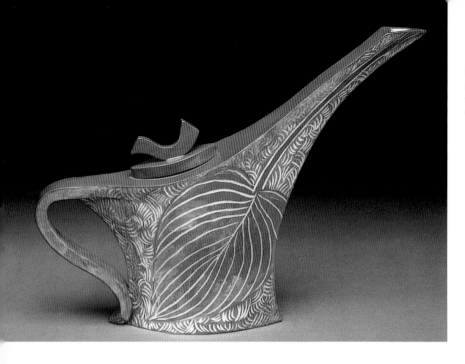

● **SUSAN FARRAR PARRISH**
● *Tea in the Garden I*, 2001
● 11 ½ x 16 x 3 ¼ in. (29.2 x 40.6 x 8.2 cm)
● Slab-built; painted with underglazes while leather-hard, then carved; bisqued; clear glaze cone 6

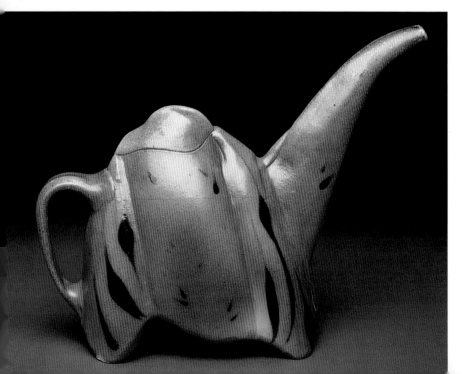

● **MARILYN DENNIS PALSHA**
● *Sculptural Teapot*, 2001
● 10 x 13 x 4 in. (25.4 x 33 x 10.2 cm)
● Slab-built stoneware; sprayed slip; bisqued; brushed black glaze; cone 10 soda/salt

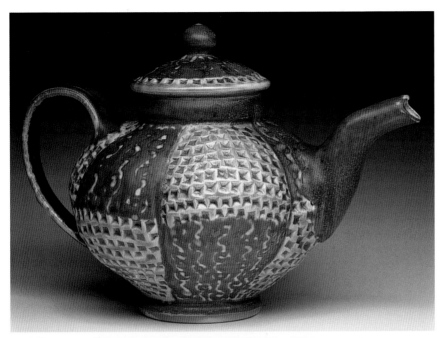

DIANE ROSENMILLER

Teapot, 2001

9 x 10 x 6 in. (22.9 x 25.4 x 15.2 cm)

Wheel-thrown and stamped porcelain; trailed glaze; cone 10 soda

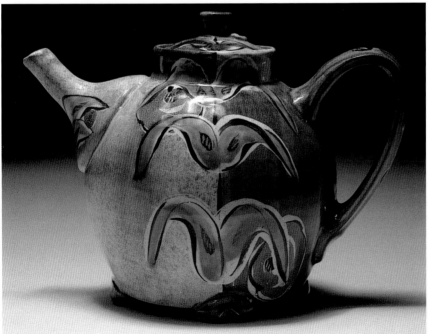

POSEY BACOPOULOS

Oval Teapot, 2001

7 x 8 x 5 ½ in. (17.8 x 20.3 x 14 cm)

Wheel-thrown, altered, and assembled; majolica on terra cotta; bisque cone 06; glaze cone 04

Photo by D. James Dee

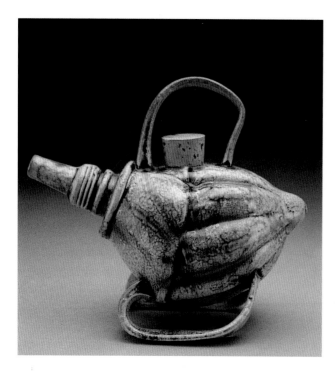

HARRY WONG
For Lovers and Rockers, 2000
7 x 7 ½ x 4 ½ in. (17.8 x 19 x 11.4 cm)
Slip-cast and hand-built with cork lid; iron
oxides; bisque cone 07; cone 10 soda

SCOTT D. CORNISH
Teapot with Reed Handle, 2000
17 x 5 x 4 in. (43.2 x 12.7 x 10.2 cm)
Wheel-thrown porcelain; reed handle; cone 10 soda

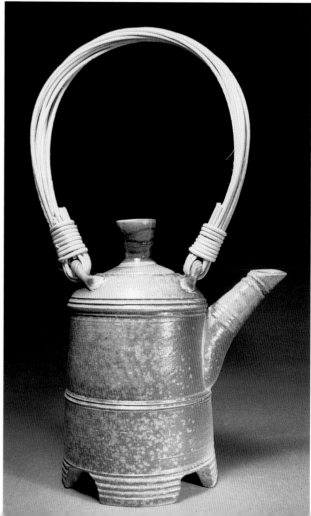

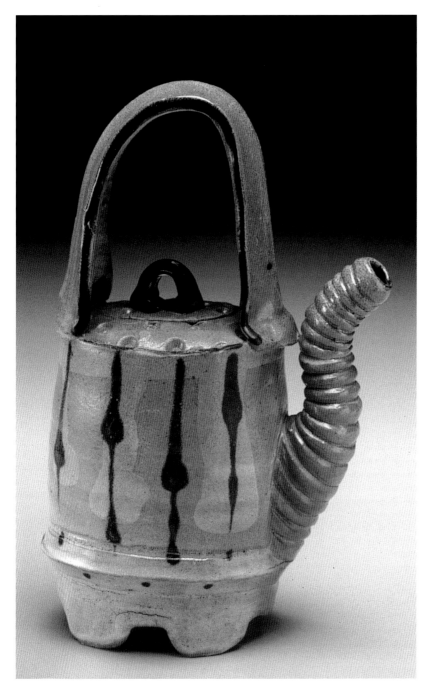

TERRY GESS
Striped Teapot, 2000
10 x 6 x 4 in. (25.4 x 15.2 x 10.2 cm)
Wheel-thrown and hand-built; multi-layered
porcelain; textures with brushwork; bisque
cone 08; lightly salted cone 10 atmospheric
Photo by Tom Mills

I once met a woman who looked like her cat.
It was a subtle thing, but there was an unmistakable
bond between pet and owner, some collaborative
demeanor or design sense. Potters and their pots
are really no different.

 During the years of steadily making, marking,
and firing pots, something distinctively myself has
slipped into the process. It's a sensibility as intangible
and basic to me as the way in which I hold the salt
shaker when I tilt it to pour, how I turn the pages
of a book, or how I kick my potters' wheel.

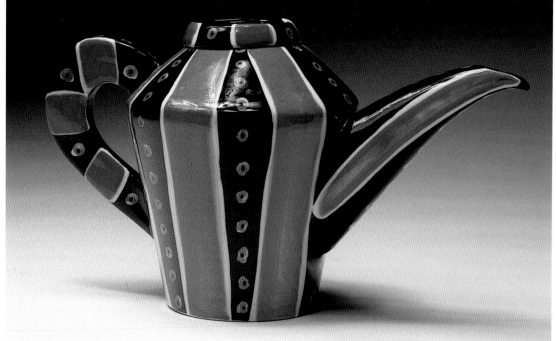

● **MATTHEW A. YANCHUK**
● *Stripe Teapot*, 2001
● 6 x 6 ½ x 4 in. (15.2 x 16.5 x 10.2 cm)
● Slip-cast construction; wax-resist decoration; hand
 painted; bisque cone 04; glaze cone 06
● Photo by D. James Dee

I approach my work with a sense of fun and get my inspiration
from my environment. Much of the work is made somewhat
organically, even though I make them by slip-casting.

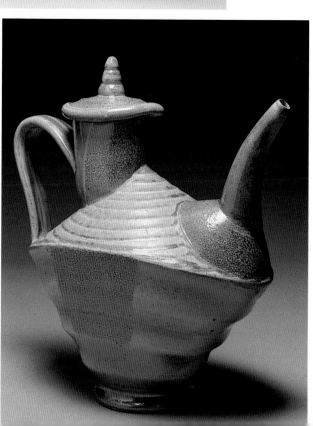

● **MARK JOHNSON**
● *Teapot*, 2001
● 12 x 12 x 6 in. (30.5 x 30.5 x 15.2 cm)
● Wheel-thrown and assembled white
 stoneware; wax resist and glaze;
 cone 10 soda
● Photo by artist

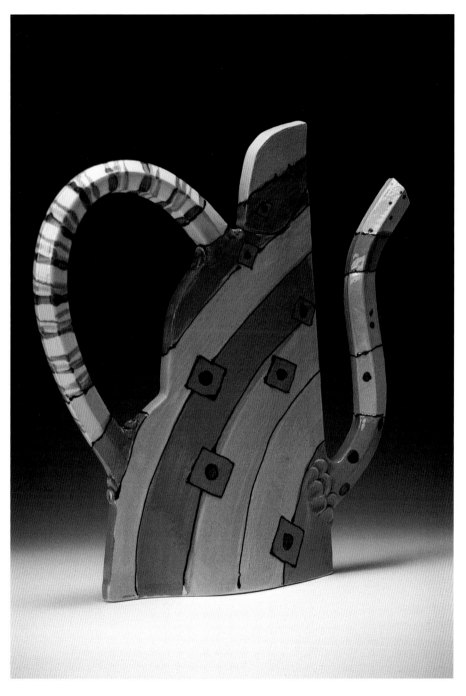

DAVE DABBERT
PAT DABBERT
Joker, 1999
15 x 10 x 3 in. (38.1 x 25.4 x 7.6 cm)
Slab construction; extruded handle and spout; slip design using stains for color; clear glaze cone 6

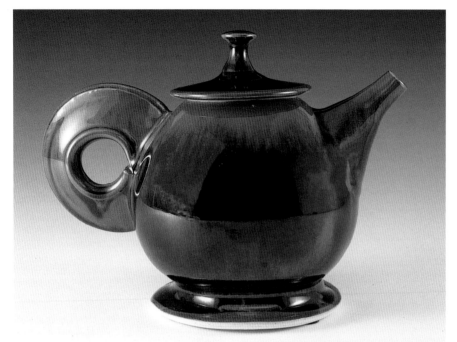

JOHN BRITT
Tenmoku Teapot, 2000
8 x 8 x 7 in. (20.3 x 20.3 x 17.8 cm)
Wheel-thrown, altered, and assembled porcelain; Hamada Rust glaze; cone 10 gas reduction

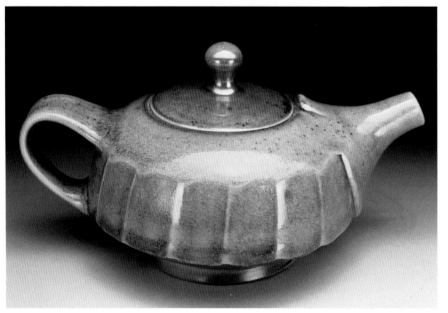

THOMAS ROHR
Teapot, 2001
6 x 9 x 6 in. (15.2 x 22.9 x 15.2 cm)
Wheel-thrown porcelain; shino glaze cone 12 wood

- **SUZE LINDSAY**
- *Footed Teapot*, 2001
- 10 x 8 x 3 in. (25.4 x 20.3 x 7.6 cm)
- Wheel-thrown and hand-built stoneware
 elements; slips and glaze; cone 10 salt
- Photo by Tom Mills

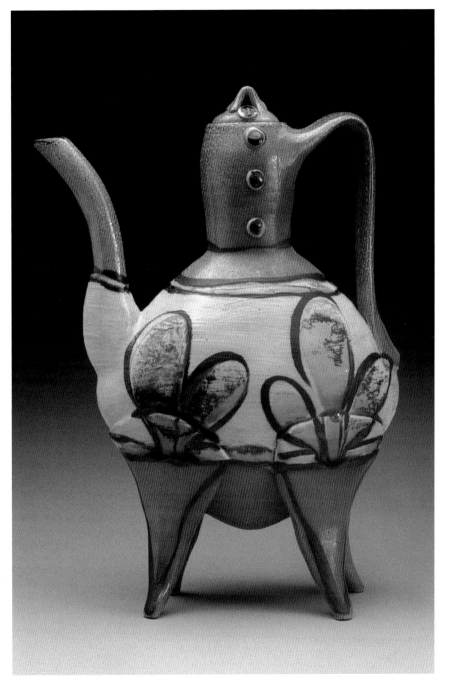

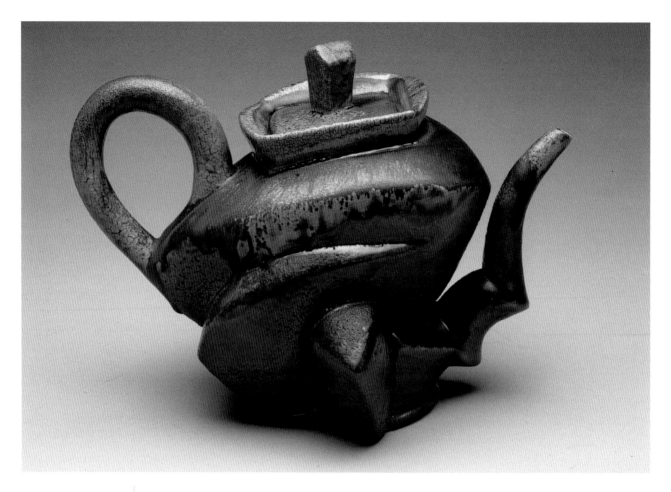

- **CHRIS GUSTIN**
- *Teapot 0106*, 2001
- 7 ½ x 10 x 6 ½ in. (19 x 25.4 x 16.5 cm)
- Wheel-thrown and coiled stoneware construction; slip; cone 12 wood anagama
- Photo by Stewart Clements and William Howcroft. Collection of the Art Complex Museum, Duxbury, Massachusetts.

WILL RUGGLES
DOUGLASS RANKIN

Side-Handled Teapot, 2001

5 ½ x 7 ½ x 7 ½ in. (14 x 19 x 19 cm)
Wheel-thrown white stoneware; slips;
cone 9 wood salt/soda

Photo by W. Ruggles

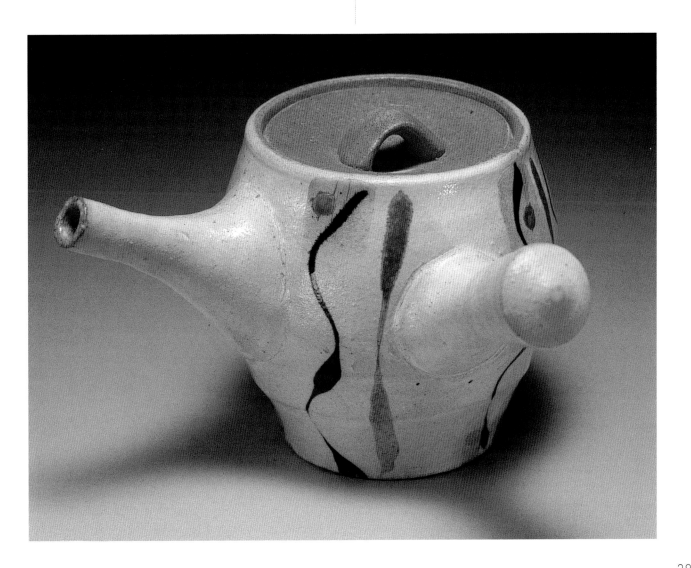

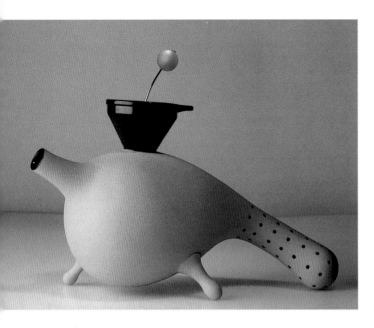

FRANÇOIS RUEGG
Green Tea, 2000
8 ¾ x 11 ¾ x 6 in. (22 x 30 x 15 cm)
Cast and assembled earthenware; vitrified engobes; bisque cone 021; glaze cone 03

SUSAN FILLEY
Jaunty Jewel White, 2000
7 x 5 x 2 ½ in. (17.8 x 12.7 x 6.4 cm)
Wheel-thrown, altered, and combined parts; sprayed glazes; cone 10 reduction
Photo by Tim Barnwell

My teapots have taken on a life of their own. They have departed from the functional realm in which I used to be grounded, and taken me into more playful work. I am balancing the beauty and elegance that I love in porcelain pots with a more quixotic approach.

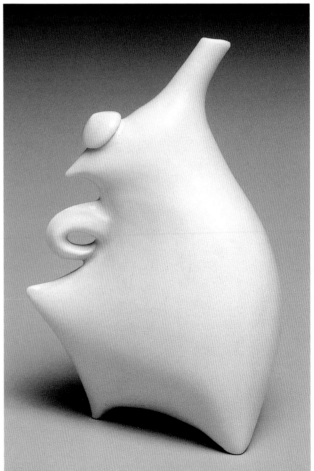

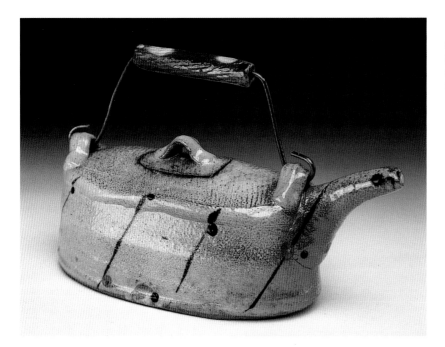

JOHN ELDER
Teapot, 2000
4 ¾ x 8 x 2 ½ in. (12 x 20 x 6.5 cm)
Wheel-thrown and altered; applied slips; wire handle; cone 10 soda

KATHLEEN GUSS
STEPHEN ROBISON
Teapot, 2001
8 x 8 x 5 in. (20.3 x 20.3 x 12.7 cm)
Wheel-thrown, altered, and hand-built porcelain; terra sigillata; woven steel handle; cone 6 oxidation
Photo by Stephen Robison

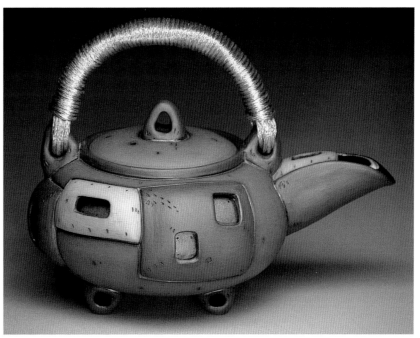

THOMAS ROHR
Teapot with Trivet, 1999
7 x 8 x 6 in. (17.8 x 20.3 x 15.2 cm)
Wheel-thrown porcelain; cone 12 wood

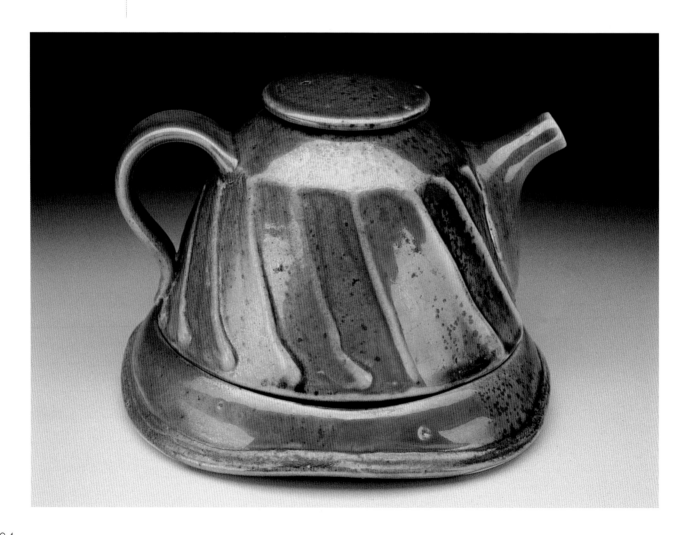

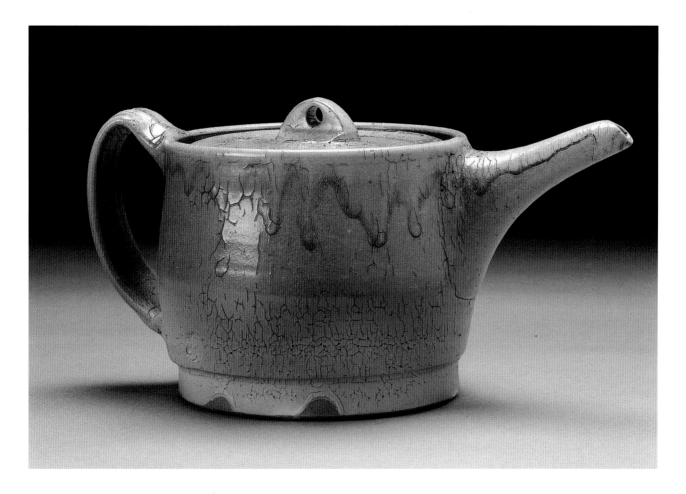

● **BILL VAN GILDER**
● *1 Quart Tea Pot*, 2001
● 6 x 7 x 5 in. (15.2 x 17.8 x 12.7 cm)
● Wheel-thrown stoneware; crackle slip
 coat; glazed interior; bisque cone 010;
 light salt glaze cone 11 wood
● Photo by C. Kurt Holter

The ritual and utensils of tea span history. As a contemporary potter I attempt to promote and continue this ceremony and the creation of necessary utensils, beginning with the teapot, which is an ever-challenging design project. Here form, surface, function, and character come together to speak quietly of nourishment, comfort, and warmth.

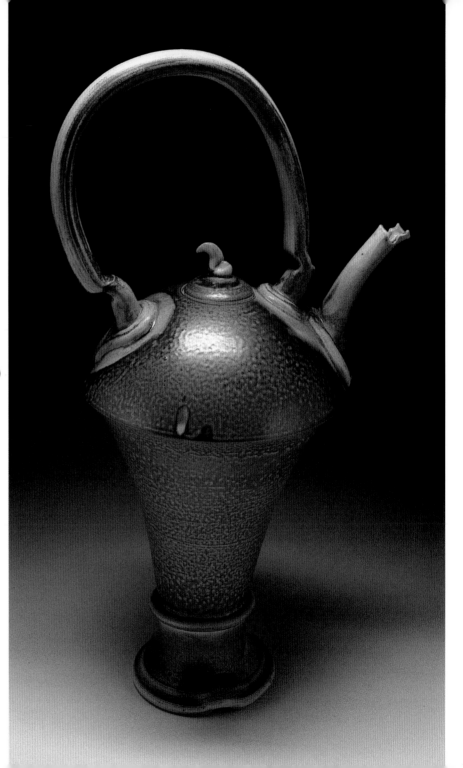

JOHN MCCLUGGAGE
Teapot, 2001
20 ½ x 11 x 8 ½ in. (52.1 x 27.9 x 21.6 cm)
Wheel-thrown stoneware; glaze cone 10
Photo by Marko Fields and Mark Braunstine

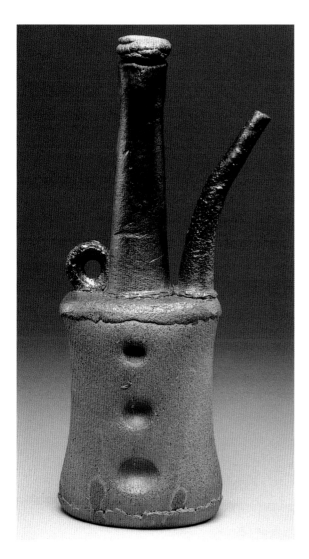

DON DAVIS

Teapot with Stand, 1995

25 x 10 ½ x 8 in. (63.5 x 26.7 x 20.3 cm)

Wheel-thrown porcelain clay with hand-built additions; oxides and glaze trail surface treatments; cone 7

Photo by Tim Barnwell

Teapots are a challenging pleasure to make. The composition of all the combined elements affords endless creative possibilities. It also seems important that a teapot actually function, no matter how we might attempt to elevate it into art.

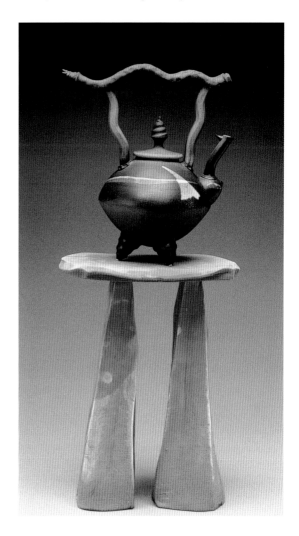

MARTA MATRAY GLOVICZKI

Woodfired Teapot, 2000

13 x 6 x 6 in. (33 x 15.2 x 15.2 cm)

Hand-built stoneware; cone 12 wood

Photo by Peter Lee

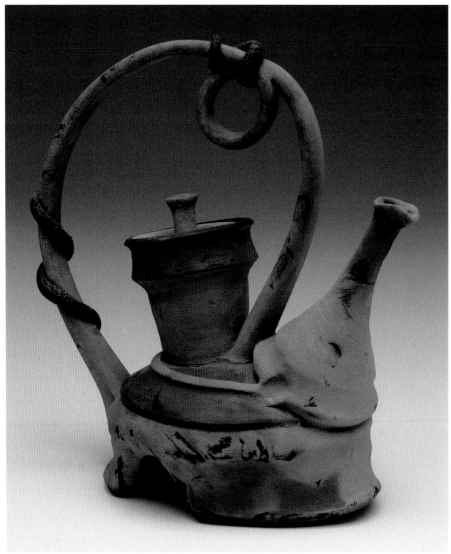

● **SHARI SIKORA**
● *Moss Teapot*, 2001
● 10 x 10 x 5 ½ in. (25.4 x 25.4 x 14 cm)
● Wheel-thrown and altered raku clay;
 copper base; bisque-and-raku fired
 cone 06 reduction
● Photo by John Carlano

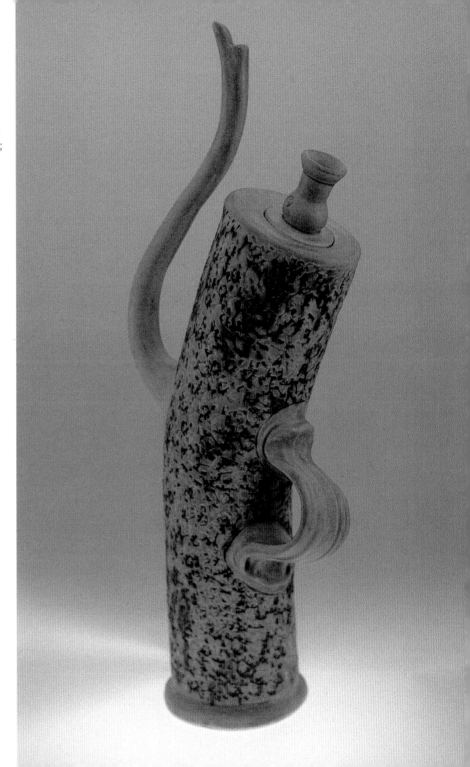

- **PATRICIA WATKINS**
- *She Wore Her Favorite Hat #1*, 2001
- 18 x 7 x 6 in. (45.7 x 17.8 x 15.2 cm)
- Wheel-thrown, slab, and extruded porcelain components; stamped and impressed decoration; bisque cone 05; oxide washes; glaze cone 06 oxidation
- Photo by artist

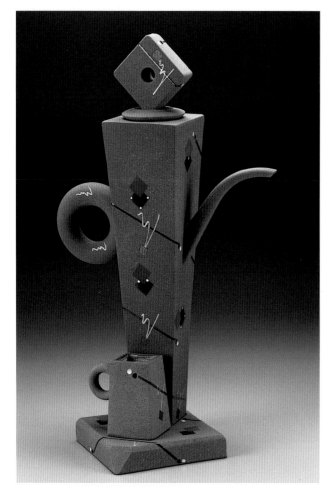

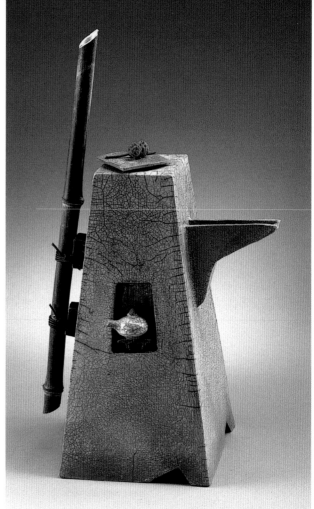

- **JONATHAN KAPLAN**
- *Still Life With Teacup*, 2000
- 18 x 6 x 6 in. (45.7 x 15.2 x 15.2 cm)
- Slip-cast terra cotta; glaze, underglaze, and non-fired pigments; cone 4
- Photo by David C. Holloway

- **DINA ANGEL-WING**
- *Teapot with Teapots*, 2001
- 16 x 8 x 6 in. (40.6 x 20.3 x 15.2 cm)
- Slab-built, wheel-thrown miniature teapots; black bamboo handle and coral; bisque cone 08; raku fired

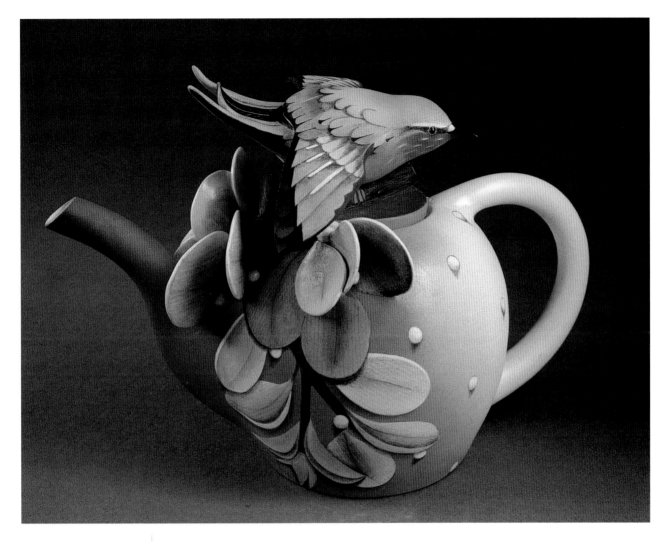

● **ANNETTE CORCORAN**
● *Lilac-Breasted Roller*, 2001
● 6 ½ x 8 ½ x 4 ¼ in. (16.5 x 21.6 x 10.8 cm)
● Wheel-thrown and altered porcelain; under-
 glazes, glazes, and overglazes at multiple firings
 and various temperatures (cone 1 highest)
● Photo by Bob Kohlbrener

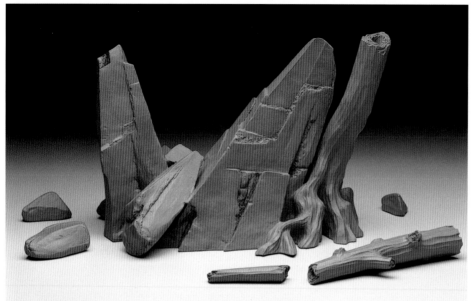

● **GEO LASTOMIRSKY**
● *Teapot #34 (verso)*, 1997
● 7 x 6 ½ x 9 ½ in.
 (17.8 x 16.5 x 24.1 cm)
● Hand-built terra cotta; terra sigillata;
 cone 04
● Photo by Tom Holt

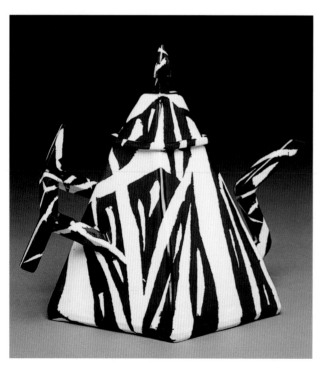

● **CINDY WATSON**
● *Untitled*, 2001
● 9 x 11 x 8 in. (22.9 x 27.9 x 20.3 cm)
● Molded, extruded, and slab-built; tape
 resist with underglaze, stain, and glaze;
 multi-fired; bisque cone 04; glaze 05
● Photo by Michael Noa

It has been said one should begin any
project with the end in mind. Indeed,
I began with a teapot in mind, but
somewhere along the way my mind
ended up in the teapot.

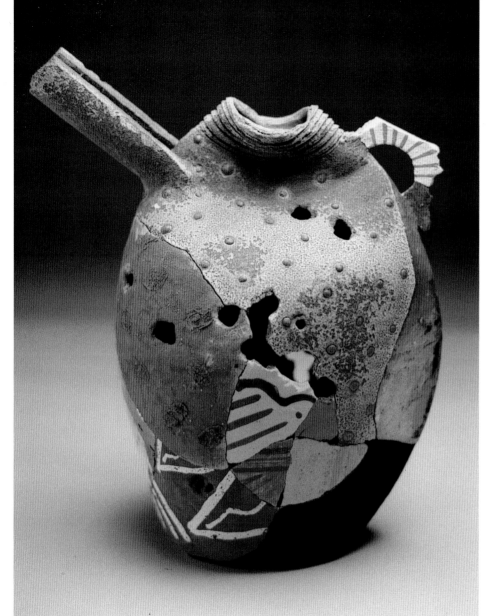

PATRICK S. CRABB

Pitcher Relic, 1999

13 x 12 x 7 in. (33 x 30.5 x 17.8 cm)

Altered, wheel-thrown form with extruded spout; bisque cone 02; fractured; slips and glazes cones 08-04 range in raku, low-temperature salt, and electric kilns

Photo by artist

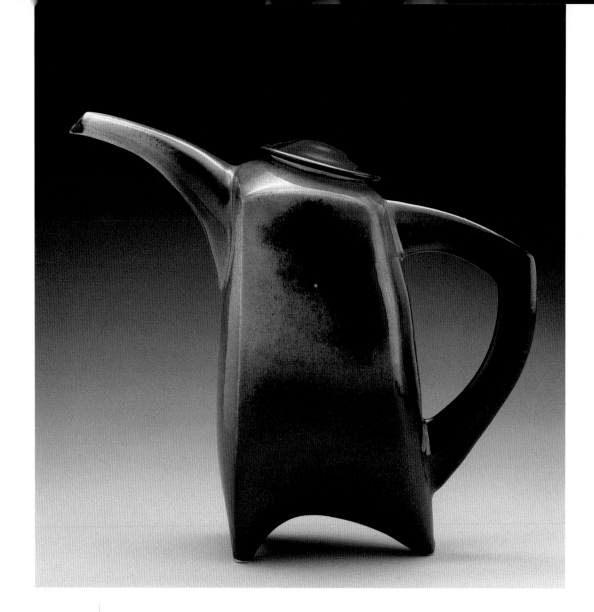

● **SUSAN FILLEY**
● *Sentinel Teapot*, 2000
● 10 x 9 x 4 ½ in. (25.4 x 22.9 x 11.4 cm)
● Wheel-thrown, altered, and combined
 parts; sprayed glazes; cone 10 reduction
● Photo by Tim Barnwell

DAVID BOLTON

Stacking Teapot (Series II), 1999

10 x 9 x 5 in. (25.4 x 22.9 x 12.7 cm)

Wheel-thrown form, pulled spout and handle; saggared porcelain; cone 9

Photo by Patrick Young

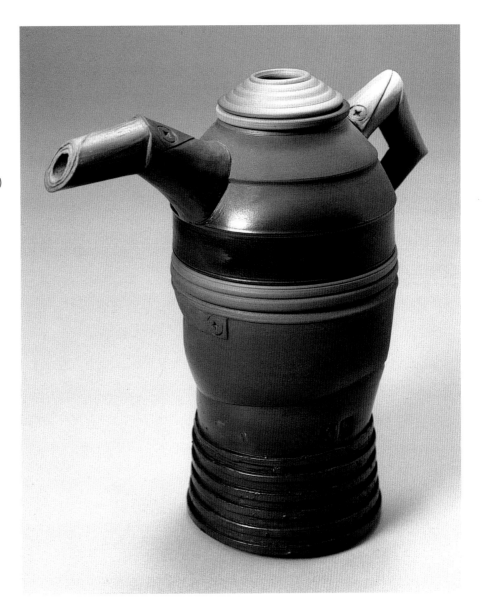

● **LINDA ARBUCKLE**
● *T-Pot: Green Balance*, 1999
● 15 x 4 ½ x 12 in. (38.1 x 11.4 x 30.5 cm)
● Wheel-thrown, altered, and constructed terra cotta; majolica glaze and decoration; cone 03
● Photo by University of Florida Office of Instructional Resources

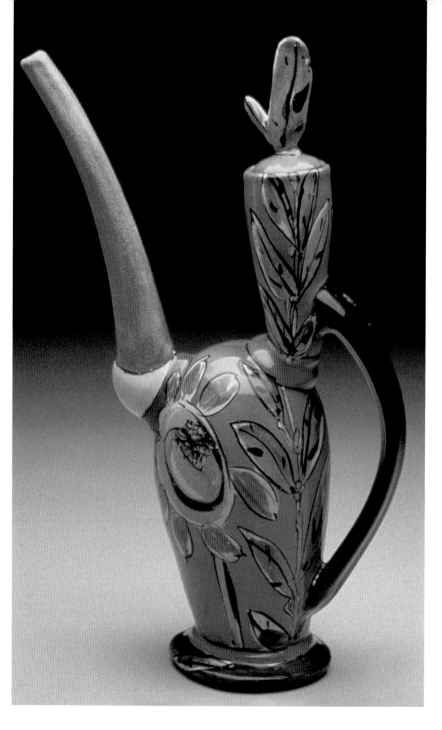

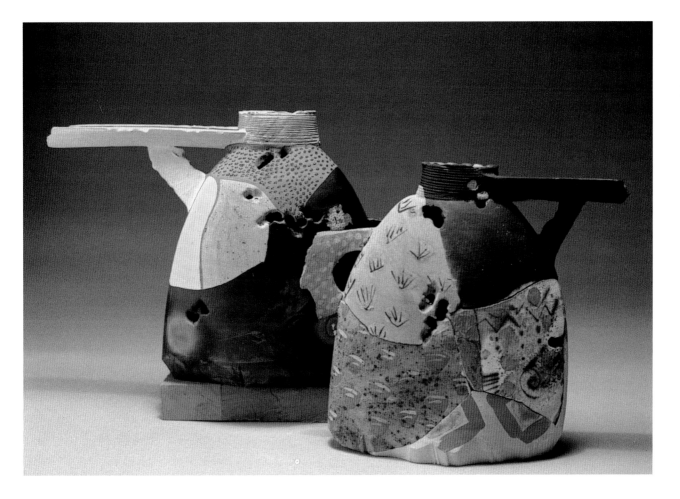

● **PATRICK S. CRABB**
● *Pitcher Relics*, 1998
● 12 x 14 x 5 in. (30.5 x 35.6 x 12.7 cm)
● Altered, wheel-thrown form with extruded
 spout; bisque cone 02; fractured; slips
 and glazes cones 08-04 range in raku,
 low-temperature salt, and electric kilns
● Photo by artist

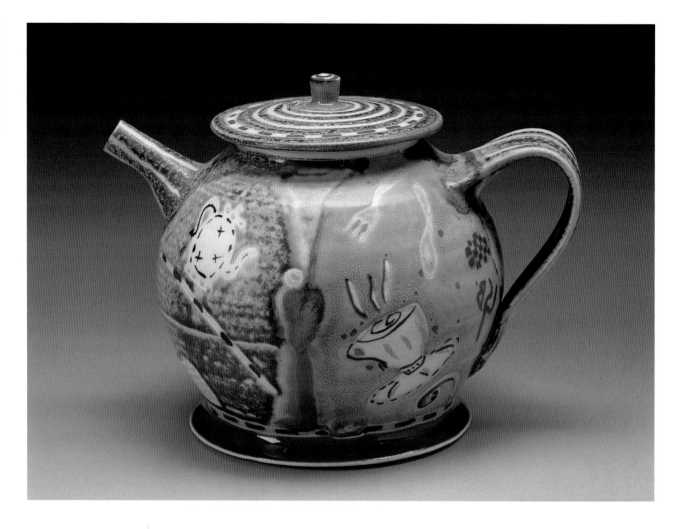

LYNN SMISER BOWERS
Teapot with Blue Striped Spout, 2001
7 x 8 x 6 in. (17.8 x 20.3 x 15.2 cm)
Wheel-thrown; oxide brush work; stencil and
wax-resist decoration; glaze cone 10 reduction

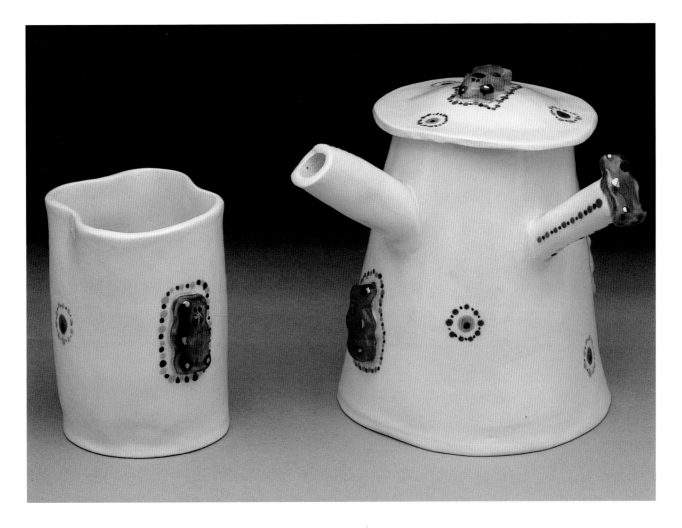

● *Bear*, 2001
● 4 ½ x 5 in. (11.4 x 12.7 cm)
● Slab-built; low-fire glazes and luster;
 bisque cone 04; glaze 06; luster cone 019
● Photo by George Post

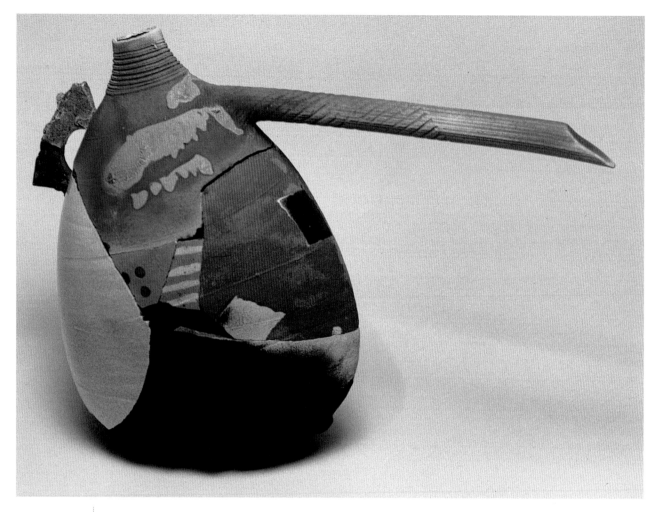

PATRICK S. CRABB
Shard T-Pot, 2001
13 x 17 x 8 in. (33 x 43.2 x 20.3 cm)
Altered and wheel-thrown, with extruded spout;
slips and glazes cones 08-04 range in raku,
low-temperature salt, and electric kilns
Photo by artist

I have always enjoyed "artifacts." The fractured technique was inspired by Rick Dillingham, and the shape is derived
from ancient Persian vessels. Fractured shards look fragile and time-worn, while the bright colors look contemporary.

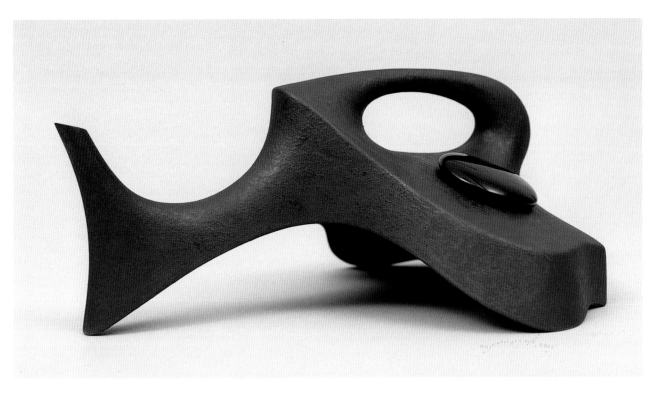

- **RICK RUDD**
- *Teapot*, 2001
- 4 ¾ x 11 x 9 ½ in. (12 x 28 x 24 cm)
- Pinched, coiled, and scraped terra-cotta clay; bisque 1742°F (950°C); glaze 2102°F (1150°C)
- Photo by Richard Wotton

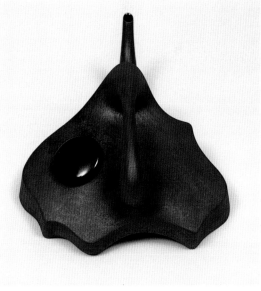

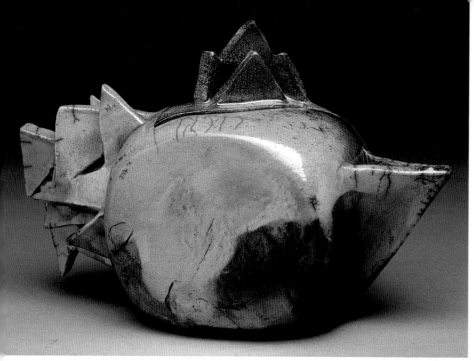

ROBERT STROTHER
Raku Tea Pot, 1998
5 x 8 x 3 ½ in. (12.7 x 20.3 x 8.9 cm)
Wheel-thrown and altered raku clay; copper luster glaze; bisque cone 04; raku fired
Photo by Walker Montgomery

RON BOLING
Raku Tea Pot - Alluding to Function, 2000
19 x 13 in. (48.3 x 33 cm)
Wheel-thrown raku clay with extruded handle; copper red glaze; bisque cone 07; glaze cone 06
Photo by John Hooper

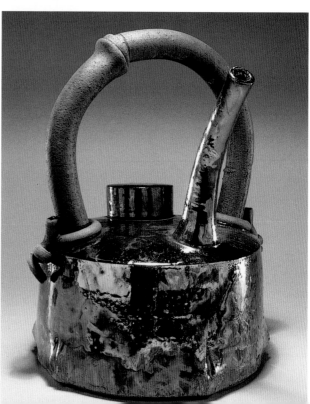

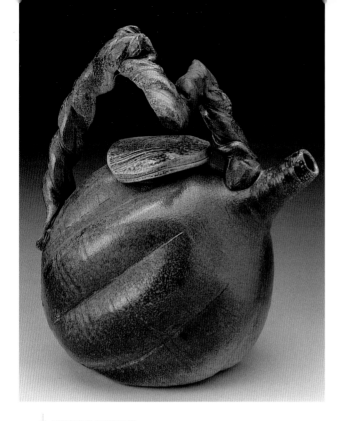

CYNTHIA BRINGLE
Teapot, 1999
9 x 8 x 6 in. (22.9 x 20.3 x 15.2 cm)
Wheel-thrown and altered; twisted handle; sprayed slip; wood/salt

DONNA COLE
Seapot, 2001
11 x 9 x 6 in. (27.9 x 22.9 x 15.2 cm)
Wire-cut slab; copper glaze; cone 6 oxidation

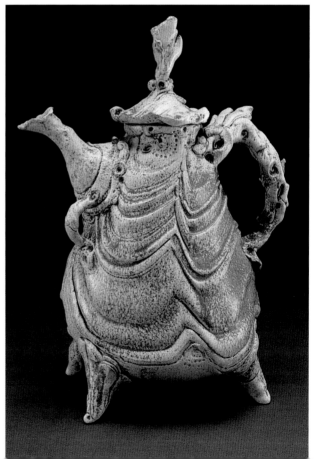

● **KRISTEN KIEFFER**
● *Teapot*, 2001
● 9 x 6 x 10 in. (22.9 x 15.2 x 25.4 cm)
● Wheel-thrown and darted porcelain; stamped and slip-trailed; multiple glazes; cone 10 soda
● Photo by artist

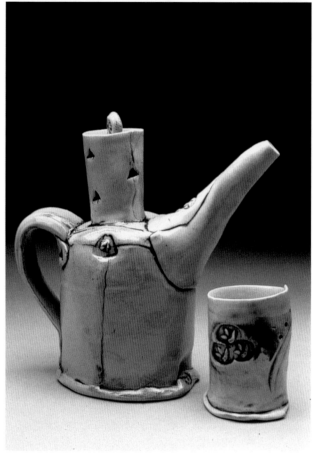

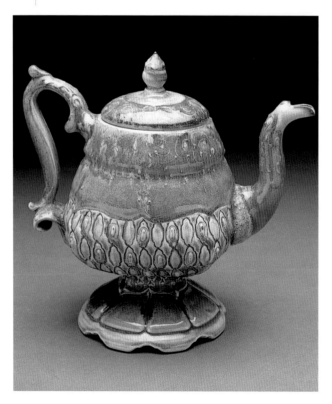

● **ANDREA FREEL**
● *Teapot with Cup*, 2000
● 7 x 5 x 4 in. (17.8 x 12.7 x 10.2 cm)
● Slab-built porcelain; stains and sprayed glazes; cone 10 reduction

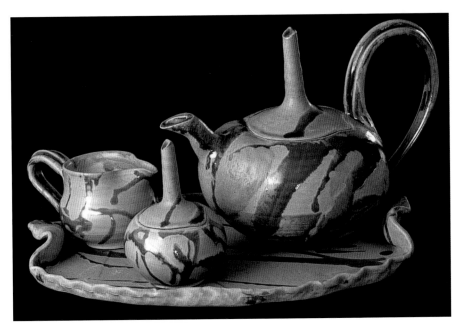

GAIL HOAG SAVITZ
In the Deep Deep Woods Set, 2000
8 ½ x 13 x 11 in. (21.6 x 33 x 27.9 cm)
Wheel-thrown; bisque cone 06, oxidation
fired to flat cone 9

The teapot and sugar bowl were thrown on
the wheel in a continuous globe and closed in
at the top. I cut the lid out of the globe, and
the lid handle was formed by the excess clay
as the pot closed in on the wheel.

KREG R. OWENS
Tea Service, 2000
14 x 20 x 12 in. (35.6 x 50.8 x 30.5 cm)
Hand-built teapot with attached sprig, legs,
handle, and finial; surface treated with terra
sigillata and/or underglazes; burnished; inte-
rior black gloss glaze; single-fired cone 04
Photo by artist

The majority of my time is dedicated to
making large-scale sculpture, fountains,
and custom furniture, so my functional
work tends to reflect elements of all of
those things on a smaller scale.

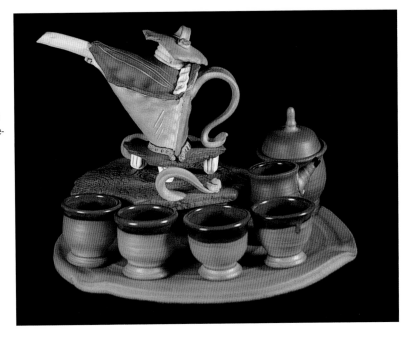

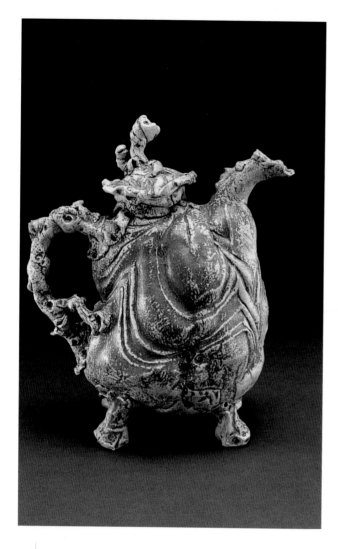

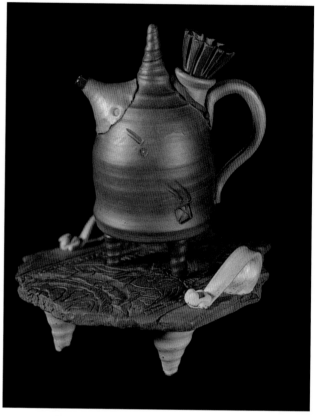

DONNA COLE
Seapot, 2001
9 x 8 x 6 in. (22.9 x 20.3 x 15.2 cm)
Wire-cut slab; copper glaze; cone 6 oxidation

KREG R. OWENS
Teapot with Carved Trivet, 2001
11 x 7 x 7 in. (27.9 x 17.8 x 17.8 cm)
Wheel-thrown, closed form with
wheel-thrown spout and legs, pulled
handle, wheel-thrown stopped neck
and hand-built stopper; burnished
terra sigillata; interior black gloss
glaze; single-fired cone 04
Photo by artist

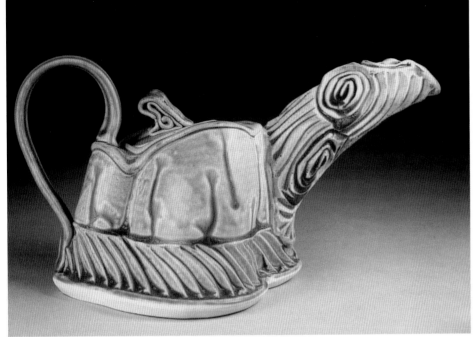

DENISE WOODWARD-DETRICH
Teapot, 2000
8 x 11 x 6 ½ in. (20.3 x 27.9 x 16.5 cm)
Wheel-thrown and altered; slab-built
spout; carved; glaze cone 10 electric

BILLIE JEAN THEIDE
Butte # Czech-3, 1997
5 x 10 x 2 ¾ in. (12.7 x 25.4 x 7 cm)
Slip-cast, altered porcelain; clear glaze;
cone 15 gas reduction; vintage ceramic
decals; cone 015 electric

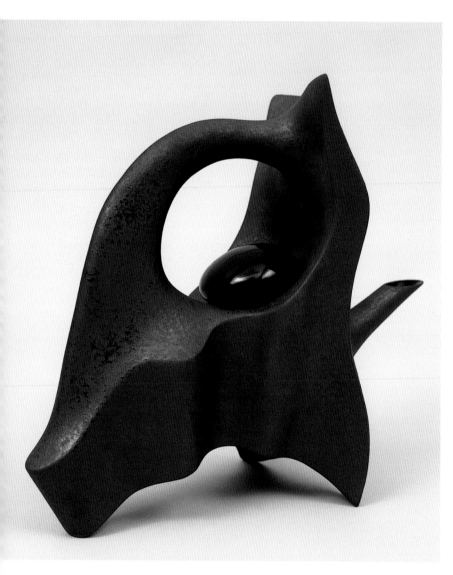

RICK RUDD
Teapot, 2001
9 x 11 x 5 in. (23 x 28 x 13 cm)
Pinched, coiled, and scraped terra cotta;
bisque 1742°F (950°C); glaze 2102°F (1150°C)
Photo by Richard Wotton

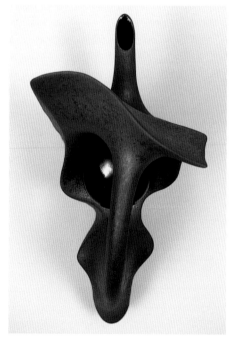

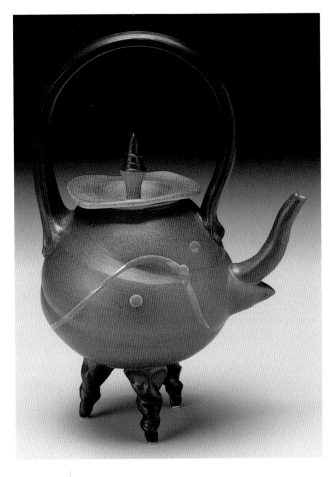

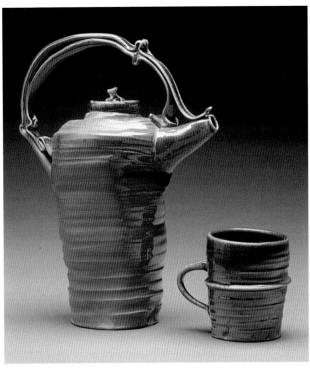

 JANET BUSKIRK
- *Anagama-Fired Tea Set*, 1998
- 10 x 7 x 5 in. (25.4 x 17.8 x 12.7 cm)
- Wheel-thrown white stoneware; cone 13 anagama
- Photo by Bill Bachhuber

DON DAVIS
- *Tripod Teapot*, 1998
- Wheel-thrown porcelain with hand-built additions; sprayed oxide, engobe treatments, and glaze trail; cone 7 light reduction
- Photo by Tim Barnwell

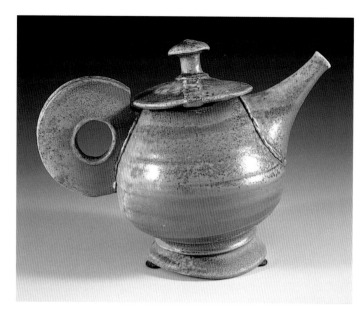

JOHN BRITT
Wood-Fired Teapot, 2000
8 x 10 x 6 in. (20.3 x 25.4 x 15.2 cm)
Wheel-thrown, altered, and assembled porcelain; Avery slip with natural ash; bisque 05; cone 13

DAVID BOLTON
Stacking Teapot (Series IV), 2001
8 x 5 x 9 in. (20.3 x 12.7 x 22.9 cm)
Wheel-thrown and extruded stoneware; cone 9 reduction
Photo by Patrick Young

The stacking teapots are my solution to the meeting of form and function. The teapots have infusers, which aid in brewing loose tea, and there is a container under the teapot for storing tea. This separation of form also allows for more freedom in the composition, lifting the form from the plane on which it sits.

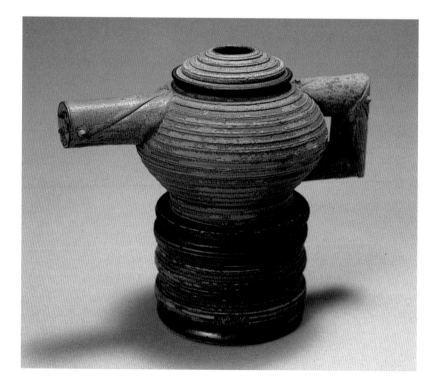

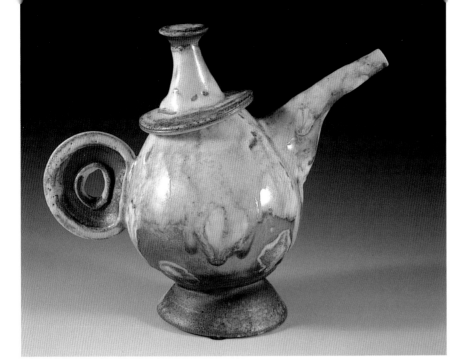

JOHN BRITT
Wood-Fired Teapot, 2000
9 x 11 x 7 in. (22.9 x 27.9 x 17.8 cm)
Wheel-thrown, altered, and assembled; bisque cone 05; Meyer shino and Avery slip cone 13 wood

KRISTEN KIEFFER
Teapot, 2001
10 x 5 x 10 in. (25.4 x 12.7 x 25.4 cm)
Wheel-thrown and darted porcelain; stamped and slip-trailed; multiple glazes; cone 10 soda
Photo by artist

The forms, colors, textures, and parts, such as the knobs, handles, etc., are layers of ornamentation, as well as fanciful signifiers of the bridge between function and adornment.

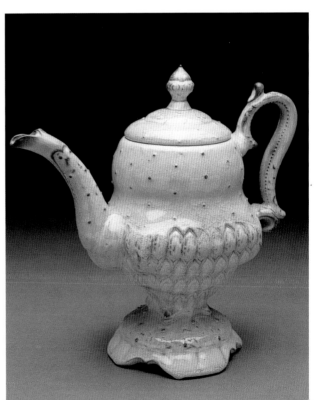

411

ACKNOWLEDGMENTS

Heartfelt appreciation and thanks must go to the many hundreds of incredible, dedicated, and talented potters from around the globe who sent slides of their teapot creations. Their contributions were a joy to see. Grateful recognition is also due Rosemary Kast, whose careful attention to detail was an indispensable contribution to such a large project; art director Tom Metcalf, for his enthusiasm and elegant design; and to Shannon Yokeley, for her tireless assistance to the book's art production.

Suzanne J. E. Tourtillott, Editor

ABOUT THE COVER ARTIST

Tyler Gulden, of Newcastle, Maine, works with the Watershed Center for the Ceramic Arts. He coordinates projects with schools and community organizations through its Mudmobile program, and with artists coming to Watershed for residencies. Tyler received his Bachelor of Fine Arts from New York State College of Ceramics at Alfred University and his Master of Fine Arts from the University of Massachusetts Dartmouth. He makes his home in Walpole with his wife, Kat, a nurse; pre-school son Camden; and newborn Jarrett.

INDEX